比喻
SIMILE

逐光追影及它義
Chasing Light, Shadows, and
Alternative Meanings

隱喻
METAPHOR

目次

Contents

部長序

自攝影技術發展以來，攝影家們不斷探索著光影的藝術魅力。在構築影像的過程中，攝影成為創作者情感投射的對象與感知傳達的媒介，隨著觀者對影像解讀角度日趨多元，攝影家所創造的影像意涵，亦經由觀者的想像與詮釋，而有了表象以外的多層「它義」。

本次國家攝影文化中心推出的「比喻・隱喻：逐光追影及它義」展覽，匯集1950年代至今的臺灣攝影家作品，以作品中經由光、影所營造的構圖、內容、喻意為基礎，引導觀眾去覺察思考攝影家對鏡頭下人、事、物、事件的主觀情思或解譯觀點。本展探討在明示與隱喻的不同表現方式下，如何透過「光影」而豐富攝影影像以外的「它義」。創作者以各異其趣的視角賦予作品微隱或外延的意義，觀者亦可在鑑賞影像的同時，透過個人的生命經驗、社會歷練等，為作品提供不同於創作者角度的多元解讀方式。

臺灣攝影文化的保存、研究與展示是文化部關切的重點工作，國家攝影文化中心以保存國家影像資產為目標，透過攝影展覽籌辦及攝影美學推廣活動，促進當代攝影藝術的交流與對話。本展讓觀者了解光、影是攝影中缺一不可的存在，並探討藝術家的美學創意如何豐富了作品意涵，並激發多元解讀可能性。期許國家攝影文化中心持續以獨特的策展觀點、豐富的展覽內容，呈現臺灣攝影及影像藝術的創新思維。

文化部　部長　

Minister's Foreword

Ever since the emergence of photographic technology, photographers have been exploring the artistic charm of light and shadow. Through the process of image composition, photography has become a medium for creators to project emotions and convey senses, with the meanings behind the created images being filtered through the diverse imaginations and interpretations of the viewers, adding multi-layered 'alternative meanings.'

The exhibition *Simile · Metaphor: Chasing Light, Shadows, and Alternative Meanings* presented by the National Center of Photography and Images (NCPI) gathers the works of Taiwanese photographers from the 1950s to the present day. The images present compositions, content, and metaphors through light and shadow, guiding viewers in a contemplation of the subjective sentiments or perspectives of the people, incidents, objects, and events captured by photographers. This exhibition aims to investigate how the 'alternative meanings' outside of the photographic image is enriched through 'light and shadow' and the various explicit and metaphorical expressions. Photographers use different creative approaches to give works subtle or extended meanings, and when appreciating the works, viewers can add their own interpretations based on their personal life experiences and social encounters that are different from the original intent of the artist.

The preservation, research, and display of the photography culture of Taiwan is a central focus of the Ministry of Culture. The mission of the NCPI is to preserve national photography assets, encouraging exchange and dialogue in contemporary photographic art by arranging photography exhibitions and events that promote photographic aesthetics. Through this exhibition, viewers may gain a further understanding of how light and shadow are irreplaceable existences in photography, and be inspired to explore how the aesthetic creativity of artists enriches the meaning of the works, while, at the same time, inspiring diverse interpretations. I hope the NCPI will continue to present unique curatorial perspectives and exciting exhibitions that showcase the innovative thinking of Taiwan photography and image art.

Minister of the Ministry of Culture

館長序

「光」與「影」，是攝影中並存共在的兩大元素。「光」是讓所有事物能夠被看見的源頭，在影像作品裡，「光」既能代表希望、喜悅或智慧，亦是投射心理狀態、主觀情感的抽象載體。「影」是「光」投射在物件上所形成的陰影或剪影，它的深淺與造型變化，不但能突顯影像細節並烘托出作品的主題，亦能經由創作者的轉譯與安排，反映出不同的氛圍與意境。

隨著人們對圖像的解讀角度日趨多元，攝影家所創造的影像意涵，亦經由觀者的想像與詮釋而有其它理解的可能性。國家攝影文化中心本次邀請姜麗華、呂筱渝兩位策展人共同策劃「比喻‧隱喻：逐光追影及它義」展覽，此展由「比喻之光」與「隱喻之影」兩檔獨立展覽組成，共集結了 38 位藝術家的 166 件作品，透過攝影家們「逐光」與「追影」的影像創作手法，呈現作品背後的言外之意。「比喻之光」聚焦於攝影家運用光線、光暈或光的其他形式，來勾勒出人事物或事件的意象、內容，亦或營造氛圍、衍伸性寓意的相關作品。「隱喻之影」則選展攝影家們捕捉陰影、剪影、投影、倒影等豐富層次的精采影像，展現他們表達精神印記、視覺幻象或主觀意識的創造力。而兩項展覽的共同訴求，則在解放作品被「多重性」詮釋的可能性，鼓勵觀眾在品賞這些光影交織、極富視覺感染力的影像時，除了尋思作者所欲傳達的比喻或隱喻之意，也回返自身，感受自己深受激盪與啟發之處，自由發展出獨屬於個人觀點的「它義」解讀。

「比喻‧隱喻：逐光追影及它義」展，試圖展現攝影中的光影變化與視覺意涵的多元層次。策展人特別關注光與影在影像構築上的創造性表現，同時欲帶領觀者一同以觀察與反思的角度，來深入了解攝影「複義性」與「多義性」的迷人之處。國家攝影文化中心邀請觀眾追隨作品中的光影，凝視自身內心，逐步發掘更多潛藏於攝影影像內的外延性意涵。

國立臺灣美術館　館長

Director's Foreword

'Light' and 'Shadow' are two coexisting and key components of photography. 'Light' allows objects to be seen, and in visual works, 'light' represents hope, joy, or wisdom, but it is also an abstract vehicle for the mental state or subjective sentiments. 'Shadows' is darkness or silhouettes that emerges when 'light' is projected upon an object: the different darkness of shadows, their creation and their metamorphosis, not only accentuate details of the work and enhance the subject matters, but can also create different ambiances and imagery through the artist's interpretative or creative arrangement.

As people's interpretation of images grows increasingly diverse, the meaning behind images created by photographers also diversifies, filtered as it is through the imagination and interpretation of the viewers. The exhibition *Simile · Metaphor: Chasing Light, Shadows, and Alternative Meanings*, curated by Chiang Li-Hua and Lu Xiao-Yu, is composed of two independent exhibitions, *The Simile of Light* and *The Metaphor of Shadows,* and includes the 166 works by 38 artists. The works showcase the photographers' creative methods of 'chasing light and shadows,' highlighting the messages hidden within the works. *The Simile of Light* shows how photographers use lighting, halo, or other forms of light to depict the imagery, message, atmosphere, or extended meaning of the featured people, objects, or events; *The Metaphor of Shadows* displays the compelling images that the photographers created through capturing shadows, silhouettes, projections, or reflections, showcasing the artists' creativity in expressing the imprint of the spiritual, the illusion of the visual, or the subjectivity of the consciousness. Apart from inspiring viewers to deliberate on the similes or metaphors that the photographers wish to convey, immersing themselves in the impactful intertwinement of light and shadow, the shared mission of the two exhibitions is to guide viewers to reflect and savor the inspirations that arise, liberating the possibilities of 'multiple' interpretations and inspiring viewers to form their own 'alternative meanings.'

Simile · Metaphor: Chasing Light, Shadows, and Alternative Meanings attempts to showcase the multi-layered visual meanings behind the changes of light and shadow in photography. The curators spotlight the creative expressions of light in their image composition while guiding viewers into a deeper understanding of the charm of the 'complexity' and 'ambiguity' of photography through an observative and reflective approach. Through the light and shadow within the works, the National Center of Photography and Images invites visitors to gaze into their own hearts and minds to uncover the extended meaning hidden within these photographic images.

Director of the National Taiwan Museum of Fine Arts

策展論述
Curator's Statement

逐光追影及它義
比喻・隱喻：

策展人｜姜麗華／國立臺灣藝術大學專任教授
　　　　呂筱渝／巴黎第八大學婦女與性別研究博士

"

照片是光與時間的化石⋯⋯壓印於化石上的痕跡，不僅僅是過去的遺跡，
對現在正在觀看的人來說，刻畫在其中的訊息，不只是過去的事，
針對現在，甚至是未來，實際上教導我們非常多的事。
也因為懷有這種感覺，我才會認為化石是活的。

—— 森山大道，《畫的學校 夜的學校》[1]

"

1 森山大道著，廖慧淑譯，《畫的學校 夜的學校》（臺北：商周，2010），頁 89。

前言

眾所周知，攝影沒有光（light）就無法成影（image/shadow），唯有借助光才能產生影像／影子，光是影的源頭，影則是光的見證。回顧攝影史的濫觴，無論是尼葉普斯（Nicéphore Niépce, 1765-1833）運用瀝青混有碳粉的薰衣草油形成感光劑，經數小時長時間在陽光下曝曬獲得的「太陽光畫」（héliographie）（又稱「日光蝕刻法」或「日光攝影法」），或是長期專注於經由光產生透視畫幻境的達蓋爾（Louis Daguerre, 1787-1851），接續並改良尼葉普斯的研究，在拋光如鏡的銅版上鍍銀，置入碘蒸氣形成感光版，曝光後取得正像的「銀版攝影術」（Daguerreotype），抑或塔爾伯特（William Talbot, 1800-1877）的「卡羅攝影術」（Calotype），透過在紙上塗布硝酸銀及碘化鉀混合而成的碘化銀形成感光層，以太陽光為光源取得負像，並稱之為「光的素描」（photogenic drawing），皆在在說明光的重要性。

然而，沒有攝影者經由暗箱（camera obscura）或照相機（當今攝影機具眾多，連手機皆可拍照）捕捉這些光，就無法形成影像，凝固這一道道的光，絕非僅是出自意外或偶然。以《浮光》一書談論攝影的臺灣文學家吳明益（1971-）說：「光是從我們的眼睛出來的，流向世界，唯有如此，這一切才是相機所要捕捉的，才是值得捕捉的。」[2] 而我們的眼睛究竟看到了什麼？創作者與觀者看到的影像世界，是否一致？法國學者羅蘭・巴特（Roland Barthes, 1915-1980）以符號學解構了觀看攝影的迷思，在 1980 年出版的《明室：攝影札記》提出解讀攝影的兩項元素「刺點」（*punctum*）與「知面」（*studium*）所指何意？國家攝影文化中心本檔展覽「比喻・隱喻：逐光追影及它義」針對攝影家在作品裡強調光與影的營造與構圖，讓畫面產生的象徵符號（sign）及隱含的喻意，使得觀看者產生個人式的「刺點」。誠如吳明益所言：「無論是感通、靈視、神韻或物哀，都非常強調一種氛圍與臨場經驗。它原本應該是難以言傳的，卻被一些藝術家的作品，成功地轉移到觀看者／讀者的身上了。」[3] 我們從暗箱所見，到我們在明室所思，凝視（gaze）由光與時間聚合的「化石」──照片，從過去、現在甚至未來，經由我們的感官知覺、記憶與情感詮釋照片的多義性，也活化了化石。

2 吳明益，《浮光》（臺北：新經典，2014），頁 51。
3 同上註，頁 268。

多義的象徵符號

Semiology（符號學）一詞源於希臘文 *semeion*，指的是符號、標示或象徵，符號學主要是指語言符號，是一門研究符號（sign）的科學，探索人類溝通過程中，如何透過記號、符碼等符號產生意義。後來被應用在視覺藝術的符號學，並非為了解釋藝術作品而產生，而是著重研究藝術作品如何被觀者所理解，是屬於觀者的範疇。嚴格來說，語言符號學源於瑞士語言學家索緒爾（Ferdinand de Saussure, 1857-1913）研究符號在社會生活中扮演的角色。索緒爾透過「能指」（signifier 或稱「符徵」、「意符」，指承載或產生意義的東西）和「所指」（signified 或稱「符旨」、「意指」，指意義本身）之間的關係來定義符號，他認為「能指」與「所指」之間的關係是任意的（arbitrary），例如在語言中，能指的「紅色」並不是所指的紅色色彩而已，還可能產生其他不同的意義，例如熱情、犧牲、奉獻、瘋狂等它義。在美國創立符號學的哲學家皮爾士（Charles Sanders Peirce, 1839-1914），提出一切經驗與思想都是符號活動，他挑戰了符號不僅只產生單一的想法，亦能產生任意的聯想，即使索緒爾和皮爾士在研究過程中並無交集，研究結果和索緒爾有不少相似之處。另外，皮爾士提出符號學的功能有三個位階：一、「符號」代表某事物的圖像；二、「解釋物」（interpretant）也稱為意義，意指詮釋和心理意象；三、「對象」（object）也是所指之物，符號所代表的事物。皮爾士又將符號區分成三個層面：一、圖像（icon）與能指相關的符號，它的外觀近似於所代表的事物，如交通號誌的圖示所指示的資訊。二、索引（index）藉由可見的符號，指出不可見的意涵，例如眼淚的圖像暗喻悲傷或感動等，抑或孔洞的符號亦能意指神秘不可知的空間等。三、象徵（symbol）以一種任意或既定的方式連結「能指」與「所指」，但它不像圖像和索引一樣是具有實質性和邏輯性，如各家族旗幟上的家徽符號，各廠牌的汽車商標符號，意指著多層的意義。

而巴特則是第一個將符號學思想應用到視覺圖像，如食品廣告、服裝體系、攝影和電影等。他認為攝影是由符號組成，包含人物的手勢、態度、表達，或是影像裡的場景、顏色或效果等，它們在某個社會實踐下被賦予某種意義，我們會依據個人的知識基礎與文化素養，來解讀照片的內容。因此，照片中可以同時存在許多符碼，觀看照片的人則會透過自己的知識與社會文化來解讀照片中的意義。巴特延續索緒爾的觀點，援用語言學的基本概念，試圖分析我們所賦予圖像意義並非是我們所見自然的結果，換言之，在我們理解所見的過程中，圖像的意義並非不言而喻或普遍同一的。儘管文化不能完全決定我們的反應，當我們賦予影像意義，常與特定文化有所關聯。巴特將觀看時立即產生的視覺衝擊稱為「外延意義」（denotation），或稱「明示義」，而觀者賦予它的文化意義則稱為「內涵意義」（connotation），或稱「隱

含義」。「外延意義」是對一張圖像或照片所指涉內容的認識，等同於解讀攝影的元素之一「知面」：依據其個人的知識文化背景，對相片加以解讀的普通情感，具有語碼或固定意義；而「內涵意義」則是對於圖像有所詮釋、賦予意義，而這類的意義有可能反對或超出創作者原有的意圖，等同於主動且猛烈襲擊觀者的「刺點」：有可能存在於相片的細節裡，出乎意料而偶然擾動觀看者的內心，吸引觀者的注目與聯想，並將之連結個人經驗或記憶。同時，刺點不屬於製造的範疇，卻屬於對影像接收的範疇，易言之，是屬於觀者的範疇。甚至巴特強調：「無論其輪廓是否分明，刺點都是一額外之物：是我把它添進了相片，然而它卻早已在那裡。」[4]

在巴特的分析中表明影像提供了兩個層面：外延意義與內涵意義，同時指出攝影的創作理念不可能全然屬於創作者個人的，必定會摻合社會文化的情境脈絡，例如辛蒂‧雪曼（Cindy Sherman, 1954-）1970年代創作的《無題電影靜照》（Untitled Film Still）系列攝影作品中，使用了「女人」作為符號的概念，她進行各種女人身分的扮裝自拍，表現1950年代美國好萊塢電影中女性氣質的刻板印象。雪曼完成的影像不再僅是她個人肖像照的外延意義，她在攝影中運用多層面的社會文化意識形態，使得「女人」這符號無法被固定在特定含義上，形成多重面向的內涵意義，觀者亦能賦予各自任意的解讀。因為任意武斷的主觀需要，將事物由它原始的脈絡中抽離出來，甚至以一種全新的方式來看待它，或是以簡約的方式把事物組合在一起。這種斷裂、不連續、脫落，形成攝影本質的一部分，也造成攝影影像的多重意義性，而攝影的迷人之處往往在於它的複義與多義。正如森山大道（1938-）說：「就算相機是複製的機器，因為在照片裡加入了會生氣、會感傷的個人，也因而出現了兩種含義與多重性。」[5]而這些被製造的意義，常常是攝影者不經意下所賦予，換言之，雖然攝影者曾經「在場」，被攝客體也曾經在鏡頭前真實存在過，然而一旦成為相片裡的意象，它即成為不再「在場」的客體，那麼攝影影像呈現的意象，究竟是真實、幻覺，或只是假象？誠如現象學主要的觀點，意象是物之虛有，它曾經在場絕不容置疑，卻又已延遲異化，[6]變成讓觀看者可以透過每個細節產生徹底的悲憫或愛戀等情感，感受每個屬於觀者個人的刺點。

其實在1967年巴特發表「作者已死」（The Death of the Author）之說，便從符號學重新了解人類的主體性，認為追溯文本原始意義的嘗試都是徒勞，將一個固定意義強加到文本上，將限制了文本多重意義的可能性，提出由讀者進行開創性的文本解讀，而非在文本或作品（work）的源頭（origins）中尋找意義，意義存在於讀者帶領文本抵達的目的地（destination）之中，就此他說原有的作者死了，讀者誕生了。相隔兩年，1969年另一位法國學者米歇爾‧傅柯（Michel Foucault, 1926-1984）雖然和巴特同樣駁斥將作者視為作品（文本）的根源，但他進一步提出「作者——機能」（The Author-Function，或譯作者功能）的概念，闡明作者已不

4 羅蘭‧巴特著，許綺玲譯，《明室：攝影札記》（臺北：臺灣攝影，1997），頁67。
　法文原文："Dernière chose sue le punctum : qu'il soit cerné ou non, c'est un supplément : c'est ce que j'ajoute à la photo et qui cependant y est déjà."。
5 森山大道著，廖慧淑譯，《畫的學校 夜的學校》，頁70。
6 羅蘭‧巴特著，許綺玲譯，《明室：攝影札記》，頁94。

再受限於表達（expression）的需要，而是成為符號的交互作用，它不是受制於「所指」的內容，而是受制於「能指」的本質。傅柯這樣的說法主要目的不是要復興所謂原創性的主體，而是要把握作者賦予社會某些話語（discourses）的存在、流通以及運作的機能，因而產生各式各樣的自我和主體地位，重視作者所占據多重的主體位置，而這些位置由作者所處當代的諸多文化論述所建構，作者也可以同時介入改變這些文化論述。綜合這兩位學者的說法，作者只是眾多話語運作機能中的來源之一，而非傳統論述下話語的絕對創造者，同時讀者與作者皆擁有詮釋作品（文本）的話語權。反觀當今作者的主體性並非建構自其創造的作品本身，可能通過作者的作品重構作者的思想和體驗，或是來自於藝評家對作品意義的詮釋和書寫，以及觀眾對其作品意義的共鳴等途徑。

本展覽主題「比喻・隱喻：逐光追影及它義」以符號學作為策展理念，主要探討攝影家（作者）特意在構圖之中所捕捉／安排光線抑或影子，是否具有何種意涵？或是在展呈時刻意製造光影的效應，試圖建構怎樣的意義？觀看者對於這些光與影，又如何詮釋之？每位觀看者所見所思是否雷同？從創作者的作品（work）之中，經由觀者與作者本身，又能夠衍異而生多少不同的意義？

詮釋光影的複義性

光，可以指日光、燈光等，能由視覺器官接收，使人察覺物體存在的電磁輻射；光也可以指榮耀與名譽、景色風光、時間光陰等；也能形容明亮、光滑或有裸露之意。同樣的，影，可以指圖像或人物的形象，也可指光線被遮擋而造成的陰暗形象，也能形容仿照、描摹或是掩蔽、隱藏等意。[7] 當攝影家特意在影像畫面裡呈現光或影，所製造的意象與觀者所接收的意涵，是否雷同或有所差異？森山大道說：「像我這樣的攝影師，就是日日夜夜將無數的外界複製、收集起來。然後將收集起來的片段，以製作一本攝影集的方式，將至今解體的影像，依循個人的意識與意志，首度嘗試將它們收錄在一起。這時因為現今的自己反映、投射在上面，產生了另一張照片，而一個世界也慢慢地顯現。」[8] 攝影者將所視的世界複製收集起來，依循其個人的意識與意志反映投射在照片上，使得影像產生外延義與內涵義構成了創作者與觀者的所思世界。然而，創作者與觀者所見所思的世界，可能截然不同，也可能相去不遠。

7 以上詞意解釋，見《教育部重編國語辭典修訂本》，https://dict.revised.moe.edu.tw/index.jsp，2022/12/25 檢索。
8 森山大道著，廖慧淑譯，《畫的學校 夜的學校》，頁 51。

以日本攝影家杉本博司（Hiroshi Sugimoto, 1948-）《劇院》系列作品為例，他因興起將電影拍攝成照片的想法，特意將相機曝光時間和電影放映的時間等長。在影片播放時打開 B 快門，隨著時間推移，銀幕上的影像持續播映，在該影片劇終時關閉快門，無論播放的影片劇情內容為何，在長時間曝光下電影銀幕簡化成一片熾白的光。杉本博司在〈虛之像〉一文說：「與其說電影放映在螢幕上，不如說電影被投映在螢幕上，然後再往『空虛』移去。」[9] 對創作者杉本博司來說：「這個動作，把現實中模糊存在的實像轉化為擁有明確方向性和意義的虛像，定影在底片上。」[10] 觀者的角度傾向德國藝術史學家漢斯・貝爾丁（Hans Belting, 1935-2023）在〈幻象劇場〉（The Theater of Illusion）一文中對《劇院》的觀察：「在我們自身的銀幕上描繪了我們生命中的電影，就其意義而言，同時也超越時間的虛空活動。」[11] 現實的時間計量（影片的長度）變得毫無意義。另外，英國作家傑夫・代爾（Geoff Dyer, 1958-）談及杉本博司〈聯合市汽車露天電影院，聯合市〉[12] 作品則指出，杉本博司致力於感受不是什麼的撫慰光芒，冒著過度浪漫的危險，生命已讓位給它曾經「玷染」的永恆白光。[13] 銀白色空無一物的螢幕，隱喻了時間的永恆性。他們兩位觀看者對於創作者杉本博司拍攝的「虛像」——泛白的電影螢／銀幕，提供略有差異的解讀，演繹影像多重的內涵意義。

此外，同樣利用光影與身體、空間結合，所呈現的意象因人而異，觀者解讀影像的感受亦不盡相同。例如劉瑞琪在《陰性顯影：女性攝影家的自拍像》書中，將曼・雷（Man Ray, 1890-1976）的作品〈回歸理智〉（Return to Reason，原為法文 Le Retour à la raison, 1923）[14] 與法蘭雀斯卡・巫德曼（Francesca Woodman, 1958-1981）自拍作品〈無題。波爾德，科羅拉多州〉（Untitled. Boulder, Colorado）[15] 進行比較。劉瑞琪認為前者是展示被動的身體，屈服於空間一般化的觀視力量，而犧牲了個體的主體性，而後者主動營造身體與周遭環境影響而蛻變的自我意象。[16]

實際上，1920 年代曼・雷通過將物體直接放在感光紙上並暴露在光線下製造實物投影（rayogram）[17] 的照片中，光既是主體又是媒介。〈回歸理智〉延續光的研究，他將實物投影這樣的技術擴展到動態影像——他將鹽和胡椒灑在一張膠片上，然後用別針別在另一張膠片上，並加入了遊樂場的夜間鏡頭，以及一段移動中的紙正與自己的影子共舞。〈回歸理智〉這支影片的最後一集介紹了曼・雷的傳奇模特兒愛麗絲・普林（Alice Prin）——也被稱為蒙帕納斯的琪琪（Kiki）——赤身裸體，她的身體被窗外經過的光照亮並留下各種彎曲線條的動態影子。而巫德曼在學習階段，雖曾從曼・雷超現實主義攝影作品中汲取靈感，但她極力發展出自己的風格。她透過許多自畫像捕捉她個人在運動中模糊或部分隱藏在家具或建物等後

9 杉本博司著，黃亞紀譯，〈虛之像〉，《直到長出青苔》（新北：大家，2010），頁 120。
10 同上註，頁 126。
11 Hans Belting, "The Theater of Illusion," in Hiroshi Sugimoto: Theaters (New York & London, Sonnabend Sundell & Eyestorm, 2000), p.12.
　　參閱原文："The film of our life that is pictured on a screen in ourselves, by its very meaning also transcends the empty activity of time."，筆者譯。
12 圖片參閱：傑夫・代爾（Geoff Dyer）著，吳莉君譯，《持續進行的瞬間，談攝影及其捕捉的心靈》（臺北：麥田，2013），頁 220。
13 參閱傑夫・代爾著，吳莉君譯，《持續進行的瞬間，談攝影及其捕捉的心靈》（臺北：麥田，2013），頁 219-220。
14 圖片參閱：劉瑞琪，《陰性顯影：女性攝影家的自拍像》（臺北：遠流，2004），頁 121。
15 同上註，頁 114。
16 同上註，頁 113-121。
17 曼・雷（Man Ray）的 rayogram 與拉斯洛・莫荷里－納吉（László Moholy-Nagy, 1895-1946）的 photogram 是一樣的技法，可翻譯成「實物投影」、「光的投影」、「光繪成像法」、「物影成像」、「物影照片」或譯為「影畫」、「光影畫」、「影繪」等。

面，影像內容提供關於性、身分和自我建構幽靈般的冥想。這件作品〈無題，波爾德，科羅拉多州〉她手拿鍋蓋，讓光在她身體上篩灑彎曲的線條影子，其身體已非單純的身體，「超現實地將身體扮裝成神祕的面容」。[18] 她以此作品向曼·雷致敬，同時也表露女性主動展現身體的主體性。

此外，吳明益談及美國攝影之父史帝格立茲（Alfred Stieglitz, 1864-1946）的作品〈光線——寶拉，柏林〉（*Sun Rays-Paula, Berlin*）[19]，畫面裡呈現因百葉窗打開讓光柵灑入室內產生一道道的斜影，像似一張小說式的照片：「有河流式的情緒，與迷人的小細節。從窗戶走進來的光線，主人翁正在寫信的情境，如此像維梅爾描繪日常的畫作。這並不讓人意外，因為他在『攝影——分離』時期，確實追尋過如畫的影像表現。」[20] 事實上，這張照片是史帝格立茲拍攝他的愛人寶拉（Paula），畫面中牆上的照片包括一張史帝格立茲本人的肖像，他在1889 年拍攝卻遲至1921 年才展出這張照片，也是在轉變以直接攝影為主之後，他才意識到這張照片具有現代主義風格。經由吳明益對此影像的詮釋，被拍攝的主人翁與攝影者之間的情愫顯得更為豐富。

綜上所述，觀者在欣賞創作者逐光追影的影像之際，往往會產生與個人生命經驗相關的聯想，尤其是畫面中特有的光線或是陰影容易形成一種符號，正如巴特在《神話學》談到照片如何使人感到震驚，提醒藝術家應製造具有一些曖昧性，一種厚度滯留的符號，才能將觀者捲入視覺性超越知性的驚訝，而非太具意圖的表象，[21] 進而延伸多義的圖像意義。

攝影術發展至今，攝影家不但藉由相機這個暗箱製造照片，也利用電腦這個黑盒子（black box）創生影像。此次攝影展覽的宗旨，除強調攝影沒有光就無法成影之外，也企圖闡述當我們觀看攝影作品時，影像裡的光影象徵某種符號並具有多重延伸的它義。同時，「一個被相機所拍攝下的瞬間，唯有在讀者賦予照片超出其記錄瞬間的時光片刻，才能產生意義。」[22] 影像裡原有承載的「外延意義」能夠經由他者而演繹出多重且可能意想不到的意涵，形同延伸出它義的「內涵意義」，進而產生轉喻的描述。這些意義的產生具有任意性，無論是經由作者或是讀者，讓影像作品（work）被理解的角度更為開放多元。

18 劉瑞琪，《陰性顯影：女性攝影家的自拍像》，頁114。
19 圖片參閱：吳明益，《浮光》，頁74。
20 吳明益，《浮光》，頁76。
21 羅蘭·巴特（Roland Barthes）著，許薔薔、許綺玲譯，《神話學》（臺北：桂冠，1997），頁108-109。
22 約翰·伯格（John Berger）著，吳莉君等譯，《攝影的異義》（臺北：麥田，2015），頁97。

結語：延伸的它義

總結而言，「比喻・隱喻：逐光追影及它義」匯集國家攝影文化中心典藏1950年代以降早期攝影家拍攝的傳統攝影作品，與當代攝影家運用的器材不僅有類比相機、現代濕版火棉膠、偏光板和偏光鏡形成的複屈折（雙折射）影像、縮時攝影影片、運用數位軟體變造影像等精心創製的作品。每張照片蘊含當時社會的各類人事物／事件，同時「當事件的影像以照片方式呈現時，同樣也會成為文化建構的一部分。」[23] 讓後世的觀者能夠回顧或是遙想前人的種種，甚或產生異於作者創作原初目的的詮釋，構築不同世代的文化觀點。參與「比喻・隱喻：逐光追影及它義」展出的攝影家藉由作品中的光或影，呈現各類人事物／事件，隱藏各式各樣的象徵符號，表現不同的人物與人性之光、城市與空間之光、物件與物體之光，以及線條與人造之光等等所傳達的外延意義之外，衍生的內涵意義形成多樣的比喻之光；抑或是表現人物、人文、心象、幾何、詭異之影，衍生的內涵意義擬似潛意識的隱喻之影。因此，即使在相似的光影中，創作者所營造的氛圍、拍攝的手法和構圖的方式皆各異其趣，而當我們觀看同一張照片時，每個人所關注的細節與詮釋不盡相同，更加豐富了攝影圖像的語意修辭。

SIMILE • METAPHOR :
Chasing Light, Shadows, and Alternative Meanings

Curators | CHIANG Li-Hua
Professor of National Taiwan University of Art

LU Hsiao-Yu
Ph.D. in Women's and Gender Studies of University of Paris 8

"

Photographs are fossils of light and time. For those who view them, the traces imprinted on fossils are relics of the past, but the information engraved upon them points also to both present and future. Fossils teach us, so they are alive to me.

from *School of Day, School of Night, Moriyama Daido* [1]

"

1 Moriyama, Daido. *School of Day, School of Night*, p.89. Translated by Hui-Shu Liao. Taipei, Cite, 2010.

Foreword

We all know that, in photography, an image or shadow cannot exist without light. Light is the source of shadow, and shadow is the witness of light. Looking back at the beginning of photography, Nicéphore Niépce (1765-1833) mixed lavender oil with asphalt and carbon powder as a sensitizer, and then exposed it to the sun for several hours to obtain héliographie (also known as solar etching, or solar photography). Louis Daguerre (1787-1851), who long focused on creating perspective illusions through light, continued and improved upon Niépce's approach. His daguerreotype process involves coating polished copper plates with silver, adding iodine vapor to create a photosensitive plate, then producing positive images after exposure. William Talbot came up with the calotype process which, by coating silver iodide on paper, forms a photosensitive layer, utilizing sunlight to create negatives: he called it a photogenic drawing. All these serve to illustrate the significance of light.

However, it is impossible to form such an image without a photographer capturing the light through a camera obscura or a camera (today, photographic equipment is ubiquitous: even mobile phones can take pictures). Photography is not random or accidental. Wu Ming-Yi (1971-), a Taiwanese writer, in the book *Floating Light*, notes, "Light comes out of our eyes and flows into the world. Only in this way, does it become what the camera must capture and what is worth capturing."[2] But what exactly do our eyes receive? Is the image world seen by creators and viewers consistent? French scholar Roland Barthes (1915-1980) deconstructed the myths of viewing photography through semiology. In his 1980 publication, *Camera Lucida: Reflections on Photography*, he introduced two elements for interpreting photography, "punctum" and "studium." What do these terms mean?

The National Center of Photography and Images' exhibition *Simile Metaphor: Chasing Light, Shadows, and Alternative Meanings* aims at the photographer's emphasis on the making and composition of light and shadow, the signs and their implicit meanings that lead to the generation of a viewer's punctum. As Wu Ming-Yi says, "Sensory communication, spiritual vision, charm, and 'mono no aware' all emphasize an atmosphere and on-the-spot experience. These should be indescribable, yet some artists successfully communicate them to the viewer."[3] Whether seeing through the camera obscura or ponder in the space of clarity, we gaze at photographs, these 'fossils', aggregated by light and time. Through our sensory perception, memory, and emotion of past, present, and future, we interpret the ambiguity of photographs and vitalize these fossils.

2 Wu, Ming-Yi. *Above Flame*, p.51. Taipei, ThinKingDom, 2014.
3 Ibid., p.268

Multiplexity of Symbolic Meanings

Semiology is derived from the Greek word *semeion*, which means sign, mark, or symbol. In the 1960s, the study of semiology mainly focused on linguistic signs, a science of how meanings are produced through the signs of human communication. Semiology was later applied to visual arts, with the focus being on how viewers understand artwork, rather than being used to interpret art. Strictly speaking, linguistic semiology originated from Swiss linguist Ferdinand de Saussure (1857-1913) and his study of the life of signs in society. Saussure defined signs with a model describing the connection between a signifier, which refers to something that carries or produces meaning, and the signified, the meaning itself. He suggested the relationship between the two to be arbitrary: for example, in a language, 'red' as a signifier is not just the color it refers to; it may also establish other differing meanings such as passion, sacrifice, dedication, and madness.

Charles Sanders Peirce (1839-1914), a philosopher and pioneer in semiology in the United States, theorized that all human experience and thinking are conducted through signs. Though he did not come across Saussure during the research process, Peirce came to a similar conclusion that signs do not always produce single ideas, but encompass a variety of arbitrary concepts. Peirce saw semiology as having three levels of function: a sign is a visual representation of something; interpretants are meanings, indicating both interpretation and disposition; lastly, an object refers to something given connotations, a subject matter of a sign and an interpretant. Peirce also categorized three main types of signs: icons are signs that resemble their referents in terms of appearance or physical traits, like explicit images on traffic signs; indexes relate the invisible meanings to visible referents, such as the sorrowful to tears, or the mysterious unknown to holes; as for symbols, they are signs connecting arbitrary and conventional meanings. The connections do not necessarily originate from pragmatism or logic. For example, family crests and company logos on cars can carry many layers of meaning.

Roland Barthes pioneered studying visual cultures, such as food advertisements, fashion and clothes, photography, and films, with semiology as the method. He considered photography to be composed of signs, including gestures, attitudes, expressions, settings, and colors or effects of images. These signs are given specific meanings through social practice, and people interpret what they see in photographs according to personal knowledge and cultural understanding. Barthes departed from Saussure's views and adopted basic concepts in linguistics to explain that the meanings of images are not attributed to nature; that is, the implications generated through our viewing and understanding are not necessarily self-evident or homogeneous. Though cultures cannot ultimately determine how we react to images, specific cultural components are often involved in giving meanings. Barthes used 'denotation' to refer to the direct visual impact we receive, and the cultural meanings given by viewers is named 'connotation.' Denotation is a person's understanding of the content in an image or a photograph and equates with 'studium', one of the elements of photography. Studium refers to the ordinary emotions felt when interpreting pictures according to one's intellectual and cultural background, with social

or linguistic codes. Connotation, on the other hand, appears as ideas or feelings in addition to the creator's intention and becomes a "punctum," aggressively impacting viewers. A punctum might exist in the tiny details of photographs, disrupting the mind, attracting the attention, and triggering associations with personal experiences and memories. Punctum is about receiving images, the realm of the viewers, rather than about producing them. Barthes emphasized, "Whether or not the contour is clear, punctum remains. I add it to the image, yet it was already there."[4]

Roland Barthes's theory of denotation and connotation reveals that theories of photography are not monopolized by creators but partly attributed to social and cultural contexts. Cindy Sherman (1954-) created the photography Series *Untitled Film Still* in the 1970s. She employed women as a symbol and took selfies of herself in various costumes to represent the stereotype of femininity in 1950s Hollywood movies. Sherman's images carry not only the denotation of her portrait but the connotation, layers of cultural and social ideology she used to shake fixed concepts that were bound to woman as symbol. Extracting things from their original context, viewing them in a new way and arranging them according to simplicity and arbitrary purpose have become part of the nature of photography. This breakage, discontinuation and detachment also leads to the compounding of meanings in photography, that complex and multiplex quality that always draws attention. Moriyama Daido said, "Cameras are machinery for reproduction. When people, with all their tempers and sentiments, are added to photographs, a multiplexity of meanings appears."[5] Photographers often create these meanings unintentionally. While photographers and photographed objects are present at a shoot, once a photo is created, they are not present in its imagery anymore. Is the imagery real or illusive? As phenomenology suggests, imagery is the nothingness of things. It is present beyond doubt yet is always perceived later.[6] This quality allows viewers to experience their personal punctum through the pity or love instilled by the very detail of the images.

When Roland Barthes published *The Death of the Author*, he re-imagined human subjectivity from the perspective of semiology. He believed that attempts to trace the text's original meaning were futile, imposing a fixed sense on the text and limiting the possibility of multiplexity in the text. He proposed that the readers conduct innovative interpretations of the text rather than looking for meanings in the text's origins or work. Definitions exist in the destination where the readers lead the text. Barthes commented, "Only when the author dies can the reader be born." Two years later, in 1969, another French scholar, Michel Foucault (1926-1984), who also refuted the author as the source of the work (text), proposed the "author-function" concept. He clarified that the author is no longer limited by the needs of expression, but becomes the interaction of signs bound by the essence of signifiers instead of the signified content. Foucault did not intend to revive the subjectivity of so-called originality via such a statement, but to grasp the existence, circulation and operative functions of certain discourses endowed by the author to society that produce various self and subject positions. He emphasized the author's multiple subject positions

4 Barthes, Roland. *Camera Lucida: Reflections on Photography*, p.67. Translated by Chi-Ling Hsu. Taipei, Taiwan Photography, 1997.
 (Original text in French, "Dernière chose sue le punctum: qu'il soit cerné ou non, c'est un supplément: c'est ce que j'ajoute à la photo et qui cependant y est déjà.")
5 Moriyama, Daido. *School of Day, School of Night*, p.70. Translated by Hui-Shu Liao. Taipei, Cite, 2010.
6 Barthes, Roland. *Camera Lucida: Reflections on Photography*, p.94. Translated by Chi-Ling Hsu. Taipei, Taiwan Photography, 1997.

constructed by contemporary cultural discourses, with the author simultaneously intervening in these cultural discourses. According to the two scholars, the author is only one of the sources of the many discourse functions, not the absolute creator of discourse as traditionally believed. Both readers and authors have the discourse power to interpret works (texts). On the other hand, the subjectivity of today's authors is not constructed from the works they create. Conversely, their works, their interpretation by art critics, and the audience's perception may all reconstruct the authors' thoughts and experiences.

The exhibition's theme, *Simile · Metaphor: Chasing Light, Shadows, and Alternative Meanings*, includes semiology as its curatorial concept and explores the meanings behind photographers' (authors') captures and arrangements of light and shadow in the composition of pictures. Specifically, we would like to look at what meanings are constructed via the effects of light and shadow while exhibiting, how viewers interpret these lights and shadows, and how many different meanings can be extracted from the works by viewers and authors alike.

Interpreting the Complexity of Light and Shadow

Light can refer to sunlight, lighting, and so forth, received by the visual organs and communicating to us an awareness of the electromagnetic radiation of objects; light can refer to glory and reputation, scenery, and time. Light describes bright, smooth, or naked things. Shadow can refer to an image or the contour of a person, a dark appearance caused by the occlusion of light, and describes imitation, tracing, masking, or hiding.[7] When a photographer deliberately arranges light or shadow in an image, is the image the same or different from what is received by its viewers? Moriyama Daido once said, "A photographer like me copies and collects countless outside worlds, day and night. Then, I attempt to create a photo book, manage the fragments, and collect the disintegrated following my individual consciousness and will. The current self is reflected and projected on the collection, another shot is produced, and a world is slowly revealed."[8] The reflection and projection of the reproduction of what a photographer sees give the images denotations and connotations and constitutes the worlds of both creator and viewers. However, the worlds seen and thought by both parties may be completely different or largely similar. "The film of our life, projected on the screen of our self, transcends by its very meaning the empty activity of time."

Japanese photographer Hiroshi Sugimoto (1948-) started his Theaters collection with the idea of shooting photos of films. He set the B shutter at the beginning of films and, as time went by, the screening continued, and he closed the shutter at the end. No matter the stories on the screens, under long exposure, the films all became panels of white light. Hiroshi Sugimoto commented in his article *Virtual Image*, "Rather than just 'projecting', it is better to say that these films are projected on the screen and then moved into 'emptiness.'"[9] To Sugimoto, "This process turns the existing vague images into virtual images with clear purposes and meanings and prints them on films."[10] German art historian Hans Belting (1935-) noted in *The Theater of Illusion* that when

7 Word definition referred to *Revised Mandarin Chinese Dictionary*. National Academy for Educational Research, Taipei, Taiwan.
 Website: https://dict.revised.moe.edu.tw/index.jsp.

8 Moriyama, Daido. *School of Day, School of Night*, p.51. Translated by Hui-Shu Liao. Taipei, Cite, 2010.

9 Sugimoto, Hiroshi. *Virtual Image, Time Exposed*, p.120. Translated by Ya-Chi Huang. New Taipei City, Common Master Press. 2010.

10 Ibid., p.126.

he watched Hiroshi Sugimoto's *Theaters*, "It depicted the cinema of our lives on our screens. In a sense, it surpassed the void of temporal activity,"[11] and thus the measurement of time (the length of the films) becomes meaningless. British writer Geoff Dyer (1958-) talked about Hiroshi Sugimoto's *Union City Drive-In, Union City*,[12] pointing out that Sugimoto committed to feeling the soothing light of nothing and risked the danger of being over-romantic. Life gives way to the eternal white light it once stained.[13] The empty silver-white screens act as a metaphor for the eternity of time. As the viewers, Belting and Dyer provided alternative interpretations of the virtual images, the white screens by Hiroshi Sugimoto, demonstrating the multiplexity of connotations of images.

Additionally, the presentation of images varies from person to person, even if photographers all combine light and shadow with body and space. Viewers have different feelings when interpreting images. In the book *Negative Appearance: Self-portraits of Female Photographers*, Liu Rui-Chi compares Man Ray (real name Emmanuel Radnitzky)'s work *Return to Reason* (original French *Le Retour à la Raison*, 1923)[14] with the selfie *Untitled. Boulder, Colorado* (1972-1975) by Francesca Woodman (1958-1981).[15] Liu Rui-Chi believes that the former shows the passive body that surrenders to the power of generalized space and sacrifices the individual's subjectivity. The latter actively creates the body and a self-image transformed by the influence of the environment.[16]

In the 1920s, Man Ray placed objects directly on photosensitive paper and exposed them to light to create rayographs, where light is both the subject and the medium.[17] Continuing the study of light with *Return to Reason*, he extended the techniques of the rayograph to moving images. He sprinkled salt and pepper on a film, then pinned it to another film, and added a nighttime shot of a playground and a piece of paper dancing with its shadow. The final episode of *Return to Reason* introduced Man Ray's legendary model, Alice Prin, also known as Kiki of Montparnasse. Naked, her body was illuminated by the light passing through the windows, leaving dynamic shadows of curved lines. While Woodman was developing, she drew inspiration from Man Ray's surrealist photography, yet managed to develop her style. Capturing herself blurred in motion or partially hidden behind furniture and buildings in many self-portraits, her images offer ghostly meditations on sexuality, identity, and self-construction. In *Untitled. Boulder, Colorado*, she holds a pot lid in her hand, letting the light cast curved shadows on her body, which is no longer straightforward. "Surreally transforming body into mysterious visages," she paid homage to Man Ray with this work and revealed the subjectivity of women's initiative in showing their bodies.[18]

Furthermore, Wu Ming-Yi talked about *Sun Rays-Paula, Berlin*[19] by Alfred Stieglitz (1864-1946), the father of American photography. The slanting shadows filtrating through blinds form a photo seemingly from a novel, "with river-like emotions and charming small details."[20] The light coming

11 Hans Belting, *The Theater of Illusion, in Hiroshi Sugimoto: Theaters*, p.12. New York & London, Sonnabend Sundell & Eyestorm, 2000.
12 Dyer, Geoff. *The Ongoing Moment*, p. 220. Translated by Li-Chun Wu. Taipei, Rye Field Publishing Co., 2013.
13 Ibid., pp.219-220.
14 Liu, Rui-Chi. *Feminine Image Development: Selfies of Female Photographers*, p.121. Taipei, Yuan-Liou, 2004.
15 Ibid., p.114 .
16 Ibid., p.113-121.
17 Rayograph by Man Ray is the technique of László Moholy-Nagy's photograph.
18 Liu, Rui-Chi. Feminine Image Development: Selfies of Female Photographers, p.114. Taipei, Yuan-Liou, 2004.
19 Wu, Ming-Yi. *Above Flame*, p.74. Taipei, ThinKingDom, 2014.
20 Ibid., p.76.

in from the window and the scene of the protagonist writing a letter are like Vermeer's paintings of everyday life. Unsurprisingly, during the "photography-separation" period, he did pursue a more picturesque mode of image expression. The photo is of Stiglitz's lover Paula. The pictures on the wall include a portrait of Stiglitz himself, taken in 1889, but exhibited as late as 1921. After he switched to candid photography, he realized that this photo had a modernist style. Wu Ming-Yi's interpretation enriches the relationship between the object and the photographer in the image.

To sum up, viewers often associate personal life experiences with the unique symbols formed by light and shadow, appreciating a photographer's pursuit of the same. As Roland Barthes discussed in *Mythology*, photos could shock people, and he reminded artists to create ambiguity, a kind of thick and lingering symbol that swirls viewers into a visual surprise beyond rationality, avoiding intentional appearance, and thus extending the polysemy of the image.[21]

Conclusion: The Other Meaning of Extension

Since the development of photography, photographers have evolved from the camera obscura to creating digital images using computers. Along with the emphasis on the coexistence of light and shadow in photography, this exhibition discusses the multiplexity of extended meanings of light and shadow. "A moment captured by the camera can only produce meaning when the reader gives the photo the time beyond the moment the photographer took it."[22] The denotation in images can be extrapolated into multiple and possibly unexpected meanings, extending the connotation, and producing metonymic descriptions. The generation of these meanings is arbitrary, whether through author or reader, opening diverse perspectives through which to understand the works.

In conclusion, *Simile · Metaphor: Chasing Light, Shadows, and Alternative Meanings* presents traditional post-1950s post-1950s photographic works from the National Photographic Culture Center's collection, as well as works created by contemporary photographers using analogue cameras, wet plate collodion, colored rayograph, double refraction, time-lapse photography, and digital alteration. Each photo contains the events, people and things from that time. "Representation in the form of images also becomes part of the cultural construction."[23] They allow viewers of later generations to look back to or think about the past, and produce interpretations differing from the authors' original intentions, building their own cultural perspectives. The photographers in the exhibition hide various symbols behind the light and shadow in the photos. These works present the denotative meanings of character and human nature, cities and spaces, objects, lines, and artificial light. In addition, the connotations establish a variety of symbolic auras. Under the shadows of characters, humanity, mentality, geometry and oddity, the connotations are like the branching shadows of the subconscious. Even within this common medium of light and shadow, the photographers create unique atmospheres, using a wide variety of different shooting techniques and compositional methods. Looking at the same photo, everyone pays attention to distinct details and interpretations, enriching with their own light the shadowy semantics of the photographic images on display.

21 Barthes, Roland. *Mythology*, pp.108-109. Translated by Chiang-Chiang Hsu and Chi-Ling Hsu. Taipei, Laurel, 1997.
22 Berger, John. *Understanding A Photograph*, p.97. Translated by Li-Chun Wu, et al. Taipei, Rye Field Publishing Co., 2015.
23 Ibid., p.100.

專　文
Essays

影的觸覺

從光的蹤跡到

策展人 ｜ 呂筱渝／巴黎第八大學婦女與性別研究博士
姜麗華／國立臺灣藝術大學專任教授

一般對光與影的普遍概念是，光與影是一體之兩面。影的出現必然代表有光照射著物體，影見證了某種現在進行式，一個當下、某種依存關係。然而我們很容易對光與影之間的中介物視而不見，例如，當冬日的斜陽映照出我們長長的身影，是眼前變形、不合比例且無法觸摸的黑影令人著迷，而不是這個可碰觸的肉身：影子既反射了「我」，卻又不是「我」——影是讓我們迷惑的「它我」（alter ego），一個如影隨形，既是「非我」，但也非「非我」，難以名狀的存在體。

就此而言，表面上看來光似乎不如影來得重要，但絕非如此。眾所周知，沒有光何來影，光影的依存關係緊密，即便是一片稀薄的雲層，在陽光下都能在大地投下一片陰影，因此欠缺被光照耀的人、物、雲等的中介體，也就不會產生影子。於是「光—物—影」形成微妙的三角關係，作為光影中介的「物」之所以令人忽略，正是因為它是真實的物質存在，以及它的穩定與單調，相形之下，光與影是非物質的存在，稍縱即逝且變化多端。對仰賴視覺為主要感知途徑的人們而言，記錄這變幻多彩的偶然片刻，與之共在並將之留存，即是森山大道口中的「照片是光與時間的化石」。[1] 本展「比喻‧隱喻：逐光追影及它義」，「逐光」與「追影」的概念看似被動地等待或邂逅那令人為之驚異的刹那，然而透過攝影，它能主動地凸顯已存在或創造不存在的光與影之對話。

1 森山大道著，廖慧淑譯，《畫的學校 夜的學校》（臺北：商周，2013），頁89。

一、光為上帝所創，影像為人所造

神說：「要有光。」（《聖經》〈創世記 1:3〉）就有了光，
創造浩瀚穹蒼的上帝也創造了光，而攝影家所造的影像成為光的化石，
我們從中看到光之神聖及其演繹。

光之神聖

何經泰〈小米梗〉向上噴散的氬氳、高志尊的〈Firenze〉一道從天井流瀉而下如瀑布的光芒，
和張武俊〈青瓜寮〉一束夢幻的月光，含蓄而聖潔的光，莫不令人升起敬畏之心。而最貼合宗
教主題創作的，莫過范晏暖的裝置創作。范晏暖的作品圍繞著「光」這一主題，進行科學性
與宗教性的探討，儘管兩者的立論不同，但在靈性的詮釋方面卻具有相同的神性象徵意義——
光既是色彩，也是造形；是明亮的光線，也是清澈的本體；光能照耀聖殿，亦能驅走黑暗。
對藝術家而言，光本身就是上帝，而藝術作品的生成，是為了表達永恆神國的靈性追求。此
外，基督宗教的十字（cross），是最能代表耶穌的象徵符號，在杉本博司拍攝安藤忠雄的光
之教堂，一道白光從鏤空的十字牆面射入暗室，營造上帝之光驅走黑暗的神聖感，而傅朝卿
〈聖吉米安諾大教堂〉，也同樣在教堂中捕捉到這種光與建築的巧妙結合。與西方教堂對應
的臺灣佛寺，簡榮泰的〈高雄大樹〉，也用一縷光芒自高處斜射而下，照亮佛龕直至僧侶身上，
來表達寺廟的清淨莊嚴。除了教堂寺院等具體空間以外，張志達的〈逆光飛翔：轉身後的自由〉
將二度與三度空間，並存在同一張影像，踩在十字形光線下的孩童，他所處的廢墟，其實只
是真實世界裡一片斑剝的牆面，將文學修辭的迴狀嵌套法（mise en abime）運用在影像創作上。

十字的光是聖潔的象徵，那麼十字形的影，在張國治的光影系列是兩組對立符號的相遇：西
方的十字形 vs. 東方的回字紋（〈一樣的光影〉）、希臘羅馬柱式 vs. 閩式建築（〈1973 年〉），
以及光的理性 vs. 影的抒情。光與影的關係，與其說「『逐』光『追』影」，毋寧說是「『採』
光『納』影」，如他所言，是在「外在不確定因素浮動發展的現象，亟待光明方向的指引」。[2]
而少了十字光中一豎，則完全脫離了宗教意涵，成為象徵潛意識的一道可見的光束。李毓琪

的作品《近郊》，指的並非住家附近的郊外，而是隨時可抵達的夢境。既然是夢，便與黑夜有關。夢境中的一道藍光，猶如探照燈般不斷前進，劃破了黑暗，也照亮經過的地方。這條藍色的夜光也是一道穿射的（人造）光芒，將畫面一分為二。如果暗夜的近郊比擬為心靈，那這束不停行走照射的藍光，又是否是主體的潛意識呢？

從黑夜回到白天，從潛意識回到現實。林國彰的〈忠孝西路北門〉，捕捉斜陽穿透城門外壁窗洞的片刻，逆光的剪影，烘托出朗朗晴空下巍峨的承恩門。在這市景多變的臺北，令人心裡安穩踏實的，莫過於這座矗立百年的歷史建築。

光之歷史，人之生存

陽光是萬物生存的要件之一，沒有光照耀萬物，也就沒有人類。然而在陽光普照的世界裡，唯獨自亙古走來的人類，能為自己的物種創造文明的萬丈光芒，而文明的起點奠基於生存與繁衍。阮義忠〈臺南億載金城〉中，一行參加婚禮的親友走進臺南安平二鯤鯓砲臺的門洞，彷彿穿越清朝沈葆楨建立的時光隧道，接受人類歷史的見證與洗禮；照亮門洞廊道的燦燦日光，也為這場婚禮帶來希望、喜悅和祝福的氣息。

可惜人類的文明之光未必總是璀璨無瑕，歐陽文的〈歸途（牛車）〉，記錄了綠島中寮村一名女孩牽著牛車踏上歸途，這個場景一片透光的積雲還鑲著金邊，但雲層以外的天空卻是漫天的陰霾。經歷二二八事件同時也是白色恐怖受難者的歐陽文，在 1950 年代暗房設備極為簡陋的綠島——樸實的綠島上關押政治迫害的無辜人民——沖印出這幀充分反映時代氛圍與歷史意義的攝影作品。然而倘若享有基本的生存權都無法指望人類，那麼寄望神明保佑似乎是唯一可行的方式。邱德雲〈水褲頭相簿（二）96〉，一張燈盞熒熒的神桌前祈求闔家平安，這個市井小民最卑微的願望，端賴是否能擲得神明應允的聖筊。走出生命的陰霾，就在陽光的映照下，周鑫泉的〈自修功課〉與林柏樑的〈周夢蝶〉有著類似的主題——知識與文人——知識是驅走愚蒙的途徑。斜射的日光象徵智慧之光照亮屋外倚牆閱讀的女孩，而睿智的詩人則端坐室內，他拘謹自持的特質融入滿室溫煦的冬陽。

光之科技

現代人忙著留意別人的動態或傳來訊息，或為了在未來炫耀必將消逝的「現在」而忙著自拍，這種無法專注當下的狀態，不知是人際的疏離帶來資訊（圖像）成癮現象，還是成癮現象造成了人際的疏離？抑或是人性的特質之一？

王鼎元挪用了西方藝術史上的名畫，通過他所說的戲仿諧擬的畫面，將畫作中的情境轉變為現代生活的場景，以戲劇化的畫面反諷沉溺在數位科技中的現代人。這種現代科技無所不在的「光」，充斥且支配了人類的食衣住行、工作型態與溝通模式。在簡易、便利、迅速的效益下，人與人不須四目交接，也不必把酒言歡，手機、電腦、平板等 3C 產品所製造和傳輸的影像、影片、視訊與音訊，取代了傳統的身體互動的溫度，一切都可以去物質化和數位化！《臉上的光彩 2.0》系列，除了展現藝術在觀察現象、提出問題的社會功能外，也以古今中外對照的方式，讓我們回顧還沒發明 3C 產品的世界和歲月，思考現在的我們，究竟是役物，還是役於物？

隨著物理光學研究的進展，光與物質的交互作用所產生的雙折射（birefringence，又稱複屈折），即一條入射光線產生兩條折射光線，造成不規則、對稱、紋飾、幾何、疊影等圖案，也成了攝影愛好者感興趣的視覺圖像。由於偏振現象產生詭異色彩和奇特條紋，此種影像本身蘊含「虛像」與「幻覺」的思考空間元素。林芙美認為：「『虛像』源之於實有物體的再造與顛覆，屬於外在的辨識空間；『幻覺』源之於實有物體經外力之改變後，所引發的錯覺、錯視與錯認，屬於內在的省思範疇。」[3] 林芙美結合實物與偏振光構成的系列影像，配以感性的標題如「邂逅」、「孕育」等，宛如創造一個奇幻的想像空間，為自然具象的光影之外，增添了一種來自抽象世界獨有的語彙。而深深為表層底下的隱藏世界所吸引的劉永泰，則透過 X 光攝影，拍攝自己的頭部（〈自我頭殼（X 光）〉），或如〈自我手鍊（X 光）〉是以手掌、鐵鍊、魚、蝦、雞頭等並置所拍攝構成，又或者拍攝鐵釘此種單一物件，來呈現出事物的表相下色彩繽紛的幽微空間。

的確，放大並觀察物件的細部，能夠 化我們的感官能力，去發現日常生活細微之處那些不易覺察的光的蹤跡，則是邱誌勇《空間物件》系列的主要命題，這些藝術家所謂「細微日常」的光或電流，之於邱誌勇，意謂著「透過攝影家的眼睛，觀察日常生活中細微而美麗的物件或風景，從中發現其有意味的形式。」[4] 也讓觀者的視線，馳騁在各自的想像空間。

3 引自林芙美《交集與干涉》創作自述，參閱本展覽專輯，頁 238。
4 引自邱誌勇《空間物件》創作自述，參閱本展覽專輯，頁 263。

消光與滅影

儘管上帝說：「要有光。」世界便有了光。但攝影家說：「滅了吧。」存在的景象就「消失」了。洪世聰從原有的影像裡面抹除了建築的違章、街道的招牌、懸晃的電線……。如同清道夫般，他「清理」了本不屬於這個環境裡累贅、雜蕪的物品。於是，原本被贅物所掩蓋、干擾的、真正屬於此時此刻的「浮現物」始為存在。

在三重通往臺北的忠孝橋上，視覺的邊界變得遼闊，視線貫穿忠孝東、西路直達臺北 101 大樓，而作為臺北人歷史記憶的北門，成為這條視覺軸線上的焦點。車水馬龍的臺北車站前，沿路的電線桿提示我們正身處臺北最繁忙的街道之一，這排照明的路燈，也與對面高聳的商業建築互相呼應著。然而在這裡，一切恰如其分，被抽離的色彩就像被隔離的噪音，留白的地面讓馬路得以呼吸，人群不太擁擠、車輛悄聲行進，彷如白雪覆蓋的瞪瞪世界，冷冽、靜謐——這是現代都市人內心投射的奇境——唯有寂靜，與秩序。

這些眼前熟悉的景象，通過洪世聰操控滑鼠的手，變成被剝除的實景；它存在，並且在影像的層次上它會是更好的存在。他說：「人可以看盡精華而沒辦法拍盡所見，所謂鏡頭中浮現的初始就在其中，讓所觀察的『浮現物』成為『攝影後作為』的自我的解析，發掘並浮現出越來越有『去』新的樣貌。」這個他所謂的「攝影後作為」[5]，同時也轉換了攝影的紀實功能，宛如將實體和影像一分為二，再為後者披上超現實主義的外衣。

心理的光及其空間

光能影響人對空間的感受，不同的光線營造出不同的氛圍，相對於客觀的物理空間，在此稱為主觀的心理空間，而這樣的心理空間不但是主觀，而且是片面的，例如葉清芳的《現實‧極光‧邊緣》系列。此地乃是位居臺灣東北角，曾因礦產而風光一時的繁榮小鎮，儘管1980 年代因礦業沒落、人口持續外流，景氣亦隨之蕭條，但仍然吸引身為瑞芳人的葉清芳為它留下珍貴的影像紀錄。他所拍攝的九份昇平戲院名聞遐邇，自日治時期一直是戲劇演出與電影播放的舞臺，也是銜接西方文明的入口，曾幾何時，這座文明的象徵在 1980 年代末期，也不敵席捲全臺的牛肉場風潮，搖身一變成為大膽露骨的「清涼秀」表演場。然而葉清芳眼

5 引自洪世聰〈視而浮現〉創作自述，參閱本展覽專輯，頁 246。

中的昇平戲院，呈現空間的沉鬱和時間的凝滯，一種蕭索的時空——這像是一個剝除了大部分現實的客觀條件，由葉清芳投射出的心理空間——清冷、寥落。

山城之外，深夜的大城市也有它的心理空間。法籍攝影家余白（Hubert Kilian）作品裡的燈泡、燈管和路燈幾乎如同空氣般無所不在：燈光驅離黑暗，創造了一個臨時棲身的空間；日光燈下熱情招呼客人的麵攤老闆，兩人共存於此時此刻，在燈的見證下、在黑暗的包圍下，共度一碗麵的時間。然而暫時「安放」人們身心的一隅，不過是相遇的陌生人家的騎樓、巷口的麵攤、偶爾光顧的饅頭店、路過的檳榔攤等，甚至只是一張布滿陳年油汙的廉價餐桌。

在臺灣，旅館提供另一種私密的相遇。這些供人短暫休憩的旅館，透過燈光設計與精美裝潢製造情慾導向的空間。陳淑貞的《After》系列，走訪臺灣各個城市的汽車旅館，經由拍攝旅館的內部空間，發現人們在不同空間裡的設計性光源，也會重組自我存在的不同樣貌，例如居家的燈照明燈具與汽車旅館的燈光設備，因兩者的功能和需求不同，該空間的光源所傳達的訊息和被賦予的意義就會有所不同。陳淑貞指出：「空間因『光』而存在，我們自身也因『光』重組了自我存在的樣貌。」[6] 黑暗的我們雖然身處空間之中，卻無法感知空間的界線，也就無從確立自我與空間的分野。因此，光的存在不僅使我們身體、心理等內外的邊界變得可見，也使得因光被喚醒的自我感有所不同。然而弔詭的是，光與影是伴隨而生的，在看似不存在的「影」、或者「影」被視而不見的物理空間裡，「影」其實是潛抑至我們的心理空間；影是光作用於物體上所產生的視覺重量，光與影之關係的交纏與不可解，正如陳淑貞的結論：「投射了自我生命的本質與那種——生命裡不可承受的輕」。[7]

疏離的天光之下

夜幕撤離，逐漸被天光下占領的首善之都，是金融、工商、服務業蓬勃發展之地，也是全臺各地移居者匯聚的所在。高密度人口與高房價，臺北不僅居大不易，人與人的關係也不若農業社會雞犬相聞的街坊型態，「疏離」彷彿是都市人擺脫不了的宿命。林國彰的〈中山北路臺北故事館〉，拍攝北美館廣場上一件空間裝置作品，它是由六十七片偏光片（polarizer）組成的環狀廊道。進入作品空間內部的母女三人，與映射在偏光片上的周遭景物相互重疊，顯得迷幻而疏離，在視覺呈現上，首先看到的是外在扭曲的景物與內部人像交疊的影像，而這偏光片上的虛像，與落在遠處、真實的臺北故事館再度形成對比。

6 引自陳淑貞《AFTER》創作自述，參閱本展覽專輯，頁 260。
7 同上註。

葉清芳拍攝的動物園〈現實．極光．邊緣系列 -46〉也有類似的表現手法，相片中的貓頭鷹被關在厚重的玻璃門裡面，門裡一株傾斜橫生的假樹作為牠棲息的枝頭，也與戶外真實的林樹互相輝映。駐足在玻璃門外的男孩，顯然對這隻禽鳥很感興趣，在葉清芳抓取的角度下，孩童的臉孔恰巧與門內的貓頭鷹幾乎完全重疊在一起，呈現一種分不清是人是鳥的詭異情景。而玻璃門片同時也反射出鏡頭之外的情景：一對站在較遠處，也正在觀看貓頭鷹的父女、路過的遊客側影、今日已不復見的供人休憩的白色鐵製公園坐椅和不鏽鋼垃圾桶。同樣帶著一種疏離寂寥的氣息，賴譜光偌大的〈影像 1-2：天下無不散的筵席．木柵動物園〉宛如一個神秘入口、〈影像 1-3：與常玉不期而遇．淡水河左岸〉悠哉的狗群與草地上倒放的帆船、〈影像 1-1：徵婚啟事．香港東鐵〉車廂內冰冷對坐的兩人，這三件作品也都給人一種不真實的詭異感受。

二、影是光作用於物產生的視覺重量

肉眼可見的光源發射的光線，一旦遇到不能穿透的物體，直線前進的光線便會在物體背後產生無光區域，即為該物的投影，也就是我們常說的影子。西方傳統繪畫中，陰影的主要用途在表現物體的立體感，或用以烘托作品主題；它沒有主體性，為附屬或源自某物，至多稱之為某物的「影」，亦是一種難以命名的現象／存在。然而，似乎在攝影的範疇裡，陰影所扮演的角色，不只是彰顯主題、表現立體感，也不是呈現材質的深層變化，而是成為一種攝影的形式，到達「一個詩意的境界，一個充滿夢幻的形式，能夠將虛構變成藝術創作。」[8]

陽光共生的陰影

早期的黑白攝影，除了追求主題明確、人物場景清晰，以及構圖技巧良好，也時常借用影的形狀、大小、濃暗來凸顯主題，或增加畫面的穩定性與層次感，有時也有增添趣味的效果。石萬里的《高雄市政發展》系列 -89，記錄高雄市衛生單位派遣水肥車為民眾抽取家中水肥的情景。畫面中人物有的穿木屐戴草帽，有的穿功夫鞋戴斗笠，有的則著襯衫西裝褲，從這幾種風格迥異的衣裝風格並存，可看出各種文化留存在高雄這塊土地的痕跡。而豔陽下挑肥工的影子，不僅將對角線構圖且略為擁擠的畫面變得活潑，也將視覺焦點分散到影子黝黑變形的造形上。

8 安德烈．胡耶（André Rouillé）著，袁燕舞譯，《攝影：從文獻到當代藝術》（浙江：浙江攝影出版社，2018），頁 214。

阮義忠的〈宜蘭南澳武塔〉拍攝迷你的武塔小學學童參加升旗典禮唱國歌的情景，透過地上左右橫列的影子烘托學童嚴肅的表情，更顯得趣味橫生。周鑫泉〈羊群歸途〉影子則是反客為主似的，羊群像在自己影子引領下踏上歸途，而他的〈共謀大計〉與謝震隆的〈倒影〉、〈橋下〉，也都有影子比人物更為活靈活現的視覺效果。另一種影子的運用方式，是採取逆光或剪影的呈現，例如李鳴鵰〈工作一天要回家啦〉、秦凱〈水車〉和鄭桑溪〈打球〉，這幾件作品的剪影彷彿是從主體產生的無光區域，被攝者本身同時也是不被穿透的主體，形成了既是剪影也是影子的雙重角色。另有葉裁的〈鄉間馬路三人行〉，這幀相片在托盤山崗俯視拍攝而成，畫面蜿蜒伸展的道路構成主要的背景。被陽光照得亮晃晃的鄉間馬路，三名剪影般的人物，位置分布錯落有致，如同一匹白布的圖案，共同織就一幅靜謐生動的鄉間景致。

然而在彩色的世界，光、影、物三者之外，還另外需要考慮到色彩的部分，相較於黑白攝影的詩意，彩色相片帶來的影像是夢境式的。中國四川的白公祠一道斑駁的外牆，經夏日午後陽光的斜照，形成占畫面三分之一明亮、三分之二幽暗的對比。亮面的金黃璀璨、暗面的沉靜優雅，僅僅由偏斜的日光，和牆沿幾株稀疏有致的植栽所構成一幀色澤溫煦、層次豐富的影像。投影於牆面的一叢樹影，一如旁生而出的枝葉，與它的本體一同凝止在永恆的剎那，吸引莊靈拍下〈白公祠牆外——重慶忠縣〉這幅與光並存的心靈映像。而張國治的〈溫柔的拒馬圍籬〉題旨，是更接近時代脈動也更為尖銳的作品。強烈的陽光照射在黃色塑膠帆布上，將蕭殺的拒馬和圓潤的枝葉一同投影在帆布上，藩籬和生機並置，冷峻與溫柔共存，由此削弱了鏡頭外街頭運動的暴戾之氣。

影之為印記／創傷

李鳴鵰臉部布滿陰影線條的〈女子像〉，令人聯想到泰雅族的紋面傳統，不過李鳴鵰僅僅借用投影的線條，讓這位戴耳環、笑容滿面的原住民女性，猶如面具作用代替真實的刺青。但並非所有的陰影都是裝飾功能，臺灣有一群白色恐怖受難者，動輒被判十幾年期刑，因而身心受創、家破人亡，一輩子難以平復的人不在少數。這段臺灣人的苦難史，何經泰選擇以黑色布幕當作《白色檔案》系列肖像照共通的視覺符號，並根據每個人物特質與命運變換黑布的用途，象徵如影隨形的汙名形同一塊陰影，籠罩受難者的一生，藉此為受難者發聲。外在加諸的創傷如此，個人生命的不如意何嘗不是？汪曉青《陷入黑色低潮的女人》系列，透過製造強烈的光影對比，將陰影比擬為創傷：陰影遮蔽半露的臉、以左側的人像暗喻真實的人的低潮，或是畫架的影子覆蓋一半的人體，或是一團陰影占據臉的大部分。光和影的關係是變動不居的，但它們又是必然的共生狀態，而光與影的交織狀態正猶如人生的起落。張照堂

著名的〈板橋〉一作,通過陽光斜射將頸部以下的身軀投影於牆上,呈現一具有身無頭的人形,其中虛無、荒誕的隱喻不言而喻。而白晝的另一頭,兩具身影在教室裡縱情跑跳,楊士毅稱為《黑暗中的自然》,因此看似幢幢的鬼影,其實象徵自我追尋者在兩人的狂歡舞會中,自然的、恣意奔放的身影。

從視覺到觸覺的影

儘管是單純的圓形構圖,張志達的〈Cycle〉卻充滿象徵意涵,意指追求世俗價值者所遵循的道路與方向,其中圓形的缺口代表出入口,進出與否全憑個人的衡量與取捨。傅朝卿的〈時向:編號 1986-1(臺北地下道)〉、〈時向:編號 1985-1(斯德哥爾摩市政廳)〉則多了些抒情氣息,運用秋冬時節迤邐的斜影,成為貫穿畫面的主要線條。

搭配建築本身的造形,高志尊《光的調色盤》系列,將畫面簡化至幾何色塊,〈京都〉、〈Hawaii〉兩件作品,將色、光、影、物四者重新配置,達到攝影家所言「簡潔、明快的空間構成;素淨或飽和的色彩運用;明亮或陰暗的光線配置」,[9] 並藉以反映創作者的主觀意境。

張宏聲的作品組成元素豐富,抽象幾何 vs. 具象人體、2D 平面幾何 vs. 3D 立體雕塑,彩色 vs. 黑白,以及白光 vs. 黑影,將性質對立的元素不著痕跡地揉合為一,就連作品名稱〈一切的因緣,起於執起相機之剎那;一切之心念,終於快門結束的當下。〉,它既是標題,也是內文,對於攝影者 vs. 攝影行為的自我指涉的概念也頗富禪意。謝明順《雕塑情懷的「像雕」》,其中的〈自在〉一幀,三角幾何的水面陰影刻劃著細膩的波紋,而水面亮處則倒映人影,其構圖遊走在幾何和雕塑的造形之間。

蔡文祥的《墨行》系列,則透過諸如直線、橫線、方形等的基本幾何圖形,並以光影的深淺,相互交織一種純粹而抽象的空間,一個通過陰影而被賦予觸覺感知的空間,體現了法國攝影史學家樂馬尼(Jean-Claude Lemagny, 1931-)所主張的「攝影的軀幹是陰影」,[10] 並結論出「一張照片最後的現實存在於材質中,且這個材質的最終性質是觸覺。」[11] 蔡文祥作品中牆壁與水管粗糙的顆粒、平滑細緻的地磚,調配以大塊面積的濃厚陰影……。誠如樂馬尼一再強調,攝影表現的陰影的肌理、筆觸等觸覺感知,是過去繪畫所不能比擬的,攝影的造形能力亦不亞於繪畫──攝影家將攝影從純粹的視覺領域,銜接並拓展至觸覺範疇──《墨行》系列或許是明顯的例證之一。

9 引自高志尊《光的調色盤》創作自述,參閱本展覽專輯,頁 277。
10 Jean-Claude Lemagny, "La photographie est-elle un art plastique," L'ombre et le temps, 轉引自安德烈‧胡耶(André Rouillé)‧
　《攝影:從文獻到當代藝術》,頁 215。

結語：逐光追影，及／即它義

對光的追求決定了視覺的優先地位，也影響了藝術發展的方向。從上帝造光，以及光被賦予
聖潔的意涵開始，凡光照之處必有人類蒙集，必然有社會群體與歷史文明。在光天化日之下，
山川風景、人文地理，無一不是藝術的題材。從火炬、油燈走向電燈的時代，光的歷史與人
類生活息息相關，人類造光，起先是為了夜間照明，隨後是為了驅走心底眼裡的黑暗，如今
則以隨身不離的手機藍光創造虛擬的陪伴。

光愈強，影愈深，不可諱言地，光與影的存在對一張影像的構成極為重要，少了明亮的光或
少了渾厚的影，畫面變得灰暗、平板，缺乏景深和空間感。影的出現伴隨著光與物，它的存
在不僅是任意的，也是偶然的。即便影反映物的某部分輪廓，但影並非標指符號（indice），
也非標記符號（index），它僅僅是某個當下之物的投影。儘管影是虛像，只是物的整體或
局部的輪廓，有時映射物的整體外形，有時則是片段甚至變形，但正因為它的形狀變化多端、
深淺濃度不一，帶來不可預期的觀看樂趣和想像空間。

此外，光與影並非日升則月落，它們不是非此即彼、交互輪替，而是並存共在的關係。攝影
家通過影像，記錄或創造逐光追影的過程，再以符號學和修辭學角度來閱讀，如本展覽「比
喻・隱喻：逐光追影及它義」分成兩個子題：「比喻之光」及「隱喻之影」所要指涉的，或
說攝影家想要呈現的，永遠是在此之外的它義，那光影背後的言外之意。法國美學家弗朗索
瓦・蘇拉熱（François Soulages, 1943- ）說：「攝影捕捉的並非純粹的真實，而時常是我們肉
眼不可見的現象。因此，藝術家所召喚的，更大程度上是我們的想像，而非我們的視覺。」[12]
姑且不論取景的攝影／留影的動作或許是一種機械、物理性的記錄活動，但人們對圖像的解
讀更多時候是一場主觀的內心投射過程，有意識或無意識地在圖像中來回逡巡，在構圖、色
彩、主題、氛圍等等尋找熟悉的構成元素。影像猶如一面鏡子，在我們凝視它的同時，是否
也等我們回答它所召喚的想像，究竟是我們生命經驗之外難以言說的感知？還是沉積在意識
之下魂牽夢縈的鄉愁？

11 同上註。
12 弗朗索瓦・蘇拉熱著，陳慶、張慧譯，《攝影美學：遺失與留存》（上海：上海人民美術出版社，2021），頁 86。

The Trace of Light to the Touch of Shadow

Curators | LU Hsiao-Yu
Ph.D. in Women's and Gender Studies of University of Paris 8

CHIANG Li-Hua
Professor of National Taiwan University of Art

Light and shadow are two sides of the same coin, with shadow appearing whenever light is shed on objects. They represent a simultaneous moment of coexistence and dependence. However, we often disregard the intermediaries between light and shadow. For instance, during a winter sunset, we are captivated by our deformed, disproportionate, and intangible black shadows, rather than our tangible physical bodies. Shadows reflect 'me' but are not 'me.' They are an alter ego that is difficult to define, presenting neither 'me' nor 'not me.'

In this sense, light may seem less significant than shadow, but that is not the case as shadows only exist in the presence of light. Even a thin covering of clouds can cast shadows on the earth in sunlight. Without the intermediaries like people, objects, or clouds being illuminated by light, there would be no shadows. Thus, there exists a delicate triangular relationship between light, objects, and shadow. The intermediaries are often overlooked as they have a real, tangible, and monotonous material existence. By comparison, light and shadow are fleeting, non-material entities that are constantly changing. Those who rely on visual perception capture and preserve these colorful and accidental moments in what Moriyama Daido calls "photographs as fossils of light and time."[1]

The exhibition, *Simile · Metaphor: Chasing Light, Shadows, and Alternative Meanings,* appears to suggest a passive waiting for these amazing moments. However, through photography, artists actively emphasize the existing light and shadow, or create them altogether.

I. God Created Light; Humans created Images

In Genesis 1:3 of the Bible, it is written, "And God said, let there be light: and there was light." In creating the vast expanse of the universe and the earth, God also created light. Photographers, in turn, capture images that become fossils of light, allowing us to witness the divinity of light and all its interpretations.

1 Moriyama, Daido. *School of Day, School of Night*, p.89. Translated by Hui-Shu Liao. Taipei, Cite, 2010.

The Divinity of Light

From the mist rising in Ho Ching-Tai's *Singil*, to the waterfall-like light pouring down through the skylight in Kao Chih-Chun's *Firenze*, 2001, and the dreamy moonlight in Chang Wu-Chun's *Qinggualiao*, these works form a realm of awe-inspiring wonder. Among these artworks, Fan Yen-Nuan's installation art stands out for its religious themes. Through his exploration of light, Fan Yen-Nuan delves into both scientific and religious aspects, offering differing, yet complementary interpretations. For the artist, light is more than just a color and a form: it is a bright and clear essence; a spiritual force that illuminates the divine temple and drives away the darkness. In his view, light itself is God, and the creation of art is a way to express the spiritual pursuit of the eternal kingdom. Sugimoto Hiroshi's photograph of Ando Tadao's *Church of Light* captures the essence of the cross, a symbol of Christ, as white light shining through the hollowed-out, cross-shaped wall, creating a sense of divine light driving away the darkness. Similarly, Fu Chao-Ching's *San Gimignano Collegiata* captures the subtle combination of light and architecture in a church. By contrast, Chien Yun-Tai's *Kaohsiung Dashu* from the *Familiar Town* Series illuminates the solemnity of the temple by capturing a beam of light slanting down from above onto the Buddha's niche and the monk. Finally, Chang Chih-Ta's *Flying Against the Light: Freedom After Turning Away* incorporates second and third dimensions into the same image. The artwork features a child standing on a cross-shaped beam of light in a ruined building that is just a peeling wall in the real world, the literary rhetoric of mise en abyme within an image.

The light of the cross is a symbol of holiness. In Chang Kuo-Chih's image Series, the cross-shaped shadow meets with the opposing symbol of the Chinese character ' 回 ' (in *The Same Scenario Image Series*). Similarly, Greco-Roman columns are juxtaposed with traditional architecture from Fujian Province (in *1973*), the rationality of light meeting the emotion of shadow. Rather than merely 'chasing light and shadows,' the Series focuses on the concept of 'capturing light and taking in shadows.' As the artist puts it, it is "a phenomenon that develops and fluctuates due to external uncertainties, in urgent need of guidance towards the direction of the light."[2]

When the vertical beam of the cross is removed from the light, it completely loses its religious connotations and becomes a visible beam of light that symbolizes the subconscious. Li Yu-Chi's *Suburbs* Series refers not to the outskirts near one's home, but to the dreamland that can be reached at any time. A blue light in the dream moves forward like a searchlight, breaking through the darkness and illuminating the path ahead. This blue light at night is also a penetrating (artificial) light that divides the picture into two halves. If the dark suburbs are the metaphor for the soul, then surely this continuously moving and shining blue light is the subconscious of the subject?

From night to day, from subconscious to reality, Lin Kuo-Chang's *Zhongxiao West Road North Gate* captures the moment when the setting sun shines through the windows in the outer wall of the city's ancient gate, creating a backlit silhouette and highlighting the majestic Cheng'en Gate under the clear sky. This century-old historic building stands out as a beacon of peace and tranquility in the ever-changing Taipei cityscape.

2 Introduction of work of *Summer in Beijing 798 Image* Series by Chang Kuo-Chih. See the exhibition catalogue, p.242.

The History of Light and the Survival of Humans

Sunlight is an indispensable component for the survival of all living organisms. Without its radiance, humans would not exist. Walking the earth for countless generations, humans have the capacity to create brilliant civilizations. The foundation of civilization is laid upon survival and reproduction. In Juan I-Jong's *The Eternal Golden Castle,* a group of relatives and friends attending a wedding walk through the gate of a fortress, as if passing through a time tunnel established by Shen Baochen during the Qing Dynasty. They bear witness to and receive the baptism of human history. The bright sunlight illuminating the corridor also brings a sense of hope, joy, and blessings to the wedding.

However, the light of human civilization is not always dazzling and impeccable. In Ouyang Wen's *The Way Back (Ox Cart),* a scene is captured of a girl leading a cart with an ox on the way home from Zhongliao Village on Green Island. The backdrop is a translucent cumulus cloud with gold edges, but the sky outside the cloud is shrouded in gloom. Ouyang Wen himself, who experienced the February28 Incident and was a victim of the White Terror, happened to capture this photograph in 1950s Green Island using just crude darkroom equipment, a place where innocent people were imprisoned as part of political persecution. The work fully reflects the atmosphere of the times and its historical significance. If human beings cannot even rely on their basic rights to life, turning to the gods for solace may seem like their only viable option. In Chiu De-Yun's *The Shorts Album (Two) 96,* a brightly lit temple altar is used to pray for safety. It represents the humblest wishes of ordinary people who cast sacred moon blocks and hope for the gods to answer. Emerging from the gloom of life, both Chou Shin-Chiuan's *Self-Study* and Lin Bo-Liang's *Zhou Meng-Die* share a similar theme of the search for knowledge by the literati. Knowledge, after all, dispels intellectual darkness. The girl reading against the wall is illuminated by the slanting sunlight, while the poet sits indoors, his reserve and restraint blending into the warm winter sun.

The Technology of Light

Nowadays, people are preoccupied with information, taking selfies to capture the fleeting present. Is this addiction to information and images causing interpersonal alienation, or is it the other way around? Is this phenomenon simply a characteristic of human nature? Wang Ding-Yuan uses a parodic approach to appropriate famous Western paintings, or, as he described it, "transforming the situational context of the paintings into contemporary life scenes and using dramatic images to satirize people who are immersed in digital technology." The ubiquitous "light" of technology dominates all aspects of human life, work patterns, and communication modes, allowing people to avoid eye contact and in-person conversations in the name of simplicity, convenience, and efficiency. Physical interaction is replaced by images, videos, and audio produced and transmitted by 3C products, as nearly everything can be dematerialized and digitized. The *Glow on the face 2.0* Series demonstrates the social function of art in

observing social events and raising questions. By comparing different cultures, both past and present, we may revisit the world and time before the invention of 3C products and ask whether we are using these artifacts or are enslaved by them.

Birefringence, also known as double refraction, occurs when light interacts with matter to produce two refracted rays from a single incident ray. With the progress of physical optics research, photography enthusiasts find this phenomenon increasingly visually appealing due to its irregular, symmetrical, decorative, geometric, and overlapping effects. These images contain elements of both virtual image and illusion, and this is due to the phenomena of polarization, which creates unique colors and stripes. Lin Fu-Mei suggests that virtual images originate from the reconstruction and subversion of actual objects, which belong to the external recognizable space, while illusion originates from the misperception and misidentification caused by external forces acting on actual objects, belonging to the internal, contemplative realm.[3] Combining images of physical objects and polarized light with emotive titles such as *Encounter* and *Cultivation*, Lin creates a fantastical imaginary space and adds a vocabulary unique to the abstract world. Liu Yung-Tai, deeply attracted to the hidden world beneath the superficial, uses X-ray photography to take photographs of his own head. *My Skull (X-Ray),* juxtaposes his hands, iron chains, fish, shrimp, chicken heads and so forth. In *My Bracelet (X-Ray),* Liu Yung-Tai photographs single objects like nails to present the colorful and subtle space hidden under the appearance of things.

Observing the details of objects sharpens our senses. To discover the traces of light that are not easily noticed in everyday life is the proposition of Chiu Chih-Yung's *Spatial Objects* Series. The subtle light, the current of everyday life, represents, according to Chiu, "discovering meaningful forms by observing the beauty of objects or scenery in daily life through the eyes of a photographer."[4] Standing before the works, the viewers' gaze can roam freely in their own imaginative space.

Faded Light and Extinct Shadow

Although God said, "Let there be light," and the world had light, photographers prefer to turn off the light, and make the scenes disappear. Hung Shih-Tsung erases the illegitimate structures of buildings, signs on the streets, and swaying power cords from the original images. Like a cleaner, he 'cleans up' the burdensome and messy that do not belong to the environment. What emerges was originally covered and interfered with by extraneous objects. They come to the fore in their own moment.

On Zhongxiao Bridge, which connects Sanchong to Taipei, the visual boundaries become vast, and the line of sight passes through Zhongxiao East and West Road straight to Taipei 101. The North Gate, a historical memory for Taipei's people, becomes the focus of this visual axis. In front of the bustling Taipei Station, rows of power poles along the way remind us that we are on one of Taipei's busiest streets. The streetlamps echo the towering commercial buildings on the opposite side. Everything is just right here: the color that has been stripped away is like isolated noise; the emptiness allows the ground to breathe. The crowds are scarce, and the vehicles move quietly, as if in a world covered in white snow, cold and quiet. It is wonder projected into the hearts of contemporary urbanites, just silence and order.

3 Introduction of work of *Intersection and Interference* by Lin Fu-Mei. See the exhibition catalogue, p.238.
4 Introduction of work of *the Spatial Objects* Series by Chiu Chih-Yung. See the exhibition catalogue, p.263.

These familiar scenes, seen through Hung Shih-Tsung vision, are the stripped away version of the real. They exist and yet are bettered. Hung said, "People can see the essence but cannot capture everything they see. The initial appearance in the lens allows the observed 'emerging object' to become a self-analysis of 'photography after-action,'[5] and it discovers new forms of 'removal.'" This so-called 'photography after-action' transforms the documentary function of photography, as if separating the entity and the image into two and dressing the latter in the cloak of surrealism.

Psychological Light and Space

Different lighting can create varying atmospheres and influence people's perceptions of space. Yeh Ching-Fang's *Ruifang* Series exemplifies a subjective and one-sided psychological space, in contrast to the objective physical space. Ruifang, a once prosperous town in the northeast corner of Taiwan known for its mining industry, faced an economic recession in the 1980s due to the decline of mining and continuous outflows of population. Despite this, Yeh Ching-Fang, a Ruifang resident, left precious visual records. He photographed the Shengping Theater in Jiufen that had been a stage for theatrical performances and movie screenings since the Japanese colonial era, a gateway to Western civilization. However, it was unable to withstand the craze sweeping Taiwan at the end of the 1980s, and was transformed into a venue for erotic dance shows. Yeh Ching-Fang's depiction of the theater conveys depression and a sense of timelessness, a desolate space-time, stripped of most objective conditions of reality, cold and lonely.

Turning to the big city at nightfall, French photographer Hubert Kilian captures the ubiquitous lights. The light drives away the darkness and creates a temporary shelter. Under fluorescent light, a noodle vendor warmly welcomes customers, and together they share a moment over a bowl of noodles. The temporary corner where people settle can be a stranger's storefront, a noodle stall in an alley, a steamed bun vendor, a betel nut stand, or even just a cheap dining table covered in greasy stains.

In Taiwan, motels offer private spaces for brief encounters. The motel spaces are designed to stimulate desire through lighting and exquisite decoration. Chen Shu-Chen visited motels in various Taiwanese cities to create *After* Series, photographed their interiors and discovered that different lighting designs can rearrange the appearance of our existence. Lighting fixtures in homes and motels have distinct functions and requirements that convey different messages and meanings. Chen notes that "space exists because of light, and our very selves are reconstituted through light."[6] If humans dwell in darkness, we cannot perceive the boundaries of space, and thus cannot establish the demarcation between ourselves and space. Light makes the boundaries of our bodies and minds visible, awakening different self-awareness. As light and shadow coexist, where shadows are overlooked or seemingly not present, our subconscious, psychological space is covertly infiltrated by shadows. Shadow is the visual weight produced by light acting on objects, and the interweaving relationships between light and shadow reflect Chen's conclusion, "they project the essence and the unbearable lightness within life."[7]

5 Introduction of work of *Emerging into Vision* by Hung Shih-Tsung. See the exhibition catalogue, p.246.
6 Introduction of work of *AFTER* by Chen Shu-Chen. See the exhibition catalogue, p.260.
7 Ibid.

Under the Distant Daylight

The capital is a thriving hub for finance, business, and people from all over Taiwan. However, with a high level of population density and equally high housing prices, living in Taipei is challenging, and social connections have inevitably become more distant in urban settings. Lin Kuo-Chang's *Zhongshan North Road Taipei Story House, Taipei Dao* Series features a circular corridor made of sixty-seven polarizers, and a mother and daughter who enter the artwork appear dreamy and alienated as they overlap with the surrounding scenery reflected on the polarizers. Visually, the distorted external scenery, overlapping with images of people inside, contrasts with the virtual images on the polarizers and Taipei Story House in the distance.

Yeh Ching-Fang's *Reality · Aurora · Periphery -58* uses a similar approach, featuring an owl behind a thick glass door with a slanted artificial tree as its perch, while a boy standing outside appears interested in the bird. Yeh's perspective creates an eerie scene where the boy's face overlaps with the owl, making it difficult to distinguish between the two. The glass door reflects scenes beyond the camera lens, including a father and daughter watching the owl from a distance, passing tourists, and a white iron park bench and stainless-steel trash can that are no longer common today. In Lai Pu-Kuang's three works, the vast *Image 1-2: All Gatherings Come to an End. Taipei Zoo,* a group of dogs and an upside-down sailboat on a grassy field in *Image 1-3: Encountering Sanyu. Tamsui River Left Bank,* and two people sitting coldly face-to-face in a subway car in *Image 1-1: Personals. Hong Kong East Rail Line,* all convey a surreal sense of eeriness and loneliness.

II. Shadows, the Visual Weight Generated by Light Acting on Objects

Light travels in a straight line until it encounters an object, creating an area without light behind the object, known as the object's projection or shadow. In Western paintings, shadows primarily demonstrate an object's three-dimensional quality or highlight the work's theme.Shadows lack subjectivity and are either subservient or derived from something, and are difficult to name. In photography, "shadows go beyond presenting material changes, becoming a poetic and dreamy form that can transform fiction into artistic creation."[8]

Coexistence of Sunlight and Shadows

Early black-and-white photography pursued clear themes, distinct scenes, and composition skills. Photographers often used shadows' shapes, sizes, and densities to highlight themes, increase image stability and layering, and add intrigue. Shih Wan-Li's *The Development of Kaohsiung City's Governance Series-89* documents the slurry lorry sent on mission by Kaohsiung City Government. In the scene, there are figures adorned with wooden clogs and straw hats, kung fu shoes and bamboo hats, or shirts and suit pants. This diverse stylistic convergence illuminates the cultural imprints embedded in Kaohsiung. Further, the laborers' shadows, cast under the brilliant sun,

8 Rouillé, André. *Photography: From Documentation to Contemporary Art*, p.214. Translated by Yen-Wu Yuan. Zhejiang, Zhejiang Photography Publishing, 2018.

infuse vitality into the slightly congested, diagonal composition while subtly shifting the visual focus towards their dark, distorted silhouette. Juan I-Jong's *Lighthouse in Nanao, Yilan* captures the scene of the students of Wuta Elementary School singing the national anthem at a flag-raising ceremony. The shadows cast on the ground, stretching from left to right, underscore the students' solemn expressions, lending an intriguing layer to the scene. In Chou Shin-Chiuan's *Returning Flock of Sheep*, the shadow takes the lead, presenting the flock of sheep following their own shadows to head home. In Chou's *Conspiracy*, as well as Hsieh Chen-Lung's *Reflection* and *Under the Bridge*, shadows have a more vivid visual effect than the figures. Some photos use shadows in a backlit or silhouette style, such as Lee Ming-Tiao's *Heading Home After a Day's Work*, Dennis K. Chin's *Waterwheel* and Cheng Shang-Hsi's *Playing Ball*. Here, the photographed figures and objects are both the unpenetrated subject and their own shadows. Yeh Tsai's *Three People on a Countryside Road* was taken from a hill and had a bright country road as its main background, with three silhouette-like figures woven together to form a serene and lively rural scene.

Color, in addition to light, shadow, and object, is an essential component to consider in photography. While black and white photography possesses poetic qualities, color photography offers a dreamlike vista. *Outside the Wall of Baigong Shrine: Chongqing Zhong County*, captured by Chuang Ling, showcases the weathered exterior wall of the temple in Sichuan, China. The slanting afternoon sunlight illuminates the wall, creating a warm and richly layered image with one-third of the frame being bright and two-thirds being dark. The golden brilliance on the bright side and the calm elegance on the dark side are constructed solely of slanted sunlight and a few sparse, delicate plants growing on the wall. The tree shadows projected onto the wall are frozen together with the object in an eternal moment. Chang Kuo-Chih's *The Tender Barricades* presents a subject matter closer to the pulse of the times, with strong sunlight projecting subdued barricades and rounded branches and leaves onto a yellow plastic canvas. This juxtaposition of barriers and vitality softens the roughness of the street movements outside the lens, creating a coexistence of the cold and the gentle.

Shadow As Mark or Scar

Li Ming-Tiao's *Portrait of a Woman* evokes Tayal tribal tattoo traditions through the shadowy lines upon the face. The decorative projections create a mask-like effect on the smiling indigenous woman with her earrings. Yet shadows can also carry weightier implications, as in the case of White Terror victims in Taiwan who received prison sentences of over ten years, causing trauma, family tragedies, and lifelong unhealable wounds. Ho Ching-Tai uses a black curtain as a common visual symbol across his *The File of White Terror* Series, adjusting the black cloth's use to each subject's characteristics and fates in order to better represent the shadowy stigma that haunts victims for life. Annie Hsiao-Ching Wang's *The Woman*

Drowning in Black Tides Series uses strong light and shadow contrasts to equate shadows with trauma. Chang Chao-Tang's famous work *Banqiao* projects the lower part of the body onto the wall using slanting sunlight, presenting a headless figure with implicit metaphors of emptiness and absurdity. Yang Shih-Yi's *Nature in Darkness* Series captures two bodies jumping and running on a classroom podium, ghosts in the night shadows representing a carnival dance of self-discovery. The intertwining states of light and shadow, ever-changing, yet inevitably coexisting, are akin to life's ups and downs.

From Visual to Tactile Shadows

Chang Chih-Ta's *Cycle* may feature a simple circular composition, but its symbolic implications are profound. It represents the path and direction taken by those who pursue worldly values, with the gap in the circle signifying individual choice on whether to enter or exit. Meanwhile, Fu Chao-Ching's *Temporal Dimension: No. 1986-1 (Taipei Underground Pass)* and *Temporal Dimension: No. 1985-1 (Stockholm Town Hall)* employ autumn and winter shadows as its theme, lending a lyrical atmosphere to the works.

Preoccupied with the form of architecture, *The Palette of Light* Series by Kao Chih-Chun simplifies the image into geometric blocks of color. *Kyoto* and *Hawaii* rearrange color, light, shadow, and object to create, in the words of the photographer, "a clear, concise spatial composition with saturated colors and varying light."[9]

Chang Hong-Sheng's works are characterized by a rich composition of elements that seamlessly blend opposing qualities: abstract geometry versus concrete human figures, the 2D planes of the geometric versus the 3D of sculpture, color versus black and white, and white light versus black shadow. In his work *It All Began the Moment the Camera Was Raised and Ended When the Shutter Clicked*, the title itself reflects the Zen concept of self-reference in photography. Meanwhile, Vincent Hsieh's *Ease* from the *Sculptural Sentiments* Series depicts ripples on a water surface framed as a triangular mirror. The composition deftly oscillates between geometry and sculpture.

Tsai Wen-Shiang's *Movements of Ink* Series blends basic geometric shapes and varying degrees of light and shadow to create a pure and abstract space with a tactile sensibility. It embodies Jean-Claude Lemagny's (1931-) idea that "the body of photography is shadow"[10] and that "the final reality of a photograph exists in its material, which has a tactile nature."[11] In this Series, Tsai mixes rough grains with smooth tiles and thick shadows. As Lemagny argued, photography's formative ability is comparable to painting, but photography's representation of texture and brushstrokes of shadows provides a unique tactile perception. This photograph Series is a clear example of how photographers have extended photography beyond the visual domain to the realm of touch.

9 Introduction of work of *The Palette of Light* Series by Kao Chih-Chun. See the exhibition catalogue, p.277.
10 Rouillé, André. *Photography: From Documentation to Contemporary Arts*, p.215. Translated by Yen-Wu Yuan. Zhejiang, Zhejiang Photography Publishing House, 2018.
11 Ibid.

Conclusion: Chasing Light and Shadows As Alternative Meanings

The pursuit of light determines the primacy of visual culture and shapes the trajectory of artistic development. Beginning with the creation of light by God and its investiture with sacred meaning, wherever light shines, humanity convenes and civilizations arise. In daylight, every landscape, natural or cultural, becomes a subject of art. From torches and oil lamps to electric lighting, the history of light is unavoidably intertwined with human life. Initially, humans sought for light merely to illuminate the night and to dispel inner darkness, but today the glowing screens of smartphones promise us virtual companionship.

The existence of light and shadow is essential in image composition, as the stronger the light, the deeper the shadow. Without bright light or deep shadows, photographs appear flat and lack depth. While shadows outline an object's contours, they are neither an indice nor an index. Shadows represent the projection of an object at a particular moment, and may depict either the entire shape of an object, or a fragment or distortion. The dynamic nature of shadows, with their ever-changing shapes, depths, and densities, offers viewers unexpected enjoyment and imaginative possibilities.

Furthermore, light and shadow coexist, and do not simply alternate back-and-forth. Photographers capture or create the process of chasing light and shadow through images and then interpret them from semiotic and rhetorical perspectives. *Simile · Metaphor: Chasing Light, Shadows and Alternative Meanings* is divided into two sub-themes, *The Light of Simile* and *The Shadows of Metaphor* to refer to the implications beyond light and shadow and the photographers' perpetual pursuit of them. As French photographic historian François Soulages once said, "photography does not capture pure reality, but often phenomena that are invisible to the naked eye. What artists call for is our imagination, rather than our vision."[12] Despite the mechanical and physical nature of taking photographs, the interpretation of images is typically a subjective projection process in which eyes and minds consciously or unconsciously wander between images, seeking familiar elements in composition, color, theme, and atmosphere. Images are like mirrors that reflect us, waiting for our response. Are they summoning ineffable perceptions beyond our life experiences, or evoking the nostalgia deeply buried in all of us?

12 Soulages, François. *The Aesthetics of Photography: Loss and the Rest*, p.86. Translated by Qing Chen and Hui Zhang. Shanghai, Shanghai People's Fine Arts Publishing House, 2021.

如何閱讀光影家族

曾少千／國立中央大學藝術學研究所專任教授

2021 年 5 月，「比喻·隱喻：逐光追影及它義」策展人姜麗華教授邀請我為展覽圖錄寫一篇文章，並傳送一份作品清單給我閱覽。姜老師告訴我作品的選件和分類方式，是從國家攝影文化中心一萬餘件典藏品，選出格外著重光線表現及刻意留下影子的作品，另外再加入其他館藏之外的多件作品，整個展覽試圖用符號學來解讀光影的多重含義，即使因創作者和觀者的不同視角而可能產生不同的理解，攝影的開放性意義（即它義）便可擴展。

我接受這項任務後，這半年多以來不斷反覆看著資料夾裡的百餘件作品，推敲它們被選擇和歸類的緣由。我發現有時同一攝影家的同一系列作品，被拆開放入「比喻之光」、「隱喻之影」兩個不同的組別。有時一張照片明明是豔陽高照的白日，卻因行人撐傘投影在地上，而被劃定為影子之組，不免感到些許納悶。我在一個研討會碰巧遇見共同策展人呂筱渝老師，她告訴我在實際執行作品分類時，確實遇到難以決定的情況。一件光影共呈的作品，究竟該放在光還是影的類別？其實並沒有絕對的標準。換言之，分類的邊界存在彈性空間，作品可穿越滑移在不同的群體和位置。

根據策展聲明，我的理解是整體展覽的構想乃是由光影為經緯，從作品可見的明暗效果，觀察光和影在構圖中的比重和相互作用，以及閱讀延伸的涵義。光線和陰影所構成的形式要素，遂構築展覽骨幹。展覽邀請觀者進入一個視覺符號的森林，自行從光影所形成的符徵，自由解讀各式各樣的符旨。如此的策展思維，不同於一般攝影展從主題、思潮、時期或類型出發，這會引發什麼樣的觀展經驗呢？我認為此展覽銳化對於光影的視知覺，加強對於明暗分布的敏感度，藉此匯聚和提升攝影的美學能量。攝影是基於感光的造像技術，也蘊含拍照者對於現實環境的詮釋觀點和美學選擇。總體而言，本展著重在追求光影的美感經驗和延伸含義，這對於攝影媒介的理解，可能激發什麼觀點和新意？

光影家族

以光影作為線索，指引觀賞攝影作品的路徑，致使攝影的類型和閱讀模式被打破，照片的歷史和社會脈絡也隨之模糊。攝影發展過程中由來已久的分類，如紀實攝影、新聞攝影、肖像攝影、風景攝影、靜物攝影、建築攝影，於此變得次要甚至失效，因為所有作品被納入了廣義的藝術攝影範疇，在一個建制化的藝術場域被共同展示和觀賞。原來攝影之所以分類，主要是依據主題和功能而釐清區別，如今「比喻・隱喻：逐光追影及它義」的重點，並非在於攝影的內容和用途，而是在於原本襯托題材的光影之上，凸顯光影的優位和重要性。光源的存在和影子的形成，原是構成攝影的基本條件，使人像、風景、靜物、建築、新聞、風俗、敘事等題材得以視覺化，只是光影往往扮演風格形式的角色，營造階調色彩和場景氣氛，依隨、陪襯、妝點或強化主體。本展覽打散了固有的攝影類型，有如水墨畫不再以花鳥、山水、人物分類，而刻意以筆墨為主軸，強化形式元素和媒材特性。

近年的攝影展覽以光影作為關鍵詞，經常是為了掙脫攝影的機械性和通俗性，而意圖顯示攝影的成像技術和藝術潛能。例如，臺北市立美術館在 2017 年舉辦「微光闇影」攝影展，聚焦在 1980 年代以來紀實攝影和當代藝術的匯流，客觀報導和主觀意念的交會，策展聲明指出「影像從紀實出發但超越紀實，找尋不滅的靈魂」。[1] 2018 年國立臺灣博物館、國家攝影文化中心舉辦「光影如鏡——玻璃乾版影像展」，集結二十世紀上半葉攝影家林草、張清言、張朝目、宮本延人、彭瑞麟、方慶綿、鄧南光、洪孔達、吳金淼等人的作品，目的是介紹早期攝影術的源起和畫質明晰的特性，呼籲重視乾版文化資產的保存和研究，並重現日治時代的人像寫真、民俗祭典和日常生活面貌。[2]

相對而言，「比喻・隱喻：逐光追影及它義」未著重某一時期或類型的攝影，而是籠括各種攝影作品及影像裝置，無論是黑白或彩色、類比或數位、記錄或操弄現實，此展主張光影本身即是蘊含豐富意義的符號，期望觀者從光影閱讀作品的含義。於是，光影是所有作品的共同基因，衍生為跨越世代的攝影大家族。這背後隱約透露回歸形式主義的訴求，側重作品的構圖風格和視覺效果，藉此顯露攝影家善用光影的獨到眼光和創作手法。值得注意的是，當異質的攝影殊途同歸進入藝術場域，觀看作品的過程會發生什麼改變？

1 余思穎，〈微光闇影：自內在心靈空間中顯影〉，《微光闇影》（臺北：臺北市立美術館，2017），頁 48。
2 張蒼松，〈策展引言〉，《光影如鏡 —— 玻璃乾版影像展》（臺北：國立臺灣博物館，2018），頁 8-15。

紀實審美

當展覽以光影為前提時，效應之一是鼓勵觀者採用審美態度觀看作品。紀實攝影者的取景視角和技巧，如何框取空間裡的光影流動和造形趣味，於焉被標示為作品亮點。如此一來，紀實攝影作品的內容便不若風格來得顯眼，經常出現的勞動主題便趨向詩情畫意，農人的身影輪廓和包覆他的天光水色躍居欣賞的重點。從秦凱、李鳴鵰、歐陽文、謝震隆、周鑫泉、鄭桑溪、邱德雲的勞動者攝影來看，社會背景、耕作地點、農產收成、辛勤流汗付出體力等事實退居背景，注意力轉而落在田園之美的視覺構成。如果將民國到戰後的農村攝影，一致以審美的角度觀賞其逆光、順光、背光下的人影圖案，概觀大地之寧靜致遠及農村之恬適安定，便容易錯過箇中的差異，忽視不同時空下的社經背景，也難以理解攝影記錄的出發點。

縱然光影效果使得紀實攝影流露值得關注的美感，卻不免模糊了拍攝的脈絡，甚而縮減了作品之間的差異。例如，歐陽文的〈歸途（牛車）〉，畫面看似蒼茫優美，卻是他身為白色恐怖受害者，在綠島服刑擔任攝影師時的作品。歐陽文原為國小美術教師，二二八事件後被控加入叛亂組織通匪，落難在綠島服刑十二年。歐陽文創作綠島攝影系列，是在政治處出公差之餘，一心想記錄 1950 年代綠島生活和風景的圖像，他勉力使用簡陋相機和克難的暗房設備，靠目測自然光沖印相片而成。[3] 相較之下，周鑫泉在 1973 年拍攝的〈羊群歸途〉，則是經過精心經營和反覆測試之後的作品。這幅照片是周鑫泉任職澎湖望安鄉派出所所長時，經常在派出所附近看見牧羊人趕著羊群的熟悉畫面。為了想呈現黃昏逆光中羊群拉長的影子和融入背景的跨海大橋，他屢次嘗試變換視角拍攝遠景，最終想到調動消防車支援的策略，取得站在雲梯上的至高點而拉出全景視野，達成最滿意的構圖效果。[4]

從上述作品的討論得知，如果我們僅憑最終影像的外觀，偏重光影互動的審美經驗，便難以知曉拍攝者的意向和身處的環境，作品的歷史脈絡也變得朦朧不清。紀實攝影者的個別態度和拍攝條件是如此不同，實難以從光影的審美角度一視同仁。要言之，即使攝影者有心拍出講究風格形式和光影配置的佳作，然而一幅照片的產生涉及現實環境因素和對於現象的主觀詮釋，其意義往往隱藏在視覺表象之外。

3 蘇振明、蔣茉春、林昌華，《人權與藝術鬥士 —— 歐陽文生命故事》（新北：國家人權博物館籌備處，2015），頁 78-79。
4 楊永智，《臺灣攝影家 —— 周鑫泉》（臺北：國立臺灣博物館，2017），頁 52-53。

生命能量

光賦予天地多樣的色彩和亮度，在可見的現象背後，光也蘊含形上學和哲學、神學的悠久傳統。安伯托‧艾可（Umberto Eco, 1932-2016）的著作《美的歷史》，娓娓道來世界許多文化，看待神等同於光，如閃族的巴爾（Baal）神、埃及的拉（Ra）神、波斯的阿戶拉‧馬之達（Ahura Mazda）神，都將太陽或光加以神格化。之後進入新柏拉圖主義和基督教思想體系，將上帝視為瀰漫全宇宙的光輝。[5] 中世紀的神學家和哲學家看待光為上帝至高的象徵，他們相信光散布神的真善美能量。艾可指出，十三世紀的時候，神學家波納文圖（Saint Bonaventure, 1221-1274）認為光是一切美的原理所在，唯有透過光這個媒介，天地才顯現豐富的光彩。他提出認識光的三個要點：光（lux）、傳光體（lumen）、色彩和光輝。[6] 簡言之，光代表造物者的崇高光華，是生命和創造力的根源，也是美和至福的體現。

本展覽並未呼應西方知識體系，也未直接觸及光和宗教的關聯，然而有幾幅人物攝影作品，卻表現前現代時期光源特有的神聖性，以光環和光暈賦予被攝主體一股特殊的力量。例如，林柏樑在 2001 年拍攝的〈周夢蝶〉肖像，冬日寂靜的屋內迎來一道溫熱的光芒，對映詩人的內在之光，隱喻其豐沛的想像力。詩人有如傳光體，容受穿透空間的光，同時也製造投影在牆面上。此肖像作品並非讚頌神，而是透過光線烘托文學家澄澈巧慧的心靈之眼，洞見冷冽虛無的世間。另一件肖像攝影也將人物表現為奇異的傳光體，何經泰的〈陳家巫師（林陳湘瑜）〉（2018），在莊嚴的光線有如祖靈化身，降靈在巫師身上，她的傳統服裝、頭飾、玻璃珠以及臉龐、眼神迎向古老信仰的熠熠光輝，背景泛光的祖靈屋刻有象徵貴族祖先的百步蛇紋樣。何經泰為了拍攝排灣族五年祭的儀式和人像，特別使用十九世紀濕版火棉膠攝影術，表現意外且不均勻的手工痕跡。[7] 畫面上有飄忽的光點和漫漶的陰影，適切描繪巫師祈福驅邪的特殊角色，她透過光的洗禮附有靈力，搭起凡世溝通靈界的橋梁。

在世俗題材方面，自然光和人工光能製造熱度、亮度或色調，並使得物體的實質形式顯示出來。林國彰和余白以敏捷的街頭攝影，觀察同一城市的日間和夜晚生活。林國彰對焦在臺北日頭高照下的北門窗洞，閃耀著刺眼灼熱的陽光，在黑白高反差下，此百年的清代城門剪影以昂然姿態，屹立在近年修建的忠孝西路上。林國彰採用的對稱構圖，也可見於他捕捉寶慶路和國父紀念館街景中，頂著炎炎日照的行人在繁忙的市區中擦身過街，不同的形影和軌跡在此交會。余白的《臺北原味》和《臺北之胃》作品，在夜行中造訪巷弄裡的路邊攤和市場，強調日光燈散發的蒼白光束，照見肉舖老闆切豬骨、檳榔攤販等待顧客，以及麵店打牙祭的男子。這些生動俐落的街頭攝影，不僅呈現城市人的生活方式，也逼近人物的行為、表情和姿態，放大了光照下的身體及所處環境。

5 安伯托‧艾可（Umberto Eco）著，彭淮棟譯，《美的歷史》（臺北：聯經，2006），頁 102。
6 同上註，頁 129。
7 姜麗華，〈何經泰訪談紀錄〉，《臺灣攝影家：何經泰》（臺中：國立臺灣美術館，2021），頁 158-160。

暗影潛伏

如果光代表生命能量，賦予事物存在的實質形式，那麼影子意謂著什麼？在西方和東方的思想裡，影子有正反不一的含義。藝術史學家麥可‧貝可森德（Michael Baxandall, 1933-2008）在《影子與啟蒙》一書中，指出啟蒙時代的知識界，認為影子從黑暗散發出來，沒有實體，沒有固定的形狀或連續的存在。它是光的缺口，像是光的敵人和寄生蟲。影子常令人想到鬼魂、怪物，以及匿跡、秘密、威脅的事物。貝可森德表示，柏拉圖的洞穴比喻影響西方思想甚遠，使得日後的哲學家將影子視為錯誤知識的來源，因為被囚禁在洞穴的人們只能看到物體投射在岩壁上的幻影，無從知道真相。[8]

就西方藝術史而言，從古羅馬時期的馬賽克到超現實主義，藝術家皆十分關注影子的描繪，無論是自然光或人工光源，無論影子是清楚或微茫，影子在圖像史中擁有舉足輕重的地位。藝術史學者宮布利西（Ernst Hans Josef Gombrich, 1909-2001）的著作《影子：西方藝術中的陰影描繪》，探討影子的多重功能：凸顯光源、增強物體的堅實感、營造環境氣氛、加重敘事的戲劇效果。[9] 如果我們看待攝影為漫長的圖像史之一環，影子在各式照片中所發揮的美學效應亦相當類似。

相對於西方現代科技所追求的明亮照明，日本作家谷崎潤一郎所寫的《陰翳禮讚》，則依戀日本崇尚的幽暗美學。谷崎潤一郎表示，從和室、器物、衣裳到美人的深奧風味，皆適合在昏暗的微光中欣賞。陰翳引發冥想氛圍和思古幽情，賦予眼前事物一番特別的寂趣、雅緻和歲月感。[10] 在如此的闡述中，陰翳成為抵抗現代化潮流的文化底蘊，提供細緻雋永的審美經驗。

本展覽作品並非追求陰翳之美，有些攝影家善用幢幢黑影傳遞不安的威脅和生存的重壓。儘管有些許微光沁入，仍無法驅散夢魘陰森之氣。例如，汪曉青 1993 年的《陷入黑色低潮的女人》，瀰漫著如黑色電影的詭譎氣氛，強烈的明暗對比翻折成表現主義式的扭曲空間。這系列形似電影劇照，將低壓情緒感染觀者，使其墜入光的背面，孤立在幽閉恐懼的暗影之中。照片裡的女子飾演抑鬱的角色，臉龐有大塊黑影盤踞，襯托內心的糾結掙扎。

8 Michael Baxandall, *Shadows and Enlightenment* (New Haven & London: Yale University Press, 1995), pp. 144-145.
9 Ernst Hans Josef Gombrich, *Shadows: The Depiction of Cast Shadows in Western Art* (London: National Gallery, 1995), pp. 27-59.
10 谷崎潤一郎著，劉子倩譯，《陰翳禮讚》（臺北：大牌，2016），頁 5-65。

另外，有些作品呈現無人的場景，流露犯罪現場般的氣息，引發觀者揣想曾經出沒此空間的缺席者。例如，李毓琪的《近郊》（2021），在夜間不知名的地點遭到強烈的光束侵入，像是偵測防盜的雷射光，不留情面地分割畫面，同時也照亮周遭沈睡的植物草叢或牆壁廊道，引人好奇探查其中曾經發生過的事跡。陳淑貞的《After》系列（2017），取自臺灣汽車旅館主題，看似寂靜尋常的私密房間，卻因光線飄忽且陰影籠罩，使得人去樓空的旅館設施像是事件後的蒐證場景。原本汽車旅館的燈光設計，是為了顧客消除疲勞和增添感官情趣之用。《After》系列色調幽微深沉，卻一絲不苟地呈現房客離開後的蛛絲馬跡，隱約暗示此處可能藏有不法勾當或不倫關係的內情。

抽象圖案

本次展覽作品當中，有不少趨近抽象的色彩和形體，關注整體畫面如何構成某種意境，而非指涉特定的事物和時刻。再者，攝影家如張國治、高志尊也在創作自述中，吐露對於非具象的偏好和寫意抒懷的傾向。的確，以往攝影進入藝術領域的過程裡，常採取抽象化的視覺策略，一方面讓攝影接近繪畫和詩學，一方面觸及心靈世界，挖掘難以言傳和再現的思緒。如此一來，攝影所指涉的現實更加褪色無蹤，取而代之的是顏色、光影、線條的美學安排，以及開放各種不同的閱讀方式。

有些作品從自然的體驗和四季的禮讚，提煉出抽象的造形語言。例如，張武俊擅長捕捉微妙的色溫和氤氳色調，從臺灣南方獨特的惡地、彩竹、芒花、沙丘、峽谷主題中，將風景凝縮為繽紛絕倫的圖案，造就賞心悅目的韻律美感。范晏暖 2015 年的作品《記憶與光照》，透過花卉草木剪影、蕩漾水波、浮雲意象，投射內心情感和想像。她在季節交替的自然變貌中，編織文字符號和室內靜物，將意識流和轉瞬的時光封存為晶體。

除了禮讚自然之外，亦有攝影作品探索建築的幾何空間。蔡文祥《墨行》（2020），表現影子的巧妙作用，使牆柱結構更顯立體堅固，也使空間景深更加深邃通透。此系列玩弄攝影的物體性和平面性，一方面顯示稜角鋒利的建物實體偉岸聳立，一方面又將它壓扁為幾何圖案。光和影成為連續體，此起彼落而綿延不絕。

小結

如何閱讀光影和照片傳遞的意義，這是展覽「比喻‧隱喻：逐光追影及它義」所提出的問題。此展匯集各類型的攝影作品，組成光影的大家族，回歸攝影生成的根本要素在於光影的相互作用。本文討論此展覽召喚的觀看方式，主要是訴求視覺感知和美學經驗，強調光影對於攝影的美學和表意方面占有重要角色。在閱讀光影的涵義時，筆者嘗試回復攝影的歷史脈絡，綜合考量形式和主題之間的緊密關聯。光給予萬物實質形式，具有神聖性、生命力和啟蒙的涵義。影是光的反面和追隨者，常有錯覺、惡夢、鬼魅、犯罪的負面隱喻。本展覽不少攝影作品不僅對於光影構成有純熟的表現，也對於光影的文化意義有深刻理解。

展覽從光影的角度觀看攝影，似乎偏重攝影的藝術價值，彰顯拍攝者的創作意識和運用光影的風格手法。關於攝影是否為藝術的討論，從十九世紀以來出現過繁多的辯論，如今已不是迫切的關鍵議題。針對攝影傾向藝術化的後果，符號學理論家羅蘭‧巴特（Roland Barthes, 1915-1980）感到質疑和憂心。他在《明室：攝影札記》指出，攝影具有其他媒介缺少的「此曾在」（ça a été）獨特本質，因為它並非透過符號和隱喻而是直接重現過往的事物。正是這番見證時間的力道，充分顯示它的藝術性。然而他警醒我們，攝影和真實的臍帶相連，正遭受兩種方式的破壞：一是將攝影視為藝術，使用繪畫修辭和舉辦展覽，二是將凡事變成可消費的影像，導致人類的衝突和慾望全然去真實化了。[11]

或許，我們無須像巴特那般悲觀，而是抱持謹慎態度面對藝術和攝影之間的交會和張力。攝影脫離不了對於現實的視覺感知，同時也擺盪於具象和抽象、安排和偶然、臨在和缺席之間的灰色地帶。我們不妨從攝影特有的多樣性、常民性和複製性，反思藝術論述和體制中的固有框架和思維，是否會圈限攝影的潛能。一張照片除了禮讚可見的光影之外，更透露易受忽視的日常生活細節，以及拍攝者對於社會現狀提出的問題和詮釋觀點。最後，本文借用亨利‧卡提耶－布列松（Henri Cartier-Bresson, 1908-2004）的話當作結語：「關於攝影在造形藝術中應該有什麼位階、占據什麼位置的辯證，從來都不在我關心範圍裡，因為這個階級性的問題，在我看來純粹是學院性的。」[12] 誠如布列松關切的並非攝影是否被接受為藝術，更值得思索的是，攝影如何以視覺形式發問，以複雜曖昧的方式流露對於生命的領悟。

11 Roland Barthes, *Camera Lucida: Reflections on Photography*, translated by Richard Howard (New York: Hill and Wang, 1981), pp. 45, 117-119.
12 亨利‧卡提耶－布列松（Henri Cartier-Bresson）著，張禮豪、蘇威任譯，《心靈之眼：決定性瞬間 —— 布列松談攝影》（臺北：原點，2014），頁 16、42-43。

Reading the Family of
Light and Shadow

TSENG Shao-Chien
Professor of National Central University Graduate Institute of Art Studies

In May 2021, professor Chiang Li-Hua, curator of the *Simile · Metaphor: Chasing Light, Shadows, and Alternative Meanings* exhibition, invited me to write an article for the exhibition catalog and sent me a list of exhibited works as a reference. Professor Chiang told me how the works emphasizing light and shadow were selected and categorized out of over 10 thousand works from the National Center of Photography and Images (NCPI) collection, then added with several othe r works from outside of the collection. The entire curation attempts to interpret the multiple meanings of light and shadow through semiotics and explores how the open (alternative) meanings of photography allow different understandings, despite being created by different artists and interpreted from viewers' differing perspectives.

After I accepted the mission, I spent the last six months repeatedly gazing at the hundred-or-so works in the folder, speculating and contemplating the reasons why they were selected and the thinking behind their categorization. I noticed that, on some occasions, works from the same Series by the same artist were separated into different categories, such as one into *The Light of Simile* category and the other into *The Shadow of Metaphor*. One photograph showed broad daylight with a beaming sun, but the shadows that the pedestrians' umbrellas cast on the ground meant that the work was sorted into the shadow category. This left me slightly perplexed. I met Lu Hsiao-Yu, the joint curator for the exhibition, at a conference by chance, and she told me that there had indeed been challenging moments when sorting the images where decision-making had not been straightforward. Should a work that showed both light and shadow be categorized into the light category or the shadow category? There was no absolute standard. In other words, there was flexibility in how the works were sorted and the images could wander between different groups and positionings.

Based on the curatorial statement, my understanding of the overall concept for the exhibition is to view light as the benchmark. The works show the effects of light and shadow, allowing observations of how light and shadow are proportioned and interact, as well as their extended meanings. The elements of form shaped by light and shadow make up the core structure of the exhibition. The exhibition invites viewers to enter a forest of visual symbols, a forest where they are free to interpret for themselves the

different symbols formed by light and shadow. This curatorial mindset differs from conventional photography exhibitions, which center around a main topic, thought, period, or genre. What viewing experience does this lead to? I believe this exhibition will sharpen the viewers' visual cognition towards light and shadow, hone their sensitivity toward the composition of bright and dark areas, and, in turn, aggregate and elevate the aesthetic energy of photography. Photography is an imaging technique rooted in light sensitivity, but it also requires the photographer's interpretation and perspective on reality and their aesthetic choices. All in all, this exhibition focuses on the aesthetic experiences of light and shadow, as well as their extended meanings. What kind of new perspectives and innovation does this inspire regarding the medium of photography?

The Family of Light and Shadow

The method of guiding viewers' appreciation of photographic works using light and shadow as clues transcends genre and viewing method; it also blurs the historical and social boundaries of photography. Here, genres that have long existed throughout the development of photography, such as documentary photography, news photography, portrait photography, landscape photography, still life photography, and architectural photography, seem secondary, even ineffective, since all works are included in the genre of art photography in the broader sense, especially when displayed and viewed together in an institutionalized art setting. These conventional categorizations of photography were mostly based on subject matter and functionality; however, Simile · Metaphor: Chasing Light, Shadows, and Alternative Meanings does not lie in the content and function of photography, but stresses the importance of light and shadow, which originally served to accentuate the subject matter. The existence of light and the formation of shadow are the basic conditions of photography, allowing subject matter, such as images of individuals, landscapes, still life, architecture, news events, culture, and narratives to be visualized. However, in the past, light and shadow mostly served stylistic purposes, creating color gradations and atmosphere, accompanying, complementing, ornamenting, or accentuating the central theme. Just as ink paintings no longer feature flowers and birds, landscapes, or figures, and instead draw focus to brushwork and ink, this exhibition shatters existing photographic genres and focuses on the characteristics of form and medium.

Exhibitions in recent years have positioned light and shadow as keywords, mostly in order to escape from the mechanical universality of photography; instead, they draw attention to photography's imaging techniques and artistic potential. For instance, Taipei Fine Arts Museum's 2017 exhibition Faint Light, Dark Shadows features the convergence of documentary photography and contemporary art since the 1980s, as well as the space between objective report and subjective will. The exhibition's curatorial statement points out that the displays "begin with documentary but transcend documentary in search of the everlasting soul."[1] The Mirror of Time: Dry Plate Photography Exhibition at the NCPI and National Taiwan Museum in 2018 gathers works by photographers from the first half of the 20th century, including figures such as Lin Cao, Zhang Qing-Yan, Chang Chao-Mu, Peng Ruey-Lin, Fang Ching-Mian, Deng Nan-Guang, Hong Kong-Da, and Wu Jin-Miao, and attempts to explore the origins of early photographic techniques and the characteristics of picture quality and clarity. The exhibition calls for the preservation and research of dry plate cultural assets and values photographs of figures, cultural and religious ceremonies, and everyday life during Japanese Rule.[2]

1 Sharleen Yu, Faint Light, Dark Shadows: Images in Inner Spaces, p.48. Taipei: Taipei Fine Arts Museum, 2017.
2 Jhang Cang-song, Curatorial Introduction, The Mirror of Time: Dry Plate Photography Exhibition, pp.8-15. Taipei: National Taiwan Museum and the National Center of Photography, 2018.

In comparison, *Simile · Metaphor: Chasing Light, Shadows, and Alternative Meanings* does not emphasize images from a certain period or genre but instead includes different photographic works and image installations, regardless of black and white or color, analog or digital, documentary or manipulated reality. The exhibition proposes that light and shadow are themselves symbols rich with meaning and hopes viewers can interpret the works through them. Therefore, light and shadow are common elements in all the works, forming a photographic family that transcends generations. What this alludes to is an appeal to return to formalism, stressing the compositional style and visual effects of the works to disclose the photographers' unique eye and creative method in light and shadow. What's worthy of contemplation is, when heterogeneous photography enters the realm of art, how does it change the process of viewing the works?

Documentary Aesthetics

When an exhibition lists light and shadow as its premise, one of the effects is that it encourages viewers to see the works from an aesthetic perspective. Perspectives and techniques that documentary photographers apply to frame changes of light and shadow and their design nuances are featured as the center of the work. Therefore, the content of documentary photography is surpassed by its style, and the frequent subject matters of labor are interpreted in poetic and painterly approaches, putting the silhouettes of farmers and the scenery that envelops them at the center. In the photography work on laborers by Dennis K. Chin, Lee Ming-Tiao, Ouyang Wen, Hsieh Chen-Lung, Chou Shin-Chiuan, Cheng Shang-Hsi, and Chiu De-Yun, realities of the figures, such as the social background, farming location, harvest, and physical hardship, all retreat into the background; instead, the attention is drawn to the visual compositions of the beauty of the rural landscape. If we view the backlit and front-lit figures and scenes in rural photography from the Republic of China period to the post-war era from an aesthetic point of view, immersing ourselves in the beauty of the land and the serenity of country living, we may easily overlook the differences between the works and the varying social and economic backgrounds, which further leads to difficulty in understanding the reason for photographic documentation.

Although the effects of light and shadow give documentary photography an aesthetic that deserves attention, it also inevitably blurs the context of photography and decreases the difference between works. For instance, the scene in Ouyang Wen's *The Way Back (Ox Cart)* seems vast and beautiful, but the work was in fact taken when the artist was a victim of the White Terror and while serving his sentence as a photographer on Green Island. Ouyang Wen was originally an elementary art teacher, but after the February 28 Incident, he was accused of joining a rebel organization and of conspiring with the Communists, which led to a twelve-year sentence on Green Island. Ouyang Wen's Green Island photography Series was taken when the artist went on a work trip at the Division of Politics, and he was eager to document life and the scenery of Green Island in the 1950s. The photographer used a humble camera and less-than-ideal darkroom facilities, detecting natural light with his naked eye when developing photographs.[3] In comparison, Chou Shin-Chiuan's 1973 work *Returning Flock of Sheep* was

3 Su Chenming, Jiang Mo-Chun, Lin Chang-Hua, *An Art and Human Rights Warrior: Life Story of Oyo San*, pp.78-79. New Taipei City: National Human Rights Museum Preparatory Office, 2015.

created through meticulous planning and repeated testing. The image of herders herding sheep was a scene that frequently appeared in front of the police station when Chou was the chief of Wangan Police Precinct in Penghu. To present the backlit, elongated shadows of sheep with the Penghu Great Bridge merging into the background, Chou experimented with different perspectives when taking long shots. Finally, Chou came up with the idea to deploy a fire truck and managed to take a panoramic view from the highest point of the ladder, finally accomplishing a composition he was satisfied with.[4]

From the discussions above, we know that if we only rely on the final appearances of the images and stress the aesthetic experiences of the interactions between light and shadow, it would be difficult to understand the intentions of the photographer and the situations they were in, and the historical contexts of the works will also become blurry. The attitudes and photography conditions vary greatly between documentary photographers, and it would be difficult to treat them with the same aesthetic perspectives. Even if photographers have the intent of taking outstanding works that stress style, form, and the arrangement of light and shadow, the image's production method, real-life conditions, and the subjective interpretation of the phenomenon all occlude the final result.

Energy of Life

Light has endowed the world with varying colors and brightnesses, and behind the visual phenomena, light also contains the extensive traditions of metaphysics, philosophy, and theology. Umberto Eco's work *History of Beauty* lists how many cultures across the world have viewed their gods as light. For instance, the god Baal of the Semitic People, the Ra of Egypt, and the Ahura Mazda of Persia, all deified the sun or light. The ensuing Neoplatonism and Christianity thought system viewed god as the light that spread across the entire universe.[5] Medieval theologians and philosophers saw light as the symbol of the superiority of God and believed it spread God's truth, virtue, and beauty. In the 13th century, theologian Bonaventure believed light to be the root of all beauty; only through the medium of light could the heavens and earth be filled with rich colors. Bonaventure proposed three focal points in the study of light: lux, lumen, and splendor.[6] Simply put, light represents the creator's supreme glamor; it is the root of life and creativity and the manifestation of beauty and utmost blessing.

This exhibition does not echo the knowledge systems of the West, nor does it reference the connection between light and religion. However, a few photographic works that feature human figures show a sanctity of light that is unique to pre-modern times, giving the subject matter a unique force through nimbus and luminosity. For instance, Lin Bo-Liang's 2001 portrait *Zhou Meng-Die* welcomes a warm ray of light to a quiet house on a winter's day, reflecting the poet's inner light and alluding to his vibrant imagination. The poet is like a vehicle for light that also projects images on the wall. This work does not praise God but accentuates the mind's eye of a man of letters through light, casting his insight into the world. Another portrait also spotlights the figure as an extraordinary carrier of light. Ho Ching-Tai's *The Chen Family Shaman (Lin Chen Xiang-Yu), The Hundred-Year Covenant Between Man and God* Series (2018) involves solemn lighting that seems to be a manifestation of ancestral spirits descending on the shaman, her traditional clothing, headwear, glass beads, and face, all depicting the incandescence of ancient belief, the luminous ancestral house carved with hundred pace snakes, a

4 Yang Yung-Chih, *Photographers of Taiwan: Chou Shin-Chuan*, pp.52-53. Taichung: National Taiwan Museum of Fine Arts, 2017.
5 Umberto Eco, *History of Beauty*, p.102. Translated by Peng Huai-tung, Taipei: Linking Publishing, 2006.
6 Ibid., p.129.

symbol of aristocratic ancestors. To photograph rituals and portraits at the Paiwan Maljeveq Festival, Ho deliberately used the 19th century collodion technique to create unexpected and uneven hand-crafted traces.[7] The scattered specks of light and shadow appropriately frame the shaman's unique role of praying for blessings and warding off evil; through the cleansing power of light, she becomes a portal between the secular and spiritual worlds.

As for worldly subject matters, natural and artificial lighting has the ability to create heat, brightness, and color tone, allowing the actual form of objects to be presented. Through agile street photography, Lin Kuo-Chang and Hubert Kilian observe life in the days and nights of the same city. Lin Kuo-Chang focuses on the wall openings in the North Gate under the Taipei midday sun, the silhouette of the hundred-year-old Qing dynasty city gate towering under the beaming sunlight and highly contrasted white and black, erected tall on the recently reconstructed Zhongxiao West Road. Lin Kuo-Chang's symmetrical composition can also be seen in the photographer's work on the street scenes of Baoqing Road and National Sun Yat-Sen Memorial Hall. The pedestrians pass by in the busy street under the beaming sun, merging different forms, shadows, and traces. Hubert Kilian's *The Original Flavour of Taipei* and *The Stomach of Taipei* feature food stands and markets at night, showcasing the pale fluorescent lights and a butcher cutting pork, betel nut merchants and waiting customers, as well as male figures eating in a noodle shop. These vivid images are not only presentations of urban lifestyle but also feature the people's behavior, facial expressions, and stances within close proximity, enlarging the bodies under the lights and their surroundings.

Hidden Shadows

If light represents the energy of life and gives form to events and objects, then what do shadows represent? Shadows have opposite meanings in Eastern and Western thought. In the book *Shadows and Enlightenment*, art historian Michael Baxandall points to the intellectual circle of the Enlightenment and believed shadow to be an extension of darkness, lacking stable form or continuous existence. It is the absence of light, an enemy and parasite of light. Shadows often remind people of ghosts, monsters, concealment, secrets, and threatening events and objects. Baxandall noted that the Plato's cave analogy deeply impacted Western thought, leading later philosophers to view shadows as the source of incorrect knowledge, with those imprisoned in the cave seeing only the shadows cast on the cave wall and having no way of learning the truth.[8]

In the history of Western art, from ancient Roman mosaics to Surrealism, artists have been deeply concerned with depictions of shadows. Either through natural or artificial lighting, depicted clearly or in a blur, shadows hold a pivotal role in the history of images. Art history academic Ernst Hans Josef Gombrich's *Shadows: The Depiction of Cast Shadows in Western Art* explores the multiple functions of shadows: accentuating the sources of light, adding to the physical sturdiness of objects, creating atmosphere, and stressing the theatrical effects of narrative.[9] If we view photography as a part of an extensive history of images, then the aesthetic effects of shadows in images should be similar.

7 *Ho Ching-Tai Interview*, interview by Chiang Li-Hua, *Photographers of Taiwan: Ho Ching-Tai*, pp.158-106.
 Taichung: National Taiwan Museum of Fine Arts, 2021.

8 Michael Baxandall, *Shadows and Enlightenment*, pp.144-145. New Haven & London: Yale University Press, 1995.

9 Ernst Hans Josef Gombrich, Shadows: *The Depiction of Cast Shadows in Western Art*, pp.27-59. Lodon: National Gallery, 1995.

Compared with modern Western technology, which pursues brightness and illumination, Japanese writer Tanizaki Junichiro's *In Praise of Shadow* gives prominence to Japan's shadow aesthetics. Tanizaki notes that Japanese rooms, objects, clothing, and the luring appeal of beautiful women, are all best appreciated in faint lighting conditions. Shadows inspire contemplation and nostalgia, giving the vistas before us a unique sense of lonesome charm, elegance, and time.[10] In this description, shadows have cultural depths that resist modern trends and allow timeless aesthetic experiences.

This exhibition does not emphasize the beauty of shadows; some photographers are experts at deploying shadows to convey restless threats and the weight of survival. Although faint light seeps through, it does not disperse the gloom of nightmares. For instance, Annie Hsiao-Ching Wang's 1993 work *The Woman Drowning in a Black Tide* gives an eerie sense that reminds viewers of Film Noir, the high contrast forming distorted spaces of Expressionism. The images of this Series are like film stills, impacting viewers with their gloomy atmosphere and luring them out of the light, isolating them in claustrophobia-inducing shadow. The woman in the photography is suppressed and dreary, the shadow cast on her face alluding to her inner struggles and anxieties.

Some works showcase scenes without people, resembling crime scenes that inspire the imagination regarding the people that once existed in these spaces. For instance, Li Yu-Chi's *Suburbs* (2021) shows an unknown place intruded upon by a strong ray of light, like a laser beam for detecting thieves and robbery, mercilessly sectioning the image while illuminating the surrounding slumbering plants, greenery and corridor walls, sparking our curiosity toward what took place. Chen Shu-Chen's *After* Series (2017) captures the theme of Taiwan's motels. The quiet, ordinary, and intimate space filled with shadows and flickering lighting, an empty space resembling a crime scene. The original lighting of the motel was designed to alleviate fatigue and induce sensuality. However, the gloomy colors of the *After* Series meticulously showcase the details after the lodgers have left, hinting at illegal conduct or clandestine relationships.

Abstract Forms

Throughout this exhibition, many works show colors and forms that border on the abstract, stressing how the scene constructs certain atmospheres instead of referencing specific objects, incidents, or times. Furthermore, in their creative statements, photographers such as Chang Kuo-Chih and Kao Chih-Chun express preferences toward non-figurative and lyrical styles. Indeed, as photography enters the realm of art, photographers often adopt abstract visual strategies, which, on the one hand, gives the photographs a kinship to painting and poetics, and, on the other, allows the images to reach deep into the inner states of the viewers, unearthing thoughts ineffable and difficult to manifest. Here, the reality that photography refers to fades away, and in its place remain the aesthetic arrangements of color, lighting, and lines, as well as an openness toward different interpretations.

Some works feature abstract forms mellowed through the experience of nature and an ode to the seasons. For instance, Chang Wu-Chun specializes in capturing subtle tonal temperatures and nuanced colors, framing the unique landscapes of Southern Taiwan: the badlands, colorful bamboo, silver grass, sand dunes, and canyons, into brightly colored shapes and patterns that inspire rhythmic and pleasing aesthetics. Fan Yen-Nuan's 2015 work

10 Tanizaki Junichiro, *In Praise of Shadows*, pp.5-65. Translated by Liu Zi-Qian, Taipei: Streamer Publishing House, 2016.

59

Memories and Illumination projects the artist's emotions and imagination through the silhouettes of flowers, plants, trees, movements of water, and the imagery of clouds. Fan weaves texts and indoor still-life together amid the changing natural scenery, crystalizing stream of consciousness and fleeting moments.

Along with admiring nature, some photographic works explore geometric architectural spaces. Tsai Wen-Shiang's *Movement of Ink* (2020) presents the clever expressions of shadows, giving the wall structure more definition and a sense of sturdiness while adding depth to the space. This Series plays with the physicality and planarity of photography: on the one hand, depicting angled, towering buildings; on the other, compressing them into geometric shapes. In these works, light and shadow become continuous existences that ebb and flow.

Conclusion

Simile · Metaphor: Chasing Light, Shadows, and Alternative Meanings explores ways of reading light and shadow and the meanings behind photographs. The exhibition gathers photographic works from different genres into a family of light and shadow, returning to the root of how images take form, which is through the interaction between light and shadow. This article discusses the viewing methods this exhibition inspires with an emphasis on visual and aesthetic experiences, spotlighting the importance of light and shadow in the aesthetic and expression of photography. When reading the meanings behind light and shadow, I return to the historical context of photography and take into consideration the tight knit relationship between form and subject matter. Light gives form to all things and is a metaphor for sanctity, vitality, and enlightenment. The shadow is the opposite, a follower of light, and is often used negatively as a symbol for illusions, nightmares, ghosts, and crime. Many works in this exhibition feature sophisticated expressions toward the composition of light and shadow, as well as profound cultural understandings.

The exhibition views photography from the perspective of light and shadow, emphasizing the artistic value of photography, accentuating the creative mindset of photographers and their stylistic approaches to light and shadow. Since the 19th century, there have been numerous discussions on whether photography counts as art, but the topic ceases to be relevant today. Semiotic theorist Roland Barthes expressed doubt and worry about the artistic tendencies of photography. In *Camera Lucida*, Barthes pointed out that photography has the unique quality of "that which has been," a character that other mediums lack, since photography does not rely on symbols and metaphors when referring to past events but instead re-presents them in a direct manner. This force of bearing witness to time is on full display in its artistic quality. However, Barthes cautions us that the connection between photography and reality is under destruction through two forces: viewing photography as art by adopting painterly rhetoric and holding exhibitions, and viewing all things as consumable images, which leads to the complete derealization of human conflict and desires.[11]

11 Roland Barthes, *Camera Lucida: Reflections on Photography*, pp.45, 117-119. Translated by Richard Howard, New York: Hill and Wang, 1981.

Perhaps we need not be as pessimistic as Barthes and should instead be cautious toward the encounter and tension between art and photography. Photography is inseparable from visual perceptions of reality and wanders amid the grey area between figurative and abstract, arrangement and occasionality, presence and absence. We might as well reflect on whether the existing frameworks and mindsets in the versatility, universality, and replicability of photography would become restrictions to its potential. Apart from praising visible light and shadow, photography also presents details of daily life that are often overlooked, as well as the photographer's questioning and interpretation of the status quo of society. Finally, this article would like to close by quoting Henri Cartier-Bresson: "The debate about the place of photography in the plastic arts is not my concern, because it is a matter of class, which I see as purely academic."[12] Whether photography is accepted as art is not the concern of Cartier-Bresson, but what is worthy of further contemplation is how photography raises questions through visuality and presents an understanding of life in a complex and ambiguous manner.

12 Henri Cartier-Bresson, *L'imaginaire d'après Nature*, pp.16, 42-43. Translated by Chang Li-Hao and Su Wei-Zen, Taipei: Uni-Books, 2014.

比喻之光

比喻：基於兩物之間的相似性或共通點，以具有某種特質、生動的形象，來描述或形容所要說明的對象。本展藉此一修辭學的概念，將作品中各種光線或光暈的呈現，視為構圖形式、主題元素的比喻手法，並由具象之物衍伸至抽象意義，包括人物與人性之光、城市與空間之光、物件與物體之光，以及線條與人造之光等作品，描繪造形靈動的符號，形構攝影家主觀意識下的景象，由此開展出觀看者對作品的投射與想像的多重含義，交織出千姿百態的比喻之光。

THE LIGHT OF SIMILE

Simile : A figure of speech composed of unique, vivid descriptions based on the similarity or shared qualities between two objects to describe or illustrate the subject being discussed. This exhibition applies this rhetorical concept to interpret the lighting in the works as similes of the composition and subject matter, extending from the figurative to the abstract, encompassing aspects such as the human aura, the radiance of cities and spaces, the physicality of objects, and the interplay of lines and artificial lighting. The curation shapes these into expressive symbols composed of the photographer's subjective images, which are further intertwined with the different projections and imaginations of viewers, weaving a tapestry of the multifaceted simile of light.

歐陽文	OUYANG Wen	何經泰	HO Ching-Tai
周鑫泉	CHOU Shin-Chiuan	洪世聰	HUNG Shih-Tsung
邱德雲	CHIU De-Yun	張宏聲	CHANG Hong-Sheng
謝明順	Vincent HSIEH	葉清芳	YEH Ching-Fang
林芙美	LIN Fu-Mei	賴永鑫	LAI Yung-Hsin
張武俊	CHANG Wu-Chun	范晏暖	FAN Yen-Nuan
劉永泰	LIU Yung-Tai	陳淑貞	CHEN Shu-Chen
簡榮泰	CHIEN Yun-Tai	賴譜光	LAI Pu-Kuang
阮義忠	JUAN I-Jong	余 白	Hubert KILIAN
林國彰	LIN Kuo-Chang	張志達	CHANG Chih-Ta
林柏樑	LIN Bo-Liang	邱誌勇	CHIU Chih-Yung
張國治	CHANG Kuo-Chih	王鼎元	WANG Ding-Yuan
高志尊	KAO Chih-Chun	楊士毅	YANG Shih-Yi
傅朝卿	FU Chao-Ching	李毓琪	LI Yu-Chi

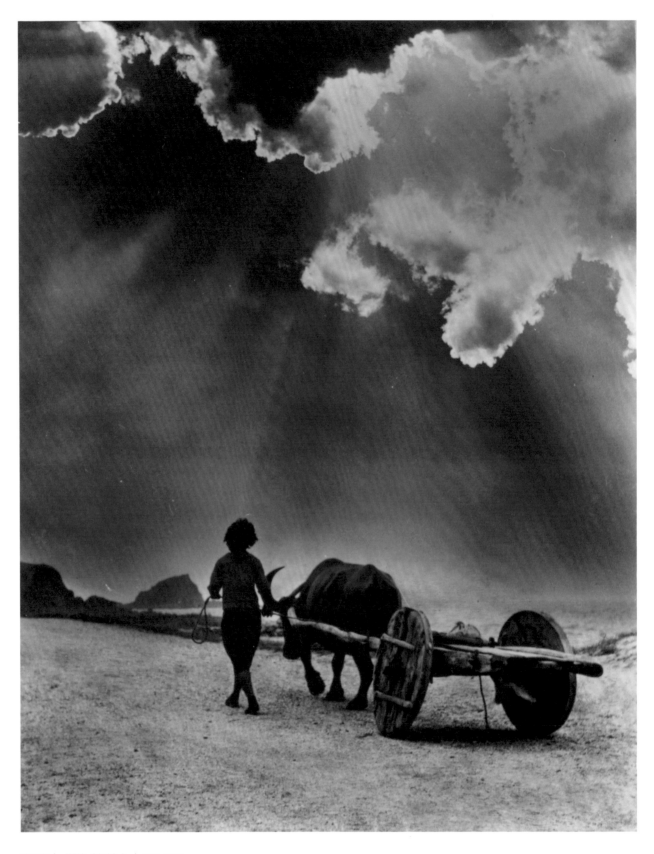

歐陽文 │〈歸途（牛車）〉│ 1950-1969
明膠銀鹽 │ 15.9 × 12.5 公分 │ 國家攝影文化中心典藏

OUYANG Wen │ *The Way Back (Ox Cart)* │ 1950-1969
Gelatin silver print │ 15.9 × 12.5 cm │ Collection of the National Center of Photography and Images

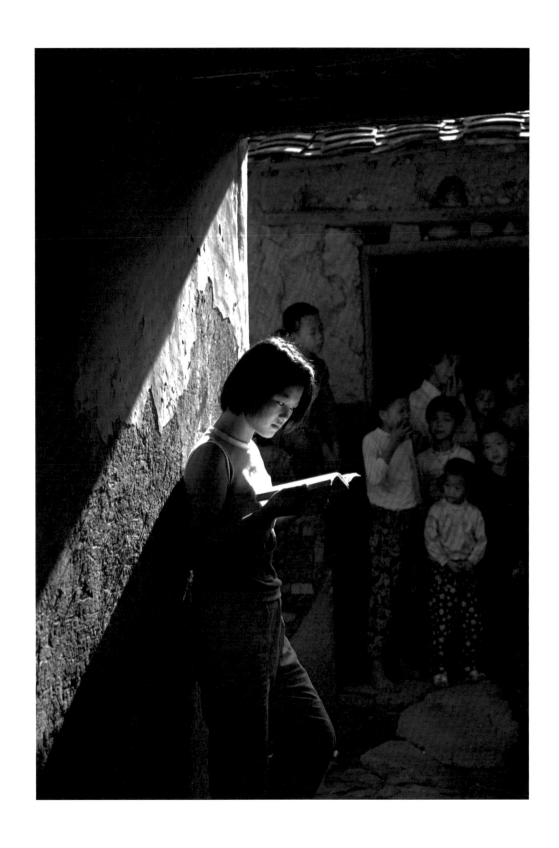

周鑫泉 │〈自修功課〉│ 1973
數位銀鹽 │ 50.4 × 35.1 公分 │ 國家攝影文化中心典藏

CHOU Shin Chiuan │ *Self-Study* │ 1973
Digital silver print │ 50.4 × 35.1 cm │ Collection of the National Center of Photography and Images

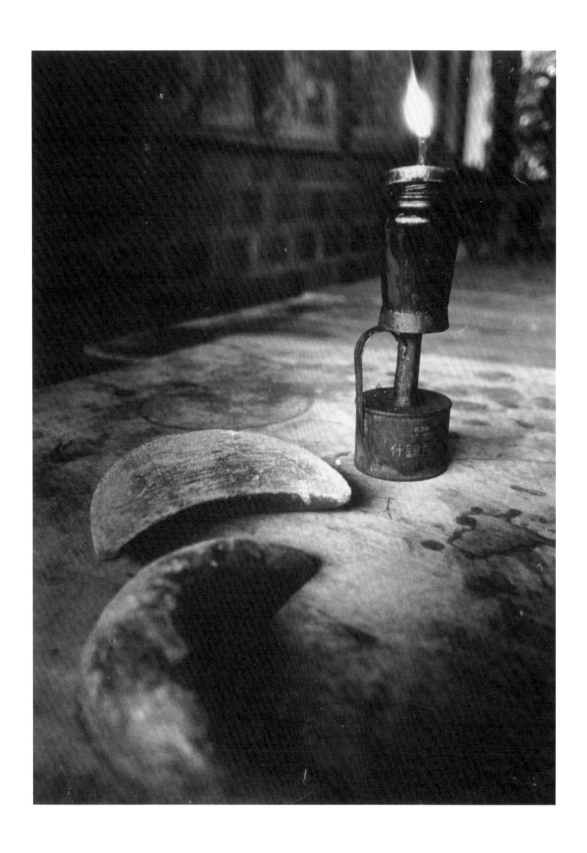

邱德雲｜〈水褲頭相簿（二）96〉｜1990-2000
明膠銀鹽｜16.6 × 11.8 公分｜藝術家授權

CHIU De-Yun｜*The Shorts Album (Two) 96*｜1990-2000
Gelatin silver print｜16.6 × 11.8 cm｜Courtesy of the artist

謝明順 ｜〈敬天〉，《雕塑情懷的「像雕」》系列｜ 1997
西霸彩色相紙｜ 50.8 × 65.8 公分｜藝術家授權

Vincent HSIEH ｜ *Honoring the Heavens, Sculptural Sentiments Series* ｜ 1997
Cibachrome ｜ 50.8 × 65.8 cm ｜ Courtesy of the artist

謝明順 │〈漫遊〉，《雕塑情懷的「像雕」》系列│ 1997
西霸彩色相紙 │ 50.8 × 65.8 公分 │ 藝術家授權

Vincent HSIEH │ *Roam, Sculptural Sentiments Series* │ 1997
Cibachrome │ 50.8 × 65.8 cm │ Courtesy of the artist

謝明順｜〈蓄勢〉，《雕塑情懷的「像雕」》系列｜1997
西霸彩色相紙｜50.8 × 65.8 公分｜藝術家授權

Vincent HSIEH｜*Gathering Momentum, Sculptural Sentiments Series*｜1997
Cibachrome｜50.8 × 65.8 cm｜Courtesy of the artist

林芙美｜〈孕育〉，《交集與干涉》系列｜1994
西霸彩色相紙｜44 × 27.2 公分｜國家攝影文化中心典藏

LIN Fu-Mei｜*Cultivation, Intersection and Interference Series*｜1994
Cibachrome｜44 × 27.2 cm｜Collection of the National Center of Photography and Images

林芙美 │〈交容〉,《交集與干涉》系列 │ 1994
西霸彩色相紙 │ 44 × 27.2 公分 │ 國家攝影文化中心典藏

LIN Fu-Mei │ *Merge, Intersection and Interference Series* │ 1994
Cibachrome │ 44 × 27.2 cm │ Collection of the National Center of Photography and Images

林芙美 | 〈相依〉,《交集與干涉》系列 | 1994
西霸彩色相紙 | 61 × 51 公分 | 藝術家授權

LIN Fu Mei | Dependence, Intersection and Interference Series | 1994
Cibachrome | 61 × 51 cm | Courtesy of the artist

林芙美 | 〈相融〉,《交集與干涉》系列 | 1994
西霸彩色相紙 | 26.7 × 40 公分 | 國家攝影文化中心典藏

LIN Fu-Mei | Integration, Intersection and Interference Series | 1994
Cibachrome | 26.7 × 40 cm | Collection of the National Center of Photography and Images

林芙美 ｜〈開天〉，《交集與干涉》系列 ｜ 1994
西霸彩色相紙 ｜ 51 × 61 公分 ｜ 藝術家授權

LIN Fu-Mei ｜ *Opening Up the Sky, Intersection and Interference Series* ｜ 1994
Cibachrome ｜ 51 × 61 cm ｜ Courtesy of the artist

林芙美 ｜ 〈邂逅〉，《交集與干涉》系列 ｜ 1994
西霸彩色相紙 ｜ 51 × 61 公分 ｜ 藝術家授權

LIN Fu-Mei ｜ *Encounter, Intersection and Interference Series* ｜ 1994
Cibachrome ｜ 51 × 61 cm ｜ Courtesy of the artist

張武俊 ｜ 〈金山〉，《夢幻月世界》系列 ｜ 1990
藝術微噴 ｜ 42 × 80 公分 ｜ 藝術家授權

CHANG Wu-Chun ｜ *Jinshan, Dreamy World Series* ｜ 1990
Giclée ｜ 42 × 80 cm ｜ Courtesy of the artist

張武俊｜〈青瓜寮〉，《夢幻月世界》系列｜ 1990
藝術微噴｜ 70 × 50 公分｜藝術家授權

CHANG Wu-Chun｜*Qinggualiao, Dreamy World Series*｜ 1990
Giclée｜ 70 × 50 cm｜ Courtesy of the artist

張武俊 | 〈龍崎烏山頭〉,《夢幻月世界》系列 | 1993
藝術微噴 | 40 × 50 公分 | 藝術家授權

CHANG Wu Chun | *Wushantou, Longqi, Dreamy World Series* | 1993
Giclée | 40 × 50 cm | Courtesy of the artist

劉永泰 ｜〈自我手鍊（X 光）〉，《光之再現》系列｜ 1990
藝術微噴｜ 82.5 × 97.5 公分｜藝術家授權

LIU Yung-Tai ｜ *My Bracelet (X-Ray), The Re-Emergence of Light Series* ｜ 1990
Giclée ｜ 82.5 × 97.5 cm ｜ Courtesy of the artist

劉永泰｜〈自我頭殼（X 光）〉，《光之再現》系列｜ 1990
藝術微噴｜ 82.5 × 97.5 公分｜藝術家授權

LIU Yung-Tai｜*My Skull (X-Ray), The Re-Emergence of Light Series*｜ 1990
Giclée｜ 82.5 × 97.5 cm｜Courtesy of the artist

劉永泰 ｜〈聚散〉，《光之再現》系列｜ 1980
藝術微噴 ｜ 82.5 × 97.5 公分｜藝術家授權

LIU Yung-Tai ｜ *Accumulation and Dispersion, The Re-Emergence of Light Series* ｜ 1980
Giclée ｜ 82.5 × 97.5 cm ｜ Courtesy of the artist

劉永泰 ｜〈齊飛〉，《光之再現》系列 ｜ 1985
藝術微噴 ｜ 82.5 × 97.5 公分 ｜ 藝術家授權

LIU Yung-Tai ｜ *Flight in Unison, The Re-Emergence of Light Series* ｜ 1985
Giclée ｜ 82.5 × 97.5 cm ｜ Courtesy of the artist

簡榮泰 ｜〈高雄大樹〉，《舊鄉》系列 -16 ｜ 1980
明膠銀鹽 ｜ 40.5 × 50.5 公分 ｜ 國家攝影文化中心典藏

CHIEN Yun-Tai ｜ *Kaohsiung Dashu, Familiar Town Series-16* ｜ 1980
Gelatin silver print ｜ 40.5 × 50.5 cm ｜ Collection of the National Center of Photography and Images

阮義忠 │〈臺南億載金城〉，《失落的優雅》系列│ 1977
明膠銀鹽 │ 50.5 × 61 公分 │ 國家攝影文化中心典藏

JUAN I-Jong │ *The Eternal Golden Castle, Lost Grace Series* │ 1977
Gelatin silver print │ 50.5 × 61 cm │ Collection of the National Center of Photography and Images

何謂《臺北道》？

關於臺北

臺北。既近實遠。你我常遊的城市。一座歷史與地理患了健忘症的城市。沿淡水河上行。一艋二稻三城內。1709 年艋舺開墾。1851 年大稻埕建街屋。1884 年臺北城竣工。這三地相鄰的聚落。組成三市街。稱為臺北。

臺北城。今日看不見城。看見的是江山易代之際。後殖民者拆毀城牆。顛覆地景。錯置街道。原本清代的街名。日治的日式路名。與光復後民國以大陸城市命名的街路。三方疊層轉移。改變了臺北過去的街道與風土。也改變了我們認知的地景與空間記憶。

清代臺北城牆早夷平為路。成為今天的忠孝西路。中華路。愛國西路與中山南路。這四條道路圍起的區域。就是 1884 年的臺北城原址。1895 年日本攻佔臺北。1904 年拆城牆。只剩北門尚存原貌。西門消失。其他三座城門。經改造為中國北方宮殿式城樓。建築原貌磨滅。偽地景製造偽歷史。偽歷史陷真實於不義。

今日拍攝臺北地景現貌。紀實一個歷史與地理的交界處。一個時間與空間的接觸帶。觀測那時那地那事。天地人與乎街路更迭。不確定的場景。不時檢視差異。一再重複探訪。

想像臺北大湖。昨日蠻煙瘴雨。山川蒼茫。

想像臺北盆地。城不設防。沒有了城牆的街路。

想像臺北道。凱達格蘭族來過。 葡萄牙來過。西班牙來過。荷蘭來過。鄭氏王朝來過。清朝來過。臺灣民主國來過。日本來過。民國來過。

關於道

道。是一個人走到十字路口停下來。
觀察。思考。抉擇。

—— 林國彰

What is *Taipei Dao?*

About Taipei

Taipei. Both near and far. The city you and I often visit. A city with amnesia in history and geography. Go up the Tamsui River. One Meng, two rice and three cities. In 1709, Mengka was reclaimed. In 1851, a street house was built in Dadaocheng. In 1884, Taipei City was completed. These three adjacent settlements. Composed of three city streets. called Taipei.

Taipei city. The city cannot be seen today. What I saw was when the country changed from generation to generation. Later colonists demolished the city walls. Upend the landscape. Misplaced streets. The original street name in the Qing Dynasty. The Japanese style street name of the Japanese Occupation. And the street named after the mainland city after the Republic of China. Three-way stack transfer. Changed the streets and customs of Taipei in the past. It also changes our cognitive landscape and spatial memory.

In the Qing Dynasty, the city wall of Taipei was razed to the ground. Become today's Zhongxiao West Road. Zhonghua Road. Aiguo West Road and Zhongshan South Road. The area surrounded by these four roads. It is the original site of Taipei City in 1884. In 1895, Japan captured Taipei. In 1904, the city wall was demolished. Only the north gate remains in its original form. Simon disappears. The other three gates. It was transformed into a palace-style tower in northern China. The original appearance of the building is obliterated. Pseudo-landscapes create pseudo-history. Pseudo-history traps truth in injustice.

Today, I took pictures of the landscape of Taipei. Documentary a junction of history and geography. A zone of contact between time and space. Observe what happened then and there. Heaven, earth, people, and the streets and roads change. Uncertain scene. Check for differences from time to time. Repeat visits again and again.

Imagine the great lake in Taipei. It was quite smoky and rainy yesterday. The mountains and rivers are vast.

Imagine the Taipei Basin. The city is not fortified. Streets without walls.

Imagine Taipei Road. The Ketagalan came. Portugal has been here. Spain has been here. Holland has been here. The Zheng Dynasty came. The Qing Dynasty came. The Democratic Republic of Taiwan has been here. Japan has been here. The Republic of China has come.

About Road

Road. It was a man who came to an intersection and stopped. observe. think. choice.

— **LIN Kuo-Chang**

林國彰 ｜〈中山北路臺北故事館〉，《臺北道》系列｜ 2020
白金照片｜ 25.4 × 25.4 公分｜國家攝影文化中心典藏

LIN Kuo-Chang ｜ *Zhongshan North Road Taipei Story House, Taipei Dao Series* ｜ 2020
Platinum print ｜ 25.4 × 25.4 cm ｜ Collection of the National Center of Photography and Images

林國彰｜〈忠孝西路北門〉，《臺北道》系列｜2017
白金照片｜25.4 × 25.4 公分｜國家攝影文化中心典藏

LIN Kuo-Chang｜*Zhongxiao West Road North Gate, Taipei Dao Series*｜2017
Platinum print｜25.4 × 25.4 cm｜Collection of the National Center of Photography and Images

林柏樑 ｜〈周夢蝶〉｜ 2001
明膠銀鹽 ｜ 50.4 × 60.8 公分 ｜ 國家攝影文化中心典藏

LIN Bo-Liang ｜ *Zhou Meng-Die* ｜ 2001
Gelatin silver print ｜ 50.4 × 60.8 cm ｜ Collection of the National Center of Photography and Images

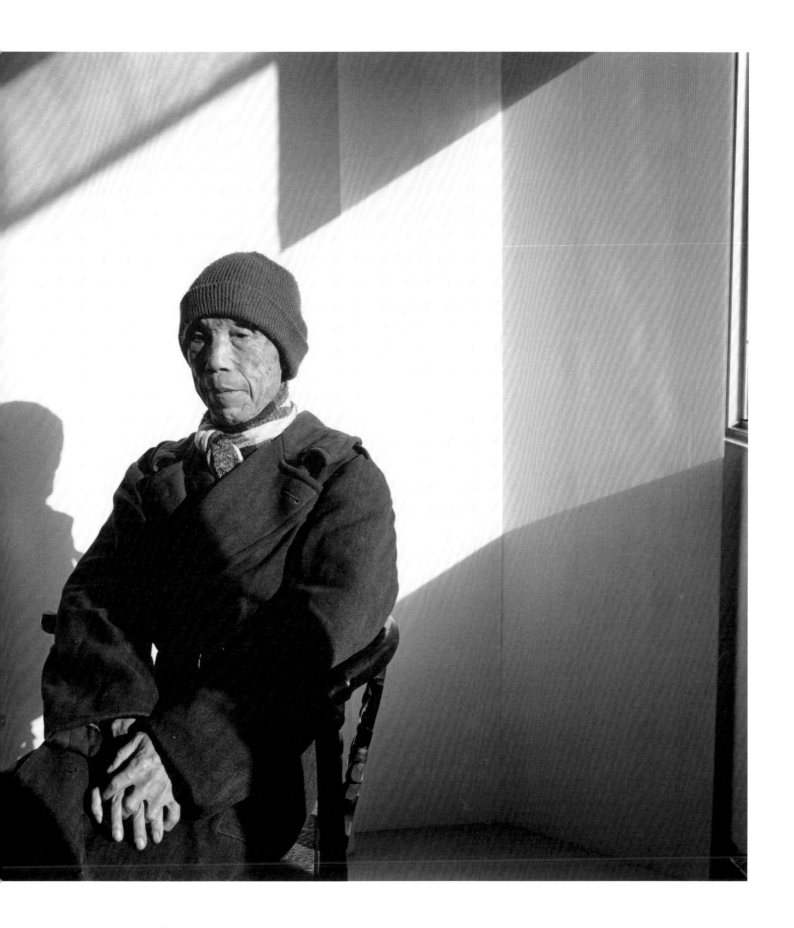

《光影圖騰》系列

習慣寫作、放大影像、繪畫，暗中作息的我，時常潛泳到夢境，並時有一種無止盡的墜落或漂浮感，從黑暗中所形成的巨大陰影甦醒在日升的邊緣，那時刻，光對我而言，是某種神聖的召喚。

我是受光指引才著迷於攝影的，在金門城長大，童年時候的我睡寢在叔叔嬸嬸的紅眠床，進入日暮後全然暗黑的戰地宵禁歲月，燭火或煤油燈昏沉中伴讀，直到黑暗中砲聲侵入，攪亂徬徨的心靈，經常不得安寧胡亂進入夢鄉，夢裡時而潛入意識拼湊的圖像及符號。唯獨晨光從狹長天窗透射入屋，我在那道透射入內的光絲漂浮中胡亂思考人生，對光的懼怕或迷戀，甚或是對影的暗悼，都在我人生交互對比中進行，形成諸多符號和指涉。

選擇了繪畫和攝影，光影之交集及組構，都是創作時最大表現元素思考所在。由不同年代拍攝，尋找出封箱之作，從構圖上的形式掌握，內涵中充滿了複雜的情感，從符徵到符旨，光和影的存在倚附心靈投射的形體，皆有其可詮釋的線索。

—— 張國治

Light and Shadow Totem

I am used to writing, magnifying images, painting, and working in the dark. I often dive into dreams, and sometimes have an endless sense of falling or floating. I wake up from the huge shadow formed in the darkness on the edge of the rising sun. At that moment, the light For me, it's some sort of divine calling.

I was fascinated by photography because of the guidance of light. I grew up in Jinmen City. As a child, I slept in the red bed of my uncle and aunt. I entered the dark curfew years of the battlefield after sunset, and read with candlelight or kerosene lamp in the dimness. The sound of guns invades in the dark, disturbing the wandering mind, and often falls asleep indiscriminately without peace, and sometimes sneaks into the dreams and images and symbols patched together by the consciousness. Only the morning light penetrates into the room through the long and narrow skylight, and I think about life randomly in the floating light thread that penetrates in. My fear or obsession with light, or even mourning for shadows, are all carried out in the interactive comparison of my life. Many symbols and references are formed.

I chose painting and photography, the intersection and composition of light and shadow, which are the biggest expressive elements in my creation. Shots taken in different years, find out the sealed works, grasp the form from the composition, the connotation is full of complex emotions, from symbols to symbols, the existence of light and shadow depends on the shape projected by the soul, all have their potential interpretation clues.

— **CHANG Kuo-Chih**

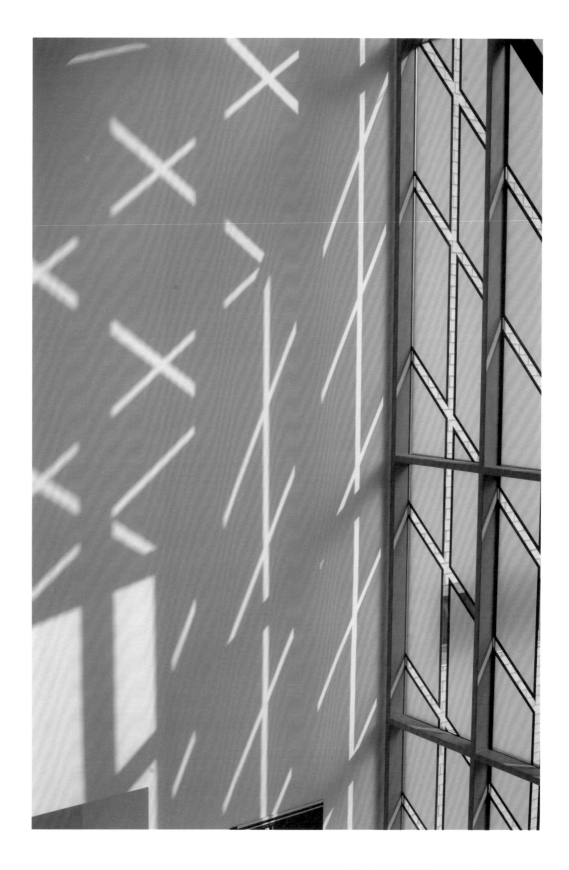

張國治｜《一樣的光影》系列 -1｜2006
數位輸出｜35.56 × 27.94 公分｜藝術家授權

CHANG Kuo Chih｜*The Same Scenario Image Series -1*｜2006
Digital print｜35.56 × 27.94 cm｜Courtesy of the artist

張國治 │ 《北京 798 的夏日》系列 -1 │ 2005
數位輸出 │ 35.56 × 27.94 公分 │ 藝術家授權

CHANG Kuo-Chih │ *Summer in Beijing 798 Image Series -1* │ 2005
Digital print │ 35.56 × 27.94 cm │ Courtesy of the artist

張國治 │ 《北京 798 的夏日》系列 -2 │ 2005
數位輸出 │ 27.94 × 35.56 公分 │ 藝術家授權

CHANG Kuo-Chih │ *Summer in Beijing 798 Image Series -2* │ 2005
Digital print │ 27.94 × 35.56 cm │ Courtesy of the artist

張國治 | 〈1973 年〉 | 2005
數位輸出 | 27.94 × 35.56 公分 | 藝術家授權
CHANG Kuo-Chih | 1973 | 2005
Digital print | 27.94 × 35.56 cm | Courtesy of the artist

張國治 ｜ 《穿越罅隙之光》系列 ｜ 2022
數位輸出、裝置作品 ｜ 29.8 × 44.7 公分，8 件 ｜ 藝術家授權

CHANG Kuo-Chih ｜ *Traveling Through the Light Coming from the Cracks Series* ｜ 2022
Digital print, installation art ｜ 29.8 × 44.7 cm, 8 pieces ｜ Courtesy of the artist

高志尊 ｜ 〈Firenze〉 ｜ 2001
西霸彩色相紙 ｜ 34.7 × 50.8 公分 ｜ 藝術家授權

KAO Chih-Chun ｜ *Firenze* ｜ 2001
Cibachrome ｜ 34.7 × 50.8 cm ｜ Courtesy of the artist

傅朝卿 | 〈幻向：編號 1994-1（巴黎羅浮宮）〉 | 1994
藝術微噴 | 40 × 27 公分 | 藝術家授權

FU Chao-Ching | *Illusory Dimensions: No. 1994-1 (Louvre Museum, Paris)* | 1994
Giclée | 40 × 27 cm | Courtesy of the artist

傅朝卿 ｜ 〈時向：編號 1994-2（聖吉米安諾大教堂）〉 ｜ 1994
藝術微噴 ｜ 40 × 27 公分 ｜ 藝術家授權
FU Chao Ching ｜ *Temporal Dimension: No. 1994-2 (San Gimignano Collegiata)* ｜ 1994
Giclée ｜ 40 × 27 cm ｜ Courtesy of the artist

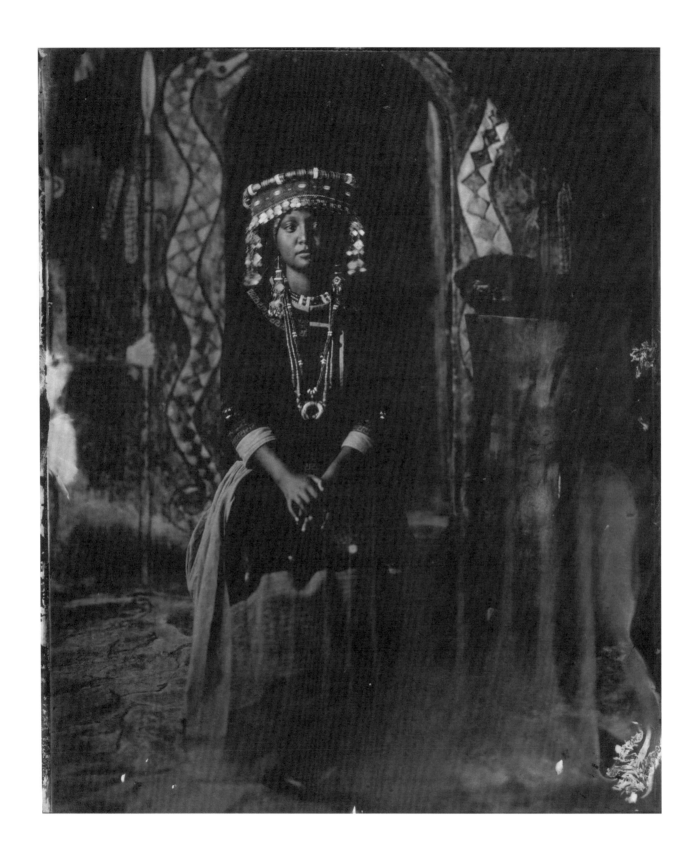

何經泰 ｜〈陳家巫師（林陳湘瑜）〉，《百年不斷的人神之約》系列｜2018
白金純棉相紙 ｜ 102×84 公分｜藝術家授權

HO Ching-Tai ｜ *The Chen Family Shaman (Lin Chen Xiang-Yu), The Hundred-Year Covenant Between Man and God Series* ｜ 2018
Platine Fibre Rag ｜ 102×84 cm ｜ Courtesy of the artist

何經泰 | 〈小米梗〉，《百年不斷的人神之約》系列 | 2018
白金純棉相紙 | 102×84 公分 | 藝術家授權

HO Ching-Tai | *Sinqil, The Hundred-Year Covenant Between Man and God Series* | 2018
Platine Fibre Rag | 102×84 cm | Courtesy of the artist

何經泰 | 〈豬頭骨〉，《百年不斷的人神之約》系列 | 2018
白金純棉相紙 | 102×84 公分 | 藝術家授權

HO Ching-Tai | *Pig Skull, The Hundred-Year Covenant Between Man and God Series* | 2018
Platine Fibre Rag | 102×84 cm | Courtesy of the artist

洪世聰 ｜ 〈視而浮現〉 ｜ 2021
數位微噴 ｜ 76.2 × 101.6 公分 ｜ 藝術家授權

HUNG Shih-Tsung ｜ *Emerging into Vision* ｜ 2021
Archival inkjet print ｜ 76.2 × 101.6 cm ｜ Courtesy of the artist

洪世聰 | 〈阿里山 1995〉，《光合》系列 | 2019
數位微噴 | 101.6 × 101.6 公分 | 藝術家授權

HUNG Shih-Tsung | *Alishan 1995, The Convergence of Light Series* | 2019
Archival inkjet print | 101.6 × 101.6 cm | Courtesy of the artist

洪世聰 ｜〈紅限〉｜ 2015
數位微噴 ｜ 80 × 140 公分 ｜藝術家授權
HUNG Shih-Tsung ｜ *Red limit* ｜ 2015
Archival inkjet print ｜ 80 × 140 cm ｜ Courtesy of the artist

洪世聰 ｜〈智慧之階〉｜ 2011-2022
複合媒材 ｜ 101.6 × 101.6 公分，210 × 240 公分 ｜藝術家授權

HUNG Shih-Tsung ｜ *Steps of Wisdom* ｜ 2011-2022
Mixed media ｜ 101.6 × 101.6 cm, 210 × 240 cm ｜ Courtesy of the artist

I 曼彻斯特大学
「Mark I 机器」写出了一個圖「丁棋程式

宇宙及人工智慧要有躯体－至可以
功、生降，与当下世界友流

1956年 達特茅斯會議：AI的誕生：「人工智慧」
「學習或是智能的任何特性，都可能被精確描述
使得機器可以也行 接摸」

1997年 深藍 計算机第一次戰勝世界西洋棋 冠軍
 • 自理。一切科學技術的基本 卡斯帕洛夫
 • 人工智慧——支配，掌向人類型的道德
 • 尚懷……人工智慧的目標
 • 学習——樹長出来的書.

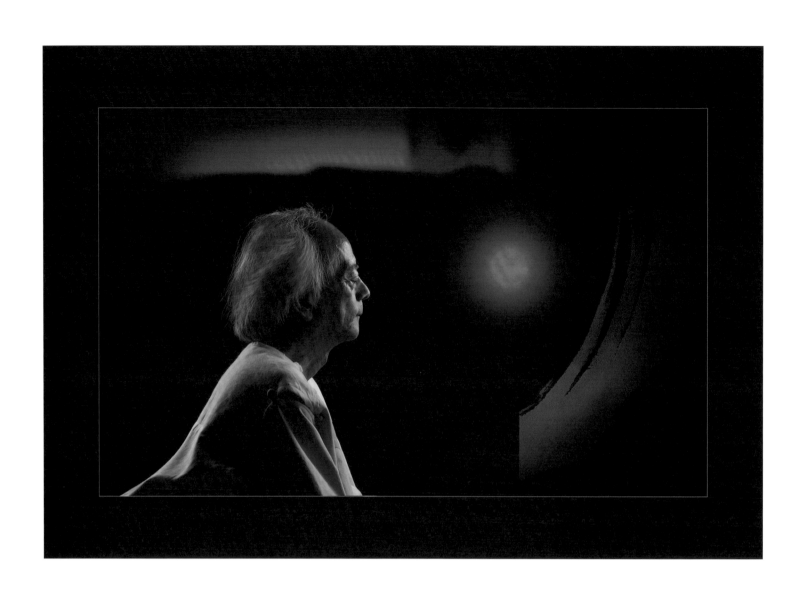

張宏聲 | 〈我曾思索：既然，每個人的一生，都是生老病死的重複，那麼，人生一趟的意義何在？〉 | 2019
藝術微噴 | 71.06 × 100 公分 | 藝術家授權

CHANG Hong-Sheng | *I Once Thought This: If Our Lives Are Nothing More Than the Repeat of Life, Old Age, Illness, and Death, Then What Is the Meaning of Life?* | 2019
Giclée | 71.06 × 100 cm | Courtesy of the artist

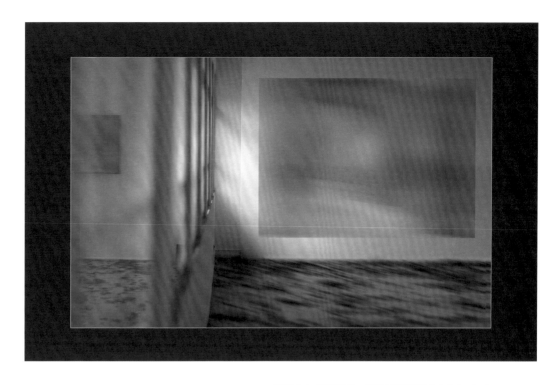

張宏聲 │ 〈我的靈魂，漫遊在寬闊孤獨的宇宙中。〉 │ 2022
藝術微噴 │ 66 × 100 公分│藝術家授權

CHANG Hong-Sheng │ *My Soul Wandering in the Vast Lonesome Universe.* │ 2022
Giclée │ 66 × 100 cm │ Courtesy of the artist

張宏聲 │ 〈燈和夜在寂靜的大地上，彼此寧靜地放逐著。〉 │ 1990
藝術微噴 │ 73.03 × 100 公分│藝術家授權

CHANG Hong-Sheng │ *Light and Night in a Silent Land, Wandering in Silence.* │ 1990
Giclée │ 73.03 × 100 cm │ Courtesy of the artist

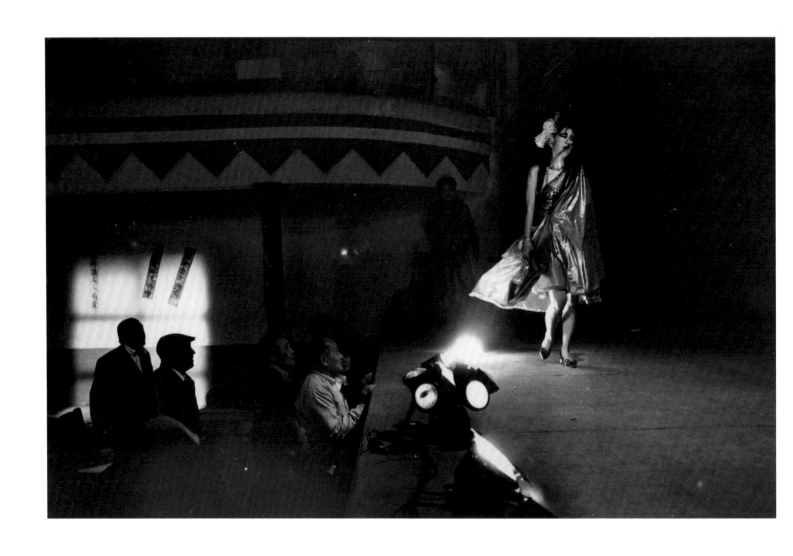

葉清芳 ｜《現實 ‧ 極光 ‧ 邊緣》—1988 臺北 ｜ 1988
明膠銀鹽 ｜ 25 × 30.2 公分 ｜ 國家攝影文化中心典藏

YEH Ching-Fang ｜ *Reality ‧ Aurora ‧ Periphery -1998, Taipei* ｜ 1988
Gelatin silver print ｜ 25 × 30.2 cm ｜ Collection of the National Center of Photography and Images

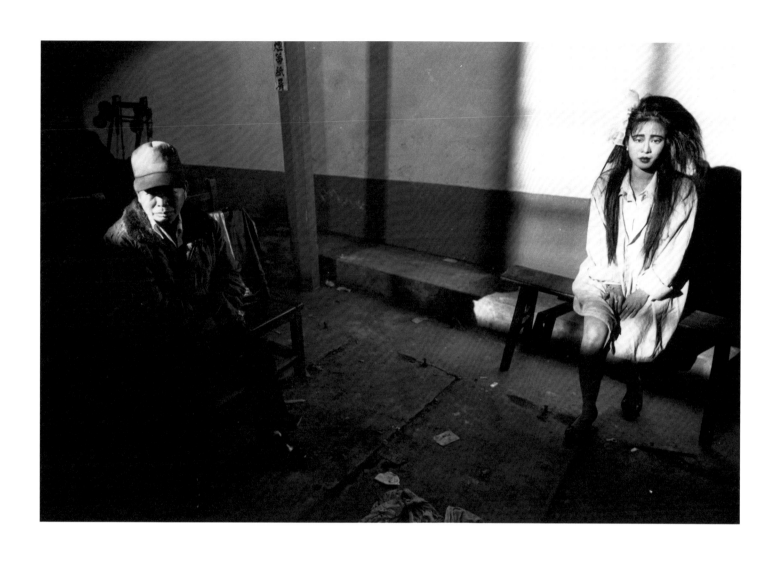

葉清芳 │《現實 · 極光 · 邊緣》—1988 九份 │ 1988
明膠銀鹽 │ 25 × 30.2 公分 │ 國家攝影文化中心典藏

YEH Ching Fang │ *Reality, Aurora Periphery -1998, Jiufen* │ 1988
Gelatin silver print │ 25 × 30.2 cm │ Collection of the National Center of Photography and Images

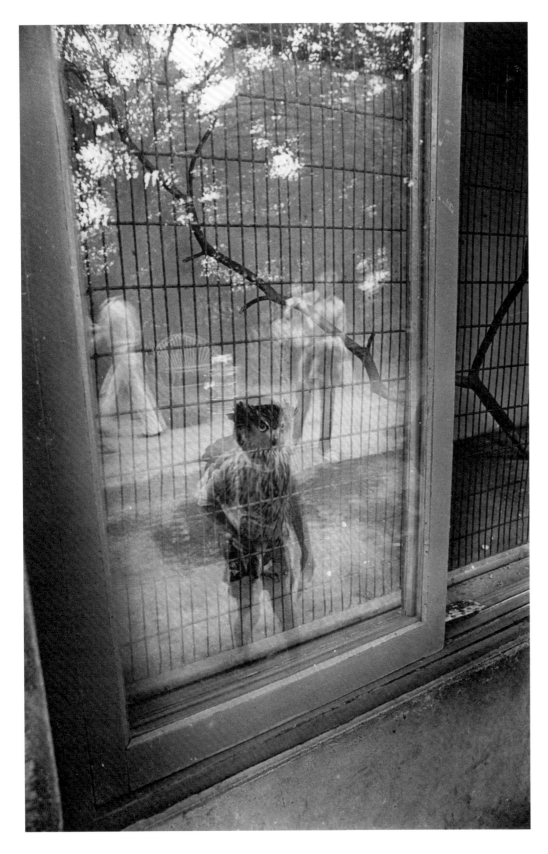

葉清芳 | 《現實 · 極光 · 邊緣》—1982 臺北 | 1982
明膠銀鹽 | 30.2 × 25 公分 | 國家攝影文化中心典藏

YEH Ching-Fang | *Reality · Aurora · Periphery -1982, Taipei* | 1982
Gelatin silver print | 30.2 × 25 cm | Collection of the National Center of Photography and Images

葉清芳 │《現實 ‧ 極光 ‧ 邊緣》—1980s 臺北│ 1980s
明膠銀鹽 │ 25 × 30.2 公分 │ 國家攝影文化中心典藏

YEH Ching-Fang │ *Reality · Aurora · Periphery - 1980s, Taipei* │ 1980s
Gelatin silver print │ 25 × 30.2 cm │ Collection of the National Center of Photography and Images

葉清芳 ｜ 《現實 ‧ 極光 ‧ 邊緣》—1980s 臺北 ｜ 1980s
明膠銀鹽 ｜ 25 × 30.2 公分 ｜ 國家攝影文化中心典藏

YEH Ching-Fang ｜ Reality · Aurora · Periphery -1980s, Taipei ｜ 1980s
Gelatin silver print ｜ 25 × 30.2 cm ｜ Collection of the National Center of Photography and Images

葉清芳 ｜ 《現實 ‧ 極光 ‧ 邊緣》—1982 八堵 ｜ 1982
明膠銀鹽 ｜ 25 × 30.2 公分 ｜ 國家攝影文化中心典藏

YEH Ching-Fang ｜ Reality · Aurora · Periphery -1982, Badu ｜ 1982
Gelatin silver print ｜ 25 × 30.2 cm ｜ Collection of the National Center of Photography and Images

葉清芳 │《現實 · 極光 · 邊緣》—1982 臺北 │ 1982
明膠銀鹽 │ 25 × 30.2 公分 │ 國家攝影文化中心典藏
YEH Ching-Fang │ Reality · Aurora · Periphery 1982, Taipei │ 1982
Gelatin silver print │ 25 × 30.2 cm │ Collection of the National Center of Photography and Images

葉清芳 │《現實 ・ 極光 ・ 邊緣》—1983 臺北│ 1983
明膠銀鹽 │ 25 × 30.2 公分 │ 國家攝影文化中心典藏

YEH Ching-Fang │ *Reality・Aurora・Periphery -1983, Taipei* │ 1983
Gelatin silver print │ 25 × 30.2 cm │ Collection of the National Center of Photography and Images

葉清芳 ｜《現實 · 極光 · 邊緣》—1983 瑞芳 ｜ 1983
明膠銀鹽 ｜ 25 × 30.2 公分 ｜ 國家攝影文化中心典藏

YEH Ching-Fang ｜ *Reality · Aurora · Periphery -1983, Ruifang* ｜ 1983
Gelatin silver print ｜ 25 × 30.2 cm ｜ Collection of the National Center of Photography and Images

葉清芳 ｜《現實 ‧ 極光 ‧ 邊緣》—1986 臺北｜ 1986
明膠銀鹽｜ 25 × 30.2 公分｜國家攝影文化中心典藏

YEH Ching-Fang ｜ *Reality‧Aurora‧Periphery -1986, Taipei* ｜ 1986
Gelatin silver print ｜ 25 × 30.2 cm ｜ Collection of the National Center of Photography and Images

葉清芳 ｜《現實 ‧ 極光 ‧ 邊緣》—1986 高雄｜ 1986
明膠銀鹽｜ 25 × 30.2 公分｜國家攝影文化中心典藏

YEH Ching-Fang ｜ *Reality‧Aurora‧Periphery -1986, Kaohsiung* ｜ 1986
Gelatin silver print ｜ 25 × 30.2 cm ｜ Collection of the National Center of Photography and Images

葉清芳 │ 《現實 ‧ 極光 ‧ 邊緣》—1986 臺北 │ 1986
明膠銀鹽 │ 25 × 30.2 公分,2 件 │ 國家攝影文化中心典藏

YEH Ching-Fang │ Reality · Aurora Periphery -1986, Taipei │ 1986
Gelatin silver print │ 25 × 30.2 cm, 2 pieces │ Collection of the National Center of Photography and Images

葉清芳 │ 《現實 ‧ 極光 ‧ 邊緣》—1987 臺北 │ 1987
明膠銀鹽 │ 25 × 30.2 公分，2 件 │ 國家攝影文化中心典藏

YEH Ching-Fang │ *Reality ‧ Aurora ‧ Periphery -1987, Taipei* │ 1987
Gelatin silver print │ 25 × 30.2 cm, 2 pieces │ Collection of the National Center of Photography and Images

葉清芳 ｜《現實 · 極光 · 邊緣》—1987 桃園｜ 1987
明膠銀鹽｜ 30.2 × 25 公分｜國家攝影文化中心典藏

YEH Ching Fang ｜ *Reality · Aurora · Periphery -1987, Taoyuan* ｜ 1987
Gelatin silver print ｜ 30.2 × 25 cm ｜ Collection of the National Center of Photography and Images

葉清芳 ｜《現實 · 極光 · 邊緣》—1988 淡水 ｜ 1988
明膠銀鹽 ｜ 25 × 30.2 公分 ｜ 國家攝影文化中心典藏

YEH Ching-Fang ｜ *Reality · Aurora · Periphery -1988, Tamsui* ｜ 1988
Gelatin silver print ｜ 25 × 30.2 cm ｜ Collection of the National Center of Photography and Images

葉清芳 | 《現實 · 極光 · 邊緣》—1988 九份 | 1988
明膠銀鹽 | 25 × 30.2 公分 | 國家攝影文化中心典藏
YEH Ching-Fang | *Reality · Aurora · Periphery -1988, Jiufen* | 1988
Gelatin silver print | 25 × 30.2 cm | Collection of the National Center of Photography and Images

葉清芳 ｜《現實 ・ 極光 ・ 邊緣》—1990s 臺北 ｜ 1990s
明膠銀鹽 ｜ 25 × 30.2 公分，2 件 ｜ 國家攝影文化中心典藏

YEH Ching-Fang ｜ *Reality ・ Aurora ・ Periphery -1990s, Taipei* ｜ 1990s
Gelatin silver print ｜ 25 × 30.2 cm, 2 pieces ｜ Collection of the National Center of Photography and Images

葉清芳 │《現實 · 極光 · 邊緣》—1990 臺北 │ 1990
明膠銀鹽 │ 25 × 30.2 公分 │ 國家攝影文化中心典藏

YEH Ching-Fang │ *Reality · Aurora · Periphery -1990, Taipei* │ 1990
Gelatin silver print │ 25 × 30.2 cm │ Collection of the National Center of Photography and Images

葉清芳｜《現實 · 極光 · 邊緣》—1991 臺北｜1991
明膠銀鹽｜30.2 × 25 公分，3 件｜國家攝影文化中心典藏

YEH Ching-Fang｜*Reality．Aurora．Periphery 1991, Taipei*｜1991
Gelatin silver print｜25 × 30.2 cm, 3 pieces｜Collection of the National Center of Photography and Images

賴永鑫 ｜〈生命樹——新北瑞芳〉｜ 2020
藝術微噴 ｜ 76.2 × 60.96 公分 ｜ 藝術家授權

LAI Yung-Hsin ｜ *Tree of Life: Ruifang, New Taipei City* ｜ 2020
Giclée ｜ 76.2 × 60.96 cm ｜ Courtesy of the artist

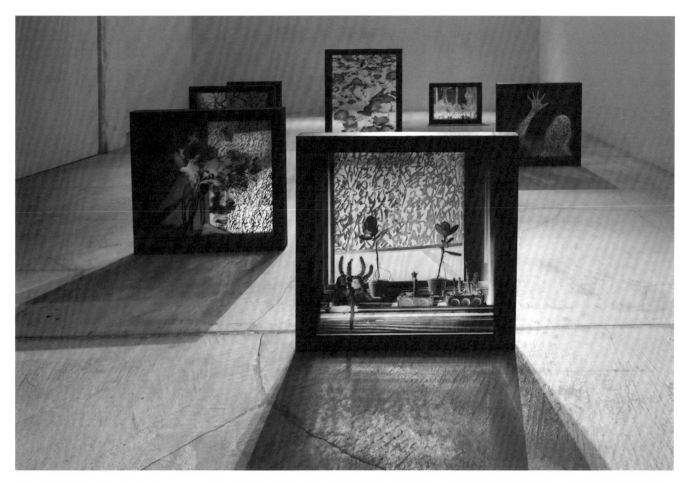

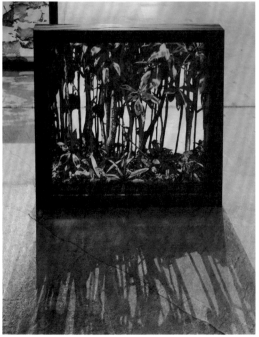

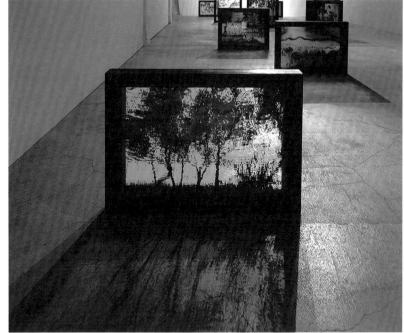

范晏暖 ｜《記憶與光照》系列｜ 2015
透明壓克力 ｜ 30 × 45 × 6 公分 × 3 件，40 × 40 × 6 公分 × 2 件，45 × 45 × 6 公分 ｜藝術家授權

FAN Yen-Nuan ｜ *Memories and Illumination Series* ｜ 2015
Acrylic ｜ 30 × 45 × 6 cm × 3 pieces, 40 × 40 × 6 cm × 2 pieces, 40 × 40 × 6 cm ｜ Courtesy of the artist

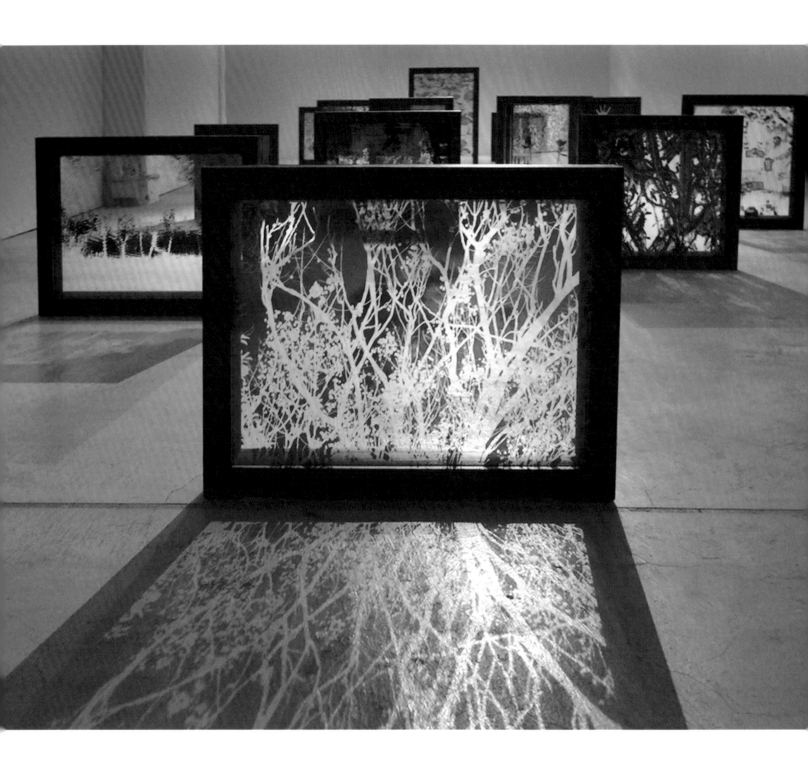

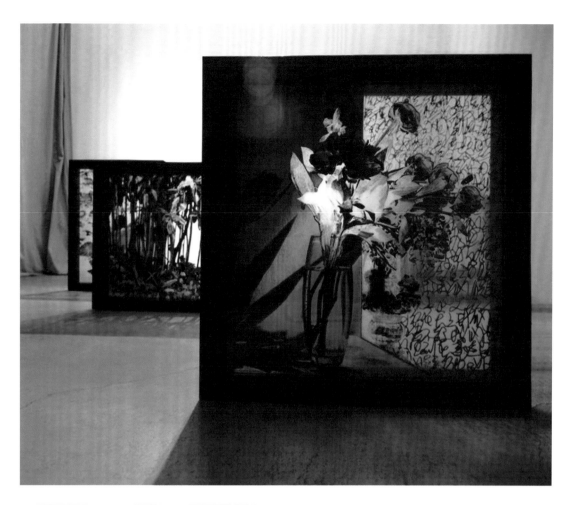

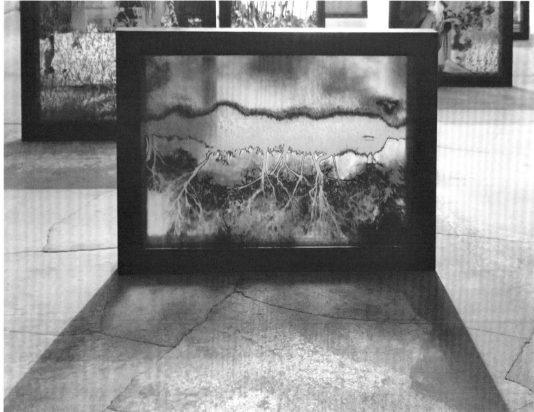

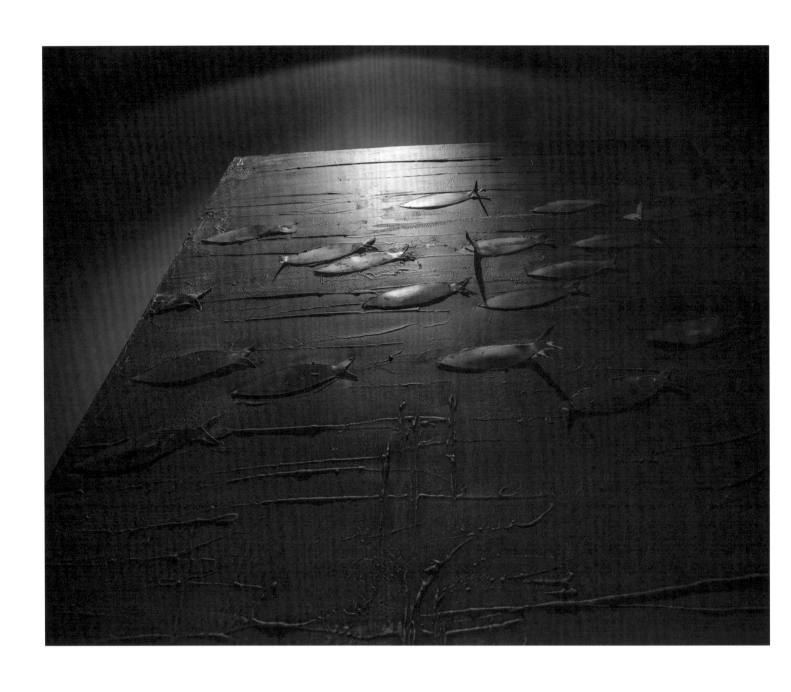

陳淑貞｜《AFTER》｜2017
藝術微噴｜48×60 公分×2 件｜藝術家授權

CHEN Shu-Chen｜*AFTER*｜2017
Giclée｜48×60 cm, 2 pieces｜Courtesy of the artist

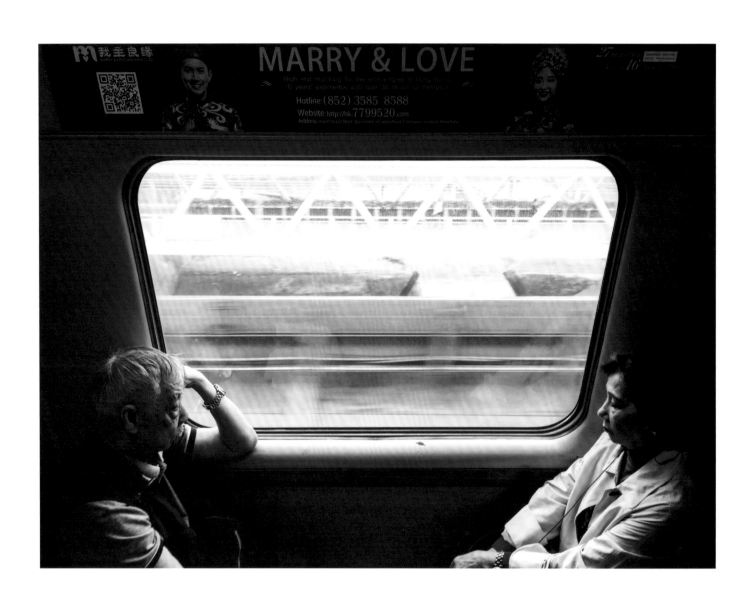

賴譜光 ｜ 〈影像 1-1：微婚啟事。香港東鐵〉 ｜ 2018
數位微噴 ｜ 50.8 × 66.04 公分 ｜ 藝術家授權

LAI Pu-Kuang ｜ *Image 1-1: The Personals. Hong Kong East Rail Line* ｜ 2018
Archival inkjet print ｜ 50.8 × 66.04 cm ｜ Courtesy of the artist

賴譜光 ｜ 〈影像 1-3：與常玉不期而遇。淡水河左岸〉 ｜ 2020
數位微噴 ｜ 50.8 × 66.04 公分 ｜ 藝術家授權

LAI Pu-Kuang ｜ *Image 1-3: Encountering Sanyu. Tamsui River Left Bank* ｜ 2020
Archival inkjet print ｜ 50.8 × 66.04 cm ｜ Courtesy of the artist

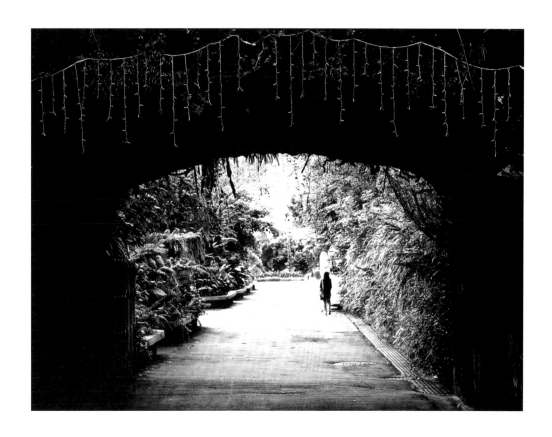

賴譜光 │ 〈影像 1-2：天下無不散的筵席。木柵動物園〉 │ 2019
數位微噴 │ 50.8 × 66.04 公分 │ 藝術家授權

LAI Pu-Kuang │ *Image 1-2: All Gatherings Come to an End. Taipei Zoo* │ 2019
Archival inkjet print │ 50.8 × 66.04 cm │ Courtesy of the artist

余白 ｜ 〈無題〉 ｜ 2012
藝術微噴 ｜ 30.48 × 40.64 公分 ｜ 藝術家授權

Hubert KILIAN ｜ *Untitled* ｜ 2012
Giclée ｜ 30.48 × 40.64 cm ｜ Courtesy of the artist

余白 │ 《臺北之胃》-1 │ 2015
藝術微噴 │ 30.48 × 40.64 公分 │ 藝術家授權

Hubert KILIAN │ *The Stomach of Taipei -1* │ 2015
Giclée │ 30.48 × 40.64 cm │ Courtesy of the artist

余白 │《臺北之胃》-2 │ 2015
藝術微噴 │ 30.48 × 40.64 公分 │ 藝術家授權

Hubert KILIAN │ *The Stomach of Taipei -2* │ 2015
Giclée │ 30.48 × 40.64 cm │ Courtesy of the artist

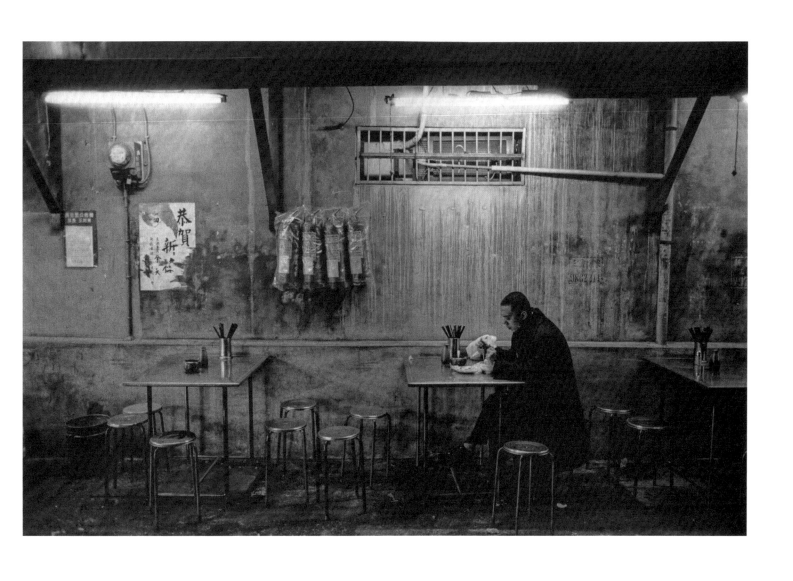

余白 ｜《臺北原味》-1 ｜ 2014
藝術微噴 ｜ 30.48 × 40.64 公分 ｜ 藝術家授權

Hubert KILIAN ｜ *The Original Flavour of Taipei -1* ｜ 2014
Giclée ｜ 30.48 × 40.64 cm ｜ Courtesy of the artist

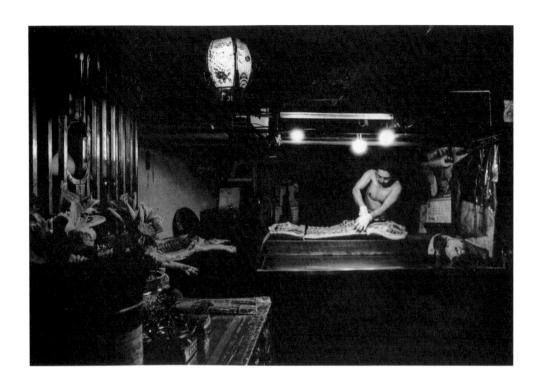

余白 │ 《臺北原味》-2 │ 2014
藝術微噴 │ 30.48 × 40.64 公分 │ 藝術家授權

Hubert KILIAN │ *The Original Flavour of Taipei -2* │ 2014
Giclée │ 30.48 × 40.64 cm │ Courtesy of the artist

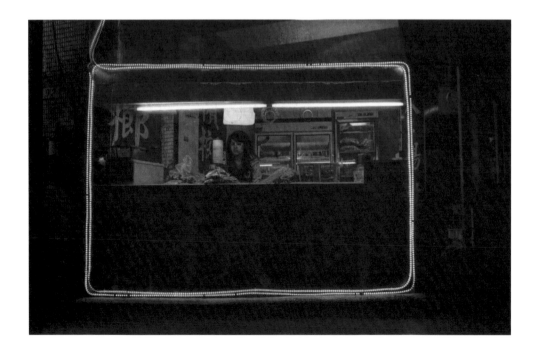

余白 │ 《臺北原味》-3 │ 2013
藝術微噴 │ 30.48 × 40.64 公分 │ 藝術家授權

Hubert KILIAN │ *The Original Flavour of Taipei -3* │ 2013
Giclée │ 30.48 × 40.64 cm │ Courtesy of the artist

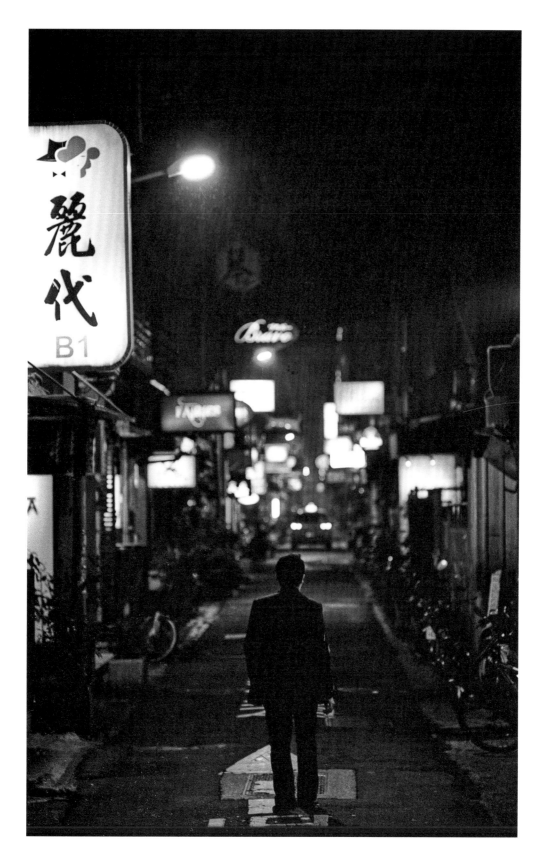

余白 ｜ 《臺北原味》-4 ｜ 2013
藝術微噴 ｜ 40.64 × 30.48 公分 ｜ 藝術家授權

Hubert KILIAN ｜ *The Original Flavour of Taipei -4* ｜ 2013
Giclée ｜ 40.64 × 30.48 cm ｜ Courtesy of the artist

張志達 ｜〈未知未來〉｜ 2022
藝術微噴 ｜ 90 × 90 公分 ｜藝術家授權

CHANG Chih-Ta ｜ *Unknown Future* ｜ 2022
Giclée ｜ 90 × 90 cm ｜ Courtesy of the artist

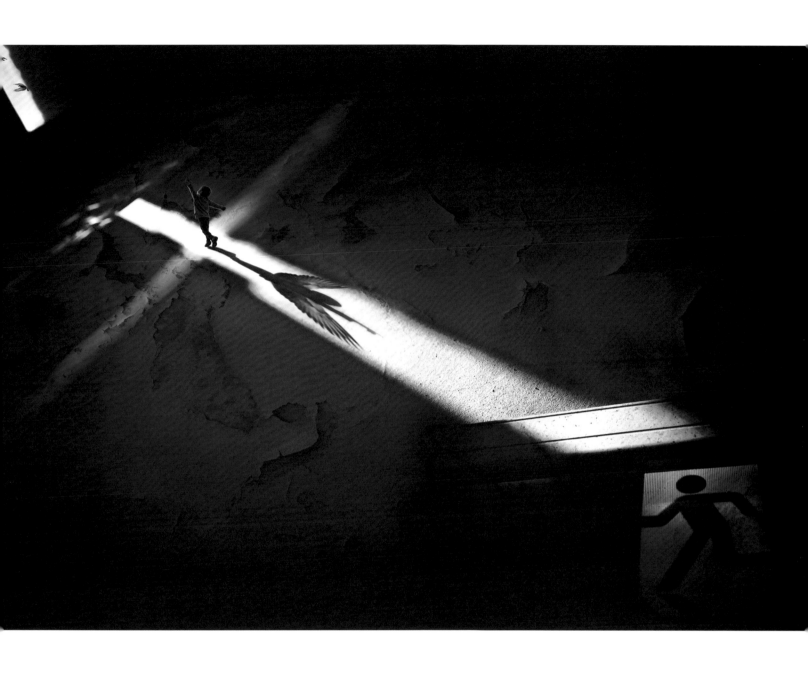

張志達 │〈逆光飛翔——轉身後的自由〉│ 2014
藝術微噴 │ 60×90 公分 │ 藝術家授權

CHANG Chih-Ta │ *Flying Against the Light. Freedom After Turning Away* │ 2014
Giclée │ 60×90 cm │ Courtesy of the artist

邱誌勇｜〈幻-1〉，《空間物件》系列｜2018
蝕刻藝術紙｜40×30 公分｜藝術家授權

CHIU Chih-Yung｜*Illusion-1, Spatial Objects Series*｜2018
Edition Etching Rag｜40×30 cm｜Courtesy of the artist

邱誌勇 ｜ 〈幻 -2〉，《空間物件》系列 ｜ 2018
蝕刻藝術紙 ｜ 20 × 16 公分 ｜ 藝術家授權

CHIU Chih-Yung ｜ *Illusion 2, Spatial Objects Series* ｜ 2018
Edition Etching Rag ｜ 20 × 16 cm ｜ Courtesy of the artist

邱誌勇 ｜〈電流 -1〉，《空間物件》系列｜ 2018
蝕刻藝術紙｜ 50 × 40 公分｜藝術家授權

CHIU Chih-Yung ｜ *Electric Current-1, Spatial Objects Series* ｜ 2018
Edition Etching Rag ｜ 50 × 40 cm ｜ Courtesy of the artist

邱誌勇 ｜〈電流 -2〉，《空間物件》系列 ｜ 2019
蝕刻藝術紙 ｜ 40 × 30 公分 ｜ 藝術家授權

CHIU Chih-Yung ｜ *Electric Current-2, Spatial Objects Series* ｜ 2019
Edition Etching Rag ｜ 40 × 30 cm ｜ Courtesy of the artist

《臉上的光彩 2.0》系列

自智慧型手機問世後，人類因手機使用習慣的改變而產生「低頭族」的社會現象。作者自 2012 年開始觀察到在使用智慧型手機的人們，臉上會映上一道被手機螢幕投射的光線，便以此作為發想創作了《臉上的光彩》系列編導攝影作品，描述人們透過智慧型手機在網路世界中聯絡彼此間的感情與關注不相識的人們，但卻忽略了現實中身邊的親友及事物。數年後延續前作的主題，創作《臉上的光彩 2.0》系列作品，作者改變畫面風格，將攝影與名畫構圖相結合，除運用編導攝影的拍攝手法外，利用數位後製加強了畫面中「光」的效果。透過戲仿諧擬的畫面反諷生活在數位時代、沉溺在電子設備中的人們，重新詮釋「低頭族」的社會現象。

—— 王鼎元

Glow on the Face 2.0 Series

Since the advent of smartphones, the social phenomenon of 'phubbing' has emerged due to changes in human mobile habits. The artist began observing in 2012 that people using smartphones had a beam of light from the phone screen reflected on their faces. It inspired the creation of the *Glow on the Face Series*, a collection of directed photography works that depict people connecting with and showing concern for strangers in the virtual world through smartphones, while neglecting friends and matters in reality. Years later, Wang Ding-Yuan continued the theme with the *Glow on the Face 2.0 Series*. He changed the visual style by combining photography with the composition of famous paintings. In addition to employing directed photography techniques, the artist used digital post-production to enhance the effect of light in the images. Through satirical, parodic visuals, he critiques those immersed in electronic devices in the digital age, offering a fresh interpretation of phubbing.

—— **WANG Ding-Yuan**

王鼎元 │〈野餐趣〉，《臉上的光彩 2.0》系列 │ 2022
藝術微噴 │ 60 × 90 公分 │ 藝術家授權

WANG Ding-Yuan │ *Picnic, Glow on the Face 2.0 Series* │ 2022
Giclée │ 60 × 90 cm │ Courtesy of the artist

151

王鼎元 ｜〈鐵板燒店〉，《臉上的光彩 2.0》系列｜ 2015
藝術微噴 ｜ 60 × 90 公分｜藝術家授權

WANG Ding-Yuan ｜ *Teppanyaki shop, Glow on the Face 2.0 Series* ｜ 2015
Giclée ｜ 60 × 90 cm ｜ Courtesy of the artist

王鼎元 │ 〈過馬路不要滑手機〉,《臉上的光彩 2.0》系列│ 2018
藝術微噴 │ 60 × 90 公分│藝術家授權

WANG Ding Yuan │ *Do not use your smartphone while crossing the street, Glow on the Face 2.0 Series* │ 2018
Giclée │ 60 × 90 cm │ Courtesy of the artist

王鼎元 │〈懷孕家庭照〉，《臉上的光彩 2.0》系列│ 2022
藝術微噴 │ 60 × 90 公分│藝術家授權

WANG Ding-Yuan │ *Pregnant family photo, Glow on the Face 2.0 Series* │ 2022
Giclée │ 60 × 90 cm │ Courtesy of the artist

王鼎元 │〈泳裝拍攝現場〉，《臉上的光彩 2.0》系列│ 2022
藝術微噴 │ 81.9 × 170 公分│藝術家授權

WANG Ding-Yuan │ *Swimsuit shooting scene, Glow on the Face 2.0 Series* │ 2022
Giclée │ 81.9 × 170 cm │ Courtesy of the artist

王鼎元 ｜〈社團會議〉，《臉上的光彩 2.0》系列｜ 2021
藝術微噴 ｜ 81.9 × 170 公分｜藝術家授權

WANG Ding-Yuan ｜ *Club meeting, Glow on the Face 2.0 Series* ｜ 2021
Giclée ｜ 81.9 × 170 cm ｜ Courtesy of the artist

楊士毅 ｜ 〈繁花盛開的祝福〉 ｜ 2021
縮時攝影 ｜ 1 分 19 秒 ｜ 藝術家授權

YANG Shih-Yi ｜ *Blessings of Blooming Flowers* ｜ 2021
Time-lapse photography ｜ 1'19" ｜ Courtesy of the artist

李毓琪 ｜ 《近郊》# 02 ｜ 2021
純棉含銀相紙 ｜ 40 × 60 公分 ｜ 藝術家授權

LI Yu-Chi ｜ *Suburbs 02* ｜ 2021
Photo Rag Baryta ｜ 40 × 60 cm ｜ Courtesy of the artist

李毓琪 ｜《近郊》#18 ｜ 2021
純棉含銀相紙 ｜ 40×60 公分 ｜ 藝術家授權

LI Yu-Chi ｜ *Suburbs 18* ｜ 2021
Photo Rag Baryta ｜ 40×60 cm ｜ Courtesy of the artist

隱喻 之影

隱喻：兩個無相關的事物，透過一物體或概念替代另一物體或概念，從而暗示兩者的類同性，使傳達的意象更為生動、簡潔並得到強化的效果。本展覽以修辭學的隱喻法作為影像的閱讀途徑，將作品中所捕捉或安排的各種投影或陰影，在人物、人文地理、心象、幾何等風格類型中，轉譯為潛意識般的夢境，營造出富有感染力的符號，並以其內涵意義形成各種型態的隱喻之影。

THE SHADOW OF METAPHOR

Metaphor : An expression that substitutes one object or concept for another unrelated one, hinting at the similarity between the two, suggesting their similarity and enhancing the conveyed imagery in a vivid, concise, and reinforced manner. This exhibition applies the rhetorical concept of metaphors as a way of interpreting images, translating the captured or arranged projections or shadows amid the various styles (portrait, cultural and geological scenery, mindscape, or geometry) into subconscious-like dreamscapes, creating moving and infectious symbols while forming different shadows of metaphors.

石萬里	SHIH Wan-Li	張國治	CHANG Kuo-Chih
李鳴鵰	LEE Ming-Tiao	高志尊	KAO Chih-Chun
秦　凱	Dennis K. CHIN	傅朝卿	FU Chao-Ching
周鑫泉	CHOU Shin-Chiua	何經泰	HO Ching-Tai
邱德雲	CHIU De-Yun	洪世聰	HUNG Shih-Tsung
謝震隆	HSIEH Chen-Lung	張宏聲	CHANG Hong-Sheng
鄭桑溪	CHENG Shang-Hsi	蔡文祥	TSAI Wen-Shiang
葉清芳	YEH Ching-Fang	賴永鑫	LAI Yung-Hsin
莊　靈	CHUANG Ling	陳淑貞	CHEN Shu-Chen
謝明順	Vincent HSIEH	賴譜光	LAI Pu-Kuang
張照堂	CHANG Chao-Tang	余　白	Hubert KILIAN
葉　裁	YEH Tsai	汪曉青	Annie Hsiao-Ching WANG
簡榮泰	CHIEN Yun-Tai	張志達	CHANG Chih-Ta
阮義忠	JUAN I-Jong	楊士毅	YANG Shih-Yi
林國彰	LIN Kuo-Chang		

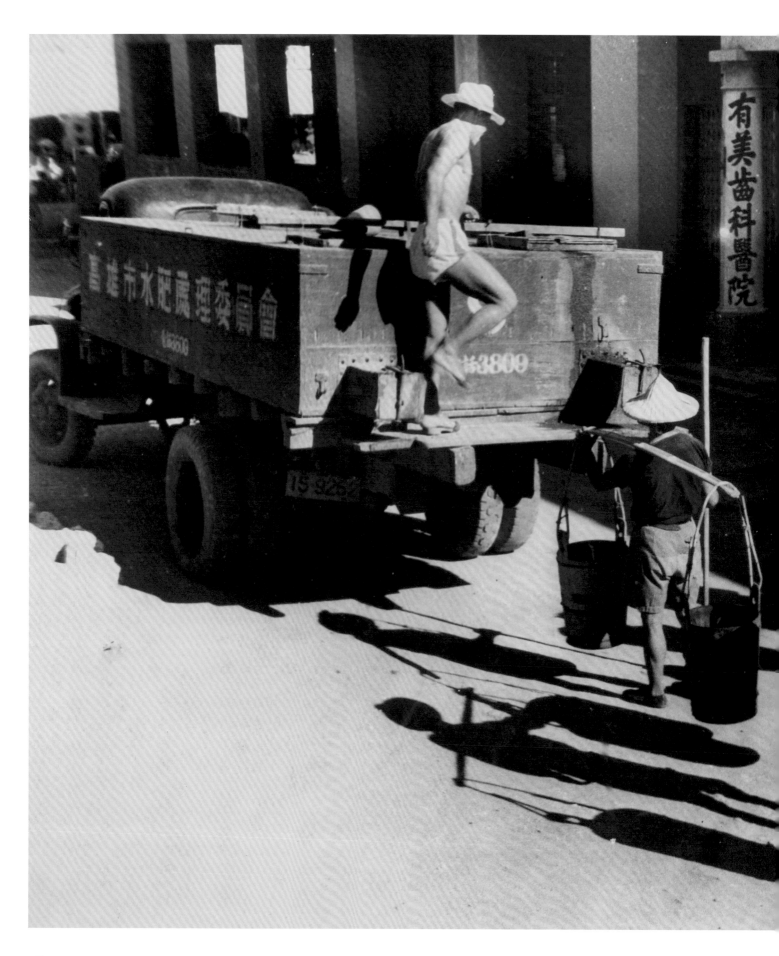

石萬里 │ 《高雄市政發展》系列 -89 │ 1954
明膠銀鹽 │ 30.3 × 38 公分 │ 國家攝影文化中心典藏

SHIH Wan-Li │ *The Development of Kaohsiung City's Governance Series-89* │ 1954
Gelatin silver print │ 30.3 × 38 cm │ Collection of the National Center of Photography and Images

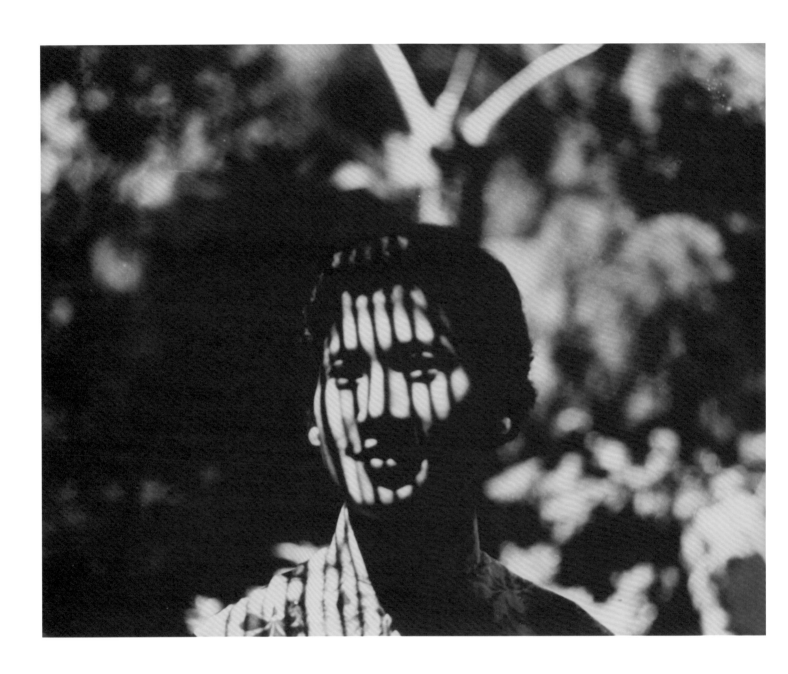

李鳴鵰 〈女子像〉 1948
明膠銀鹽 20.3 × 25.8 公分 國家攝影文化中心典藏

LEE Ming-Tiao | *Portrait of a Woman* | 1948
Gelatin silver print | 20.3 × 25.8 cm cm | National Center of Photography and Images

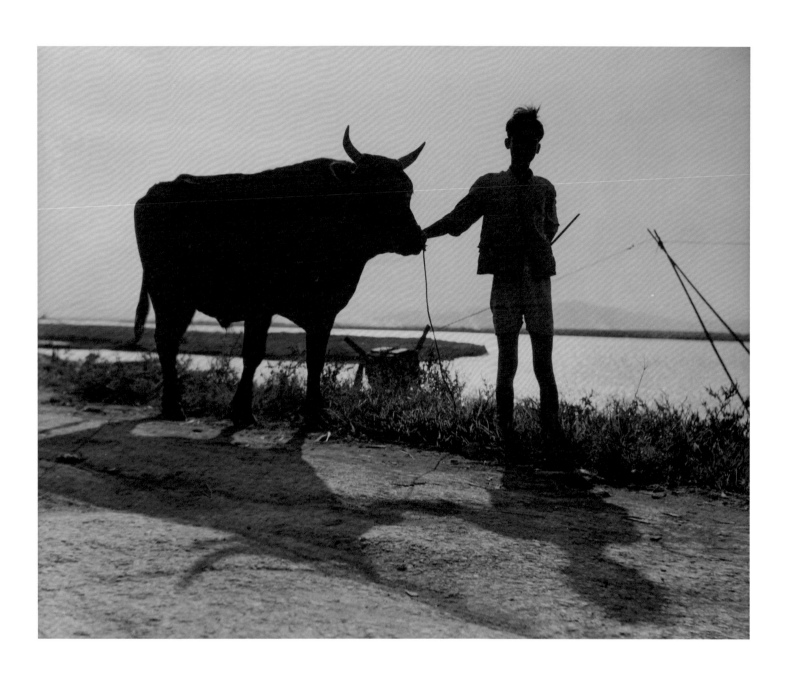

李鳴鵰 │〈工作一天要回家啦〉│ 1948
明膠銀鹽 │ 47.3 × 57.4 公分 │ 國家攝影文化中心典藏

LEE Ming Tiao │ *Heading Home After a Day's Work* │ 1948
Gelatin silver print │ 47.3 × 57.4 cm │ Collection of the National Center of Photography and Images

秦　凱｜〈水車〉｜1939
明膠銀鹽｜24 × 29 公分｜國家攝影文化中心典藏

Dennis K. CHIN｜*Waterwheel*｜1939
Gelatin silver print｜24 × 29 cm｜Collection of the National Center of Photography and Images

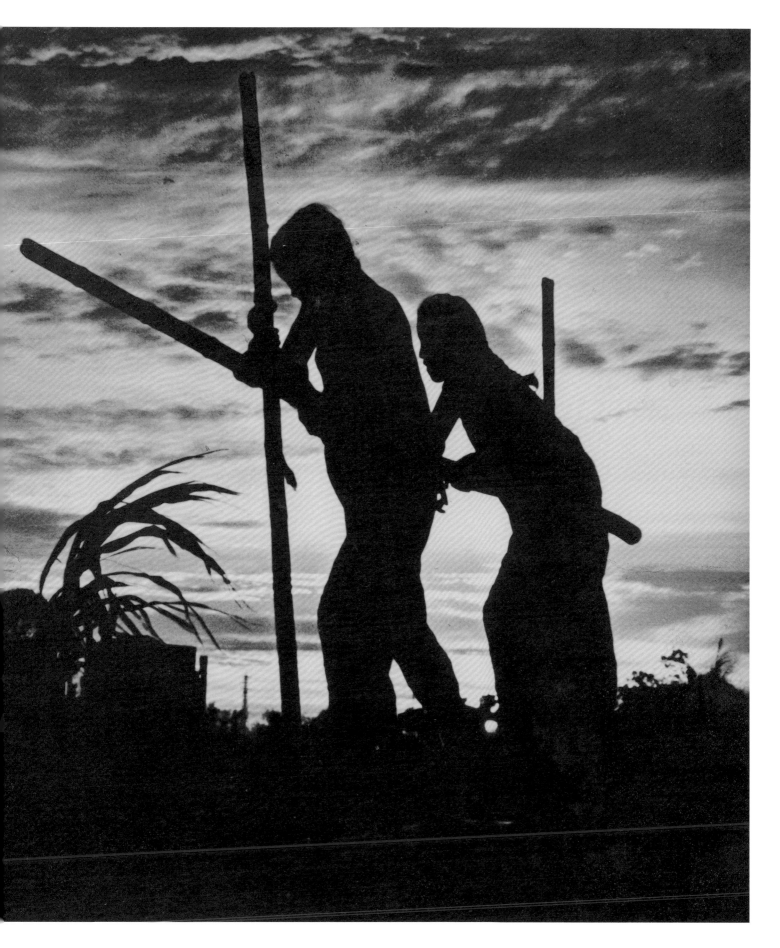

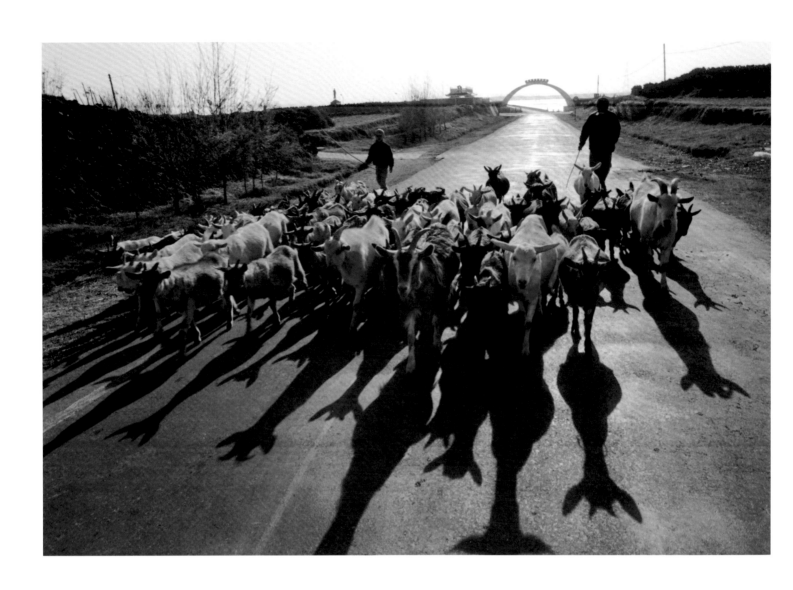

周鑫泉 │ 〈羊群歸途〉 │ 1980
數位銀鹽 │ 35.1 × 50.4 公分 │ 國家攝影文化中心典藏

CHOU Shin-Chiuan │ *Returning Flock of Sheep* │ 1980
Digital Silver Imaging │ 35.1 × 50.4 cm │ Collection of the National Center of Photography and Images

周鑫泉 | 〈共謀大計〉 | 1990
噴墨列印 | 50.4 × 35.1 公分 | 國家攝影文化中心典藏

CHOU Shin Chiuan | Conspiracy | 1990
Inkjet print | 50.4 × 35.1 cm | Collection of the National Center of Photography and Images

周鑫泉 │〈洱海漁歌〉│ 1994
數位銀鹽 │ 35.1 × 50.4 公分 │ 國家攝影文化中心典藏

CHOU Shin-Chiuan │ *Erhai Fishing Song* │ 1994
Digital Silver Imaging │ 35.1 × 50.4 cm │ Collection of the National Center of Photography and Images

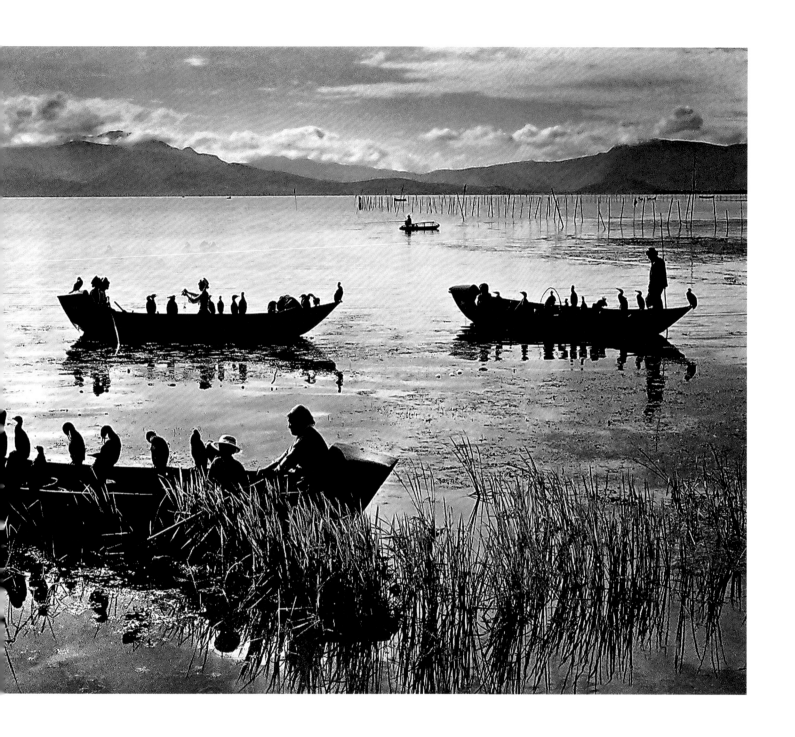

邱德雲 ｜《汗流脈絡》系列 -13 ｜ 1990-2000
明膠銀鹽 ｜ 42.5 × 50.8 公分 ｜ 國家攝影文化中心典藏

CHIU De-Yun ｜ *The Context of Sweating Series-13* ｜ 1990-2000
Gelatin silver print ｜ 42.5 × 50.8 cm ｜ Collection of the National Center of Photography and Images

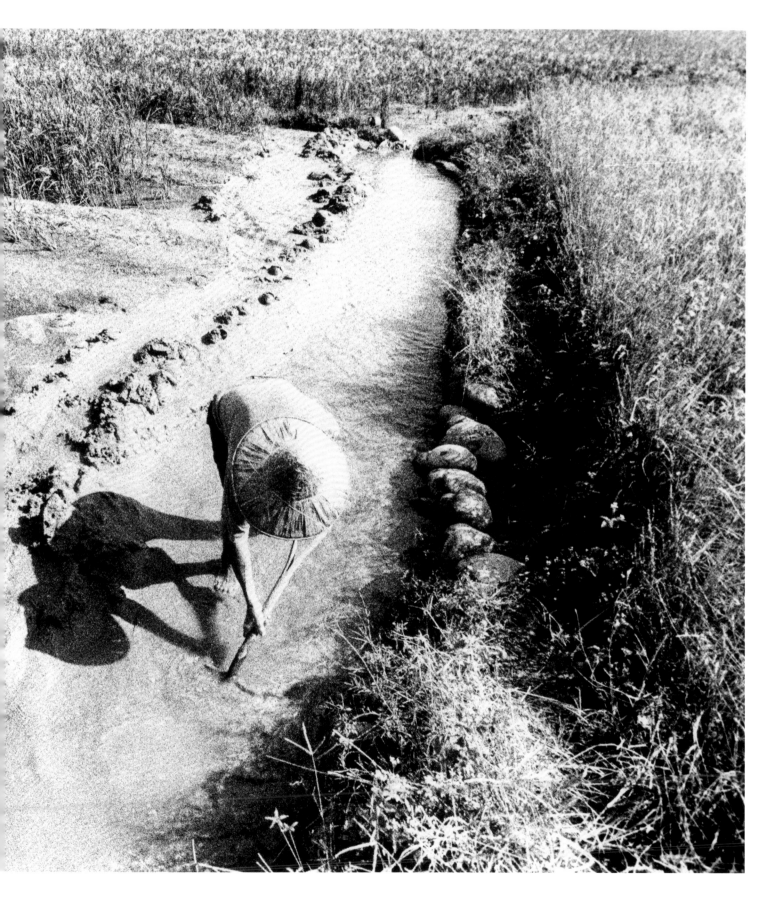

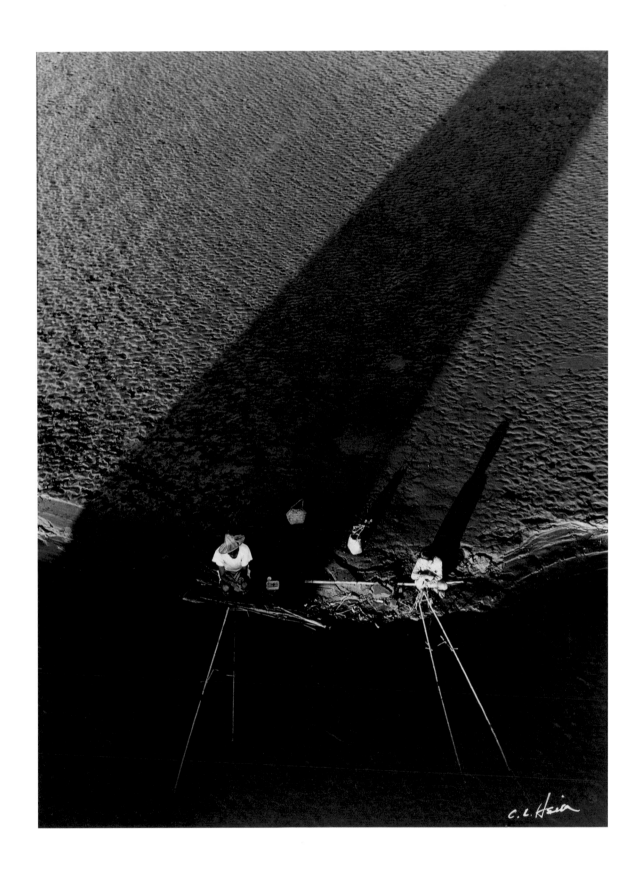

謝震隆 ｜ 橋下 ｜ 1963
明膠銀鹽 ｜ 60.8 × 50.7 公分 ｜ 國家攝影文化中心典藏

HSIEH Chen-Lung ｜ *Under the Bridge* ｜ 1963
Gelatin silver print ｜ 60.8 × 50.7 cm ｜ Collection of the National Center of Photography and Images

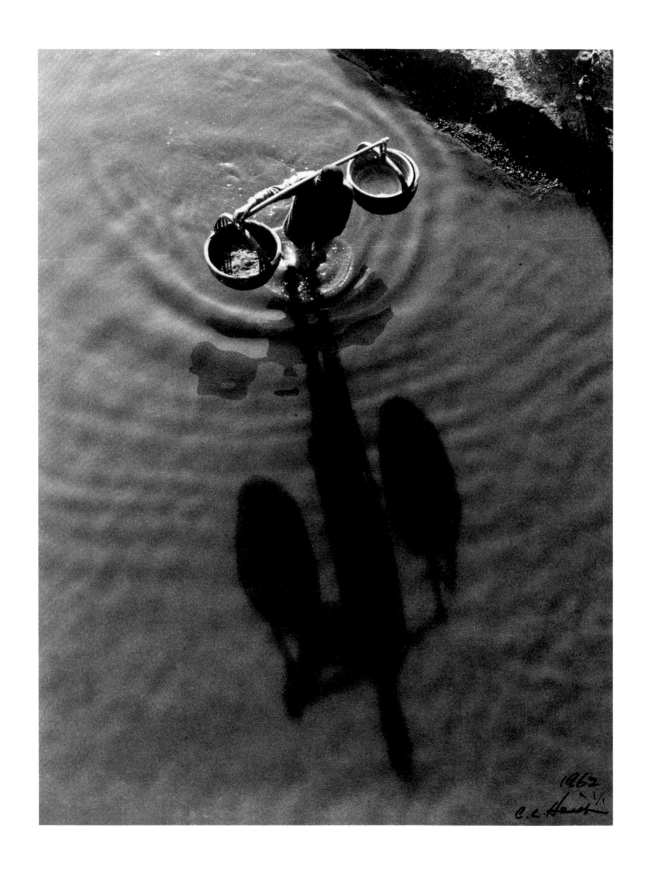

謝震隆 ｜〈倒影〉｜ 1963
明膠銀鹽 ｜ 60.7 × 46.7 公分 ｜ 國家攝影文化中心典藏

HSIEH Chen-Lung ｜ *Reflection* ｜ 1963
Gelatin silver print ｜ 60.7 × 46.7 cm ｜ Collection of the National Center of Photography and Images

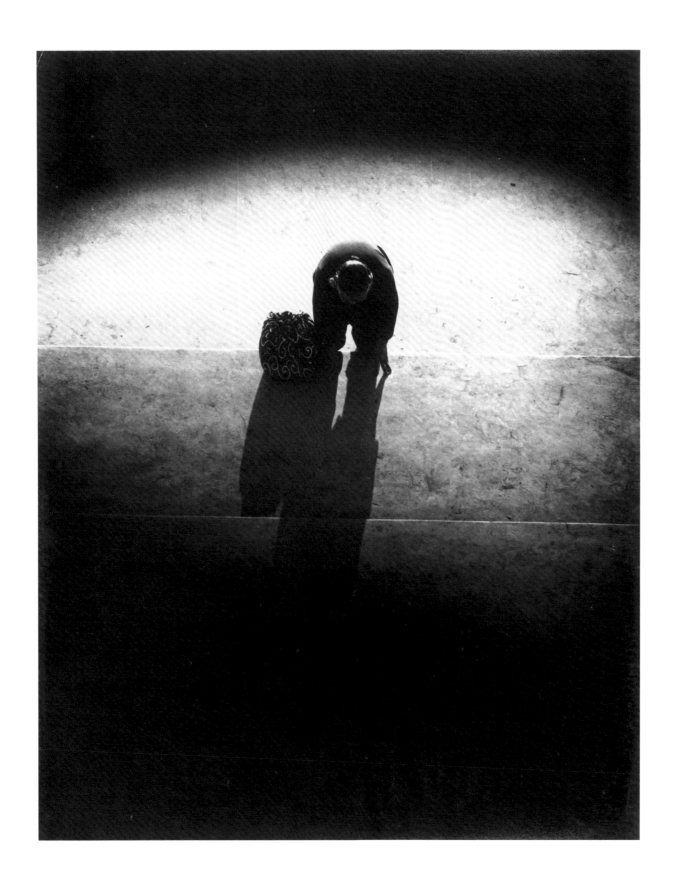

鄭桑溪 │ 〈信徒〉 │ 1963
明膠銀鹽 │ 46.2 × 35.6 公分 │ 國家攝影文化中心典藏

CHENG Shang-Hsi │ *Believer* │ 1963
Gelatin silver print │ 46.2 × 35.6 cm │ Collection of the National Center of Photography and Images

鄭桑溪 ｜〈打球〉 ｜ 1962
明膠銀鹽 ｜ 40.3 × 50.5 公分 ｜ 國家攝影文化中心典藏

CHENG Shang-Hsi ｜ *Playing Ball* ｜ 1962
Gelatin silver print ｜ 40.3 × 50.5 cm ｜ Collection of the National Center of Photography and Images

莊　靈｜〈白公祠牆外──重慶忠縣〉｜1998
明膠銀鹽｜41 × 62 公分｜藝術家授權

CHUANG Ling｜ *Outside the Wall of Baigong Shrine — Chongqing Zhong County* ｜1998
Gelatin silver print｜41 × 62 cm｜Courtesy of the artist

莊　靈│〈峽谷——花蓮太魯閣〉│1986
明膠銀鹽│90×60 公分│藝術家授權

CHUANG Ling│*Gorge — Hualien Taroko*│1986
Gelatin silver print│90 × 60 cm│Courtesy of the artist

莊　靈｜〈1950 年代臺灣省立農學院（今興大前身）各系系館長廊〉｜ 1950s
明膠銀鹽｜ 71.5 × 102 公分｜藝術家授權

CHUANG Ling｜ *The Corridors of the Department Buildings of Taiwan Provincial College of Agriculture (Present Day National Chung Hsing University) in the 1950s*｜ 1950s
Gelatin silver print｜ 71.5 × 102 cm｜ Courtesy of the artist

謝明順 ｜〈自在〉，《雕塑情懷的「像雕」》系列｜ 1997
西霸彩色相紙 ｜ 50.8 × 65.8 公分 ｜ 藝術家授權

Vincent HSIEH ｜ *Ease, Sculptural Sentiments Series* ｜ 1997
Cibachrome ｜ 50.8 × 65.8 cm ｜ Courtesy of the artist

張照堂 ｜ 〈板橋〉 ｜ 1962
明膠銀鹽 ｜ 47 × 46 公分 ｜ 國立臺灣美術館典藏
CHANG Chao-Tang ｜ *Banqiao* ｜ 1962
Gelatin silver print ｜ 47 × 46 cm ｜ Collection of the National Taiwan Museum of Fine Arts

葉　裁 ｜〈鄉間馬路三人行〉｜ 1965-1971
明膠銀鹽 ｜ 50.5 × 40.7 公分 ｜ 國家攝影文化中心典藏

YEH Tsai ｜ *Three People on a Countryside Road* ｜ 1965-1971
Gelatin silver print ｜ 50.5 × 40.7 cm ｜ Collection of the National Center of Photography and Images

186

簡榮泰｜〈臺北新莊〉，《舊鄉》系列｜1971
明膠銀鹽｜50.5 × 40.7 公分｜國家攝影文化中心典藏

CHIEN Yun Tai｜ *Xinzhuang, Taipei, Familiar Town Series*｜1971
Gelatin silver print｜50.5 × 40.7 cm｜Collection of the National Center of Photography and Images

187

阮義忠 ｜〈宜蘭南澳武塔〉，《人與土地》系列 ｜ **1980**
明膠銀鹽 ｜ 60×50 公分 ｜ 國立臺灣美術館典藏

JUAN I-Jong ｜ *Lighthouse in Nanao, Yilan, The People and Lands Series* ｜ **1980**
Gelatin silver print ｜ 60×50 cm ｜ Collection of the National Taiwan Museum of Fine Arts

林國彰 ｜ 〈西園路艋舺公園美人照鏡池〉，《臺北道》系列｜ 2021
白金相紙｜ 25.4 × 25.4 公分｜藝術家授權

LIN Kuo-Chang ｜ *Xiyuan Road Bangka Park Beauty's Mirror Pond, Taipei Dao Series* ｜ 2021
Platinum print ｜ 25.4 × 25.4 cm ｜ Courtesy of the artist

林國彰 ｜〈寶慶路西門舊址〉，《臺北道》系列｜ 2014
白金相紙｜ 25.4 × 25.4 公分｜藝術家授權

LIN Kuo-Chang ｜ *West Gate Old Site on Baoqing Road, Taipei Dao Series* ｜ 2014
Platinum print ｜ 25.4 × 25.4 cm ｜ Courtesy of the artist

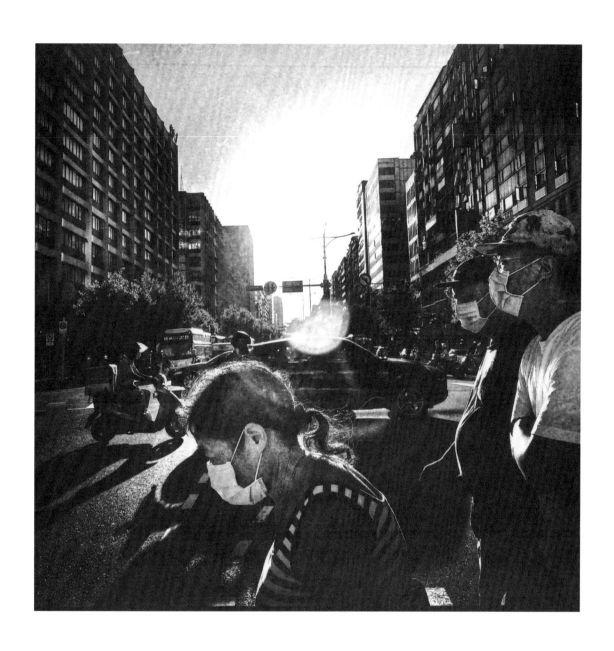

林國彰 ｜ 〈忠孝東路忠孝大道〉，《臺北道》系列 ｜ 2021
白金相紙 ｜ 25.4 × 25.4 公分 ｜ 國家攝影文化中心典藏

LIN Kuo-Chang ｜ *Zhongxiao East Road Zhongxiao Boulevard, Taipei Dao series* ｜ 2021
Platinum print ｜ 25.4 × 25.4 cm ｜ Collection of the National Center of Photography and Images

張國治 │ 〈如織的麵線歲月〉 │ 2006
數位輸出 │ 27.94 × 35.56 公分 │ 藝術家授權

CHANG Kuo-Chih │ *Noodle Years Woven Like Fabric* │ 2006
Digital print │ 27.94 × 35.56 cm │ Courtesy of the artist

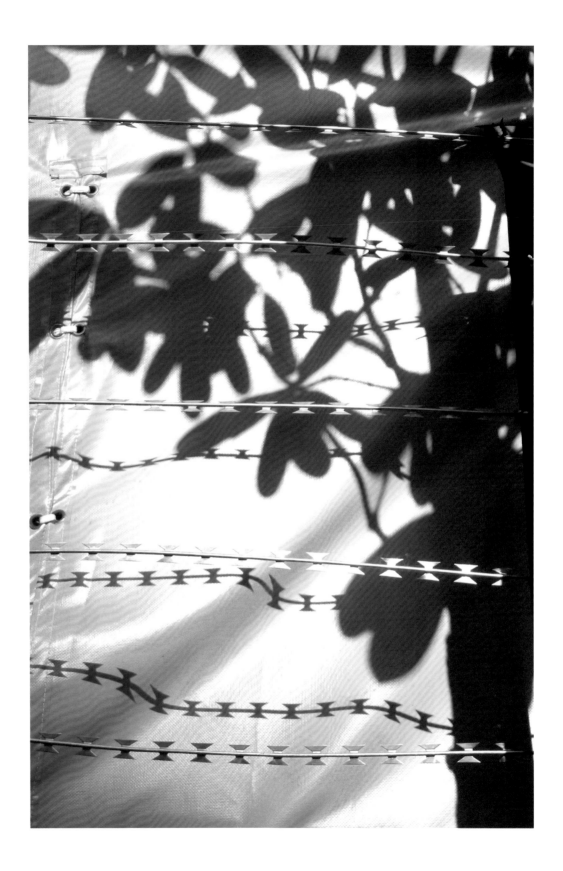

張國治 │〈溫柔的拒馬圍籬〉│ 2017
數位輸出 │ 35.56 × 27.94 公分 │ 藝術家授權

CHANG Kuo-Chih │ *The Tender Barricades* │ 2017
Digital print │ 35.56 × 27.94 cm │ Courtesy of the artist

高志尊 │ 〈Paris，1999〉 │ 1999
重鉻酸鹽膠彩攝影 │ 42×62 公分 │ 藝術家授權

KAO Chih-Chun │ *Paris, 1999* │ 1999
Gum dichromate prints │ 42×62 cm │ Courtesy of the artist

194

高志尊 ｜ 〈阿爾〉，《光的調色盤》系列 ｜ 1994
西霸彩色相紙 ｜ 34.7 × 50.8 公分 ｜ 藝術家授權

KAO Chih-Chun ｜ *Arles, The Palette of Light Series* ｜ 1994
Cibachrome ｜ 34.7 × 50.8 cm ｜ Courtesy of the artist

高志尊 ｜ 〈京都〉，《光的調色盤》系列 ｜ 1995
西霸彩色相紙 ｜ 34.7 × 50.8 公分 ｜ 藝術家授權

KAO Chih-Chun ｜ *Kyoto, The Palette of Light Series* ｜ 1995
Cibachrome ｜ 34.7 × 50.8 cm ｜ Courtesy of the artist

高志尊 ｜〈Paris，1994〉｜ 1994
重鉻酸鹽膠彩攝影 ｜ 62 × 42 公分 ｜ 藝術家授權

KAO Chih-Chun ｜ *Paris, 1994* ｜ 1994
Gum dichromate prints ｜ 62 × 42 cm ｜ Courtesy of the artist

高志尊 | 〈Hawaii〉,《光的調色盤》系列 | 1989
西霸彩色相紙 | 34.7 × 50.8 公分 | 藝術家授權

KAO Chih-Chun | *Hawaii, The Palette of Light Series* | 1989
Cibachrome | 34.7 × 50.8 cm | Courtesy of the artist

傅朝卿 ｜〈時向：編號 1985-1（斯德哥爾摩市政廳）〉｜ 1985
藝術微噴 ｜ 40 × 27 公分 ｜藝術家授權

FU Chao-Ching ｜ *Temporal Dimension: No. 1985-1 (Stockholm Town Hall)* ｜ 1985
Giclée ｜ 40 × 27 cm ｜ Courtesy of the artist

傅朝卿 ｜ 〈時向：編號 1986-1（臺北地下道）〉 ｜ 1986
藝術微噴 ｜ 40 × 27 公分 ｜ 藝術家授權

FU Chao-Ching ｜ *Temporal Dimension: No. 1986-1 (Taipei Underground Pass)* ｜ 1986
Giclée ｜ 40 × 27 cm ｜ Courtesy of the artist

何經泰│〈陳家祭司（謝慧光）〉，《百年不斷的人神之約》系列│2018
白金純棉相紙│102 × 84 公分│藝術家授權

HO Ching-Tai │ *Chen Family Priest (Xie Hui-Guang), The Hundred-Year Covenant Between Man and God Series* │ 2018
Platine Fibre Rag │ 102 × 84 cm │ Courtesy of the artist

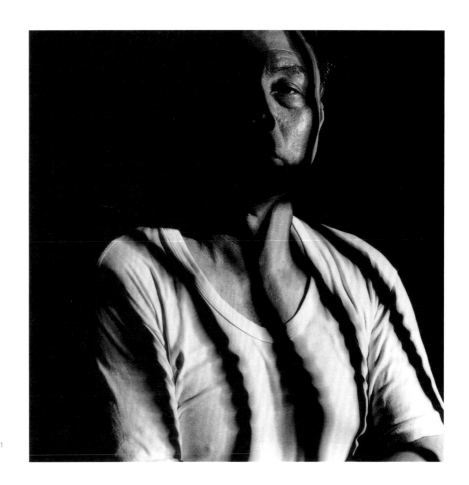

何經泰 │〈陳栢淵〉，《白色檔案》系列│ 1990-1991
白金純棉相紙│ 84×84 公分│藝術家授權

HO Ching-Tai │ *Chen Bo-Yuan, The File of White Terror Series* │ 1990-1991
Platine Fibre Rag │ 84×84 cm │ Courtesy of the artist

何經泰 │〈李明輝（化名）〉，《白色檔案》系列│ 1990-1991
白金純棉相紙│ 84×84 公分│藝術家授權

HO Ching-Tai │ *Li Ming-Hui (Alias), The File of White Terror Series* │ 1990-1991
Platine Fibre Rag │ 84×84 cm │ Courtesy of the artist

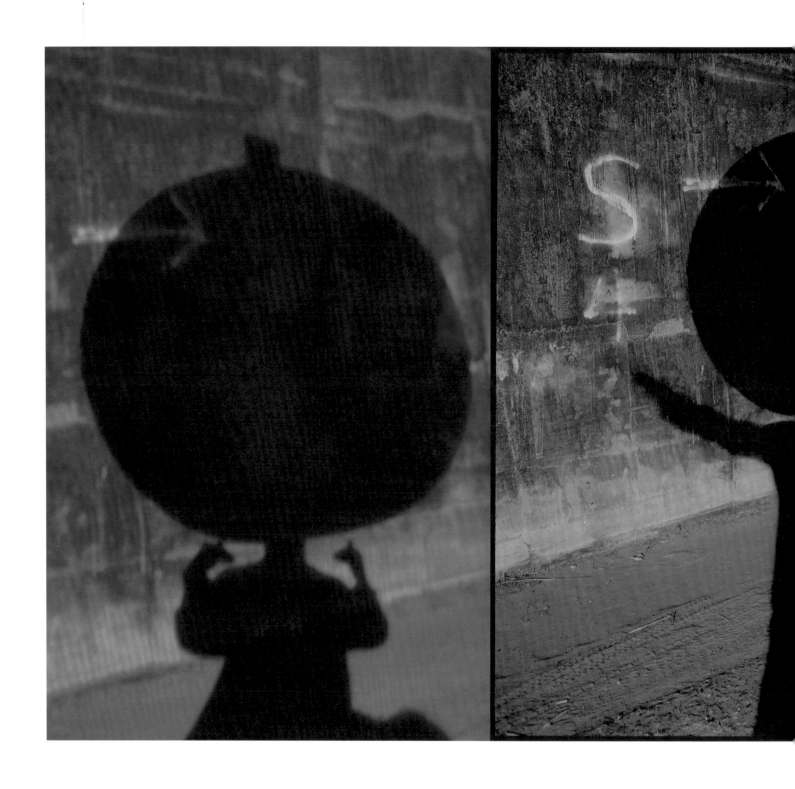

洪世聰 ｜〈頂洲-016〉，《自相似》系列 ｜ 2010
數位微噴 ｜ 90 × 210 公分 ｜ 藝術家授權

HUNG Shih-Tsung ｜ *Ding-Zhou-016, Self-Similarity Series* ｜ 2010
Archival inkjet print ｜ 90 × 210 cm ｜ Courtesy of the artist

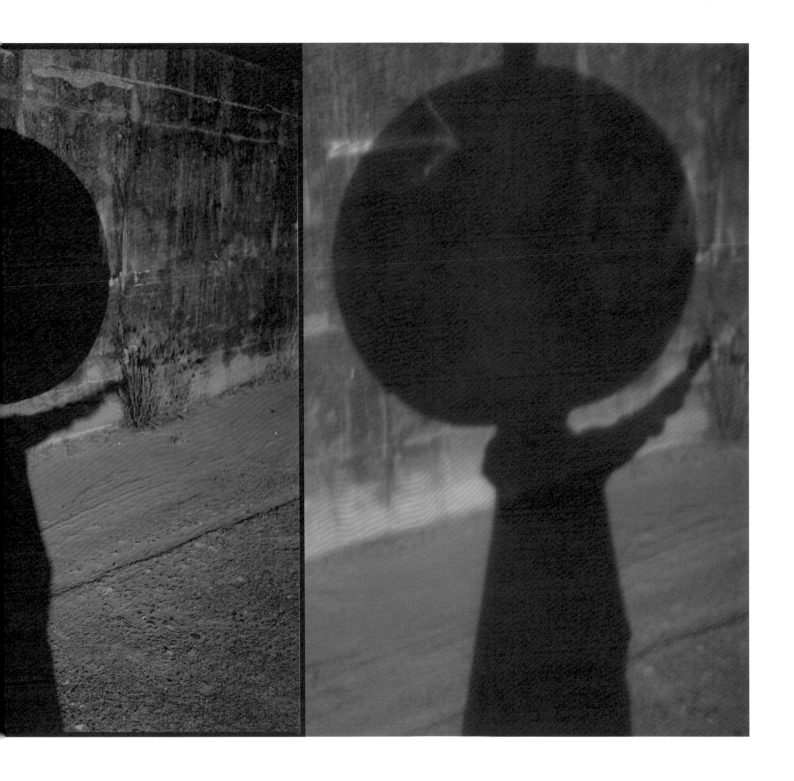

洪世聰 ｜〈古坑〉，《後設與換位》系列 ｜ 2021
數位微噴 ｜ 76.2 × 101.6 公分 ｜ 藝術家授權

HUNG Shih-Tsung ｜ *Gukeng, The Meta and Transposition Series* ｜ 2021
Archival inkjet print ｜ 76.2 × 101.6 cm ｜ Courtesy of the artist

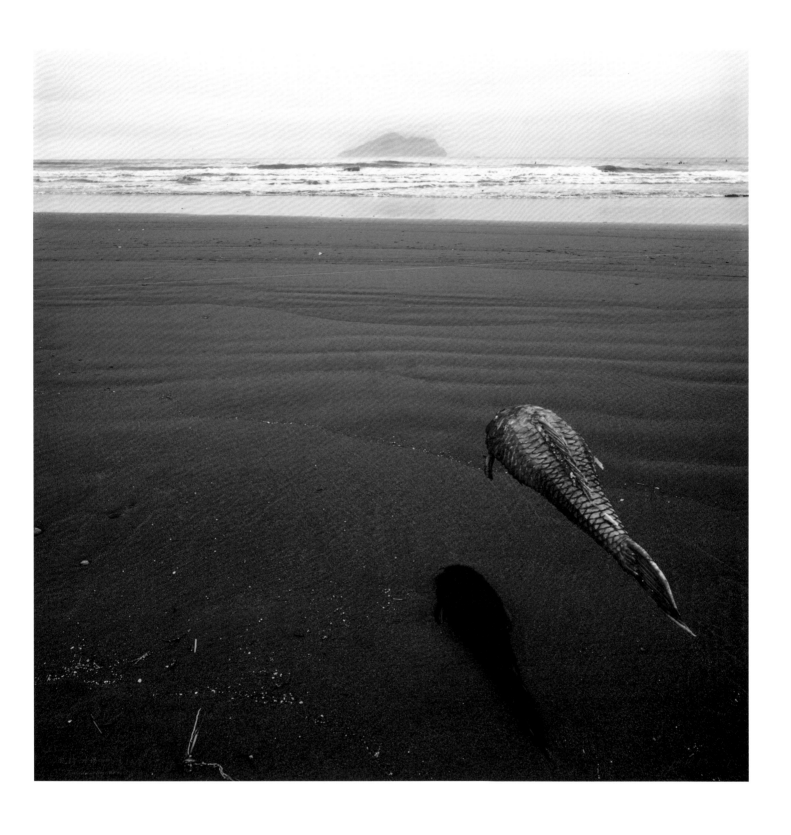

洪世聰 ｜〈外澳（2007）014〉，《迫降》系列 ｜ 2012
數位微噴 ｜ 100 × 100 公分 ｜ 藝術銀行典藏

HUNG Shih-Tsung ｜ *Forced Landing: Waiao (2017)014* ｜ 2012
Archival inkjet print ｜ 100 × 100 cm ｜ Collection of the Art Bank Taiwan

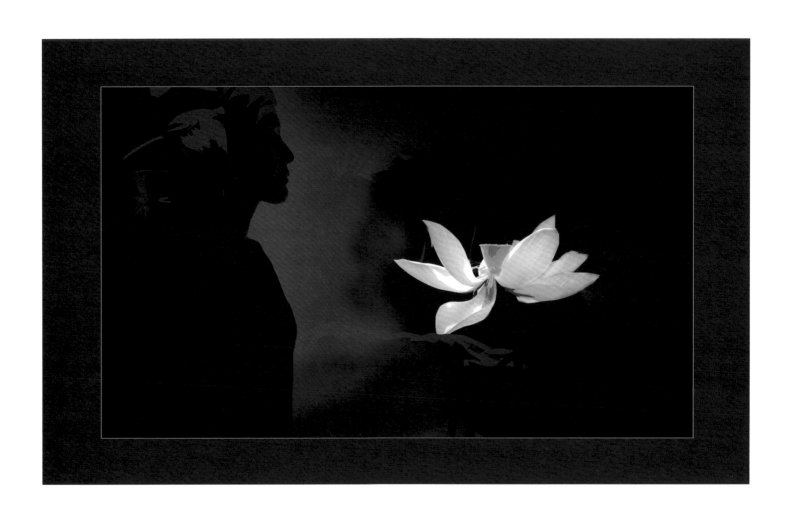

張宏聲 ｜〈花好，一如人生一般，不再回首的一程。〉｜ 2019
藝術微噴 ｜ 63 × 100 公分 ｜藝術家授權

CHANG Hong-Sheng ｜ *Flowers, Like Life, is a Journey Without Looking Back.* ｜ 2019
Giclée ｜ 63 × 100 cm ｜ Courtesy of the artist

張宏聲 ｜〈一切的因緣，起於執起相機之剎那；一切之心念，終於快門結束的當下。〉｜ 2019
藝術微噴 ｜ 66 × 100 公分 ｜ 藝術家授權

CHANG Hong-Sheng ｜ *It All Began the Moment the Camera Was Raised and Ended When the Shutter Clicked.* ｜ 2019
Giclée ｜ 66 × 100 cm ｜ Courtesy of the artist

葉清芳 │ 《現實 · 極光 · 邊緣》—1990s │ 1990s
明膠銀鹽 │ 25 × 30.2 公分 │ 國家攝影文化中心典藏

YEH Ching-Fang │ *Reality · Aurora · Periphery -1990s* │ 1990s
Gelatin silver print │ 25 × 30.2 cm │ Collection of the National Center of Photography and Images

葉清芳｜《現實 · 極光 · 邊緣》—1980s｜1980s
明膠銀鹽｜25 × 30.2 公分｜國家攝影文化中心典藏

YEH Ching Fang｜*Reality · Aurora · Periphery -1980s*｜1980s
Gelatin silver print｜25 × 30.2 cm｜Collection of the National Center of Photography and Images

蔡文祥 │ 《墨行》 │ 2020
數位輸出 │ 96 × 120 公分，6 件 │ 藝術家授權

TSAI Wen-Shiang │ *Movements of Ink* │ 2020
Digital print │ 96 × 120 cm, 6 pieces │ Courtesy of the artist

賴永鑫 ｜ 〈窺視──新北汐止〉 ｜ 2009
藝術微噴 ｜ 76.2 × 60.96 公分 ｜ 藝術家授權

LAI Yung-Hsin ｜ *Peek: Xizhi, New Taipei City* ｜ 2009
Giclée ｜ 76.2 × 60.96 cm ｜ Courtesy of the artist

陳淑貞 ｜《AFTER》｜ 2017
藝術微噴 ｜ 48 × 60 公分 ｜ 藝術家授權

CHEN Shu-Chen ｜ *AFTER* ｜ 2017
Giclée ｜ 48 × 60 cm ｜ Courtesy of the artist

陳淑貞 | 《AFTER》 | 2017
藝術微噴 | 48×60 公分 | 藝術家授權

CHEN Shu-Chen | *AFTER* | 2017
Giclée | 48×60 cm | Courtesy of the artist

賴譜光 │ 〈影像 2-1：逆光而行。臺北大稻埕〉 │ 2020
數位微噴 │ 66.04 × 50.8 公分 │ 藝術家授權

LAI Pu Kuang │ *Image 2-1: Going Against the Light. Taipei Dadaocheng* │ 2020
Archival inkjet print │ 66.04 × 50.8 cm │ Courtesy of the artist

賴譜光 ｜ 〈影像 2-2：生命的偶然與必然。臺灣北海岸〉 ｜ 2019
數位微噴 ｜ 66.04 × 50.8 公分 ｜ 藝術家授權

LAI Pu-Kuang ｜ *Image 2-2: The Chances and Certainties of Life. The Nothern Shore of Taiwan* ｜ 2019
Archival inkjet print ｜ 66.04 × 50.8 cm ｜ Courtesy of the artist

賴譜光 ｜ 〈影像 2-3：我以為我是誰。京都嵐山〉 ｜ 2017
數位微噴 ｜ 66.04 × 50.8 公分 ｜ 藝術家授權

LAI Pu-Kuang ｜ *Image 2-3: Who Do I Think I Am. Kyoto Arashiyama* ｜ 2017
Archival inkjet print ｜ 66.04 × 50.8 cm ｜ Courtesy of the artist

余　白 ｜《臺北原味》｜ 2013
數位微噴 ｜ 30.48 ×40.64 公分 ｜ 藝術家授權

Hubert KILIAN ｜ *The Original Flavour of Taipei* ｜ 2013
Archival inkjet print ｜ 30.48 ×40.64 cm ｜ Courtesy of the artist

汪曉青 │ 《陷入黑色低潮的女人》NO-10、NO-8、NO-1 │ 1993
黑白銀鹽相紙 │ 50×37 公分，3 件 │ 藝術家授權

Annie Hsiao-Ching WANG │ *The Woman Drowning in Black Tides NO-10, NO-8, NO-1* │ 1993
Black and white silver print │ 50 × 37 cm, 3 pieces │ Courtesy of the artist

張志達 ｜ 〈Blossoming〉 ｜ 2019
藝術微噴 ｜ 60 × 90 公分 ｜ 藝術家授權

CHANG Chih-Ta ｜ *Blossoming* ｜ 2019
Giclée ｜ 60 × 90 cm ｜ Courtesy of the artist

張志達 │ 〈Cycle〉 │ 2019
藝術微噴 │ 90 × 90 公分 │ 藝術家授權

CHANG Chih-Ta │ *Cycle* │ 2019
Giclée │ 90 × 90 cm │ Courtesy of the artist

221

楊士毅 ｜ 《黑暗中的自然》 ｜ 2002
藝術微噴 ｜ 72 × 108 公分，2 件 ｜ 藝術家授權

YANG Shih-Yi ｜ *Nature in Darkness* ｜ 2002
Giclée ｜ 72 × 108 cm, 2 pieces ｜ Courtesy of the artist

藝術家簡介
Artists' Biographies

石萬里
SHIH Wan-Li
1909-2008

生於遼寧省西豐縣，1937 年七七蘆溝橋事變曾任香港《大眾日報》戰地記者拍攝這場中日戰爭，抗戰勝利後擔任中廣公司大同廣播電台台長，1946 年於瀋陽創辦萬里新聞攝影社，1948 年受邀來臺灣參展臺灣博覽會，展出中國東北時事的新聞攝影照片，因逢國共內戰無法返鄉，滯留在臺灣並於 1949 年定居高雄。1950 年萬里新聞攝影社在臺恢復營運，定期發表有關時事新聞圖文並茂的刊物。他奉獻近半世紀的生命，運用鏡頭記錄在地生活，留下超過五十萬張底片，成為研究全臺灣（尤其是高雄）的人文、景觀、歷史發展與變革的最佳史料及見證。── 姜麗華

Shih Wan-Li was born in Xifeng County, Liaoning Province. During the Sino-Japanese War, he worked as a war correspondent for the Hong Kong *Popular Daily* and captured the 1937 Marco Polo Bridge Incident. After the war, he became the director of the Datong Broadcasting Station of the China Broadcasting Corporation. In 1946, he founded the Wanli News Photography Society in Shenyang. In 1948, he was invited to exhibit his press photographs from Northeast China in the Taiwan Expo. Due to the Kuomintang-Communist civil war, he settled in Kaohsiung in 1949 and couldn't return home. The Wanli News Photography Society resumed operation in Taiwan in 1950 and regularly published graphic and textual content on current events. Shih devoted nearly half a century to recording local life through his lens, leaving over 500,000 negatives that became precious materials for studying Taiwan, especially the humanities, landscape, and historical changes in Kaohsiung. — Chiang Li-Hua

pp. 164-165, p. 268

李鳴鵬
LEE Ming-Tiao
1922-2013

生於桃園大溪，1948 年參加攝影比賽獲獎，與張才、鄧南光三人並稱「攝影三劍客」（快門三劍客），翌年為《新生報》編撰「攝影漫談」專欄達半年之久，1951 年創辦《臺灣影藝》月刊，致力推廣臺灣攝影相關活動。年少曾在「大溪寫場」當學徒，開啟他接觸攝影的契機，爾後於臺北艋舺「富士寫真館」工作，習得攝影知識和修整底片的技術，曾赴廣東嶺南美術學塾研習水彩，返臺後在臺北（今衡陽路）開設中美照相器材行。他善用 Rolleiflex 雙眼相機，融合攝影專業與繪畫美學，構圖精確、內容率真並帶有寓意，透過觀景窗記錄臺灣社會人文景觀。── 姜麗華

Lee Ming-Tiao was born in Daxi, Taoyuan, and won a photography contest award held by *Taiwan New Life Daily* in 1948. He was one of the 'Three Swordsmen of Shutter' along with Chang Tsai and Deng Nan-Guang. The next year, he wrote a column titled Photography Discourse for half a year. In 1951, he founded *Taiwan Photography Art*, a monthly magazine that aimed to promote photography and related events in Taiwan. He learned photography skills and film processing techniques at the Fuji Photo Studio in Báng-kah, Taipei, where he worked after being an apprentice in the Daxi Photography Studio. He studied watercolor at the Lingnan Academy of Fine Arts in Guangdong, then returned to Taipei and opened the Chungmei Photographic Equipment Store (now located on Hengyang Road). He mastered in using the Rolleiflex twin-lens camera and blended photography and painting aesthetics to create works with precise composition, truthful content, and underlying meanings. — Chiang Li-Hua

參考來源：
林以珞─國美館重建臺灣藝術史計畫
「110 年攝影作品詮釋資料撰研計畫」

Reference:
Lin Yi-Luo, Interpretive Data Compilation and Research Project for Photography Works, ROC Era 110

pp. 166-167, pp. 268-269

秦 凱
Dennis K. CHIN
1922-2014

生於北京，素稱「老頑童」，自學攝影，十七歲擁有生平第一部相機，隨即參加上海《良友》畫報攝影比賽，初試啼聲，四張作品就一鳴驚人，囊括首獎、二獎和第七獎，成為《良友》畫報特約攝影，後相繼成為南京中央社攝影記者、哥倫比亞廣播公司 CBS 特派員等職位，1949 年隨著中央通訊社來到臺灣，因緣際會投入戰地記者行列，為國家發展留下彌足珍貴的影像。新聞崗位退休後，轉戰廣告界，開設文華與格蘭廣告公司，晚年腳印遍及多國，運用他攝影記者敏銳細膩而扎實的攝影技巧，融入抽象或唯美寫實的藝術風格，傳達「老頑童」看世界豁然的人生態度。—— 姜麗華

Dennis K. Chin, nicknamed the 'infinitely cheery soul', was born in Beijing and taught himself photography. He obtained his first camera at the age of 17 and soon won first, second, and seventh prizes in Shanghai *Liangyou Magazine's* photography competition. He then became a contract photographer for the magazine and later worked as a photojournalist for the Nanjing Central News Agency and CBS News Agency. CHINcame to Taiwan with the Central News Agency in 1949 and, by chance, became a war correspondent, capturing precious images of the country's development. After retiring from journalism, he founded the Kuohua and Grand Advertising Agencies and conveyed his cheery life attitude using his keen and solid photographic skills to capture, in his own elegant artistic style, his travels to various countries in his later years. — Chiang Li-Hua

pp. 168-169, p. 269

歐陽文
OUYANG Wen
1924-2012

生於嘉義醫生世家，自幼喜愛藝術，少年時曾親睹陳澄波作畫，後拜師學習油畫。因受二二八事件波及曾在綠島（火燒島）坐牢長達十一年（1951-1962），上級見其具攝影與美術的專長，指派他為長官或貴賓訪視綠島的攝影師，他也藉機偷拍島上部落的人文風情、建築景象、風景等難得畫面。歐陽文以讓時任政戰主任的蔣經國總離島時即能取得照片為由，說服當局准許他建立克難的暗房，由於水溫難以控制故相片多呈現粗粒子。冀望這批他偷拍私藏約四十張 1950 年代的照片，能作為百年後人類學家研究綠島的考據。解嚴後，歐陽文重拾畫筆，描繪對綠島的映像與昇華的悲慟。—— 姜麗華

Ouyan Wen, born into a family of doctors in Chiayi, Taiwan, had a passion for arts from a young age. As a teenager, he witnessed CHEN Cheng-Po's creative process and later studied oil painting under Chen. He was later imprisoned for 11 years (1951-1962) on Green Island over the 228 Incident. Recognized for his skills in photography and fine arts, he was appointed to photograph visiting officials and took advantage of this opportunity to capture rare images of the island's indigenous culture, architecture and landscapes. He convinced authorities to let him establish a makeshift darkroom by using the excuse of providing images for the then Chief of Political Warfare, CHIANG Ching-Kuo, when he visited the island. Due to difficulties in controlling water temperature, the resulting images often appeared grainy. In hopes of contributing to future anthropological studies on Green Island, he kept approximately 40 secretly taken photos. After martial law was lifted, he resumed painting, depicting his impressions of Green Island and its sublime sorrow. — Chiang Li-Hua

p. 64, p. 237

周鑫泉
CHOU Shin-Chiuan
1929-

生於湖北漢口，因戰事父母雙亡。1949 年與大哥周湘泉隨著國民政府渡臺，為謀一技之長投考警察學校，對刑事攝影與記錄攝影鑑識課程特別有興趣，也加入學校的攝影社團。1963 年調任臺南市刑警隊照相組，結識當地攝影愛好者並加入「無名攝影俱樂部」，使他從學會團體中學習到人文寫實攝影的創作理念與技巧，脫離制式化的刑事攝影。他關注純樸的常民生活景觀，認同親近土地的歸屬感，強調抓拍才能捕捉真實，認為寫實攝影家必須抓住現實，把握「時機」，因「時」制宜，見「機」行事，當「機」立斷，在變化無常的現實人生中擷取永恆的影像。—— 姜麗華

參考來源：
楊永智—國美館重建臺灣藝術史計畫
「110 年攝影作品詮釋資料撰研計畫」

Reference:
Yang Yung-Chih, Interpretive Data Compilation and Research Project for Photography Works, ROC Era 110

Chou Shin-Chiuan was born in Hankou, Hubei, and lost both parents to war. In 1949, he came to Taiwan with his elder brother Chou Shiang-Chiuan and joined the police academy, where he developed an interest in forensic and documentary photography and participated in the photography club. In 1963, he was transferred to the photography team of the Tainan Criminal Investigation Division. Chou met local photography enthusiasts in Tainan and joined the Nameless Photography Club, where he learned humanistic and realistic photography. He focused on capturing the simple life and the landscape, identifying with the sense of belonging and closeness to the land. He emphasized seizing the moment with the belief that realistic photographers must grasp opportunities to capture eternal images in an ever-changing reality. — Chiang Li-Hua

p. 65, pp. 170-173, p. 237, pp. 269-270

邱德雲
CHIU De-Yun
1931-2014

生於苗栗市農家子弟，曾在中油公司上班，1950 年代末開啟業餘攝影的人生旅程，一生未曾離鄉背井，長期記錄家鄉的各種生命軌跡。歷經 1960 至 70 年代沙龍與寫實攝影的分庭抗禮時期，雖曾一度放下相機，最後以寫實攝影為依歸。邱德雲 1991 年與家鄉攝影同好共創組「硬頸攝影群」，在黑白的鄉土攝影中發揮他的信念與使命感，透過觀景窗注視著農村環境變遷鮮為人關注的角落，經由被棄置的生活用具，表現客家人的日常作息，以及人類生存處境的深刻思索。—— 姜麗華

Chiu De-Yun was born into a farming family in Miaoli City and worked at CPC Corporation. He started his amateur photography journey in the late 1950s. Chiu remained in his hometown throughout his life, documenting the diverse life trajectories of his community. Through the periods of salon and realistic photography during the 1960s and 70s, Chiu briefly put down his camera but ultimately returned to realistic photography as his primary method. In 1991, he co-founded the Hard Neck Photography Group with fellow photographers from his hometown. He showed his belief and purpose in caring for his homeland through his black and white photography of rural life, paying attention to the often-overlooked changing countryside. He also portrayed the daily routines of the Hakka people and reflected deeply upon human survival by gazing at discarded daily items. — Chiang Li-Hua

p. 66, pp. 174-175, p. 237, p. 270

謝震隆
HSIEH Chen-Lung
1933-2023

生於苗栗，父親謝錦傳曾赴日本的東洋攝影專校學習攝影，返鄉開設雲峰寫真館維生，謝家五兄弟追隨父親走上攝影之途，成為臺灣電影界、攝影界知名的「謝家班」。謝震隆排行老二，從小耳濡目染，幫父親沖藥洗罐，在顯影劑、急制液等化學藥劑與膠捲相紙的觸摸中，對攝影產生親近與認定之情感。因跟著父親到處拍照，學到三個基本概念：（1）看好、看穩再拍。（2）控制照相機，而不是讓它控制你。（3）心中要先有一種「主意」，拍什麼？為什麼這樣拍？這三個概念強調觀察與思考的能力，讓謝震隆養成在介於「動靜」之中敏銳的觀察力。—— 姜麗華

Hsieh Chen-Lung was born in Miaoli to Hsieh Jin-Chuan, who studied photography at the Toyo Photography School in Japan and ran Yun Feng Studio to make a living upon returning to his hometown. The five brothers followed in their father's footsteps and have a great reputation in Taiwan's film and photography industries as the Hsiehs. Hsieh Chen-Lung, the second eldest, was exposed to photography from a young age, helping his father develop film and wash containers. Through his interactions with chemicals such as developing agents and fixers, as well as handling films and papers, he established a close and affirmed relationship with photography. By accompanying his father on photo shoots, he learned three fundamental concepts: (1) observe carefully and steadily before shooting, (2) control the camera instead of being controlled by it, and (3) have a purpose in mind - what to shoot and why. The three concepts emphasize the ability to observe and think, allowing Hsieh Chen-Lung to cultivate a keen eye for observing movement and stillness. — Chiang Li-Hua

pp. 176-177, p. 271

鄭桑溪
CHENG Shang-Hsi
1937-2011

生於基隆，1955 年加入張才指導的「新穗影展」啟發他的攝影觀念，1959 年就讀政治大學新聞系創辦藝術攝影研究會，1965 年與張照堂舉辦「現代攝影」雙人展，他展出運用逆光、焦點錯置等技法，表現嶄新的攝影視覺，引領臺灣攝影界邁向前衛的作品。1967 年製作並主持臺灣第一個只談攝影的電視節目「攝影漫談」，1968 年擔任《綜合月刊》和《婦女雜誌》專任攝影，他以拍攝「紅葉棒球隊的故事」享譽國內攝影界。1975 年他與各地影友組成「鄉土文化攝影群」，推展根植於土地和庶民的鄉土紀實攝影，其執著、樸實和專業開拓的態度，成為許多後進晚輩的典範。—— 姜麗華

Cheng Shang-Hsi was born in Keelung and his photographic journey began in 1955 when he joined the *New Harvest Photography Exhibition* directed by Chang Tsai. While studying journalism at National Cheng chi University in 1959, he founded the Art Photography Research Association at the school. In 1965, Cheng held a joint exhibition with Chang Chao-Tang titled *Modern Photography*, showcasing his innovative techniques such as backlighting and focus displacement, leading Taiwan's photography towards its avant-garde breakthrough. Cheng's influence extended beyond exhibitions, as he produced and hosted Taiwan's first television program solely dedicated to photography, *Talk Photography*, in 1967. Next year, he started a job as a full-time photographer for *Integral Monthly* and *Women's Magazine*, earning recognition for his work on the story of the Red Maple teen baseball team, which has since become a classic within Taiwan's photography scene. In 1975, he formed the Grassroot Photography Group with fellow photographers from all around Taiwan, promoting documentary photography rooted in the land and its people. His commitment, sincerity, and professional approach set an example for Taiwanese young photographers to follow. — Chiang Li-Hua

pp. 178-179, p. 272

葉清芳
YEH Ching-Fang
1937-2011

生於臺北縣瑞芳鎮，曾獲「71年度全國大專院校攝影比賽」黑白組金牌獎，世界新聞專科學校（今世新大學）畢業後，進入《時報新聞週刊》擔任攝影記者，時值臺灣解嚴前後，各種政治改革、社會運動風起雲湧之際，因而拍攝了大量有關示威抗議、街頭遊行等群眾運動，他善於運用重複曝光、晃動模糊的失焦殘影，表達現實的混亂、詭異與疏離，曾於臺北爵士藝廊舉辦首次個展「殘影解像」、於巴黎展出「放浪人生」攝影個展。在工作之餘，他也留下不少生活即景、人文肖像等紀實作品，表現他細膩的觀察力，和嚴謹而熟練的構圖技巧。── 呂筱渝

Yeh Ching-Fang was born in Ruifang Township, Taipei County and received the Gold Medal Award in the black and white category of the National College Photography Competition in 1982. After graduating from the World Journalism College (now SHIH Hsin University), he worked as a photojournalist for *Taipei Times Weekly*. His photography is known for capturing protests and demonstrations in Taiwan's pre- and post-lifting of martial law, utilizing techniques such as multiple exposures and blurred, out-of-focus remnants to express the chaos, eeriness, and alienation of reality. His first solo exhibition, *Decoding Remnants*, was held at the Taipei Jazz Gallery. He produced documentary photographs of everyday life and human portraits as well, demonstrating a keen eye for observation and rigorous, skilled compositional techniques. His solo photography exhibition *Wandering Life* was once held in Paris. — LU Hsiao-Yu and Chiang Li-Hua

莊 靈
CHUANG Ling
1938-

生於貴州貴陽，1953年開始接觸攝影，從此將攝影視為一生志業，1965年起任職臺灣電視公司攝影記者二十四年，他經常肩上扛著攝影機跑新聞，同時攜帶照相機創作與記錄。具有國際視野的莊靈，也常以筆替代鏡頭，撰寫頗具前瞻性的攝影見解文字，著有《攝影藝術散論》、《新聞攝影》、《逆旅形色攝影展專集》、《看見世紀光影》及《莊靈‧ 看視》等書，深入剖析攝影思潮、攝影師創作理念以及新興攝影藝術團體的表現。榮獲金馬獎、吳三連藝術獎與國家文藝獎，並聯合攝影及藝術界好友，成立台灣攝影博物館文化學會，敦促政府成立國家攝影文化中心，以提升臺灣攝影文化水準，造福社會。── 莊靈、姜麗華

Chuang Ling was born in Guiyang, Guizhou, and began his photography career in 1953, viewing photography as his life's work. From 1965, he was a photojournalist for Taiwan Television for 24 years, often carrying a camera to create his own work while covering news events. With an international perspective, Chuang Ling penned his insights on photography, such as *Discussions on Photography Art, News Photography, On the Nomad Photography Exhibition, Seeing Light and Shadow of the Century*, and *Chuang Ling*: *Spiritual Vision*. These publications delves deep into photographic trends, photographers' creative concepts, and emerging photographic artist groups. Chuang has been honored with the Golden Horse Award, Wu San-Lien Art Award, and National Literary Award. He co-founded the Society of the Photographic Museum and the Culture of Taiwan with friends in the photography and art community to promote and advocate the establishment of the National Center of Photography and Images. — Chuang Ling, Chiang Li-Hua

謝明順
Vincent HSIEH
1939-

生於臺北，就讀延平國小時曾獲吳三連水彩畫獎第二名。成淵中學畢業後，考上第一屆國立臺灣藝術專科學校（今臺灣藝術大學）美術印刷科，預官役期間考上留學日本獎學金，進入日本大學美術系攻讀商業設計，又於國立千葉大學寫真工學系研究特殊攝影。回國與林芙美完婚並創立西瀛廣告攝影設計公司，經營之餘並兼任藝專、文化、輔仁大學等校的教職，此後各大專院校始設立廣告攝影為正式課程。2003年《像雕》展出攝影作品是國內首創於相紙上雕刻並部分塗有壓克力顏料上彩，他「先求唯一、再求第一」之創作精神至今不變。── 林芙美

Vincent Hsieh won second place in the Wu Sanlian Watercolor Painting Award while attending Yanping Elementary School in Taipei City. After graduating from Chengyuan Middle School, he was admitted as the first group of students to the National Academy of Arts (now National Taiwan University of the Arts) in the Department of Fine Arts and Printing. During his pre-service military officer training, Hsieh got accepted for a scholarship to study in Japan and soon entered the Department of Commercial Design at Nihon University. Later, he also studied special photography at the Department of Photographic Engineering, Chiba University. Returning to Taiwan, Hsieh married Lin Fu-Mei and founded the Hsi-Ying Advertising Photography Design Company. While running his advertising business, Hsieh held teaching positions at the National Academy of Arts, Chinese Culture University, and Fu Jen Catholic University. Since then, advertising photography has been established as a regular course in various universities and colleges in Taiwan. In 2003, his *Sculptural Sentiments* exhibition featured photography works with carved photographic paper that was partially acrylic-painted, an innovation in Taiwan. Hsieh's creative spirit of "striving for uniqueness, then for being the best" remains unchanged to this day. — Lin Fu-Mei

林芙美
LIN Fu-Mei
1941-

生於澎湖縣馬公，十五歲考上國立臺灣藝術專科學校美術印刷科。1965 年通過自費留日考試並赴日本大學藝術學院寫真學系三年級就讀（可抵學分），兩年後畢業再進入國立千葉大學寫真工學系專攻影像合成。1969 至 1999 年回國後擔任國立藝專、文化大學、輔仁大學兼任講師、副教授，1999 年升等教授。林芙美於 1992 年首次個展「時空的烙印」，1995 年舉辦第二次個展「交集與干涉」，以人為力量干涉直行的光線而產生空間交集的複屈折影像，在第三次個展「遊戲人間」與第四次個展「疏離的介入」中，她讓複屈折影像存在現實環境裡，令畫面形成矛盾又和諧的趣味性。—— 林芙美

Lin Fu-Mei was born in Magong City, Penghu, and was admitted to the National Taiwan Academy of Arts' Printing Technology and Arts department at the age of 15. In 1965, Lin passed the examination for self-funded studies in Japan and enrolled in the third year of the Nihon University College of Art Department of Photography (credits transferable). Lin graduated after two years and entered the Chiba University Department of Image Sciences, specializing in image synthesis. Between 1969 and 1999, Lin returned to Taiwan and became an adjunct lecturer and assistant professor at the National Taiwan Academy of Arts, Chinese Culture University, and Fu Jen Catholic University, gaining a full professorship in 1999. Lin held her first solo exhibition *The Imprints of Space and Time* in 1992, and her second solo exhibition Intersection and Interference in 1995 which involved the artificial interference of light leading to spatial overlap and the creation of double refraction images. In her third and fourth solo exhibitions *Playfulness in Life* and *The Intervention of Alienation*, Lin embedded double refraction images into real settings, endowing the image with playful contradictions and harmonies. — Lin Fu-Mei

pp. 70-75, p. 238

張武俊
CHANG Wu-Chun
1942-

生於臺南保安，1966 年與攝影結緣至今，從記錄家人的影像開始，1970 年代加入臺南市攝影學會，踏上學習之路，1987 年以專題攝影理念開創草山月世界專題攝影，從創作月世界系列投注攝影長達數十年時光。1992 年以《全臺首學》、《彩竹的故鄉》系列作品再現日常人文景物風貌之美，同年於臺北市立美術館舉辦「夢幻月世界」攝影個展，1995 年於臺北爵士藝廊、臺南市立文化中心舉辦「全臺首學」個展，2014 年的「堅毅的生命光影——張武俊攝影捐贈展」等展覽，並於 2021 年榮獲臺南卓越市民獎。—— 廖云翔

Chang Wu-Chun was born in Bao'an, Tainan, and encountered photography in 1966. Chang started documenting images of family members and joined the Photographic Society of Tainan in the 70s, starting along the path of honing his photographic skills. In 1987, Chang began Caoshan Moon World Feature Photography, to which he dedicated decades of his life. In 1992, Chang re-interpreted the beauty of cultural scenery through *The First Academy* in Taiwan and *The Homeland of Colorful Bamboo*, and held the *Dreamy World* solo exhibition at the Taipei Fine Arts Museum. In 1995, *The First Academy* in Taiwan solo exhibition was featured at the Taipei Jazz Gallery and Tainan Cultural Center, and the *Images of the Resilience of Life: Chang Wu-Chun Photography Donation Exhibition* was held in 2014. Chang was awarded the Tainan Outstanding Citizen Award in 2021. — Liao Yun-Hsiang

pp. 76-79, pp. 238-239

張照堂
CHANG Chao-Tang
1943-

生於臺北縣板橋，就讀成功高中時參加攝影社，鄭桑溪擔任該社團的指導老師，受到啟蒙後開啟他對攝影的熱情，1965 年師生二人舉辦「鄭桑溪、張照堂——現代攝影展」。1961 年張照堂進入國立臺灣大學土木工程學系就讀，吸收現代文學、存在主義哲學、荒謬劇場與超現實主義藝術思潮，並開始以實驗性極強的攝影影像作品，表現迷惘、抑鬱的情緒張力。具備多重身分，集「影視照」三棲才藝於一身的張照堂，影視業退休後，受聘於臺南藝術學院音像紀錄研究所，獲頒為榮譽教授，也是國家文藝獎與行政院文化獎得主，2022 年榮獲第 59 屆金馬獎「終身成就獎」。—— 姜麗華

Born in Banqiao, Taipei, Chang Chao-Tang joined the photography club when attending Cheng-Gong High School. At the time, photographer Cheng Shang-Hsi was the club's manager, sparking Chang's passion for photography. The duo of mentor and student opened the *Cheng Shang-Hsi and Chang Chao-Tang: Modern Photography* exhibition in 1965. In 1961, Chang Chao-Tang entered the Department of Civil Engineering at National Taiwan University. He absorbed modern literature, existentialism, absurdist theater, and surrealist art trends on campus and began creating experimental photographic works that expressed feelings of confusion and emotional tension. *Chang Chao-Tang is a multifaceted professional in photography*, film, and television. After retiring from the film and television industry, he was appointed as Honorary Professor of the Tainan Academy of the Arts' Graduate Institute of Studies in Documentary. He is a recipient of the National Award for Arts and the Executive Yuan Culture Award. In 2022, the 59th Golden Horse Awards committee honored him with a Lifetime Achievement Award. — Chiang Li-Hua

p. 185, p. 274

劉永泰
LIU Yung-Tai
1945-

生於山東萊陽，國立臺灣藝術專科學校（今國立臺灣藝術大學）美術印刷科畢業後，進入國立臺灣師範大學美術系進修。曾任國立臺南大學美術系、長榮大學視覺藝術系兼任講師，並在大專院校民間社團從事攝影教學多年，作育英才無數，榮獲國立臺灣藝術大學傑出校友獎，臺南市政府藝術獎。作品榮獲國立成功大學、臺南市政府、臺南市立文化中心、臺南市立美術館等處典藏。著有《基礎攝影學》、《劉永泰「論攝影」文集》等書。關注《光之再現》美術攝影創作，將時間、空間和光線結合成內心的意象，進入潛意識的內心世界創作出獨特風格的美術攝影，在當代攝影藝術中獨具一格。── 劉永泰

Liu Yung-Tai was born in Laiyang, Shandong. After graduating from the Printing Technology and Arts Department of the National Taiwan University of Arts (formerly National Taiwan Academy of Arts), Liu enrolled in further studies at the National Taiwan Normal University Department of Fine Arts. Liu became an adjunct lecturer at the National University of Tainan and Chang Jung Christian University Department of Visual Arts, and has devoted years to teaching in universities and civil society photography clubs, cultivating countless talents. The artist was awarded the National Taiwan University of Arts Outstanding Alumnus Award and the Tainan City Government Art Award. Liu's works have entered the collections at institutions including the National Cheng Kung University, Tainan City Government, Tainan Municipal Cultural Center, and Tainan Art Museum. Publications include *A Basic Guide to Photography* and *Liu Yung-Tai's Collected Essays on Photography*. The photographic works of *The Re-Emergence of Light* integrate time, space, and light, featuring fine art photographic mindscapes of the inner, subconscious world, making Liu Yung-Tai a unique figure in the world of contemporary art photography. — Liu Yung-Tai

pp. 80-83, pp. 239-240

葉　裁
YEH Tsai
1946-

生於彰化縣二林鎮，本名葉日裁，放牧時意外成為外國牧師鏡頭下的主角，因此萌生對攝影暗箱的好奇，埋下當攝影師的夢想。十八歲因拾物不昧，物主贈予相機答謝，從此葉裁與攝影結下不解之緣，並於1975 年被評選為美國伊士曼公司特約攝影師，專拍自然景觀及世界各地多元族群人文生活景象，足跡遍及世界。然在工作攀峰之際，他毅然回到新竹客家庄蟄居，全心投入桃、竹、苗搶救鄉土文化拍攝工作，記錄當地人文生活和自然風貌。1991 年定居北埔，以鏡頭記錄許多北埔已經或即將消失的景象，表現客家人的生活面貌、文化風采與篳路藍縷的生命史。── 姜麗華

Yeh Tsai (originally named Yeh Jih-Tsai) was born in Erlin Township, Changhua County. As a teenager, one day Yeh unexpectedly became the protagonist in a foreign pastor's photograph while herding. The encounter sparked Yeh's curiosity about photography and planted his dream of becoming a photographer. At 18, Yeh found and returned a lost item, and the owner gifted him a camera as a token of gratitude. From then on, he formed an unbreakable tie with photography. In 1975, Yeh became a contract photographer for the American Eastman Company, specializing in capturing natural landscapes and diverse cultural lifestyles worldwide, leaving his footprint across the globe. At the peak of his career, Yeh decided to return to his Hakka home village in Hsinchu and dedicate himself to documenting the local culture in Taoyuan, Hsinchu, and Miaoli. His lens captured the daily lives of the Hakka people, their cultural charm and their tenacious history. In 1991, Yeh settled in Beipu and has continued preserving disappearing scenes in the unique Hakka lifestyle and changing natural landscapes. — Chiang Li-Hua

p. 186, p. 274

簡榮泰
CHIEN Yun-Tai
1948-

生於臺北縣新莊（今新北市新莊區），時值十五歲，信手翻閱幾本《Life》雜誌，對一幅幅報導圖片感到震撼，開啟他對攝影的興趣。1983 年臺灣省教育廳主辦第三十八屆全省美展，他是第一位榮獲「永久免審查資格」，經常擔任國內多項大獎攝影類評審委員。他認為攝影並非只是對現實的反映，而是藉由創造性的思考來捕捉現實物件，甚至穿透現實物的表象。他善於拍攝與土地相關題材的地景攝影，無論是度假勝地馬爾地夫或是臺灣原鄉與金門等地，總是以顯明的色彩對比、巧妙的構圖，彰顯圖像的張力，傳達對土地的關懷與情感，試圖對當下城鄉景觀提出他個人視覺性的敘述。── 姜麗華

Chien Yun-Tai was born in Xinzhuang, New Taipei County. At the age of 15, he stumbled upon several issues of *LIFE* magazine and was struck by the documentary photographs that kindled his interest in photography. In 1983, he became the first recipient of the honor of 'Permanent Exemption from Preview' at the 38th Provincial Fine Arts Exhibition hosted by the Taiwan Provincial Department of Education. He frequently served as judge for domestic photographic awards. Chien believes that photography is not merely a reflection of reality, but a means of capturing, or even penetrating the essence of objects in the real world through creative thinking. He has been adept at shooting landscapes, whether in the Maldives, Taiwan's indigenous communities, or Kinmen Island. With vivid color contrasts and intriguing composition, he highlights the tension in images, conveys his concern and affection for the land and attempts to provide a personal visual narrative of the current urban and rural landscapes. — Chiang Li-Hua

p. 84, p. 187, p. 240, p. 275

阮義忠
JUAN I-Jong
1950-

生於宜蘭頭城木匠之家，高中即從事繪畫創作，後擔任《漢聲》雜誌攝影師，足跡遍踏臺灣，完成《北埔》、《八尺門》、《人與土地》、《台北謠言》、《四季》、《正方形的鄉愁》、《失落的優雅》、《有名人物無名氏》等攝影集並曾在世界多國舉辦個展。他關注弱勢族群、人與土地的生活，態度具有使命感，入選《全球當代攝影家年鑑》，譽稱為百分之百的人文主義者，其論作《當代攝影大師》、《當代攝影新銳》、《攝影美學七問》被視為海峽兩岸攝影啟蒙書。2018 年宜蘭市政府成立「阮義忠臺灣故事館」，係由他精心策劃藝術與人文對話的展覽空間。—— 姜麗華

Juan I-Jong was born into a carpenter's family in Toucheng, Yilan. He engaged in painting and creation since high school and later became a photographer for Han Sheng Magazine. His work has taken him across Taiwan, resulting in photographic collections such as *Beipu, Eight-Foot Gate, People and Land, Taipei Rumors, Four Seasons, Square Nostalgia, Lost Grace* and *The Famed with No Names*, among others. He has held solo exhibitions around the world. Juan stands in solidarity with minority groups and cares about the relationship between people and the land. He has a strong sense of mission and was selected for the *Global Contemporary Photographers Yearbook*, earning the title of 'a 100% humanist.' His essays, *Masters in Contemporary Photography, Newcomers in Contemporary Photography,* and *Seven Questions on Photographic Aesthetics* are regarded as the classic guides to photography across the Taiwan Strait. In 2018, the Yilan City Government established the Juan I-Jong Taiwan Story House, an exhibition space that Juan designed for artistic and humanistic dialogues. — Chiang Li-Hua

林國彰
LIN Kuo-Chang
1951-

生於嘉義，曾任《中國時報》資深攝影記者，70 年代受報導攝影啟蒙，自學攝影，認同攝影信念：以「看見」、「紀錄」、「幫助」六字，關懷人的生活、生命與生存現況，鏡頭常聚焦社會風景與城市地景。他以直觀、等待、抓拍、非虛構、辨差異、求多義，透過當下想像方式拍照，認為攝影是長期觀測，需不斷重回現場，重複按下快門，在快門一鬆一緊中體驗，攝影是自我救贖。1987 年《中式速食》獲 WPP 荷蘭世界新聞攝影比賽日常生活類金眼獎、2004 年《被麻風烙印的小孩》獲韓國東江國際攝影節最佳外國人攝影家獎、2005 年《十八年來第一班》獲金鼎獎最佳攝影首獎。—— 林國彰

Lin Kuo-Chang, once a senior photojournalist for the *China Times*, was born in Chiayi, Taiwan. He began his photography career in the 1970s with a belief in photography's power to see, document, and assist in caring for people's lives, existence, and survival. His lens often focuses on social and urban landscapes. With intuition, he waits, captures moments, creates non-fiction, distinguishing works, and seeks multiplexity in meanings through his imaginative approach. Lin regards photography as self-redemption that requires constant observation and the loosening and tightening of the shutter. His works, such as *Chinese Fast Food, Children Branded by Leprosy,* and *The First Class in 18 Years*, have won awards at international photography events, including the World Press Photo Awards, DongGang International Photo Festival in Korea, and the Golden Tripod Awards in Taiwan. — Lin Kuo-Chang

林柏樑
LIN Bo-Liang
1952-

生於高雄，出身地方望族之後，年少叛逆，讓他勇於接觸外頭的花花世界。因閱讀美國新聞處的《今日世界》而認識藝術家席德進與其所繪的臺灣鄉土畫作。爾後拜席德進為師，受其「藝術，從生活中學習」的啟迪，成為林柏樑的藝術圭臬，以相機作為創作媒介，開啟他在藝術國度永無止境的自學與實踐，使其攝影美學觀和生命歷程息息相關，深植於常民的平凡生活。他將攝影內化為個人獨特的直覺與關照，以質樸、自然、單純的心靈，面對鏡頭前的人物、風景、古蹟與人文景況，為解嚴後迅速轉變的臺灣容貌，留下珍貴的紀錄。—— 姜麗華

Born in Kaohsiung City, Lin Bo-Liang comes from a prominent local family. In his rebellious youth, Lin began to explore the vibrancy of the world. By reading *Today's World* from the American News Agency, Lin became acquainted with artist HSI De-Chin and his paintings of Taiwanese rural scenes. Subsequently, Lin became a disciple of HSI. Lin followed Hsi's guidance that "art is learned from life" to establish his own artistic direction. Using the camera as a creative medium, Lin connected his photographic aesthetics with the experiences of ordinary everyday life and people. Lin internalized photography with his unique intuition and care, confronting characters, landscapes, historical sites, and humanistic scenes with a simple, natural, and unpretentious spirit. He documented the rapidly changing Taiwan after martial law was lifted, leaving behind invaluable records. — Chiang Li-Hua

張國治
CHANG Kuo-Chih
1957-

生於金門，國立臺灣藝術專科學校美工科、臺灣師範大學美術系畢業、美國芳邦大學（Fontbonne University）藝術碩士、福建師大美術學專業文學博士。曾擔任國立臺灣藝術大視覺傳達設計學系主任兼所長、文化創意產學園區文創處處長、推廣教育中心主任等職，現任臺藝大視傳設計學系及創意產業設計博士班、臺師大美術系兼任教授，臺灣攝影博物館文化學會理事長，並多次擔任公私立單位各項比賽評審委員。從事繪畫、攝影、文學創作，亦為獨立策展人，曾主辦多項國際學術研討會，設計、攝影、繪畫等類型策展，主編詩刊文學選集，同時擅於藝文評論等書寫，著作出版至今共十九冊。—— 張國治

Chang Kuo-Chih was born in Kinmen and graduated from the National Academy of Arts, Department of Fine Arts at National Taiwan Normal University, Fontbonne University with a Master of Fine Arts degree, and earned a doctorate degree in fine arts from Fujian Normal University. Chang had served in various positions at National Taiwan University of Arts, including as Department Head and Graduate Program Chair of the Department of Visual Communication Design, Director of the Cultural and Creative Industry Park, and Director of the Extension Education Center. Currently, he is a faculty member of the Department of Visual Communication Design and Graduate School of Creative Industry Design at the National Taiwan University of Arts, and an adjunct professor of the Department of Fine Arts at National Taiwan Normal University. He also serves as the President of the Society of Photographic Museums and Culture of Taiwan and has been invited to judge committees of numerous photography competitions and art awards. Chang Kuo-Chih engages in painting, photography and literary creation. He also works as an independent curator who has organized international academic conferences and curated exhibitions in categories of design, photography and painting. Chang has edited poetry and literary anthologies and has dedicated his life to art and cultural criticism, with a total of 19 published works to date. —Chang Kuo-Chih

pp. 93-97, pp. 192-193, pp. 242-243, pp. 276-277

高志尊
KAO Chih-Chun
1957-

生於彰化，日本大學藝術學部寫真學科畢業，九州產業大學藝術學碩、博士，師事植田正治、奈良原一高。1989 年起至今於海內外舉辦過三十餘場個展，作品被文化部藝術銀行、北美館、國美館、國家攝影文化中心等公私立機構及個人典藏。曾任教於中原、淡江、世新、政大等校，擔任銘傳大學商設系教授兼系所主任。他接受完整攝影及藝術教育，兼具影像藝術的造詣與學養，出版《光的調色盤》、《視點》、《影像蒙太奇在創作中之應用》、《光畫——高志尊的私風景》、《光畫——私風景 II》等書，其中《光的調色盤》將世界物象解剖成「形」與「色」的原質構成。—— 高志尊

Kao Chih-Chun was born in Changhua, graduating with a Photography major from Department of Arts at Nihon University, and holds a Master's and Doctorate degree in Art from Kyushu Sangyo University, studying under Ueda Shoji and Narahara Ikko. Since 1989, he has held over thirty solo exhibitions at home and abroad. His works have been collected by institutions such as the Ministry of Culture's Art Bank, Taipei Fine Arts Museum, National Taiwan Museum of Fine Arts, the National Center of Photography and Images, as well as private collectors. Kao has taught at Chung Yuan University, Tamkang University, SHIH Hsin University, and National Chengchi University, serving as faculty member and once department head for Ming Chuan University's Department of Commercial Design. Having received a comprehensive education in photography and art, he boasts both artistic and scholarly achievements in image art. His publications include *The Palette of Light, Perspectives, Application of Montage in Image Arts, Light Painting: Hidden Landscapes by Kao Chih-Chun,* and *Light Painting: Hidden Landscapes II*. Notably, *The Palette of Light* dissects the world into the primal constituents of form and color. — Kao Chih-Chun

pp. 98-99, pp. 194-197, p. 244, p. 277

傅朝卿
FU Chao-Ching
1957-

生於臺南，英國愛丁堡大學建築博士，臺南文化獎得主，現任國立成功大學建築系名譽教授，亦是建築史家、作家與攝影家。1972 年開始攝影，學生時期（1972-1979）曾榮獲各種全國性攝影比賽獎項。1979 年不再參加影賽，而以照片來詮釋各種環境中的主題，把攝影從傳統單純「沙龍」與「記錄」的層面推展到「詮釋」的層面，特別是他對建築與都市的觀點，至今近千種各類著作中大量應用自己拍攝的照片。舉辦多次個展，包括 1986 年「建築與都市詮釋攝影展」、1995/1996 年「空間四向詮釋攝影個展」與 2022/2023 年「時間行囊建築心一位建築文人著作、手稿與鏡頭中的建築世界」等。——傅朝卿

Born in Tainan, Fu Chao-Ching holds a PhD in Architecture from the University of Edinburgh, is a recipient of the Tainan Culture Award, and currently serves as an honorary professor at the Department of Architecture at National CHENG Kung University. He is an architectural historian, writer, and photographer. He started taking photographs in 1972, winning various national photography competitions during his student years (1972-1979). In 1979, He stopped participating in competitions and began using photography to interpret themes within different environments, pushing photography beyond the realms of salon and documentation to that of interpretation. His architectural and urban perspectives can be seen in the nearly one thousand works he has authored, in which he has extensively incorporated his own photographs. Fu Chao-Ching has held numerous solo exhibitions, including the *Architecture and Urban Interpretive Photography Exhibition* in 1986, the *Spatial Quadrant Interpretive Photography Solo Exhibition* in 1995/1996, and *Time Capsule and Architecture Heart - An Architectural Literatus' Works, Manuscripts, and Architectural World Through the Lens* in 2022/2023. — Fu Chao-Ching

pp. 100-101, pp. 198-199, p. 244, p. 278

何經泰
HO Ching-Tai
1958-

生於韓國釜山華僑，1976 年來到臺灣求學，隔年考取國立政治大學哲學系，加入攝影社接觸新聞攝影。畢業後曾擔任《天下雜誌》、《時報周刊》、《民生報》、《自立早晚報》、《時報新聞刊》、《工商時報》等媒體的攝影記者。從 1988 年起至 1995 年間完成著名的三部曲《都市底層》、《白色檔案》、《工殤顯影 I》以及 2002 年《工殤顯影 II——家族陰影》，何經泰揭露攸關臺灣經濟底層與政治議題，以及因工作受傷者的悲情，2018 年以古典火棉膠法拍攝排灣族傳統「五年祭」《百年不斷的人神之約》，映襯原住民遵循傳統體制的精神。2003 年榮獲第七屆臺北文化獎。—— 姜麗華

Ho Ching-Tai is an overseas Chinese born in Busan, Korea who traveled to Taiwan to study in 1976. Ho gained admission into the Department of Philosophy of National Chengchi University the following year and joined the NCCU Photo Club, which was where he encountered news photography. After graduation, Ho worked as a photojournalist at media companies including *Common Wealth Magazine, China Times Weekly, Min Sheng Bao, Independence Morning and The Evening Post, China Times News*, and *The Commercial Times* . Between 1988 and 1995, Ho completed his renowned trilogy: *Shadowed Life, The File of White Terror*, and *Industrial Injury* I, as well as the *Industrial Injury II: Family Gloom* in 2002. Through his works, Ho revealed political issues concerning the economically underprivileged people of Taipei society, as well as the grief of those who suffered work-related injuries. In 2018, Ho created *The Hundred-Year Covenant Between Man and God Series*, photographing the traditional Paiwan 'Maljeveq' using the ancient collodion process. The Series features the spirit of indigenous people following traditional cultural systems. Ho was awarded the 7th Taipei Culture Award in 2003. — Chiang Li-Hua

pp. 102-103, pp. 200-201, p. 245, pp. 279-280

洪世聰
HUNG Shih-Tsung
1959-

生於嘉義縣，學習建築設計，曾參與執行國家歌劇院與音樂廳的建置。1995 年起從事攝影創作至今，2005 年作品《入默——水岸組曲》榮獲第一屆 TIVAC 傳統攝影獎首獎，2010 年作品《墨像之境》受邀於臺北市立美術館「超現攝影展」展出，以及由國立臺灣美術館策劃「感官拓樸」於廣東美術館展出。2011 年加入莊靈創辦的台灣攝影博物館文化學會，共同推動成立臺灣攝影博物館，2015-2019 年間擔任該學會第三、四屆理事長，持續推動成立宗旨，並於 2016 年受國立臺灣博物館委辦「影耀寶島攝影家眼裡的臺灣大地（III）」攝影特展，此亦為國家攝影文化中心揭幕展。—— 洪世聰

Born in Chiayi County, Hung Shih-Tsung pursued architectural design and contributed to the development of Taiwan's National Theater and Concert Hall. Embarking on his photographic journey in 1995, he achieved acclaim with his 2005 piece *A Profound Silence Prevailed Over All*, which garnered the first prize in traditional photography at the TIVAC Photography Awards. In 2010, his work *Images de l'Encre* was featured in the Taipei Fine Arts Museum's *Beyond Reality* exhibition and the Sensory Topography exhibition at the Guangdong Museum of Art. In 2011, Hung joined the Society of Photographic Museum and Culture of Taiwan, founded by CHUANG Ling, to advocate for the establishment of a national photography museum. Serving as the society's chairman from 2015 to 2019, he continued to advance its mission. In 2016, the National Taiwan Museum commissioned Hung for the special exhibition *The View of Formosa's Landscape from Photographers III*, which coincided with the inauguration of the National Center of Photography and Images. — Hung Shih-Tsung

pp. 104-109, pp. 202-205, p. 246-247, p. 280

張宏聲
CHANG Hong-Sheng
1960-

生於臺北，國立臺灣師範大學工業教育系學士，以「視聽教育」專題研究獲得公費留學，取得美國匹茲堡州立大學職業技術教育碩士。映莘攝影學堂創辦人，認同香港展能藝術會（ADA）「藝術同參與傷健共展能」以及「藝術無疆界」的信念。擔任世界展能技藝競賽攝影類資深國際裁判，期間並擔任國手培訓任務，二十九年期間為臺灣贏得三面世界金牌、兩面銀牌、一面銅牌，這些經歷讓他成為攝影教育專家，針對不同身心障礙者設計出合適的攝影教學方式。他善於營造寧靜致遠的氛圍，引領觀者進入靜默的冥想與自我觀照，無論是黑白或是彩色作品皆細膩精湛。—— 張宏聲

Born in Taipei, Chang Hong-Sheng earned a Bachelor's in Industrial Education from National Taiwan Normal University and a Master's in Career and Technical Education from Pittsburg State University, supported by Taiwanese government scholarship for his audiovisual education research. As the founder of Heart Image Photo Academy, he championed Arts in accordance with the Disabled Association Hong Kong's (ADAHK) mantras of 'Art and Participation' and 'Art without Boundaries' and has dedicated himself to accessibility and empowerment through the arts. Esteemed as a senior international judge in the World Skills Competition for photography, he has contributed to Taiwan's success in winning numerous world medals and has cultivated a specialization in adaptive photography education for individuals with diverse abilities. With a penchant for creating serene and introspective atmospheres, his evocative works—whether in monochrome or color—showcase intricate detail and draw viewers into silent contemplation. — Chang Hong-Sheng

pp. 110-111, pp. 206-207, p. 247-248, p. 281

蔡文祥
TSAI Wen-Shiang
1961-

生於臺灣基隆，就讀美國紐約視覺藝術學院並取得攝影與相關媒材藝術碩士。1998 年回臺後，曾任教於中國文化大學與國立臺北藝術大學。2019 年創辦臺灣當代攝影實驗室，從事以攝影為研究基礎的視覺創作、策展、教學與影像實驗，作品主要思考當代攝影作為跨文化閱讀的可能性。他致力整合、連結攝影藝術與社會的跨領域結合，也運用影像藝術與設計思考，實踐攝影介入社會之方法，讓攝影成為社會美感經驗的催化劑，近年來持續關注臺灣攝影文化發展，聚焦於科技創新與攝影之研究，推動亞太攝影藝術論壇，試圖建立亞洲攝影文化美學平臺。—— 蔡文祥

Born in Keelung, Taiwan, Tsai Wen-Shiang earned a Master's degree in photography and related media from New York's School of Visual Arts (SVA). Upon returning to Taiwan in 1998, he taught at Chinese Culture University and Taipei National University of the Arts. In 2019, he founded the Taiwan Contemporary Photography Lab, emphasizing visual creation, curation, teaching, and image experimentation, while exploring the potential of contemporary photography as a cross-cultural medium. Passionate about interweaving photography with society through interdisciplinary approaches, he employs visual art and design thinking to create impactful photographic experiences. In recent years, he has closely followed the evolution of Taiwan's photographic culture, focusing on technological innovation, spearheading the Asia-Pacific Photography Forum, and working to establish a pan-Asian aesthetic platform for photographic culture— Tsai Wen-Shiang

pp. 210-211, p. 282

賴永鑫
LAI Yung-Hsin
1961-

生於臺北縣，原名賴君勝，1980 年離開校園，經歷漢聲、遠流、石綠等出版公司，從事美術編輯、攝影及設計工作。1995 年進入臺北攝影藝廊，涉足攝影展覽企劃，並參與學會團體推廣攝影活動。2007 年始，執行大型攝影展覽活動，例如「『美而廉藝廊』攝影家風華再現」、「靈視 70——莊靈攝影回顧展」等。2010 年起，受邀赴大陸山西「平遙國際攝影大展」、雲南「大理國際影會」、貴州「原生態國際攝影大展」、「北京國際攝影周」等地，執行展覽、參展及創作等攝影交流及推廣活動。他擅長以鏡頭記錄故鄉的生態變化，用黑白影像呈現對大地的悲憫與生命故事。—— 賴永鑫

Born in New Taipei City as Lai Jun-Sheng, Lai Yung-Hsin began his career in 1980 as an art editor, photographer, and designer for renowned publishers like Hansound, Yuan-Liou, and Stonegreen. Joining the Taipei Photography Gallery in 1995, he curated exhibitions and fostered photography initiatives for various societies and groups. Since 2007, he has orchestrated large-scale exhibitions such as *The First Photo Gallery of Taiwan–A Legend of Rose Marie* and *Spiritual Vision 70 - Photographer CHUANG Ling's Retrospective Exhibition*. From 2010, Lai has participated in prestigious events like *Pingyao International Photography Exhibition* in Shanxi, *Dali International Film Festival* in Yunnan, *Primitive Ecological International Photography Exhibition* in Guizhou, and *Beijing International Photography Week*, promoting photography. He masterfully captures ecological shifts in his hometown, using black and white imagery to convey compassion and life stories for the earth. — Lai Yung-Hsin

p. 130, p. 212, p. 259, p. 282

范晏暖
FAN Yen-Nuan
1963-

生於基隆，1988 年畢業於國立臺北藝術學院美術系雕塑組（今國立臺北藝術大學美術學系），留學德國布朗斯威克造形藝術大學（HBK Braunschweig），並取得該校造形藝術研究院 Meisterschüler 卓越藝術家文憑。2001 年受洗成為基督徒之後，創作的主題經常圍繞宗教性的體悟。她擅長以圖像和文字，進行對天父的禮讚，作品包含數位版畫、影像再造、書寫、雕塑、立體裝置的表現形式，呈現既感性又理性的氛圍。她運用隨處拍攝的照片，特意再經過電腦軟體修圖，增修各種繪圖效果，產生綺麗的色彩與各種造形，使得原本的照片變造成具有繪畫性的圖像，傳達其內在的心靈風景圖像。——范晏暖、姜麗華

Born in Keelung, Fan Yen-Nuan earned a Bachelor of Arts in Fine Arts from National Taipei University in 1988 before studying at Braunschweig University of Art in Germany and obtaining a Meisterschüler distinguished artist diploma. Following her conversion to Christianity in 2001, her work began to center on religious contemplations. Adept at fusing imagery and text, she employs an array of mediums—including digital prints, image reconstruction, writing, sculpture, and three-dimensional installations—to honor the Heavenly Father and evoke both emotional and intellectual ambiances. By capturing candid photographs and manipulating them with computer software, she enriches colors and forms, transforming the images into painterly visuals that reflect her inner spiritual landscape. — Fan Yan-Nuan and Chiang Li-Hua

pp. 131-133, p. 260

陳淑貞
CHEN Shu-Chen
1965-

生於臺灣屏東，國立臺灣藝術大學美術學系碩士。創作類型除了影像專題，也積極運用不同形式及複合媒材特殊的並置狀態，進行異質空間的思考創作，包括 2010-2018 年《After》系列、2010-2013 年《Shoot》系列、2013 年《南科公共藝術計畫》等，呈現挪用與拼裝後的異質空間。獲得數個攝影類及複媒類國家級獎項，並受邀日本東京藝術大學、IWPA 全球巡展、中國麗水國際攝影節、英國貝爾法斯特國際攝影節、連州國際攝影年展、新加坡國際攝影節雙年展、韓國水原、泰國清邁及東歐斯洛維尼亞等國際攝影節展出。現為跨領域藝術工作者、為你設想概念有限公司負責人。 —— 陳淑貞

Born in Pingtung, Taiwan, Chen Shu-Chen holds a Master's degree from the Graduate School of Fine Arts at National Taiwan University of Arts. In addition to image-based projects, she actively explores heterogeneous spaces through the unique juxtaposition of diverse forms and mixed media, as showcased in the *After* Series (2010-2018), *Shoot* Series (2010-2013), and the 2013 *Public Art Project of Southern Taiwan Science Park*. Her works present reappropriated and assembled spaces, earning her multiple national awards in photography and mixed media categories. The artist has been invited to exhibit at various countries and international photography events such as Tokyo University of the Arts, IWPA Global Tour, Lishui International Photography Festival in China, Belfast International Photography Festival in the UK, Lianzhou International Photography Annual Exhibition, Singapore International Photography Festival Biennale, Suwon in South Korea, CHIANG Mai in Thailand, and Slovenia in Eastern Europe. Currently a multidisciplinary artist, Chen also serves as the head of U-Imagine Art Studio. — Chen Shu-Chen

pp. 134-135, pp. 213-214, p. 260, p. 283

賴譜光
LAI Pu-Kuang
1965-

生於臺北，國立臺灣大學地理系畢業適逢解嚴，成為一名不務正業的地理教師。先後擔任黑膠唱片 DJ、廣播音樂電台、獨立唱片公司相關職位，並撰寫音樂文字專欄。1993 年婚後，出走東北角金瓜石，人生再添無菜單料理和民宿主人的頭銜。年近半百，一日無意間，拾起家人汰舊的相機隨拍，未料一試成癮，從此機不離身。2015 年「被忘錄」個展，運用影像結合音樂與文字元素，開始嘗試「有聲影像詩」的多媒材創作，作品持續發聲於各媒體與展覽場域。 ——賴譜光

Born in Taipei, Lai Pu-Kuang graduated from the Department of Geography at National Taiwan University. Serendipitously aligning with Taiwan's lifting of martial law, Lai became an unorthodox geography teacher. Embracing a multifaceted career, he worked as a vinyl record DJ, radio music station broadcaster, and held positions in independent record companies, while authoring music columns. In 1993, after marrying, he relocated to Jinguashi in northeastern Taiwan, adding the roles of menu-less cuisine chef and guesthouse owner to his résumé. Approaching fifty, Lai unexpectedly developed a passion for photography after discovering a discarded camera, carrying it with him ever since. In his 2015 solo exhibition *The Forgotten Record*, he merged images, music, and text to explore multimedia creations of 'sound image poetry.' His works continue to resonate across various media and exhibition spaces. — Lai Pu-Kuang

pp. 136-137, pp. 215-216, p. 261, p. 283

余　白
Hubert KILIAN
1972-

生於法國洛特加龍（Lot-et-Garonne），1996 年踏上了攝影之路，渴望捕捉時光流轉與城市光影所帶給他的情緒感受。二十餘年以來，他一直嘗試呈現時間的概念與城市的視角，勾勒出它們的形象與流動，並記錄居民與環境的互動關係，在時間洪流之下那些逝去的存在與留存的基石之間的戲劇張力。他拍攝過巴黎、金邊、北京、京都，也曾在巴黎、京都、臺灣舉辦展覽，而臺北是他最偏愛的拍攝主體。2003 年來臺擔任記者，一直到 2016 年。2018 年幸福文化出版社為其出版《臺北原味》，2022 年大塊文化出版社為其出版《臺北之胃》。——余白

Born in Lot-et-Garonne, France, Hubert Kilian embarked on a photographic journey in 1996, eager to capture the emotional resonance of time's passage and urban light and shadow. Over two decades, he has attempted to portray the concepts of time and urban perspectives, outlining their forms and fluidity, while documenting the interactions between residents and their environment, as well as the dramatic tension between the transient and the enduring. The artist has photographed Paris, Phnom Penh, Beijing, and Kyoto, and has exhibited in Paris, Kyoto, and Taiwan. Taipei remains his favorite subject. From 2003 to 2016, he worked as a journalist in Taiwan. In 2018, Happiness Publishing House published The Original Flavour of Taipei, and in 2022, Locus Publishing published his *The Stomach of Taipei*. — Hubert Kilian

pp. 138-143, p. 217, p. 261-262, p. 284

汪曉青
Annie Hsiao-Ching WANG
1972-

生於臺北，英國布萊敦大學藝術創作博士，青田藝術空間負責人，並於國立東華大學藝術與設計學系兼任助理教授。汪曉青長年關注女性認同的攝影、繪畫之創作與教學，作品《母親如同創造者》2006 年起持續受到國際肯定，美國《The New Yorker》雜誌肯定它是世界首次將母職重新塑造為一項宏偉的事業，而英國《BBC》的電子雜誌也讚譽它改變並超越母職的陳腔濫調。近年她受邀參展於瑞士「沃韋影像雙年展」、美國「紐約 Photoville 攝影節」、祕魯「身分美學展」、英國「我屬於這」、澳洲「國際攝影雙年展」、義大利「Photolux 國際攝影雙年展」與韓國「大邱攝影雙年展」等，享譽國際。—— 汪曉青

Born in Taipei, Dr. Wang holds a Ph.D. in Art from the University of Brighton and serves as the director of Ching Tien Art Space and an assistant professor at the Department of Art and Design at National Dong Hwa University. Wang has long been focused on photography and painting in the realms of creation and education relating to female identity. Her work *The Mother as a Creator* has been internationally recognized since 2006, with The New Yorker praising it reframing motherhood as a grand creative endeavor. The BBC's digital magazine also lauded the work for changing and transcending the clichés of motherhood. In recent years, she has been invited to participate in prestigious exhibitions worldwide, including the *Festival Images Vevey* in Switzerland, *Photoville Festival* in New York, *Identity Aesthetics Exhibition* in Peru, and *I Belong to This Exhibition* in the UK, *the International Festival of Photography* in Australia, *Photolux Festival* in Italy, and the *Daegu Photo Biennial* in South Korea. — Annie Hsiao-Ching Wang

pp. 218-219, p. 284

張志達
CHANG Chih-Ta
1973-

生於臺北，國立臺灣藝術大學圖文傳播藝術學系碩士，目前就讀國立臺灣藝術大學美術學系研究所。小學三年級因校外教學，經父親簡單講解底片相機原理後，開啟對攝影的初探，高中就讀美工科則是攝影的啟蒙階段，從此和攝影結下不解之緣。近年對於「空拍機」及「時間」議題深感興趣，作品常見高空視角轉譯後的視覺語彙，從事攝影創作教學多年，教學核心價值以自我風格演繹引導學生，這些年學生們獲獎無數深感同喜，未來持續努力於創作與教學並重。作品榮獲文化部藝術銀行、屏東文化局、財團法人新光三越文教基金會典藏及國內外攝影獎項，成績斐然。—— 張志達

Born in Taipei City, Chang Chih-Ta holds a Master's degree in Graphic Communication Arts from the National Taiwan University of Arts and is currently studying at the Institute of Fine Arts at the same university. His interest in photography began when he was in the third grade of elementary school, after his father explained the basic principles of a camera during a field trip. In high school, he studied industrial arts, which marked the beginning of his photography journey, forming an inseparable bond with the art form. In recent years, he has developed a strong interest in aerial photography and the concept of time. His works often feature aerial perspectives translated into visual vocabulary. Chang has been teaching photography for many years, guiding students to develop their styles, and has shared in their numerous award achievements. He continues to strive in both creation and teaching. His works have been honored with acquisitions by the Ministry of Culture's Art Bank, Department of Cultural Affairs of Pingtung County, Shin Kong Mitsukoshi Cultural and Educational Foundation, and numerous domestic and international photography awards. — Chang Chih-Ta

pp. 144-145, pp. 220-221, p. 263, p. 285

邱誌勇
CHIU Chih-Yung
1974-

生於臺北，美國俄亥俄大學跨科際藝術系博士，雙主修視覺藝術與電影，副修美學。學術專長為數位美學、當代藝術評論與科技文化研究。榮獲日本關西大學、東京大學訪問學者榮譽、第一屆與第二屆數位藝術評論入選獎、並連續執行多項文化部、國科會研究計畫。現為國立清華大學科技藝術研究所教授暨所長、藝術學院學士班主任，同時為策展人、藝評人與影像創作者。參與 2012 年「愛在飛舞‧藝在傳揚」聯展、2015 年於松菸文創園區 LAB 實驗室創作「空白私房」實驗展演、2019 年舉辦「空間物件」個展以及 2020 年「我思故我在」聯展。—— 邱誌勇

Born in Taipei, Dr. Chiu Chih-Yung holds a Ph.D. in Interdisciplinary Arts from Ohio University, with double majors in Visual Arts and Film, and a minor in Aesthetics. His academic expertise lies in digital aesthetics, contemporary art criticism, and technology culture studies. He has been honored as a visiting scholar at Kansai University and the University of Tokyo in Japan and has received selection awards in the first and second Digital Art Criticism competitions. He has also carried out multiple research projects supported by the Ministry of Culture and the National Science and Technology Council. Dr. Chiu currently serves as a professor and director of the Institute of Technology and Art at National Tsing Hua University, as well as the director of the College of Art's bachelor program. He is also a curator, art critic, and visual creator. He has participated in the 2012 joint exhibition *Love Flies*, *Art Flows*, the 2020 joint exhibition *I Think, Therefore I Am*, held the 2019 solo exhibition *Spatial Objects*, and created the experimental exhibition *Empty Private Room* at Songyan Creative Lab in 2015. — Chiu Chih-Yung

pp. 146-149, p. 263

王鼎元
WANG Ding-Yuan
1978-

生於臺北，因父母皆曾學習攝影，自幼耳濡目染對攝影產生興趣。復興美工就讀期間正式學習攝影，然就讀國立臺灣藝術大學期間仍以繪畫為主要創作媒材，畢業後才開始以攝影接案維生，從事網拍商品與PChome及陶博館合作的商業攝影，也開啟以攝影作為創作媒材。因緣際會投入攝影教學，曾任嘉義縣同濟中學攝影老師、玄奘大學視覺傳達系講師，現任中山女高攝影社、臺北商業大學附設空院攝影社等指導老師。榮獲 TIVAC 攝影獎首獎、新光三越國際攝影大賽入選、美國 IPA 攝影比賽第二名、倫敦 LICC 創意大賽佳作、法國 PX3 攝影比賽入選、2012 年臺灣 Epson 百人攝影聯展攝影師等攝影獎項。—— 王鼎元

Born in Taipei, Wang Ding-Yuan grew up surrounded by photography, as both of his parents had studied the art form. He started learning photography formally while attending Fu-Hsin Art School. However, during his time at the National Taiwan University of Arts, he primarily focused on painting as his main creative medium. It was only after graduation that he began taking on photography projects for a living, working on commercial photography for online shopping products and collaborating with PChome and a ceramics museum. This marked the beginning of his use of photography as a creative medium. By chance, Wang ventured into photography education, serving as a photography teacher at Tongji High School in Chiayi County and a lecturer at the Department of Visual Communication at Hsuan Chuang University. He is currently a guiding teacher for the photography clubs at Zhongshan Girls High School and the affiliated high school of National Taipei University of Business. Wang has received numerous photography awards, including the TIVAC Photography Award's first prize, selection in the Shin Kong Mitsukoshi International Photography Competition, second place in the American IPA Photography Competition, honorable mention in the London LICC Creative Competition, selection in the French PX3 Photography Competition, and was a featured photographer in the 2012 *Taiwan Epson 100 Photographers Exhibition*. — Wang Ding-Yuan

pp. 151-157, pp. 264-266

楊士毅
YANG Shih-Yi
1981-

生於雲林，身兼攝影師、導演、編劇與剪紙藝術家，更廣為人知的身分則是一位「說故事的人」，多年來持續透過多元媒材說故事，創作許多充滿溫度的影片及大型藝術裝置作品。他是臺灣第一位在大學時期就榮獲國藝會攝影個展補助，也獲得版畫創作補助，其影片作品曾入圍金馬獎、柏林國際短片影展。他也是蘋果電腦臺灣 101 直營店指定藝術家，臺中花博花舞館戶外景觀園區策展人，並與新光三越、嬌生、文博會臺南館「文文仔火」、臺北燈節等企業、展覽單位合作，創作臺南安平「大魚的祝福」地景裝置、衛武營國家藝術文化中心新春剪紙藝術裝置等作品。—— 楊士毅、姜麗華

Born in Yunlin, Yang Shih-Yi is a photographer, director, screenwriter, and paper-cutting artist. Widely known as a 'storyteller,' over the years, he has continued to tell stories through various media, creating heartwarming films and large-scale art installations. He is the first in Taiwan to receive a photography solo exhibition grant from the National Arts Council during his university years and also received a printmaking creation grant. His film works have been shortlisted for the Golden Horse Awards and the Berlin International Short Film Festival. Yang is also a designated artist for the Apple Store at Taiwan 101, curator of the outdoor landscape park at the Taichung Flower Expo's Blossom Pavilion, and has collaborated with Shin Kong Mitsukoshi, Johnson & Johnson, Tainan Museum of the World Expo's *Simmering Fire*, Taipei Lantern Festival, and other enterprises and exhibitions. Yang created landscape installations such as the *Blessing of the Whale* in Anping, Tainan, and the paper-cut art installations for the New Year at the National Kaohsiung Center for the Arts. — Yang Shih-Yi and Chiang Li-Hua

pp. 158-159, pp. 222-223, p. 267, p. 285

李毓琪
LI Yu-Chi
1986-

生於臺北，世新大學廣播電視電影學系畢業後，隨即前往美國阿拉斯加工作半年，甚至到世界各地進行攝影創作與生活，2014 至 2020 年旅居北京曾任《289 藝術風尚》雜誌首席攝影師。她善於專注思考與觀察他人，創作主要關注人的精神層面與感知狀態，以及發掘某些無法被指認的部分。攝影作為其主要交流手段，同時透過錄像、聲音等不同媒介觀察社會與個體相互作用下的養成形態，嘗試理解人內在組成的精神面貌。《基本視力》系列作品榮獲 TIVAC 評審獎，曾於臺北當代藝術館、日本清里攝影美術館、國立臺灣美術館、中國大理國際攝影節等處展出。—— 李毓琪

Born in Taipei, Li Yu-Chi graduated from the Department of Radio, Television, and Film at SHIH Hsin University. After graduation, she went to work in Alaska, USA, for six months and then traveled around the world to photograph and experience life. From 2014 to 2020, she lived in Beijing and served as the chief photographer for *Art 289 Magazine*. She focuses on thinking and observing others, with her creations primarily concentrating on the spiritual aspects and perceptual states of people, as well as exploring the unidentifiable. Photography is her main means of communication, but she also explores the formative patterns of society and individuals through different media such as video and sound, attempting to understand the inner spiritual world of humans. Her *Boney Look* Series won the TIVAC Judges' Award and has been exhibited at the Museum of Contemporary Art in Taipei, the Kiyosato Museum of Photographic Arts in Japan, National Taiwan Museum of Fine Arts, and the Dali International Photography Festival in China. — Li Yu-Chi

pp. 160-161, p. 267

作品介紹
Introduction of Works

歐陽文
OUYANG Wen

〈歸途（牛車）〉
The Way Back (Ox Cart)

歐陽文的〈歸途〉，記錄了綠島中寮村一名女孩牽著牛車踏上歸途，畫面中有林投樹、芒草等。這條看似平凡無奇的鄉間道路，卻是為了當時的政治犯鋪設的大路，為的是讓警備總部的卡車運載政治犯。這個場景的天空，透光的積雲還鑲著金邊，但雲層以外的天空卻是漫天的陰霾，充滿影像修辭的反諷與寓意。
經歷二二八事件同時也是白色恐怖受難者的歐陽文，在 50 年代暗房設備極為簡陋的綠島——樸質的綠島上關押高壓統治下的無辜人民，傳神地沖印出這幀反映時代氛圍與歷史意義的攝影作品。── 呂筱渝

The photograph depicts a girl leading a cart with an ox, surrounded by Ango trees and silvergrasses, in Chungliao Village, Green Island. This seemingly ordinary rural road was constructed for transporting political prisoners. The sky in the painting features translucent cumulus clouds with golden linings. Beyond the clouds, darkness and gloominess fill the sky, conveying a powerful, ironic metaphor. As a victim of the 228 Incident and the White Terror, Ouyang Wen developed, in his primitive darkroom on rustic Green Island in the 1950s, photographic work that aptly reflected the historical significance and climate of the period. — Lu Hsiao-Yu

p. 64, p. 225

周鑫泉
CHOU Shin-Chiuan

〈自修功課〉
Self-Study

由砌石駁坎堆砌而成的土屋，這張〈自修功課〉拍攝地點是福建福州的某處學堂，簡陋的程度可想而知。按下快門的此時是下課休息時間，教室門口聚集數名學童與教員，而另一名女孩則立於走廊剝蝕的牆壁前，利用一道黑瓦屋簷斜射的陽光下閱讀。這位閱讀中的女孩並不是攝影師特意安排的模特兒，而是周鑫泉偶然間捕捉到的真實瞬刻，對他而言，在這個物質條件和硬體設備不佳的農村小學堂，這個巧遇的日常一景，更值得被賦予超越與刻苦的教育深意。── 呂筱渝

This photograph captures a serendipitous moment in a simple classroom constructed of stone and earth walls in Fuzhou, Fujian province, China. Several students and a teacher gather at the classroom door during recess, while a girl stands in the hallway, reading by the sunlight shining through the black-tiled roof. For the photographer, this ordinary moment in a rural school with limited material resources and equipment is a powerful reflection of the importance of and dedication to education. — Lu Hsiao-Yu

p. 65, p. 225

邱德雲
CHIU De-Yun

〈水褲頭相簿（二）96〉
The Shorts Album (Two) 96

《水褲頭相簿》攝影集作為苗栗縣政府的鄉土教材，拍攝內容多為「耕田人」，客家話稱之為「著水褲頭的人」，表現農稼人的辛酸與窮苦，鎮日忙於耕種、收割、稼穡等農務，發揮知足與省儉的水褲頭精神。這系列作品將早期臺灣鄉鎮農村裡百姓的生活樣貌、兒童的嬉戲與農耕的辛勤表露無遺。其中〈水褲頭相簿（二）96〉畫面背景位於鄉里某廟宇的某一角落，作為前景的桌上有對擲筊為聖筊，代表神明允諾或同意信徒行事會順利，而中景那盞點燃的孤燈散發著光影，雖然微弱單薄，卻足以代表無限光明與希望。── 姜麗華

The Shorts Album is a photographic collection created as local teaching materials, as commissioned by the Miaoli County government. The subjects photographed are mostly farmers, known in the Hakka language as 'men in sweatshorts.' These images portray the hardships of farmers busy with farming, harvesting, and sowing. They demonstrate the contentment and frugality of the 'sweatshorts' spirit. This Series captures the lifestyle of early Taiwanese rural residents, children playing, and the tough work of farming. In *The Shorts Album (Two) 96*, the background is set in a corner of a temple in a small town, with a pair of divining blocks placed on a table in the foreground. The blocks represent the approval of the gods for the actions of the faithful. In the middle of the scene, the lamp casts a faint but hopeful light. — Chiang Li-Hua

p. 66, p. 225

謝明順
Vincent HSIEH

〈敬天〉 *Honoring the Heavens*

〈漫遊〉 *Floating Cloud*

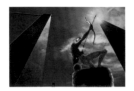

〈蓄勢〉 *Gathering Momentum*

《雕塑情懷的「像雕」》系列
Sculptural Sentiments Series

作品《雕塑情懷的「像雕」》系列，借以探問何謂藝術，何謂美，沒有定義；何謂創作，如何創作最佳，沒有正解，卻有很多答案。

攝影到底是寫實、寫意、記錄抑或只是一種再現？至今沒有定論，不過，它屬於藝術則有定見。

當攝影、繪畫和雕刻混合一體出現時，前所未有，個人稱它為「像雕」。混合媒材的創作，眾所周知，混合藝趣的手法唯我獨享；先求唯一，再求第一，個人終生不渝的「像雕」作品，只求大家的認識、認知，不奢求大家的認同。個人認為「只要我喜歡，有什麼不可以」只能巧妙地出現在藝術創作上，為沒有定義的定義下定義；因為，只有自我，才有自己。—— 謝明順

The Series embodies a sculptural sentiment and seeks to explore the nature of art and beauty. There is no definitive answer to what constitutes creativity or the best way to create, but only possibilities.
Is photography about realism, expressionism, documentation, or merely representation? There is no consensus to this day. However, it is agreed that photography belongs to the realm of art.
"When photography, painting, and sculpture converge in an unprecedented fusion, I call it, Like Sculpture. The use of mixed media in art is well-known, but the blending of artistic interests is something exclusive for me to indulge in. My life-long dedication to Like Sculpture strives for uniqueness first and foremost, and then for being the best. I only seek reception and acknowledgment from others, not necessarily their agreement. I believe the idea that 'as long as I like it, what's wrong with it?' can only be truly applied to artistic creation, defining what is undefined, because only through self can one truly find oneself." — Vincent Hsieh

pp. 67-69, p. 227

林芙美
LIN Fu-Mei

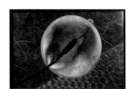

〈孕育〉
Cultivation

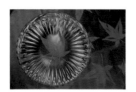

〈交容〉
Merge

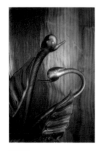

〈相依〉
Dependence

《交集與干涉》系列
Intersection and Interference Series

《交集與干涉》系列作品之一，呈現當直行的光線受到偏光板和偏光鏡的雙重干涉時，即形成物理光學中行經最為多變的偏振現象，因而產生干涉條紋和詭異色彩的「複屈折」影像。

複屈折影像蘊含「虛像」與「幻覺」的思考空間元素：「虛像」源之於實有物體的再造與顛覆，屬於外在的辨識空間；「幻覺」源之於實有物體經外力之改變後，所引發的錯覺、錯視與錯認，屬於內在的省思範疇。

「應力或外力」等人為因素的加諸，可使複屈折影像表現出抽象世界獨有的冥想和衝擊，人為力量的加入，期能創出一片綺麗而多變的思考空間與視覺語言。—— 林芙美

A part of the *Intersection and Interference* Series, this work features the phenomenon of polarization: the most extreme polarization in physical optics is achieved when a straight light falls under the twin influence of polarizer plates and polarizer lenses, resulting in the intervening stripes and eerie colors of a double refraction image.
Double refraction images involve the spatial elements of 'virtual images' and 'illusions.' 'Virtual images' involve the reconstitution and upturning of physical objects and are categorized as outer identifications. 'Illusions' are rooted in the delusions, misperceptions, and misidentifications that arise when physical objects are altered through outside forces and are categorized as inner contemplations.
The addition of human factors, such as stress or external force, allows double refraction images to present the meditative qualities and impact unique to the abstract world. Human factors are included with the hope of creating thinking spaces and a visual vocabulary both magnificent and filled with change. — Lin Fu-Mei

〈相融〉
Integration

〈開天〉
Opening Up the Sky

〈邂逅〉
Encounter

pp. 70-75, p. 228

張武俊
CHANG Wu-Chun

〈金山〉，《夢幻月世界》系列
Jinshan, Dreamy World Series

這是一幅透過人為光畫與自然融合的景觀，弦月與金山（覓境）之間的造型關係來傳達主觀視覺經驗，表達大地之氣寧靜簡約之美。—— 廖云翔

This work was composed by integrating artificial light painting with nature. The work conveys subjective visual experiences through the design connections between the crescent moon and Jinshan (a sought-after land) and captures the serene and simplistic beauty of that land. — Liao Yun-Hsiang

pp. 76-77, p. 228

〈青瓜寮〉，《夢幻月世界》系列
Qinggualiao, Dreamy World Series

影像拍攝於臺南金瓜寮，因長年穿梭於臺南近郊山林之間，感受山巒林木之間，隨著時間雲霧縹緲瞬息的萬變，而且更深刻感受到自然的內蘊之美，此幅作品透過特殊技法衍變出光線（光跡）的「空靈」是一種意境再造，予人靈魂上對美的感知。── 廖云翔

This image was taken in *Qinggualiao*, Tainan. The artist spent extensive time in the mountain forests on the outskirts of Tainan, savoring the mountains and trees amid the passing of time and the everchanging clouds and mists, leading to a more profound appreciation of the innate beauty of nature. Using unique lighting (light trajectory) techniques, this work features 'the ethereal' and inspires an inner sensibility toward beauty. — Liao Yun-Hsiang

p. 78, p. 228

〈龍崎烏山頭〉，《夢幻月世界》系列
Wushantou, Longqi, Dreamy World Series

此幅作品於臺南龍崎烏山頭所攝，鏡頭望向高雄地區，滿紅的天光是非常特殊的氣象徵候，使暗黑的夜晚仍讓人感受到大地甦醒著。── 廖云翔

This work was taken in Wushantou, Tainan, by directing the lens toward the Kaohsiung Area. The vermilion sky is a unique meteorological phenomenon that gives the sensation that the land is awake even in the dead of night. — Liao Yun-Hsiang

p. 79, p. 228

劉永泰
LIU Yung-Tai

《光之再現》系列
The Re-Emergence of Light Series

《光之再現》系列作品之一，跳脫了唯美或寫實地記錄現實景物，在暗房以實物投影（Photogram）創作出具有繪畫性的超現實影像作品。充滿幽幻意象的超現實畫面、如真似幻的異質時空，如夢似幻的意象、抽象化、奇幻化地呈現出多重光線、色彩和造形的結構關係，以別出心裁的影像語言交織出自我心靈世界的影像，幻化成寧靜與安詳的意境，開啟與潛意識對話的契機。每件作品拍攝自日常生活所見、所思、所感動之影像成為素材，運用多元影像技法、正像負像的轉換、黑白與彩色影像之間的奇幻交疊，突破光學成像的物理限制，以相機代替畫筆，結合了光影色彩賦予影像素材新的詮釋與生命，以前衛、創新、執著於超現實感的異質時空，創作出屬於個人的視覺語言。── 劉永泰

A part of *The Re-Emergence of Light* Series, this work breaks free from documenting scenes of reality through beautification or realistic approaches, but instead creates painterly, surreal images using the photogram in darkrooms. The celestial, dreamy, and surreal heterogeneous space-time presents the connection between a variety of lights, colors, and designs through illusory, abstract, and fantastical effects, weaving images of the inner landscape using an unparalleled visual vernacular, resulting in serene, peaceful scenes that inspire dialogues with the subconscious. Each work captures the scenes, thoughts, and moving images of everyday life, incorporating a multiplicity of imaging techniques, shifting between negative and positive images, and the whimsical overlapping of black-and-white and color to break through the physical limitations of optical imaging. The photographer replaces the paintbrush with the camera and further endows new interpretations and liveliness through light and color, creating personal visual expressions through avant-garde, innovative, and surrealistic heterogeneous space-time. — Liu Yung-Tai

〈自我手鍊（X 光）〉
My Bracelet (X-Ray)

〈自我手鍊（X 光）〉以自身的手纏繞鍊子，經由 X 光照射投影，創作出色彩繽紛的手骨與虛幻的線條，奇幻無比。── 劉永泰

My Bracelet (X-Ray) features the photographer's hand wrapped with a chain under the X-ray, resulting in a fascinating image that displays colorful hand bones and illusory lines. — Liu Yung-Tai

p. 80, p. 229

劉永泰
LIU Yung-Tai

〈自我頭殼（X 光）〉
My Skull (X-Ray)

〈自我頭殼（X 光）〉將自身的頭顱透過 X 光照射成像，搭配不僅五顏六色的長條形色塊，組合前後腦勺，象徵腦海浮沉在夢幻世界裡。—— 劉永泰

My Skull (X-Ray) is an image of the photographer's skull under the x-ray, paired with rectangular color blocks in different hues, piecing together the front and back of the skull and symbolizing the brain roaming in a dreamy world. — Liu Yung-Tai

p. 81, p. 229

pp. 82-83, p. 229

〈聚散〉*Accumulation and Dispersion* 〈齊飛〉*Flight in Unison*

簡榮泰
CHIEN Yun-Tai

參考來源：
周文—國美館重建臺灣藝術史計畫
「109 年度攝影類作品詮釋資料撰研計畫」

Reference:
Chou Wen, Interpretive Data Compilation and Research Project for Photography Works of NTMFA Reconstructing History of Art in Taiwan, ROC Era 109

〈高雄大樹〉，《舊鄉》系列 -16
Kaohsiung Dashu, Familiar Town Series-16

簡榮泰的〈高雄大樹〉拍攝一位站在眾多佛像的面前，背對著鏡頭，正在禮佛的出家人。畫面的右上方到左下方有一道斜射而入的光束一瀉而下，而此光線形成最吸引觀賞者的眼光焦點。不禁令人聯想暮鼓晨鐘、長伴如來的歲月，紅塵俗世不過是一場夢。那道斜射而入的光芒，也好像告訴我們該是夢醒時分了，但世上往往存在不會醒、不願醒的芸芸眾生。這道光芒也教示人們不要執著在名聞利養、家親眷屬之上，一生汲汲營營到頭來只是一場夢幻泡影，應當了知萬物皆空的道理。得獎作品（37 屆省展大會獎）〈高雄大樹〉已被多家公立美術館收藏，因捕捉到難得的瞬間，構圖看似簡單，意寓卻發人深省。—— 姜麗華

The photograph portrays a Buddhist monk standing amidst Buddha statues with his back to the camera. A diagonal beam of light from the top right to bottom left forms the focal point of the image, suggesting that it is time to wake up from the dream of the mundane world. A reminder of not to be attached to material possessions or be obsessed with relationships, the work calls awareness to the emptiness in all things. The photograph has received critical acclaim (37th Provincial Exhibition Grand Prize) and is collected by various public art museums. It invites viewers to contemplate their connection to the universe and their own individual affinities. — Chiang Li-Hua

p. 84, p. 229

阮義忠
JUAN I-Jong

〈臺南億載金城〉，《失落的優雅》系列
The Eternal Golden Castle, Lost Grace Series

臺南的億載金城原名二鯤鯓砲臺，是臺南安平附近的名勝古蹟，係為清朝沈葆楨聘請法國人所建之西式砲台，原本具有防禦工事的功能，因時代變遷而失去其作用，逐漸轉為著名的觀光景點。
阮義忠所拍的這件〈臺南億載金城〉，便是當年拍攝婚紗攝影的熱門景點，許多新人都會到此拍攝婚紗照，作為一生的珍藏。這件作品捕捉了一行參加拍攝婚紗後的親友走過砲臺門洞的愉快神情，而那一對新人還留在大炮臺旁拍攝婚紗照。迎著鏡頭走來的花童和親友們都因喜事而眉開眼笑，他們的行進彷彿穿越清朝沈葆楨建立的時光隧道，正接受人類歷史的見證與洗禮。而照亮門洞廊道的燦燦日光，也為這場婚禮帶來希望、喜悅和祝福。—— 呂筱渝

The Golden Castle, originally named Erkunshen Fort, is a famous tourist attraction near Anping, Tainan. It was a Western-style fort built by Frenchmen and hired by Qing Dynasty's official Shen Baozhen for defense purposes. Over time, it lost its function and gradually became a popular destination for wedding photography. This photograph captures the happy expressions of a group of relatives and friends participating in a wedding shoot. As they walk through the gate, the newlyweds are still taking photos near the cannons. The flower girls and the guests walking towards the camera are all smiling happily, as if traveling through a time tunnel constructed by Shen Bao-zhen during the Qing Dynasty. The bright sunlight illuminating the corridor brings hope, joy, and blessings to the wedding. — Lu Hsiao-Yu

p. 85, p. 230

林國彰
LIN Kuo-Chang

〈中山北路臺北故事館〉，《臺北道》系列
Zhongshan North Road Taipei Story House, Taipei Dao Series

圓山別莊在臺北故事館。基隆河孤獨作伴。比鄰北美館。我們呼喚朋友來看。昨日布列松在中國。今日黃華成未完成。一個人的大臺北畫派。時朔五月初一。日環食追逐者群聚廣場。逆光直視火球。直到月亮遮蔽了太陽。天狗蝕日黃金戒。這天臺北日偏食。北美館熱浪騰雲。館前展一個多重真實的膜。透過偏光片多重疊加。壓克力玻璃浮現了小孩殘影。映照似存在似不存在的幻相。左岸圓山別莊。1913 年建。日治時大稻埕茶商陳朝駿仿英國都鐸式建築。曾經立法院長黃國書宅邸。後美術家聯誼中心。王少濤記圓山陳氏舊樓作詩曰。浮雲富貴平常事。安兮平生不怨貪。來別莊。來火燒雲。直燒到童話故事裡的城堡。—— 林國彰

Maison ACME stands as today's Taipei Story House with Keelung River's company. Taipei Fine Art Museum is a neighbor. Henri Cartier-Bresson in China went yesterday, Huang Hua-Cheng's open ending comes today. We invite friends to the exhibits. One man's École de Great Taipei is on. On May 1st of the lunar calendar, a group of eclipse chasers converged in the square to witness the annular solar eclipse. As they gazed into the fiery ball of the sun, the moon eventually covered it, signifying the beginning of the eclipse. The Taipei Fine Arts Museum was enveloped in scorching heat. A film of multiple realities was put in front of the museum. Residual shadows of children emerged through overlapping polarizers. On the left bank sits Maison ACME, built in 1913 in homage to the Tudor style by Chen Chao-Jun, a tea merchant from Dadaocheng. Once the residence of the President of the Legislative Yuan, Huang Kuo-Shu, it later became a center for the Artists' Association. Poet Wang Shao-Tao described the residence: "Prosperity comes and goes as clouds float. Peace enters and keeps when contented." Come to Maison ACME. Come to the fire reaching the castle in the fairy tale.— Lin Kuo-Chang

p. 88, p. 230

〈忠孝西路北門〉，《臺北道》系列
Zhongxiao West Road North Gate, Taipei Dao Series

法國巴黎有凱旋門。臺灣臺北有北門。前臺北市長柯 P 打造北門為國門。擴大為北門廣場。北門嚴疆鎖鑰。保留不同朝代的記憶。臺北城清代最後一座城。城牆拆了。唯北門原貌屹立不移。歷經清代日治民國。歷史見證一百三十三年。國家一級古蹟。曾經輝煌今遺老。北門插過競選旗幟。扮裝慶典招牌。棲身忠孝高架橋下當路人甲。柯 P2016 年拆高架橋。2017 年整合臺北郵局鐵道部等為北門廣場。像人的生老病後殘軀。柯醫生一上任市長就急診。今日重生。這天閏六月十六。立秋。臺北氣溫飆高 38 點 5 度。立秋不見秋涼。入晚靜觀淡水河落日。北門逆光仰天長嘯。忽見城樓窗洞。綻放一輪光耀。如龍吐珠。是老靈魂還魂嗎。—— 林國彰

In France, Paris has the Arc de Triomphe. In Taiwan, Taipei has the North Gate, which former Mayor Ko has transformed into a national gateway, expanding it into the North Gate Square. The North Gate locks away memories from different dynasties, bearing witness to the history of Taipei as the last city wall of the Qing Dynasty. Despite the demolition of city walls, the North Gate stands tall and unchanged, having witnessed 133 years of history from the Qing Dynasty to the Japanese colonization and the Republic of China. It is a first-class national heritage site that was once glorious. The North Gate has held campaign flags, stood as the city's sign in festivals, and hidden under the Zhongxiao overpass. In 2016, Mayor Ko demolished the overpass and integrated Taipei Post Office and Railway Department into the North Gate Square in 2017. As if performing surgery on a human body as it ages and deteriorates, Dr. Ko renovated the North Gate upon his election as mayor. Today, the gate stands reborn, on the 16th day of the sixth lunar month, the beginning of autumn. The temperature in Taipei soared to 38.5 degrees Celsius. Despite the supposed coolness of autumn, the heat wave raged on. At dusk, sunset is seen over the Tamsui River, while the North Gate stands against the backlight, howling into the sky. Suddenly, a burst of light shines through the windows like a dragon spitting out pearls. Is it the return of an old soul? — Lin Kuo-Chang

p. 89, p. 230

林柏樑
LIN Bo-Liang

參考來源：
吳佳蓉—國美館重建臺灣藝術史計畫
「109年度攝影類作品詮釋資料撰研計畫」

Reference:
Wu Chia-Rong, Interpretive Data Compilation and
Research Project for Photography Works of NTMFA
Reconstructing History of Art in Taiwan, ROC Era 109

〈周夢蝶〉
Zhou Meng-Die

自 1998 年起，林柏樑接受委託拍攝一系列作家的肖像，完成「文學的容顏：臺灣作家群像攝影」，此乃為國立文化資產保存研究中心的計畫。在執行此計畫時，因為拍攝時間僅有短短半天時間，所以林柏樑通常會先閱讀預計被拍攝作家的文學作品，對其作品有所了解與領悟後才會前往拍攝。這幅肖像主角周夢蝶是一名詩人，他以禪意入詩的作品著稱，著有《孤獨國》、《約會》、《不負如來不負卿》等。作品〈周夢蝶〉林柏樑將被攝者安排在他的工作室，一個多角形的空間。光線從右方窗框型的位置照射進來，映在牆上呈現建築與人物的倒影，光影線條利落分明。呈現出詩人性格內向寡言，沉靜地坐於畫面中央，衣裝齊整雙手交握，臉上因光線對比強烈。周夢蝶筆名來自莊周夢蝶，既是對自由的嚮往，也是虛與實之間的探討，林柏樑在畫面裡透過建築物的影子與人物交會，讓光影表現了虛實的概念，也在單純的空間中創造出詩意的意境。—— 姜麗華

From 1998 onwards, Lin Bo-Liang was commissioned to photograph a Series of portraits of writers, culminating in the project Faces of Literature: Portraits of Taiwanese Writers for the National Research Center for Cultural Heritage Preservation. Lin read the works of the writer to be photographed to prepare for the limited half-day shooting. He proceeded with the project based on his understanding and insight into the writers' works. *Zhou Meng-Die* was a poet renowned for his Zen-inspired poetry, with works such as *Lonely Nation, Date*, and *Faithful to the Buddha, Faithful to You*. Lin photographed the poet in his studio, a multi-angular space. Light shines in from the window-like structure on the right, casting reflections of the architecture and figure on the wall, with distinct light and shadows. The portrait presents the introverted, reserved poet sitting quietly in the center of the frame, neatly dressed with hands clasped, his face illuminated by light and contrast. *Zhou Meng-Die*'s pen name originated from Zhuangzi's dream of a butterfly, symbolizing both a longing for freedom and an exploration of the boundary between illusion and reality. Lin captured the interplay between the building's shadow and the figure in the frame, representing the concept of illusion and reality utilizing light and shadow, creating a poetic atmosphere within a simple space. — Chiang Li-Hua

pp. 90-91, p. 230

張國治
CHANG Kuo-Chih

《一樣的光影》系列 -1
The Same Scenario Image Series -1

拍攝於 2006 年 11 月 29 日澳洲國立大學（NYU）新媒體藝術中心的建築空間光影採光之變化，與拍攝於 2006 年 12 月 30 日南京藝術學院外賓學人宿舍內的空間一角，一樣的光影，可讓我們思考到當西方的光影遇上東方的光影，在空間到底會形成怎樣的影像不同之處？這是有趣的符號學問題了，如圖西方的窗子在光影的透射下形成強烈的十字（cross）符號，與東方窗櫺構成類似回字紋的光影符號，兩者不同的刻劃形成非常有趣的類比且是強烈對比性的映照。—— 張國治

The artist has captured the interplay of light and shadow in two distinct architectural spaces - one at the New Media Art Center of The Australian National University on November 29, 2006, and the other within a dormitory for international visiting scholars at Nanjing University of the Arts on December 30, 2006. The Western Window reveals a bold cross pattern, while the Eastern Lattice casts a swastika-like shadow. These striking images subtly convey the cultural nuances embedded in the distinctive architectural design, forming a fascinating contrast to invite viewers to contemplate the dialogue between East and West. — Chang Kuo-Chih

p. 93, p. 231

《北京 798 的夏日》系列 -1
Summer in Beijing 798 Image Series -1

利用暑假穿梭在北京 798 進行拍攝藝術家工作室和藝術家肖像計畫的作品，遊走園區的午後，某一天光影進入某畫家的室內，讓懸掛室內的畫作或錯落的上下佛像雕刻，映顯得特別入定而具有輕鬆的詩意，從而變得模糊及綿延，時光顯得特別寧謐、深遠。光影如此迷人、此處變得與世無爭、安靜的角落。—— 張國治

During a summer vacation, Chang undertook a project to document the studios and portraits of artists in Beijing's 798 Art District. One leisurely afternoon, in a painter's studio, the light cast an enchanting glow on the paintings and intricate Buddha sculptures adorning the space. The interplay of light and shadow fostered a serene, poetic ambiance, blurring and expanding the room's boundaries. In this captivating and tranquil corner, time appeared to stand still, infusing the scene with a profound sense of peace.

p. 94, p. 231

《北京 798 的夏日》系列 -2
Summer in Beijing 798 Image Series -2

從藝術家隨手棄置於 798 園區內的夾板，在 8 月洶湧的赤熱極光照射下，投下濃重的暗影，以此暗喻園區內受外在不確定因素浮動發展的現象，極待光明方向的指引。—— 張國治

In the 798 Art District, under the scorching August sun, an artist's discarded clipboard casts a deep shadow. This serves as a metaphor for the uncertainty and fluctuating potential for development within the district, as it eagerly awaits guidance towards a brighter future. — Chang Kuo-Chih

p. 94, p. 231

〈1973 年〉
1973

此作拍攝廈門市曾厝垵一處藝術家租賃於此創作的雕刻工作室內一景,曾厝垵現為大陸享有「最文藝漁村」之稱,為「曾厝垵文創村」簡稱。位於廈門島東南部,隸屬廈門市思明區濱海街道辦事處管轄。

2005 年 2 月我循著家鄉金門小三通之途徑進入一衣帶水的廈門,那時曾厝垵尚未進入現代化的經濟過度開發,僅僅數荒涼偏僻漁村之風貌,1973 年建蓋而已老舊的工作室內一隅,堆積著藝術家翻模的 FRP 建築模型,透過逆光中的那片白光映射,讓人突然意味到這座曾為清朝政府根據 1842 年中英南京條約簽定闢為五口通商之一的通商口岸,制定《中英五口通商章程》,進一步規定通商相關事宜。

在廈門或金門的僑鄉文化,常有閩式傳統建築與希臘、羅馬柱混搭的中西合璧之建築樣貌出現。受西方建築樣式如希臘菲迪亞斯(Phidias)的帕特農神殿(Parthenon),長方形兩端形成兩個三角楣,東方人通稱為屋山牆(亦稱破風)樣式,是非常普遍的符號,而一般未受文化薰陶之民眾亦難深入探究其中文化性之原委。在廈門鼓浪嶼特區亦有鋼琴島之稱,如此類如希臘建築符號化和鋼琴、提琴等西方符號化意旨進入這座島嶼,其所產生的實質文化入侵或交融,其實有著深層的歷史思考意涵。—— 張國治

The photograph was taken in a sculpture studio rented by an artist in Zengcuo'an, Xiamen. Zengcuo'an is now known as 'China's most artistic fishing village' and is also referred to as 'Zengcuo'an Cultural and Creative Village.' Located in the southeastern part of Xiamen Island, it falls under the jurisdiction of the Binhai Subdistrict Office in Siming District, Xiamen.

In February 2005, I journeyed from my hometown Kinmen to Xiamen via the Mini Three Links. At that time, Zengcuo'an had not yet experienced excessive development or modernization, remaining a remote, desolate fishing village. In a corner of an old studio built in 1973, piles of FRP architectural models created by the artist lay scattered. The white light reflecting through the backlighting suddenly brought to mind the historical significance of this place. Zengcuo'an was once one of the five treaty ports opened by the Qing Dynasty government following the signing of the Treaty of Nanking in 1842. Subsequently, the 'Sino-British Five Ports Trade Regulations' were established, further regulating trade affairs.

In Xiamen and Kinmen, a fusion of Eastern and Western architectural styles is commonly observed, with traditional Fujian architecture blending seamlessly with Greco-Roman columns. Influenced by Western designs like the Parthenon in Greece, these buildings feature rectangular shapes with triangular pediments at both ends, known as gable walls or broken wind styles in Eastern culture. Gulangyu Island in Xiamen, also known as Piano Island, showcases Greek architectural symbols and a community culture centered around Western instruments. The cultural infiltration and blending found on this island hold profound historical significance and prompt deeper reflection. — Chang Kuo-Chih

p. 95, p. 231

《穿越罅隙之光》系列
Traveling Through the Light Coming from the Cracks Series

2022 年新創作的《穿越罅隙之光》系列,影像以約 90×300 公分(燈箱片)的尺幅裝置在展出空間。利用採光原理中的逆光概念(輪廓光),並以純粹幾何造形(寓意密集城市雜處)構成,象徵在逆光的黑暗通道中帶來了希望。在後疫情時期,人們穿梭於密集都市叢林中,憑藉夾縫中之光隙走出幽暗之谷。—— 張國治

The 2022 Series *Traveling Through the Light Coming from the Cracks* features 360 x 90 cm installations made from semi-transparent film or acrylic materials and displayed in exhibition spaces. Utilizing the concept of backlighting (rim light) and composing geometric shapes that symbolize densely populated urban areas, the Series aims to convey the light of hope emerging from the darkness of a tunnel. In the post-COVID era, people navigate the dense urban jungle, seeking their way out of gloom through slivers of light in narrow gaps.

pp. 96-97, p. 231

高志尊
KAO Chih-Chun

〈Firenze〉
Firenze

光線從教堂的天頂流瀉而下,宛如一道聖光降臨。這道光雖然映射在現實的空間,然而由於慢速快門形成的光軌,讓時間短暫超越現實俗世的空間,隨著那道光束徜徉進入與神對話的時空。—— 姜麗華

The light cascades from the apex of the church, as if a divine beam descending. The slow shutter speed creates a trail of light, allowing a brief transcendence beyond the mundane realm, establishing a timeless space for conversation with the divine. — Chiang Li-Hua

pp. 98-99, p. 231

傅朝卿
FU Chao-Ching

〈幻向:編號 1994-1(巴黎羅浮宮)〉
Illusory Dimensions: No. 1994-1 (Louvre Museum, Paris)

「詮釋攝影」是除了攝影基本的藝術及真實本質之外,再加入攝影者本身對攝影主題的看法。一張詮釋攝影的照片,不但寫實,也有美感,更重要的它表達了攝影者的思想,不只是記錄。1990 年代,我將詮釋攝影分為四大系列,分別是「形向」、「人向」、「時向」與「幻向」,一直創作至今。「形向」系列表達的形體與空間的互動關係,照片呈現物質與美學雙重特質;「人向」表達的是人與空間互動的畫面,是人與空間不經安排的自然邂逅;「時向」表達的是時間對空間造成的影響,節氣光影的變化,讓空間有了時間的痕跡;「幻向」則捕捉空間中種種如幻境的假象,暗示都市中的不真實容顏。
〈幻向:編號 1994-1(巴黎羅浮宮)〉拍攝於巴黎羅浮宮裡漂浮的影像,他利用建築物的反射特質,進而使真實的都市空間場域和反射的假象交融在一起,營造具有幻境的現代空間。明知畫面不真實,卻拍攝自真實,暗示真實世間裡隱藏許多不真實的特質。—— 傅朝卿、姜麗華

'Interpretive photography' goes beyond the conventional notions of art and reality, infusing the photographer's unique perspective on the subject matter. These photographs not only encapsulate aesthetic and realistic elements, but, crucially, embody the photographer's thoughts beyond mere documentation. Since the 1990s, the artist has devised four distinct Series within his interpretive photography: 'Formative Dimensions;' 'Human Dimensions;' 'Temporal Dimensions;' and 'Illusory Dimensions;' and this remains an ongoing creative endeavor.
'Formative Dimensions' unveils the intricate interplay between form and space, blending materiality and aesthetics within each photograph. 'Human Dimensions' captures the unscripted encounters between people and space, illustrating the dynamic interactions within their environment. 'Temporal Dimensions' conveys the profound influence of time on space, as shifting light and seasonal shadows etch the passage of time. 'Illusory Dimensions' reveals the enigmatic illusions within space, alluding to the surreal facades nestled within urban landscapes.
In this photograph taken at the Louvre Museum in Paris, the artist skillfully employs the reflective nature of architecture to blend real urban spaces with mirrored illusions, crafting a surreal modern environment. Although the scene appears unreal, it is derived from reality, suggesting a hidden layer of unreality within the authentic world. — Fu Chao-Ching and Chiang Li-Hua

p. 100, p. 231

〈時向:編號 1994-2(聖吉米安諾大教堂)〉
Temporal Dimension: No. 1994-2 (San Gimignano Collegiata)

〈時向:編號 1994-2(聖吉米安諾大教堂)〉拍攝地點是在聖吉米安諾大教堂,剛巧拍攝到光從門的縫隙照射入內,形成一個十字架的造形,此刻不是隨時可見。他著重在表現光線帶給特定空間或者具有特殊造形細部的效果,呈現一種獨特的空間意象。—— 傅朝卿、姜麗華

In the St. Giminiano Cathedral, the artist fortuitously captured a fleeting moment as light streamed through a gap in the door, forming a rare cruciform shape. The focus lies on the impact of light in shaping specific spaces and highlighting unique architectural details, resulting in a striking spatial portrayal. — Fu Chao-Ching and Chiang Li-Hua

p. 101, p. 231

何經泰
HO Ching-Tai

〈陳家巫師（林陳湘瑜）〉，《百年不斷的人神之約》系列
The Chen Family Shaman (Lin Chen Xiang-Yu),
The Hundred-Year Covenant Between Man and God Series

《百年不斷的人神之約》系列何經泰刻意運用逾百年歷史的濕版火棉膠古老攝影技術，拍攝臺東土坂部落排灣族傳承百年人神誓約的祭典「五年祭」（Maljeveq），表現祭儀物品及參與祭祀祝禱的人物，從其穿著傳統服飾與頭冠的裝飾，溯源族群的文化情境脈絡。因純手工操作濕版火棉膠所具有不穩定的特性，致使畫面產生不可預期的線條、斑點、不規則紋路的肌理，營造脫離現實的視覺經驗，拓樸出土坂村排灣人的信仰，敬神的虔誠，迴盪於天地人神交界的異質空間，瀰漫一種虛幻縹緲的氛圍。
〈陳家巫師（林陳湘瑜）〉肖像人物是一名巫師，她穿戴排灣族傳統巫師的服飾，雙手交握坐在祖靈屋內，準備為「五年祭」祭典儀式擔綱祝禱。手工製作的畫面周遭留有顯影藥水的紋路，宛如屋內散發著神靈的氣息，增添神祕的氛圍。因需較長時間曝光，銀鹽粒子凝聚人物出神的眼神，彷彿她正與神對話。——姜麗華

In *The Hundred-Year Covenant Between Man and God* Series, HO deliberately used the collodion method, which dates back over a century, to photograph the 'Maljeveq' ritual of the Paiwan people of the Tjuabal Tribe. The ritual honors the covenant between man and the gods, and the Series features the ceremonial objects and the participants of the event, showcasing traditional clothing and headwear and tracing its cultural setting and context. The instability of the collodion process leads to unpredictable lines and spots, as well as irregular patterns and textures that enable a visual experience that transcends reality and presents a topology of the faith and devotion of the Paiwan people of the Tjuabal Tribe. Lingering within the heterogeneous space between the heavens, earth, man, and the gods, the works emit an illusory sense of ethereality.
The Chen Family Shaman (LIN Chen Xiang-yu) features a shaman wearing traditional Paiwan shamanic clothing. The shaman's hands are held together, and she is seen sitting in the house of the ancestral spirits, preparing to pray for blessings at the 'Maljeveq' ceremony. The hand-crafted image leaves traces of the reagent, like the presence of spirits, adding a mysterious ambiance to the image. Because the work requires more extensive exposure time and due to the effect of silver halide particles, the gaze of the figure seems to suggest that she is engaging in dialogue with the gods. — Chiang Li-Hua

p. 102, p. 232

〈小米梗〉，《百年不斷的人神之約》系列
Singil, The Hundred-Year Covenant Between Man and God Series

〈小米梗〉靜物照中的小米梗，被安置在土坂村排灣族包家祖靈屋內的一塊木頭上，因祭儀所需祭司點燃一把小米梗來召喚祖靈，燃燒的火焰冉冉上升，煙霧裊裊被視為傳達與神溝通的橋梁。——姜麗華

The *singil* in the still life photographic work *Singil* is placed on a wooden plate in the home of the ancestral spirits of the Paiwan Bao family in the Tjuabal Tribe. Due to ceremonial needs, the priest ignites a small bunch of *singil* to beckon the ancestral spirits. The slowly ascending smoke is seen as a channel for communicating with the gods. — Chiang Li-Hua

〈豬頭骨〉，《百年不斷的人神之約》系列
Pig Skull, The Hundred-Year Covenant Between Man and God Series

〈豬頭骨〉拍攝迎接祖靈儀式重要的祭品——被犧牲的豬，割除豬肉後剩餘的豬頭骨，擺放在木頭上與宰割牲的刀，象徵族人敬神、酬謝與祈福的願望。——姜麗華

Pig Skull captures the image of important ceremonial objects used to welcome ancestral spirits. After the flesh is removed, the bones of a sacrificial pig are placed on the wood along with the knife used in the slaughter, symbolizing the tribal members' awe and gratitude toward the gods and their prayers for blessing. — Chiang Li-Hua

p. 103, p. 232

洪世聰
HUNG Shih-Tsung

〈視而浮現〉
Emerging into Vision

越來越有「去」的攝影，人可以看盡精華而沒辦法拍盡所見，讓所觀察的「物」成為「攝影後作為」的自我的解析，「浮現」出越來越有「去」的樣貌。在忠孝橋上，眼睛的軸線貫穿城市直達臺北 101 大樓，超越大馬路既定的路線，浮現顯眼的北門，成了最醒目的歷史記憶與焦點，城市大樓的冷冽，車水馬龍與照明燈桿相對矗立，人們則成為無所不在的點綴。—— 洪世聰

As photography increasingly captures the essence of 'going,' people can glimpse the highlights without capturing everything in sight, allowing the observed 'objects' to become a post-photographic self-analysis, taking on an increasingly distinctive appearance. From Zhongxiao Bridge, the viewer's gaze pierces the city, reaching Taipei 101 and transcending the conventional thoroughfares. The prominent North Gate emerges as an arresting focal point and historical memory, juxtaposed with the city's towering buildings, bustling traffic, and unwavering lampposts, while people serve as ubiquitous embellishments. — Hung Shih-Tsung

pp. 104-105, p. 232

〈阿里山 1995〉，《光合》系列
Alishan 1995, The Convergence of Light Series

1995 年在奮起湖一個常民的早晨，進入阿里山地區一處晨曦耀眼的樹景；
1999 年好奇踏上遍野紅土，龜裂成格的火燄山奇特地質土地；
2005 年進入金門堅硬的花崗岩石洞翟山坑道。
阿里山耀眼的光、火燄山乾裂的土地、翟山坑道豐沛的海水，不同的年代和三處迥異的環境，「去相合」這大地生命的元素，而成就生氣蓬勃的內視場景。—— 洪世聰

In 1995, an ordinary morning at Fenqihu led me to discover a dazzling tree scene in the Alishan region, illuminated by the morning sun.
In 1999, curiosity drove me onto a journey across the red earth, encountering the unique cracked, flame-like geology of Huoyan Mountain.
In 2005, I entered the hard granite caverns of Zhaishan Tunnel in Kinmen.
The brilliant light of Alishan, the parched land of Huoyan Mountain, and the abundant seawater of Zhaishan Tunnel – across different eras and contrasting environments, these elements of life 'converged' into a vibrant inner landscape. — Hung Shih-Tsung

p. 106, p. 232

〈紅限〉
Red Limit

紅色是緊急、禁止、驅逐邪惡、象徵危險環境的標示；
紅線，如鴻毛曲折的漂浮；
顏色象徵意義下，帶著飄忽不平的赤色警戒；
在厚重暗黑的深淵中，紅限般蠢蠢欲動的潛行。—— 洪世聰

The color red signifies urgency, prohibition, the expulsion of evil, and symbolizes dangerous environments;
Red lines, like delicate feathers, twist and float;
Within the symbolic meaning of the color, lies an elusive, unsteady crimson warning;
In the profound darkness of the abyss, red boundaries stealthily crawl, poised to act. — Hung Shih-Tsung

p. 107, p. 232

〈智慧之階〉
Steps of Wisdom

彼端的光穿越了窗，階梯，是彼此傳遞訊息的橋，智慧是被包覆在腦中的精華，每一格階梯都是可能的變數與挑戰，上臺階的付出與下階梯是緩衝，是啟動學習的過程，猶如樹木成長繁延了智慧的衍生潛入人的神經。

繪圖〈智慧樹〉傳達人類所累積的文化智慧，猶如樹木生命成長的繁延，此畫作表達了逐步潛入人腦造型的樹，也如智慧的衍生與累積。作品以智慧之階影像為基礎，延伸樹枝生長繁延的素描畫作，畫中的每一格子，代表數位化符號放大至極大值時成為單一像素，表達 AI 數位累積與演算的基本邏輯，大樹幹右方的樹枝上，繪入人類成長的智慧所累積的成果——書本，此成果並以腦的血管與路徑，由如樹枝般地潛入象徵人腦的神經中樞。——洪世聰

The light from afar traverses the window and stairs, acting as a bridge for exchanging messages. Wisdom is the essence wrapped within the brain, and each step represents possible variables and challenges. Ascending and descending stairs offer a buffer, initiating the learning process, akin to the growth of trees, extending wisdom and permeating human nerves.
The illustration *Tree of Wisdom* conveys humanity's accumulated cultural wisdom, resembling the thriving growth of a tree's life. This artwork expresses a tree gradually infiltrating the human brain, much like the derivation and accumulation of wisdom. The piece is based on the image of the staircase of wisdom, extending the sketch to depict the growth and sprawl of tree branches. Each square in the illustration represents a digital symbol magnified to a single pixel at its maximum value, expressing the fundamental logic of AI digital accumulation and algorithms. On the branches to the right of the tree trunk, books are drawn, representing the achievements of human wisdom. These achievements infiltrate the brain's blood vessels and pathways, like branches delving into the symbolic neural center of the human brain. — Hung Shih-Tsung

pp. 108-109, p. 232

張宏聲
CHANG Hong-Sheng

〈我曾思索：既然，每個人的一生，都是生老病死的重複，那麼，人生一趟的意義何在？〉
I Once Thought This: If Our Lives Are Nothing More Than the Repeat of Life, Old Age, Illness, and Death, Then What Is the Meaning of Life?

因早期深受攝影家柯錫杰與傑利·尤斯曼（Jerry Uelsmann）作品中，那種簡潔、寧靜、孤寂的氛圍所觸動，因此，於 1980 年左右，即確立了心象攝影的風格。他的作品謹慎而細膩，一絲不苟地勾勒出他內心的世界，作品有種絕冷與孤寂，還有一股莫名的愁。他以心造境，攝影對他而言猶如心筆。在他的作品中，具有詩與禪意，並有著文人的哲思與宗教的情懷，以西方的攝影技巧來展現東方的哲思。對於影像的堆疊、重組、留白的虛、物體的實等，組合成看似不存在的抽象世界，我們如神遊太虛般照見攝影者的內心世界。或許你也可說，他的靈魂是一位似風一般無形、如雲一般寫意、像水一般柔情、若樹一般觀看世界的人。
〈燈和夜在寂靜的大地上，彼此寧靜地放逐著。〉畫面如題，僅有一盞燈和一戶人家，以及黯黑寧靜的夜空及大地，正負像的效果，讓具象的世界變得如此的抽象，如此具有禪意⋯⋯。——張宏聲、姜麗華

Deeply influenced by the simplicity, tranquility, and solitude found in the works of photographers Ko Hsi-Chieh and Jerry Uelsmann, CHANG Hong-Sheng established his unique style of mental imagery photography around 1980. His meticulous and delicate creations carefully delineate his inner world, evoking feelings of chilling detachment, loneliness, and unexplainable melancholy. For him, photography serves as a brush to paint his mind's landscape. His works encompass poetic and Zen elements, embodying the philosophical thoughts of scholarly and religious sentiments, while utilizing Western photographic techniques to depict Eastern philosophy. By layering, reassembling, and contrasting the emptiness and substance within his images, he constructs abstract worlds that seemingly do not exist, allowing viewers to peer into the photographer's inner realm as if floating through the void. Through photography, his soul is represented like formless winds, expressive clouds, tender waters, and a tree standing observing the world.
The photo shoot took place in a photography studio, with a mother-and-child statue as the central subject. The statue's shadow was cast under the light in a way that resembled either a Buddha or the photographer's imagination. The imaginings are a reflection of the artists' thoughts and perceptions. — Chang Hong-Sheng and Chiang Li-Hua

p. 110, p. 232

張宏聲
CHANG Hong-Sheng

〈我的靈魂，漫遊在寬闊孤獨的宇宙中。〉
My Soul Wandering in the Vast Lonesome Universe.

〈我的靈魂，漫遊在寬闊孤獨的宇宙中。〉畫面如題，孤獨不可見的靈魂，飄忽地穿梭漫遊在廣袤的平行宇宙空間……。—— 張宏聲、姜麗華

The image, as the title suggests, features a lonely and invisible soul drifting and wandering through vast parallel universes. — Chang Hong-Sheng and Chiang Li-Hua

〈燈和夜在寂靜的大地上，彼此寧靜地放逐著。〉
Light and Night in a Silent Land, Wandering in Silence.

〈燈和夜在寂靜的大地上，彼此寧靜地放逐著。〉畫面如題，僅有一盞燈和一戶人家，以及黯黑寧靜的夜空及大地，正負像的效果，讓具象的世界變得如此的抽象，如此具有禪意……。—— 張宏聲、姜麗華

The image features only a lamp, a house, and the dark, the tranquil night sky and earth. The positive and negative effects make the concrete world appear abstract and full of Zen-like contemplation. — Chang Hong-Sheng and Chiang Li-Hua

p. 111, p. 232

葉清芳
YEH Ching-Fang

《現實 ‧ 極光 ‧ 邊緣》系列—1988 臺北
Reality ‧ Aurora ‧ Periphery -1998, Taipei

1988 年因景氣蕭條而停止電影放映的昇平戲院，變成上演牛肉場歌舞秀的舞臺。登臺表演的女郎，在九份的冬天夜晚穿著隨時必須脫掉的披風，露出鑲滿俗麗亮片的「清涼」內衣甚至裸裎以對，在滿場的豔光四射裡，滿足臺下男性觀眾的集體意淫，那是一群飢渴的、聚精會神且又迫不及待的貪婪目光。葉清芳選擇以高感光底片拍攝，刻意的過度曝光使得整件作品的畫面粒子較為粗糙，且明暗的對比相當強烈，特別表現在這位被舞臺前方聚光燈強力照射的歌舞女郎身上，蒼白的光束烘托著她漠然的表情，似乎也象徵無奈而悲涼的命運。—— 呂筱渝

This photo was taken in 1988 at the Shengping Theater, which had fallen into decline and ceased its original performances to become a stage for strip shows. The female performers wore capes that could be easily removed, exposing their bodies in the winter nights of Jiufen. In the dazzling lights, they satisfied the collective fantasies of male audiences below the stage, whose focused and impatient gazes were full of lust. Yeh Ching-Fang's use of high-sensitivity film and intentional overexposure resulted in a rough graininess and strong contrast throughout the work. The pale beam of light illuminating the dancer's indifferent expression seems to symbolize her helpless and bleak fate, accentuating the overall effect. — Lu Hsiao-Yu

p. 112, p. 227

《現實 ‧ 極光 ‧ 邊緣》系列—1988 九份
Reality ‧ Aurora ‧ Periphery -1998, Jiufen

一名牛肉場舞孃與一位老伯沈默坐在昇平戲院的角落，成為被葉清芳捕捉的臺下一景。這幕由女子與老人分別坐在畫面左右側，卻同時被戲院的聚光燈照射出各自的臉部表情。女子一臉木然地直視鏡頭，由強光照亮的表情，慘白而更顯悽惻；燈光照射的白牆，彷彿又將女子框入一個被觀看的視覺空間、眾人的焦點所在。左邊的老伯，在快門按下的瞬間頭微低，斜側著臉，燈光由帽沿形成一塊遮蔽眼睛的黑影，無從得知他的視線所指，但從他厚重保暖的外套可判斷出當時應是寒冬，由此也更顯出女子身上衣衫的單薄。左側的歐吉桑、右側的女子，以及前景下方的水泥地上的垃圾，巧妙地形成視覺上穩定的三角構圖形式，而滿地的紙屑煙蒂和簡陋的木柱也呈現了當年昇平戲院頹敗破落的景象。—— 呂筱渝

The photograph captures a moment between a strip club dancer and an elderly man in the corner of the Shengping Theater. The woman stares blankly at the camera, her face pale and her expression poignant under the intense light. The white wall, lit by the spotlight, frames the woman as if she is on display, the center of attention. The man on the left, at the moment the shutter clicked, had his head slightly lowered and his face turned away, with the light from the brim of his hat casting a shadow over his eyes, making it impossible to know what he is looking at. His heavy winter coat indicates that it is winter, accentuating the woman's thin clothes. The triangular composition of the elderly man on the left, the woman on the right, and the garbage on the cement floor emphasizes the theater's rundown condition. — Lu Hsiao-Yu

p. 113, p. 227

《現實 ‧ 極光 ‧ 邊緣》系列—1982 臺北
Reality ‧ Aurora ‧ Periphery -1982, Taipei

1982 年的動物園還座落在圓山原址，當時的圓山動物占地有限，無法擴建，1986 年才遷至今日的木柵動物園。空間之窄仄，從這幅作品可以略窺端倪。相片中的貓頭鷹被關在厚重的玻璃門裡面，門裡一株傾斜橫生的假樹作為牠的棲息的枝頭，也與戶外真實的林樹互相輝映。駐足在玻璃門外的男孩，顯然對這隻禽鳥很感興趣，在葉清芳抓取的角度下，孩童的臉孔恰巧與門內的貓頭鷹幾乎重疊在一起，呈現一種分不清是人是鳥的詭異情景。而玻璃門片同時也反射出鏡頭之外的情景：一對站在較遠處、也正在觀看貓頭鷹的父女、路過的遊客側影、今日已不復見的供人休憩的白色鐵製公園坐椅和不鏽鋼垃圾桶。這件作品充分表現攝影師迅速攫取此一決定性瞬間的專業能力。—— 呂筱渝

The photo was taken in 1982, when Taipei Zoo was still located at its original site in Yuanshan, which was limited in space. It was not until 1986 that the zoo relocated to Muzha. The narrowness of the space can be glimpsed in this work. The photograph depicts an owl trapped behind a thick glass door, with a slanted artificial tree providing a perch for the bird inside the door. The boy standing outside the glass door is clearly interested in the bird, and Yeh Ching-fang's angle of capture coincidentally makes the boy's face almost completely overlap with the owl, creating a strange scene that blurs the line between human and bird. The glass door also reflects the scene outside the lens, including a father and daughter watching the owl from a distance, the silhouette of a passing tourist, a white iron park bench that is no longer seen today, and a stainless steel trash can. This work fully demonstrates the photographer's professional skill at capturing such a decisive moment. — Lu Hsiao-Yu

p. 114, p. 227

《現實 ‧ 極光 ‧ 邊緣》系列—1980s 臺北
Reality ‧ Aurora ‧ Periphery -1980s, Taipei

1982 年的瑞芳，男孩背後的牆身，是以傳統臺式建築常見的磚塊疊砌而成，但牆身的外壁並非水泥所覆，而是粉刷了混合泥土的白石灰，容易斑剝，也不耐潮濕。這堵凹凸不平的牆看起來飽受侵蝕，它淺色部分是脫落的石灰泥層，深色的地方則布滿了厚重的苔癬。
廣角焦距的運用，使得狹仄的甬道看似寬敞，然而後方另一名男孩，以他張開的雙臂長度間接地標示了走道狹窄的程度。最後，背光的男子立在通道的底端，三個人讓這件作品了有了近、中、遠的空間層次。男子朦朧的身形背後，引領觀看者的目光通向最後的那一小片光亮所在。—— 呂筱渝

It was 1982 in Ruifang. The boy stood against a wall constructed of traditional Taiwanese bricks. Rather than cement, its exterior features a blend of mud and white lime, a delicate coating susceptible to dampness and peeling. The wall's uneven surface, marked by eroded patches of light and dark and moss-covered areas, adds character.
A wide-angle lens lends the impression of spaciousness to the narrow passage, while the other boy's outstretched arms subtly emphasize its confined nature. The backlit man at the passage's end establishes a spatial hierarchy with the three figures, guiding the viewer's gaze towards a faint glimmer of light in the distance. — Lu Hsiao-Yu

p. 115, p. 227

《現實 ‧ 極光 ‧ 邊緣》系列—1980s 臺北
Reality ‧ Aurora ‧ Periphery -1980s, Taipei

他是葉清芳的父親。就像臺灣大部分老一輩、農工社會的傳統父親形象一樣，他們的外表穩重，性格嚴肅、敦實而木訥。他們的鼻樑上總架著黑框厚重的老花眼鏡，讀報時聚精會神，抬頭看遠處時會把眼鏡下拉到鼻頭，然後收斂下巴、揚起雙眉，此時抬頭紋便清楚地爬滿整個額頭——滄桑歲月公平地在每個年長者的臉上犁出溝紋。
父親所處空間的牆邊地板堆放的物品，隱約透露這個地方，也許是葉家的寓所，也許是葉父電器行的生意店內。而此刻葉清芳的父親表情凝重，眼神銳利，鬚毛、白髮和鬍髭看起來堅硬粗礪，似乎渾然不知兒子正調遠焦距在拍自己。
與以往正襟危坐的家族肖像拍攝手法不同，葉清芳以側寫的抓拍方式，在他認為最恰當的時機迅速捕捉閃逝的一刻，光線溫煦地照亮父親的臉龐，自然而傳神。這幀父親肖像，是葉清芳表達他對父親感情的誠摯之作。—— 呂筱渝

This is a picture of Yeh Ching-Fang's father. Like most Taiwanese elderly and father figures in the traditional, agricultural and industrial society, Yeh's father is a man of few words, has a calm and steady personality, and often seen with a solemn expression. They often wear black-framed reading glasses, focused in deep concentration when reading the newspaper. They sometimes pull their glasses down to the tip of their nose when looking up or gazing afar, tucking in their chin, eyebrows raised, filling their foreheads with wrinkles. The years have fairly spread folds on the faces of every elderly figure.
The objects randomly placed in the corners of the space hint that it is a scene of the Yeh residence, perhaps within Yeh's father's electronics shop. Yeh's father has a stern expression, his eyes sharp, the white sideburns, hair, and beard appear coarse, seemingly unaware that his son is adjusting the focus of his camera and taking a picture of him.
Unlike formal portraits of family members taken in posed sitting positions, Yeh's photography adopts a snap shot approach to take his father's profile, capturing the fleeting scene at the perfect moment. The soft, warm lighting falls on his father's face, making the image natural and lifelike. This portrait of Yeh's father is a heart-touching manifestation of Yeh's affection for his father. — Lu Hsiao-Yu

p. 116, p. 227

《現實 · 極光 · 邊緣》系列—1982 八堵
Reality · Aurora · Periphery -1982, Badu

沒有紛呈的色彩，只有簡單的黑白色調，這張作品卻奇異地透著一股柔和、靜謐的氛圍。這名襁褓中嬰孩貼在母親背上，讓蓋毯緊緊包裹著，他骨碌碌、清澈無瑕的雙眸，乾淨的臉龐還未沾染現世的塵埃。除了母親的身形依稀可辨以外，他的周圍幾乎是漆黑或朦朧不清；身邊人事物的不可辨，唯一清晰的是母親皎白的毛衣質地，也反倒襯托著嬰兒純淨的面容。照片中母親以傳統長布背巾將嬰孩後揹的習慣，由於受到歐美傳入的前揹式的影響，在九〇年代以後變得相當少見。
於是我們想像葉清芳在民國 71 年昏暗的八堵車站，手持標準鏡頭相機，將光圈調大，用俯視的角度，攫取了這偶然的片刻。這名宛如被一道聖潔光暈照耀的幼小嬰兒，映射出葉清芳的思緒，也反映了我們內心不可復返的遙遠鄉愁。── 呂筱渝

With only simple black and white tones and no vibrant colors, this work singularly alludes to a sense of softness and serenity. The baby, swaddled tightly in a blanket, is carried on its mother's back, its bright, clear eyes untainted by the world. Apart from the vague outline of the mother's physique, the surrounding is either black or blurry. The indiscernible surroundings, with the mother's white sweater being the only distinguishable portrayal, add to the pure nature of the baby. The traditional Taiwanese practice of carrying infants on the back with a long scarf gradually diminished after the 90s when front-carrying methods, prevalent in Europe and the US, were introduced to Taiwan.
Imagine Yeh Ching-Fang holding a standard lens camera in Badu Station 1982, adjusting the aperture to its widest setting, capturing this moment in a downward perspective. This infant, who seems to be bathed in a glow of innocence and purity, reflects Yeh's thoughts and the deep-seated nostalgia in our hearts. — Lu Hsiao-Yu

p. 116, p. 227

《現實 · 極光 · 邊緣》系列—1982 臺北
Reality · Aurora · Periphery -1982, Taipei

這張相片拍攝的是民國七十一年的台汽客運吳興街口站街景。當時的公車站牌還是高高在上的旗桿式站牌，人行道上還可以任意停放摩托車、可以就地架起竹竿晾曬衣物、在路旁堆積木箱雜物也是司空見慣的事。三張犁吳興街一帶原是農田水圳，自都市更新計畫後逐漸興建大樓。相片中的磚瓦屋和紅磚牆和周遭灰撲撲的老式公寓，是早期常見的住宅景觀。而這所有的景象，巧妙地從一片公車的破窗映入我們的眼簾。
這張以公車的三片車窗作為構圖的基準，垂直與水平線工整地構成一張穩定而封閉的圖像。公車內部光線不明，但仍可見公車座椅的椅背及乘客的頭部。整個作品畫面的中心點是破窗外面一位行道樹下候車的女子，她被樹幹遮住一半的臉部表情，反而勾起觀看者的好奇心，成為這件作品引人入勝之處。── 呂筱渝

This photograph is a street scene of the "Wuxing Street Intersection" station of Taiwan Motor Transport taken in 1982. At the time, bus station stop signs were like towering flag posts, motorcycles could randomly park on the sidewalks, bamboo poles could be erected to dry laundry, and wooden boxes piled on the sides of the roads were commonly seen.
The area of Sanzhangli Wuxing Street was an agricultural irrigation canal. After the urban renewal project, buildings started to be constructed. The brick houses with tiles, red brick walls, and surrounding old condos were views of residential areas commonly seen in the early days. All of these scenes cleverly fall into view through a broken window glass of the bus.
The composition of this photograph is structured with the three windows of the bus, forming a stable and enclosed image both vertically and horizontally. The interior lighting of the bus is dim, but viewers can still make out the back of the chairs and the head of a passenger. The center of the work is a female figure waiting for the bus under a street tree outside the broken window. Half of the woman's face is hidden behind the tree trunk, igniting the viewer's curiosity, which makes the work even more interesting. — Lu Hsiao-Yu

p. 117, p. 227

《現實 · 極光 · 邊緣》系列—1983 臺北
Reality · Aurora · Periphery -1983, Taipei

從葉清芳留下的多件有關幼兒、孩童的作品，很難不令人認為，如果不是他溫暖純樸、敏銳易感的秉性，又何以讓這位後來在政治新聞前線衝鋒陷陣的攝影記者，展露他對老人、小孩、動物的細膩又溫柔的觀察呢？

例如這件作品，一名幾個月大的嬰兒，被葉清芳在陸橋上拍下酣睡的模樣。這名嬰孩是葉清芳姊姊的小孩，他的頭髮梳得整齊服貼，身上的長袖棉質衣服看起來柔軟又暖和。母親懷中的稚兒睡得如此深沉，就連陸橋外面的熙攘喧囂也無法吵醒他。在這座居高臨下箱形人行陸橋，底下的十字路口不過是他未來要面對的世界的小型縮影，萬家燈火、車水馬龍，以及清冷寂寥，街景交通的循環，也是人生階段的意象。

這座 1980 年 5 月啟用，位於臺北市忠孝東路和松山路口的天橋，它的包覆式屋頂，具有遮陽避雨的功能，在當時可說是相當新穎的公共工程建設。── 呂筱渝

From the numerous images of infants and children, it would be difficult for one not to think that Yeh Ching-Fang's warm and keen sensitivity allowed the photojournalist known for his proactive stances in political news to capture warm and delicate images of older people, children, and animals.

For instance, in this work, a baby who is a few months old is captured sleeping by Yeh Ching-Fang on a skywalk. This baby is the child of Yeh Ching-Fang's older sister; the baby's hair is neat, and he wears long-sleeved cotton clothing that seems soft and cozy. The baby slumbers in his mother's arms, undisturbed by the commotion outside the skywalk. The intersection below this elevated skywalk epitomizes the world and life ahead, filled with the ongoing cycle of bustling light, cars, noise, and silence.

Constructions of the skywalk at the interaction of Taipei City's Zhongxiao East Road and Songshan Road were completed in May 1980. The skywalk was known for its roof cover, providing shade and shelter for pedestrians, an innovative approach to public infrastructure design at the time. — Lu Hsiao-Yu

p. 118, p. 227

《現實 · 極光 · 邊緣》系列—1983 瑞芳
Reality · Aurora · Periphery -1983, Ruifang

瑞芳鎮，一個以礦業風光一時的北部濱海小城。一名打著赤膊、捲起褲管的男子躺在瑞芳車站的長凳睡覺，裸裎的上身與伸展的四肢顯示這是一個炎熱的夏天，而男子或許是附近施工的勞動者，趁著休息時間到公共空間小憩，也或者他是當地的居民，或是居無定所的街友。

顯而易見地，這是個窒悶的空間，打開的木製格子玻璃窗用以增加對流和降溫，男人將整個背部貼著椅背的奇特睡姿，像是為了散熱的翻身動作。路經窗外的男孩好奇停駐，一臉不解地注視鏡頭。在這個尋常而沒落的小鎮車站，還有什麼值得記錄下來？

窗框上的塑膠碗、剝落的牆壁、騎樓的男童與交談的人們、外頭絡繹不絕的車輛，無一不是瑞芳的日常所見，無一不是瑞芳的真實模樣。── 呂筱渝

Ruifang is a small seaside village in northern Taiwan that was once known for its mining industry. A man without a shirt and wearing rolled-up trousers lies asleep on the Ruifang station bench. His bare upper body and stretched limbs suggest it was a hot summer day, and the man is likely a worker working nearby who found rest in the public space during his break; or, he could be a resident from the nearby neighborhood or a homeless person.

The wooden-grid windows are opened to increase air circulation and to ease the stifling heat within the enclosed space, while the man's eerie sleeping position of pressing his back against the chair seems to suggest that he is trying to lower his body temperature. The boy walking past the window stops with curiosity; his expression is one of perplexity. What is worthy of documenting in this dull, declining village station?

The plastic bowl on the window frame, the peeling walls, the boy in the pedestrian arcade, people in conversation, and passing cars, are all truthful scenes of everyday life in Ruifang. — Lu Hsiao-Yu

p. 119, p. 227

《現實・極光・邊緣》系列—1986 臺北
Reality · Aurora · Periphery -1986, Taipei

林正杰，人稱「街頭小霸王」，曾經發起十二天街頭狂飆，肇因於他在 1986 年擔任臺北市議員，在議會質詢某黨市議員的銀行超貸案，反遭對方控告誹謗和違反選罷法，最後臺北地方法院罔顧市議員的言論免責權，將林正杰判刑一年六個月，褫奪公權三年。

此幀照片拍下林正杰到臺北地方法院庭訊，儘管遭到法警拉扯，他仍滿臉笑意走出審判庭的情景。由於拍攝地點在室內光線不足，葉清芳必須使用慢速快門與閃光燈拍照，被攝體移動速度比快門還快，且因慢速快門，使得葉清芳的相機感光到其他攝影記者不同角度的閃光燈，而造成照片有多處重複的雙影效果。

這種光軌般流瀉的晃動，使得林正杰前後兩種表情同時出現在一張影像中，讓現場的氣氛顯得有點恍惚和迷離。而那些無所不在的手的疊影，除了製造浪潮似的韻律感之外，似乎也有政治黑手的隱喻意涵。——呂筱渝

Lin Zheng-Jie, also known as "Little Street Tyrant," once initiated a 12-day street protest for an incident in 1986. During council interpellation as a council member, Lin interpellated another city council member for a bank over-loan but was later accused of defamation and violating the Civil Servants Election and Recall Act. In the end, the Taipei District Court ignored the legislative immunity of city council members, and Lin was sentenced to 18 months in jail and the deprivation of civil rights for three years.
This photograph captures Lin en route to Taipei District Court for his court hearing. Despite being jerked and pulled by the bailiff, Lin smiles as he walks out of the court. Due to insufficient interior lighting, Yeh Ching-Fang had to use the slow shutter setting and a flash, but because the photography subject moved faster than the shutter speed, Yeh's camera detected lights from the cameras of other photojournalists from different directions, resulting in several double exposure effects.
The trails of light allow the two different expressions of Lin to appear in the same image, creating an atmosphere of bewilderment and ambiguity. The multiple hands create a wave-like rhythm and hint at the clandestine hands of politics. — Lu Hsiao-Yu

p. 120, p. 227

《現實・極光・邊緣》系列—1986 高雄
Reality · Aurora · Periphery -1986, Kaohsiung

身後不遠處的海平線上，躺著一艘擱淺旗津海域的廢棄船隻——遠洋郵輪烏干達號（SS Uganda）。宛如一尾巨大的魚屍，船隻在海面上載沉載浮，湧動的浪濤一波波拍打沙灘，勁風掀翻其中一名男子的西裝外套下擺，也吹得他們眼睛睜不開。這艘服役長達三十四年的船舶（1952-1986），原本隸屬英印輪船公司，1986 年來到高雄等待拆解，翌年因韋恩颱風將船隻颳上海灘無法動彈，直至 1992 年由拆船業者以重機駁船才得以移出旗津。

就構圖而言，作品中的三個男人，在視覺上以幾近相等的距離站立，縱向將畫面分割為三等份，而背景的海平線、海洋和沙灘，也各占三分之一的比例，海岸線也從右上角至左下角對切成二，形成一幅縱橫交錯但又四平八穩的幾何構圖。

此外，作品中三名遊客，在姿勢上以極大的一致性表現某種趣味性——他們都有相似的站姿、同樣都將一手插進褲袋，另一手吸菸。

除役後的烏干達號，在海上等待它成為廢鐵的最終命運。這件作品以其嚴謹而複雜的構圖比例，融合人物的詼諧，為高雄留下寶貴的歷史見證。—— 呂筱渝

On the horizon not far behind lies an abandoned ship stranded on the territorial waters of Qijin, the ocean liner SS Uganda. Like a corpse of a colossal fish, the boat bobbles up and down on the sea's surface, waves crashing onto the beach. The wind blows the hem of a man's blazer, and the wind is so strong that they can't keep their eyes open. This ship worked for 34 years (1952-1986) and originally belonged to the British-India Steam Navigation Company; it arrived in Kaohsiung to be scrapped in 1986. However, Typhoon Wayne drove her ashore the following year, and it was finally removed by shipbreakers using a barge in 1992.
In terms of composition, the three men in the image are standing at almost equal distances, separating the scene into three equal vertical sections; the horizon, ocean, and beach also take up one-third of the composition each, while the coastline divides the image into the right upper part and left lower part, creating a composition that is intertwined but balanced.
In addition, the three tourists in the work also show a high degree of similarity, all standing with one hand in their trouser pockets and the other holding a cigarette.
The SS Uganda, relieved from its post, awaits its destiny of becoming a heap of metal waste. Through its complicated composition and proportions, the work integrates the playfulness of the human figures while bearing witness to this historical moment in Kaohsiung. — Lu Hsiao-Yu

p. 120, p. 227

《現實 · 極光 · 邊緣》系列—1986 臺北
Reality · Aurora · Periphery -1986, Taipei

民國 75 年舞禁開放，臺北正式成立第一家合法舞廳，從此莘莘學子再也不用害怕少年隊警察突然抓人、成年人也不再擔心警察盤查取締，總算可以光明正大地通宵達旦、勁歌熱舞了。

事實上，早在 1986 年舞禁解除以前，全臺已有不少地下舞廳林立，例如林森北路。尤其在經濟起飛的八〇年代，民眾休閒娛樂多樣化的需求也隨之增加，加上西洋電影熱舞片的影響，更令人人心嚮往之。

葉清芳在該年的耶誕夜，拍下臺北某家舞廳舞池一隅。在這個深色牆面的空間裡，舞池內的男男女女隨意搖擺，牆上嵌著新穎的燈光設備，牆板上托著幾個菸灰缸……拍攝者並沒有保留框邊人物的完整，唯一完整的是舞池裡的女子，並透過照射在她肩背與地上的燈光，以及晃動的殘光疊影，營造成葉清芳作品中慣有的朦朧與迷茫感。—— 呂筱渝

When the dance ban was lifted in 1986, Taipei opened the first legal dance club; students no longer had to fear that they would be suddenly arrested by the police, and adults didn't need to worry about police inspections. Finally, they could dance to their heart's content.

In truth, before the dance ban was lifted in 1986, several underground dance clubs existed throughout Taiwan, such as along the Linsen North Road. The 80s was a time of economic prosperity, which led to the rising need for different entertainment. In addition, the impact of Western dance films also fueled people's desire for dance.

On Christmas Eve that year, Yeh Ching-Fang took a picture of the dance floor of a dance club in Taipei. Men and women moved with the music between the dark-colored walls, installed with new lighting equipment a few ashtrays are seen on the wall panels. The people on the edges of the frame are incomplete, and the only person fully depicted is the woman on the dance floor. The light falls on her shoulders and back and on the floor, and the moving light and shadows give Yeh's work a sense of blurriness. — Lu Hsiao-Yu

p. 121, p. 227

《現實 · 極光 · 邊緣》系列—1986 臺北
Reality · Aurora · Periphery -1986, Taipei

臺灣在戒嚴時期這段漫長的三十八年，嚴格限制人民的人身、言論、新聞、秘密通訊、集會結社、遷徙等權利，連舞禁也是其中一項。未解禁之前，除了土風舞、民族舞蹈、芭蕾舞少數舞蹈被政府認可以外，其餘多為不合法而嚴加禁止，警察也常以扭腰擺臀、傷風敗俗的名義予以取締。當時想要跳舞唯一的途徑，只有去政府特許的合法舞廳和飯店夜總會，然而這些舞廳多半是特權人士（美軍、政要權貴、名門商賈）才能踏入，因此一般民眾除非遁入地下舞廳，冒著警察臨檢的風險，才能享受這項娛樂帶來的舒壓解鬱及樂趣。直至黨國體制逐漸鬆動的八〇年代，髮禁、舞禁、黨禁、報禁等各種禁令陸續解除。此幀作品即是拍攝1986 年舞禁解除後，臺北市教育局開放的第一場舞會，畫面中汗流浹背的男子正激昂吶喊，揮動緊握的拳頭，用力地擺動身軀，而他身邊的舞客也正隨著現場的旋律，一同熱烈地以手打著拍子。—— 呂筱渝

Throughout the 38 years of Martial Law, people's physical freedom, speech, the news, secret communication, assembly and association, and change of residence were restricted; even dancing was banned. Before the Martial Law was lifted, only a select few types of dances, such as folk dance and ballet, were permitted. Most other forms of dance were deemed illegal, often resulting in police cracking down on dancers under the guise of preventing "indecent behavior." The only places where dancing was officially allowed were government-approved dance halls and hotel nightclubs. However, these establishments were primarily accessible to privileged individuals—such as members of the US military, politicians, the wealthy and powerful, or renowned business personnel. Consequently, most people could only experience the cathartic pleasure and joy of dance by visiting underground dance halls, despite the ever-present risk of police intervention.

When the party-state system gradually loosened in the 80s, restrictions on hairstyles, dance, joining political parties, and newspaper bans were gradually lifted. This work was taken after the dance ban was lifted in 1986, and the first ball was held by the Taipei City Government Department of Education. The man in the image, perspiring profusely, is seen shouting, waving his clenched fist, and moving his body rhythmically. Nearby, others are also engaged in the revelry, moving and clapping in sync with the rhythm. — Lu Hsiao-Yu

p. 121, p. 227

《現實 · 極光 · 邊緣》系列—1987 臺北
Reality · Aurora · Periphery -1987, Taipei

民進黨立委康寧祥於 1987 年選舉的演講現場。揮手、握手、比讚、吸菸和持旗幟……，各種手勢在圖像中生動地傳達各自的含意，即使是在這種黑白影像裡，也能將每個人高昂的情緒展露無遺。葉清芳在這個擁擠、混亂的場面，將在場人物的表情、動作，通過重複曝光的拍攝手法，形成雙重影像互相交疊，組成某種多視點、多角度的透視法，整個畫面毫無留白之處，被人手、人臉和旗幟滿滿充塞，形塑出一幅熱鬧、鼓譟卻又有種魑魅魍魎的氛圍。然而每個鼓動的動作、狂喜的表情，在交纏重疊、彼此覆蓋的效果中，都具有值得玩味的細節。總之，這場熱鬧的演講場合中狂熱的眾生相，被葉清芳濃縮收攏在這幀作品裡，如此瘋狂的選舉氣氛數十年如一日，迄今亦然。—— 呂筱渝

This is an image of the Democratic Progressive Party legislator Kang Ning-Xiang's talk in 1987; waving, handshaking, thumbs-up, smoking, and flags in hand…different gestures expressing different meanings. Even in the black-and-white picture, the intense emotions of each person are manifested. In this crowded, disorderly scene, Yeh Ching-Fang captured individuals' facial expressions and movements through multiple exposures, resulting in double images and a perspective with multiple visual points and viewing angles. The scene does not include any blank spaces and is filled with hands, faces, and flags, forming a vibrant scene of noise that seems somewhat eerie. However, the layering of different movements and facial expressions of excitement all contain details that deserve closer inspection. The people of the scene are captured in the photograph of Yeh Ching-Fang, and this lively, even chaotic, scene of Taiwan's election still exists today. — Lu Hsiao-Yu

p. 122, p. 227

《現實 · 極光 · 邊緣》系列—1987 臺北
Reality · Aurora · Periphery -1987, Taipei

不論是白天，還是黑夜，1987 的臺北街頭是熱鬧滾滾的一年。激揚的群眾在總統府、立法院、中山堂等重要的行政機關附近集會遊行。

這個旗海飄揚的夜晚，熠熠發光的不是夜空的皎月明星，而是臺北人行道上萬頭鑽動的群眾。此刻的民眾不再奮力揮動旗幟，也卸下了額頭的白布條，不似白天的熱力四射，也使得這場康寧祥夜間舉行的演講場合氣氛變得平和許多，宛如開辦一場情感交流、商議時事的聚會，發起的組織並在此間發放自行編印的刊物。人行道內幾張宣傳海報懸掛在某機關外圍的柵欄，其中一張內容依稀可辨的大海報寫著：「所有支持臺灣民主的朋友／不可錯過的歷史鏡頭／林正杰街頭抗議實況錄影帶」。各個海報之間穿插民進黨黨旗和立委康寧祥的旗幟。

葉清芳以一貫的殘光疊影，俯視的角度，在調大的光圈、慢速的快門中，將這場喧譁熱烈的場面悄悄攝入相機底片中。 —— 呂筱渝

Whether during the day or at night, the streets of Taipei City are always bustling with energy in 1987. Passionate crowds gather in front of the Presidential Office, the Legislative Yuan, Zhongshan Hall, and other major administrative buildings.
On this night, with flag waving everywhere, the light does not come from the moon or the stars in the night sky but from the flocks of people on the sidewalks of Taipei City. The people are no longer waving their flags and have taken off the white cloths tied on their heads; they no longer look as energetic as in the daytime, making the evening talk more peaceful, as if the event is an exchange of sentiments and ideas. The hosting organization is handing out publications that they have printed themselves.
On the sidewalk, a few posters hang on the fences of a government building, and the words: "To everyone who supports the democracy of Taiwan/A historical scene not to be missed/video recordings of Lin Zheng-Jie's street protest" can almost be seen on one of them. Between the posters are the flags of the Democratic Progressive Party and legislator Kang Ning-Xiang.
Yeh Ching-Fang's signature overlapping lighting and shadow and downward perspective capture the bustling scene in the film through wide aperture and slow shutter speed in the photography film. — Lu Hsiao-Yu

p. 122, p. 227

《現實 · 極光 · 邊緣》系列—1987 桃園
Reality · Aurora · Periphery -1987, Taoyuan

1986 年 11 月 14 日，成立不久的民進黨率領上百位支持群眾，到桃園機場迎接返臺的七名民進黨海外組織代表團，他們也是長年流亡海外的異議人士。由於其中四人遭海關拒絕入境，在機場等候的多位民進黨民代與無黨籍議員試圖與海關人員及警方交涉未果，雙方在檢查大廳發生衝突，七人亦無奈地轉機離臺。而群眾的激昂程度，內斂地表現在記者後方一群引領企盼的群眾中，有一名跨坐在父親肩上的孩童。
如同這張新聞攝影所記錄的，被隔離在鋁框玻璃欄杆外的大批媒體記者，爭先恐後地擠在玻璃欄杆旁拍照，其擁擠的程度從這張作品晃動、模糊和充滿殘影的失焦程度可以略窺一二。作品景框內傾斜的空間，以及轉身背對記者的政治人物尤清，似乎顯示這張照片可能是葉清芳在按下快門的一刻，以超廣角鏡頭而且眼睛沒有透過觀景窗的抓拍（Snap Shot）技巧拍攝而成的。 —— 呂筱渝

On November 14, 1986, the newly-established Democratic Progressive Party (DPP) led up to one hundred supporters to Taoyuan Airport to welcome the seven members of the DPP overseas organizations, dissidents who had been exiled abroad for several years. Four of the individuals were denied entrance by the customs, and the DPP public representative and independent council members attempted to negotiate with customs officers and the police, but to no avail, ultimately breaking into conflict in the security hall. In the end, the seven individuals had no choice but to board another plane to leave. The crowd's emotions are subtly captured through the image of a child sitting on its father's shoulders amid the anticipating crowd.
Just as documented in this news photograph, the flocks of media personnel and reporters blocked outside the glass and aluminum railings fought to take pictures, and the commotion can be seen through the blurriness caused by movement and the lack of focus in this image. The slanted composition and the image of the politician You Ching, with his back toward the reporters, all show that Yeh Ching-Fang probably took this photograph using an ultra-wide-angle lens and that it was a snap shot that the photographer took without looking through the viewfinder. — Lu Hsiao-Yu

p. 123, p. 227

《現實 · 極光 · 邊緣》系列—1988 淡水
Reality · Aurora · Periphery -1988, Tamsui

1980 年代，臺灣電影在小野、吳念真、侯孝賢、楊德昌等人發起臺灣新電影（1982-1986），為電影注入一股活水，從此開啟臺灣藝術電影的新浪潮。
1988 年葉清芳離開中時晚報的工作，成為電影「童黨萬歲」的劇照攝影師。「童黨萬歲」上映於 1989 年，由作家蕭颯擔任編劇，余為彥導演，演員陣容包括李志希、李志奇、徐貴櫻、李明依、張世、鄧安寧等人。這幀相片記錄了淡水拍片現場的一景，場記拿著場記板供攝影師拍照，板上的資訊包括片名、場景、鏡號和當天日期，後面幾個童星裡，表情各異，但都俏皮可愛，有的還偏著頭唸唸有詞，一臉渾然忘我，其他人有的觀察現場狀態，有的看向鏡頭或演員。此外有趣的是，除了身穿小學生制服的童星以外，其他人都穿著稍嫌不合腳、過大的拖鞋——這是他們人生中一場機動而臨時的演出。—— 呂筱渝

In the 1980s, the Taiwan New Wave (1982-1986) emerged in the Taiwanese film scene through the efforts of figures including Hsiao Yeh, Wu Nien-Jen, Hou Hsiao-Hsien, and Edward Yang, breathing new life into films and announcing a new chapter for the art films of Taiwan.
In 1988, Yeh Ching-Fang left his post at the China Times Express and became a film still photographer for Tongdang Wansui. Tongdang Wansui premiered in 1989, with author HSIAO Sa as the screenwriter and YU Wei-Yen as the director, while actors and actresses include Li Chih-Hsi, Li Chih Chyi, Hsu Kuei-Ying, Emi Lee, Chang Shih, and Danny Deng. This photograph documents a scene of the filming site in Tamsui, with the script supervisor holding the clapperboard for the photographer. Listed on the clapperboard is information including the film title, scene, number of takes, and date, while the adorable child actors at the back have different facial expressions. One is mumbling to herself with her head tilted, immersed in the scene; one observes the surroundings, while another looks toward the lens or performers. Interestingly, apart from the child actor wearing an elementary school uniform, others are wearing slippers that are too large for them; this is a last-minute performance. — Lu Hsiao-Yu

p. 124, p. 227

《現實・極光・邊緣》系列—1988 九份
Reality・Aurora・Periphery -1988, Jiufen

「康樂隊」原本指的是國防部為了宣慰國軍而成立的表演團體，在 1960 年代以後逐漸為藝工隊取代而慢慢消失，但卻在經濟起飛的 1980 年代，因工地秀、牛肉場等綜藝舞台秀的大量需求，原本盛行於南部的小型樂團在解嚴前後開始風靡全臺。這種在草根味濃厚的舞台秀裡總少不了他們的康樂隊，基本組成為鼓手、貝斯手和鍵盤手，有時視秀場大小調整編制多寡。

秀場的進行透過主持人妙語如珠的機智反應，和色情笑話的串場來炒熱氣氛。在 1988 年九份昇平戲院的舞台上，來自臺北的黑貓康樂隊只用了一塊白布搭成布景，簡陋的程度可見一斑。

畫面右邊的艷舞女郎正步入舞台，舞台地板的聚光燈打在她裸露的下半身，晃動的披風預示著一場大膽露骨的「清涼秀」（即牛肉場）即將登場。—— 呂筱渝

"Recreational groups" originally referred to performance groups that the Ministry of National Defence organized to entertain the army, but after the 1960s, they gradually disappeared and were replaced by Performance Troupes. However, with the economic boom of the Taiwan Miracle in the 80s, the great demand for construction site performances and "Beef Venues (places with erotic performances)" made small-scaled music groups that were popular in Southern Taiwan famous all across Taiwan around the lifting of the Martial Law. Recreational groups, commonly seen in grassroots performance venues, usually consist of a drummer, bass player, and keyboardist, and their size changes with the venue's spaces.

The performance was fueled by the quick-witted remarks of the charismatic host and the interjection of risqué jokes. On the stage of Jiufen's Shengping Theater in 1988, the Taipei band Black Cat Recreational Troupe used a simple white cloth to set the stage, giving viewers a hint of the modest, unassuming setting. On the right side of the image, the female sex dancer is stepping onto the stage, and the lights on the stage shine on her bare legs. The moving cape suggests that a daring "Beef Venue" show is about to take place. — Lu Hsiao-Yu

p. 125, p. 227

《現實・極光・邊緣》系列—1990s 臺北
Reality・Aurora・Periphery -1990s, Taipei

葉清芳生長在一個五姊一弟的家庭，排行老六。對深受傳宗接代與人力需求影響、且正由農業社會過渡到工商業時代的臺灣社會而言，十口以上的三代同堂並不罕見，而子女眾多的葉家也稱得上家大口闊、食指浩繁，要能養活一家子需有相當能耐。幸好適逢經濟起飛年代，彼時凡勤奮工作的父母大抵都能提供家庭成員衣食無虞的生活，尤有甚者，購屋置產、栽培兒女出國深造者大有人在。

葉清芳拍了不少人像，但家人的相片較為少見，除了父親以外，這張的主角是姊姊。姊弟倆都有寬大的額頭、豐厚的嘴唇，高挺的鼻梁、雙眼皮及下巴有痣等特徵。這件作品除了路上的姊姊與狗，只剩遠處晃動的燈影依稀可辨，除此之外就再也沒有別的了。

是現實，也是隱喻。閃光燈下若有所思的姊姊，和搔背的狗兒，成為黑暗中唯一可見的存在——也是葉清芳生活中極為重視的情感連結。—— 呂筱渝

Yeh Ching-Fang was the sixth child in his family, with five older sisters and one younger brother. Influenced by the societal expectation of producing offspring and the demand for manual labor during Taiwan's transition from an agricultural society to an industrial one, it was not unusual to see three generations of a family with over ten members living together. Yeh's family, being one with many children, was considered large, and providing for such a large family was no easy task. Fortunately, it was during an economic boom, and most diligent parents could offer a comfortable life for their families; some were even able to buy properties and afford to send their children abroad to study.

Yeh Ching-Fang took many photographs of human figures, but photographs of his family members were few. Apart from the other work depicting his father, the central figure in this picture is Yeh's older sister. Both Yeh and his older sister had broad foreheads, plump lips, prominent and straight nasal bridges, double eyelids, and moles on their chins. Apart from Yeh's sister and the dog, only the light in the distance is discernable.

This is at the same time reality and a metaphor. Yeh's sister, deep in thought under the flash, and the scratching dog, become the only existences in the darkness, and they also represent the emotional bonds in Yeh's life. — Lu Hsiao-Yu

p. 126, p. 227

《現實 · 極光 · 邊緣》系列—1990s 臺北
Reality · Aurora · Periphery -1990s, Taipei

一張葉清芳與外國朋友瑪莉合照，畫面左下方突兀的人臉，是知名藝術家林鉅，臺式酒館「攤」的老闆之一，也是葉清芳的好友。

如果我們將視線放在這對朋友身上，看到的是交情甚篤的兩人，為拍攝的這一刻擺出極為認真的表情。然而有趣的是，我們眼角的餘光似乎又被什麼干擾著……。

是畫家林鉅一臉詭異且帶點喜感的表情，像是不經意或不受控地闖入鏡頭，神秘而詼諧。他無視後面擺好姿勢的葉清芳和瑪莉的存在，而不足的光線讓他的模樣看起來有點鬼祟，眼睛又彷彿在斜睨什麼？順著他視線的方向迂迴而行，畫面最右邊的碗櫥側板上，貼著一張明眸皓齒、身穿比基尼的清涼美女照，答案昭然若揭了！

原本是一張單純拍攝葉清芳和瑪莉的相片，意外地因林鉅搞怪的表情，為這張友誼留念照，增添了逗趣的喜劇效果。—— 呂筱渝

This is a photograph of Yeh Ching-Fang and a foreign friend called Mary. The unexpected face on the lower left corner of the image is the face of the renowned artist LIN Chu, one of the owners of the Taiwanese bistro "Thuann (攤)" and a close friend of Yeh.

If we direct our gaze to the pair of friends, what falls into view is the scene of two close friends consciously framing their expressions for the picture. Interestingly, our vision seems to be interrupted by something…

It is the strange and whimsical facial expression of the painter Lin Chu, who seems to have accidentally or deliberately intruded into the scene, mysterious and playful. Lin disregards the existence of Yeh and Mary, while the insufficient lighting makes him seem sneaky; what is he trying to say with his eyes? Follow his sightline, and viewers will see the picture of a beautiful woman wearing a bikini and smiling on the side panel of the cupboard on the far right. Now we understand.

A playful and comic touch is added to the ordinary photograph of Yeh Ching-Fang and Mary through the funny facial expression of Lin Chu. — Lu Hsiao-Yu

p. 127, p. 227

《現實 · 極光 · 邊緣》系列—1990 臺北
Reality · Aurora · Periphery -1990, Taipei

一個不知名的夏日夜晚，一群朋友聚會結束後仍在外頭流連不去，在路燈和葉清芳相機閃光燈的照耀下，為這場相聚留下片刻的永恆回憶。每個歡聲笑語，自然地展露在這群青春的臉龐；伴隨著啤酒、飲料的潑灑痕跡，透露著夥伴間方才曾嬉鬧過。這些無聲的歡樂，隱隱被路面的水漬形狀記錄著。或倚或抱、或蹲或爬，即使在黑夜，他們仍洋溢著青春熱力，相片中的笑聲彷彿不絕於耳。

1990 年初，數十年威權的雕像才要倒下，人們在此之前與在此之後經歷一連串由解嚴、解除報禁黨禁、各種街頭運動以及野百合運動的變革時代，言論箝制與思想禁錮的藩籬正被打破，一個拆除後將要重建的時代。而這些走出聯考窄門的年輕人，有的或許還在社會的高牆內掙扎，有的或許一如葉清芳，在繁忙的新聞攝影工作的崗位之外，還不忘在這場深夜的聚會，盡情地人生得意須盡歡。—— 呂筱渝

It was an unknown summer night. A group of friends finished their gathering but lingered outdoors, unwilling to leave. Under the illumination of streetlights and the flash of Yeh Ching-Fang's camera, they captured a fleeting moment that would become an eternal memory. Each joyful laughter naturally revealed itself on the faces of these youths. The traces of spilled beer and drinks show the playful moments they had just experienced, and the shapes of water stains faintly record the silent joys on the pavement. Leaning, hugging, crouching, crawling – even in the darkness, they glow with youthful energy, the laughter in the photos lingering.

At the beginning of the 1990s, the statue representing decades of authoritarian rule was just about to collapse. The period before and immediately after this was a Series of societal changes brought forth by the lifting of the Martial Law, the liberation of the press ban and restrictions on forming political parties, various street movements, and the Wild Lily Student Movement. The chains of speech and thoughts were broken; it was a time when the old were taken down, awaiting the new to be constructed. Some of the young people who had squeezed past the gate of the Joint College Entrance Examination were still struggling behind the tall wall of society, while others, such as Yeh Ching-Fang, did not forget to take part in this late-night gathering, living life to the fullest despite his busy position as a news photographer. — Lu Hsiao-Yu

p. 128, p. 227

《現實 · 極光 · 邊緣》系列—1991 臺北
Reality · Aurora · Periphery -1991, Taipei

滿身蛋殼和蛋汁的攝影記者許村旭，不甘示弱地朝安坐桌前的妻子頭上狠砸雞蛋，其妻見狀想抵擋卻已太遲。砸在她頭上的碎蛋，飛濺的蛋汁、老婆抵擋的左手和她驚恐的模樣，和丈夫砸蛋的表情與手勢，這些生動的肢體語言，都被當場目擊的葉清芳拍了下來。由於夜間室內光線不足的緣故，閃光燈照不到的地方也產生了模糊和晃動的殘影，讓這個「案發現場」顯得更有動態影像的張力。
牆面上貼的剪紙「囍」字，告訴我們這是一場慶祝的婚宴。然而不知是刻意還是無心，這個被裁切的「囍」只留了一半的「喜」，巧妙地達到指示場景的功用，在構圖上也不會喧賓奪主，搶了這張相片的事件焦點。
賓客間的嬉笑打鬧，在這場友人的婚宴中，那些影像無法聽見的嘈雜聲響，被葉清芳以機動而精確的角度，記錄下這場歡樂的盛宴。—— 呂筱渝

Covered with eggshells and egg yolk, photojournalist HSU Tsun-Hsu retaliated by smashing an egg on his wife's head. When his wife saw what he was about to do, she attempted to defend herself, but it was too late. The flying egg, the lifted left arm of the woman, the look of shock on her face, and the facial expression and gesture of her husband were all vividly captured by Yeh Ching-Fang, who was on the scene. Due to insufficient lighting, there are blurred areas where the flash couldn't reach, making the "crime scene" seem even more dramatic and filled with more movement.
The cut-out paper of the Chinese character " 囍 (double happiness) pasted on the wall tells us this is a wedding banquet. However, whether deliberately or by coincidence, only half of the character " 囍 " is left, cleverly describing the scene while being subtle enough to not become a focal point.
Amid the playful laughter of the guests, this wedding banquet for friends and the noise not captured by the image are all documented through Yeh's swiftness and precision, depicting this joyful scene. — Lu Hsiao-Yu

p. 129, p. 227

《現實 · 極光 · 邊緣》系列—1991 臺北
Reality · Aurora · Periphery -1991, Taipei

曾經位於臺北市和平東路一段，一間磚造樓房二樓的「攤」（臺語發音），是畫家林鉅與幾位藝術界朋友共同開設的一家臺式餐飲酒館。「攤」不僅在內部擺設，而且在經營理念上都具有鮮明的本土意識和草根氣息，尤其在 1980 年末社運蓬勃的年代，吸引了不少當時活躍的藝文人士、劇場人、新聞記者和社運工作者前來光顧。這些常客晚上在此談天論地、各抒己志，或是拼酒開講。
相片中一張古意盎然的羅漢床、老舊的吊掛式電扇，以及傳統建築的松木圓柱橫梁和磚砌的直柱，這些古早的元素四平八穩地撐托起畫面中間微仰視角下看似寬闊的空間。
兩旁雜亂、尚未收拾的桌面，像是喜宴留下的杯盤狼藉。儘管牆上貼著雙囍窗花，但空無一人的場景，清冷地散發出「天下無不散的筵席」的氣息。—— 呂筱渝

"Thuann（ 攤 , pronounced in Taiwanese)," a two-story brick building that used to be located on Section One, Heping East Road of Taipei City, is a Taiwanese bistro that painter LIN Chu and a few friends from the art world opened together. The interior decorations and management all emitted a strong sense of localism and grassroots style, and the bistro attracted many creatives, theatre professionals, journalists, and social workers, especially in the 80s when social movements strived. Individuals who visited the bistro frequently gathered to talk about ideas and dreams; some even elaborated their opinions after a few drinks.
The antique-styled Luohanchuang, the aged suspended fans, and the old-style, rounded pine beam and pillars pasted with tiles often seen in traditional architecture all provided stability to the composition and guided the vision upward to look at the wide, open space.
The messy tables on either side are left after the wedding banquet. Although there is a papercut "double happiness" on the wall, the scene is empty, alluding to the saying that "all good things come to an end. — Lu Hsiao-Yu

p. 129, p. 227

《現實 · 極光 · 邊緣》系列—1991 臺北
Reality · Aurora · Periphery -1991, Taipei

酒客離開後，留下一桌面的杯盤狼藉。臺北市和平東路的臺式風格小酒館「攤」，在 1990 年代前後幾年匯聚了許許多多的人物，有名的也好，無名的也罷，在那些杯觥交錯、酒酣耳熱的時刻，他們乘著時代改革的浪潮，在此議論國家社會的大小事、交換彼此的見解，也在「攤」舉行個人的喜慶婚宴，或只是單純地閒話家常。

「不在場」的酒客，由木桌上的瓷碗、免洗筷、玻璃杯、瓷盤、台灣啤酒瓶、廉價紙巾、殘餘的食物與垃圾等使用過的痕跡——筷子擺放的位置、丟棄的面紙、碗內的花生、滿桌的污漬……，皆是使用與存在的痕跡，也象徵曾經「出場」的他們。

這幀如靜物畫般的一幕，對角斜切的寬大桌面穩定了畫面的構圖，而看似凌亂的桌面亦有物件佈局上均衡的巧思；最後，桌上的一抹光，更讓空間的明暗對比更顯豐富層次。 —— 呂筱渝

The customers have left, leaving a table of disorderly cups and plates. The Taiwanese bistro "Thuann (攤)" on Taipei City Heping East Road was the gathering place of many individuals; some were famous while others were unknown, all drinking and chatting. These people rode the wave of their times and gathered to discuss and exchange opinions on major or minor matters of the nation. Some held celebrations or weddings in the space, while others visited the place for leisure conversations.

The "absent" customers existed through the ceramic bowls, disposable chopsticks, glass cups, ceramic plates, Taiwan Beer cans, cheap paper towels, leftover food, and trash on the wooden table. The placement of the chopsticks, disposed tissue, peanuts in the bowl, and grease on the table, are all traces of their prior "presence."

This image is like a still-life painting; the large, diagonal table balances the composition. The mess on the table actually presents deliberate arrangements, while the play of light across the table gives depth and richness to the lighting contrast of the space. — Lu Hsiao-Yu

p. 124. p. 227

賴永鑫
LAI Yung-Hsin

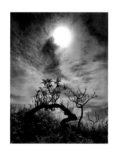

〈生命樹——新北瑞芳〉
Tree of Life: Ruifang, New Taipei City

優良的攝影作品，光、影與色彩、構圖等，雖非絕對考量因素，卻是必然的條件。

攝影是捕光捉影的遊戲，是光影的藝術，因此光及影調的運用與控制，對於表達作品情緒，有著很大的影響。

攝影，並不單單為了製造一張美麗的照片，它可以被賦予個性，可以說故事，它是理性與感性並存的交織。這是攝影的魅力及樂趣所在。

〈生命樹——新北瑞芳〉拍攝一棵樹，日日關注兩年，這天我用 1/1000 秒，捕捉了它的身影；

幾日後，它卻消失無蹤。 —— 賴永鑫

Quality photography is not solely based on light, shadow, color, and composition, but they are essential elements.

Photography is a game of capturing light and shadow. It is the art of using light and shadow to express emotions.

Photography is not just about creating a beautiful picture. It can be given personality and tell a story. It is an intertwining of rationality and emotion.

To take a photo of a tree, I observed it every day for two years, and, on the day, I used 1/1000 second to capture the image; but a few days later, it had disappeared without trace. — Lai Yung-Hsin

p. 130. p. 233

范晏暖
FAN Yen-Nuan

《記憶與光照》系列
Memories and Illumination Series

以「光」作為本作品的主題內容，描述從科學性到宗教性之探討，它雖然在不同時代中以不同的造形樣貌出現，但是在靈性的詮釋上卻有著相同的神性象徵意義。它既是色彩，也是造型，是明亮，也是清澈，它照耀聖殿，也照耀俗世，它就是上帝。因此，對造形藝術表達的探索和意圖，回到永恆神國的靈性追求中。
—— 范晏暖

'Light' serves as the central theme of this work, delving into its multifaceted nature from scientific to religious perspectives. Despite manifesting in distinct forms across various eras, its spiritual interpretation consistently conveys divine symbolism. Light epitomizes color, shape, brightness, and clarity, illuminating both sacred temples and the secular world as representations of God. Consequently, the exploration and intention of artistic expression with light harken back to the eternal pursuit of the spiritual connection with the divine realm. — Fan Yen-Nuan

pp. 131-133, p. 233

 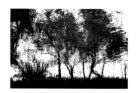

陳淑貞
CHEN Shu-Chen

《AFTER》系列
AFTER Series

《After》（空場之後）創作內容主要以臺灣汽車旅館在投宿者離開之後的空場狀態，作者在經歷創傷事件後，以身為女性的視點，重新閱讀汽車旅館裡充滿性別象徵、殘餘父權、英雄主義、金錢遊戲等符號的相關詮釋及置身於此空間時的觀察與攝影創作的關聯性，得到領略與啟發，並同時以攝影創作來自我療癒，透過介入汽車旅館空間創作時的心理衝擊狀態與影像美學轉化實踐創作，來解析臺灣汽車旅館中的特殊空間文化，充滿異質性及脫離現實感的空間特質，尤其在投宿者遺存的痕跡、氣味、食物及被單皺摺狀態，呼應將自身的觀看過程，轉化成影像實踐的創作形式。因時常在汽車旅館的空間裡，觀察並體驗「光」的流動及隱匿的「影」，當置身於這些被刻意營造設計的空間裡，有著更多異於一般平凡室內可視光源呈現，有時這現象並非只是視覺性的光感，更是一種知覺的喚醒。空間因「光」而存在，我們自身也因「光」而重組自我存在的樣貌，「光」成了一種介面，進而傳達訊息為我們詮釋並賦予意義。而隱匿的「影」，彷彿是為了「光」而存在著，他們相互依附呈現共生的自然現象。在可視的光之外，我們卻也經常沉溺於暗黑的系統裡，因著這些暗黑系統，某種程度也投射自我生命的本質與那種生命裡不可承受的輕。—— 陳淑貞

The *AFTER* Series focuses on the state of Taiwanese motels after guests have departed. The artist, having had a traumatic experience, reinterprets these spaces through a feminine perspective, examining symbols of gender, lingering patriarchy, heroism, and money games. This inquiry and photographic expression serve as a source of insight, inspiration, and self-healing. Immersing herself in motel spaces, the artist delves into the psychological impacts and aesthetics, analyzing Taiwan's distinctive motel culture and its surreal, detached nature. The remnants left by guests – scents, food, and wrinkled sheets – reflect the artist's transformation of her observations into creative practice. The artist consistently experiences and observes light and concealed shadows in these spaces, noting the extraordinary visual light sources in these intentionally designed environments. At times, the experience extends beyond visual perception to awaken the senses. Spaces owe their existence to light, which also restructures our own being. Light acts as an interface, communicating messages and bestowing meaning, while hidden shadows appear to exist symbiotically in tandem with light. Beyond visible light, people often find themselves indulging in the dark, which, to some extent, reflects the essence of life and the unbearable lightness within. — Chen Shu-Chen

pp. 134-135, p. 234

賴譜光
LAI Pu-Kuang

「哪裡有陰影，哪裡就有光」——雨果
這是一場人生的饗宴，還是自我的救贖之旅？
哪裡有陰影，哪裡就有光，一個逐光追影的獨行者。
像是傳說中的唐吉軻德或是薛西弗斯，自以為可用觀景窗捕捉生命意義的人。
受到法國作家雨果的精神召喚，踏上沒有起點、也沒有終點的音像旅程，
即使狄更斯早已預言：這是一個最光明的時代，也是最黑暗的時代。
我依然彎下身子摸石過河，在朝聖路上匍匐前行，
於明暗之間、陰陽之外，繼續尋找宇宙間最幽微的答案。—— 賴譜光

"Where There is Shadow, There is Light"—Victor Hugo
Is this a feast of life or a journey of self-redemption?
Where there is shadow, there is light; I am a lone traveler chasing light and shadow.
Like the legendary Don Quixote or Sisyphus, a photographer believes he can capture the meaning of life through a viewing window.
Summoned by the spirit of French writer Victor Hugo, I embarked on an audiovisual journey with no beginning and no end.
Even though Dickens has prophesied, "It is the best of times and the worst of times,"
I bend down to feel the stones as I cross the river, crawling forward on my pilgrimage.
Between light and darkness, beyond Yin and Yang, I keep searching the universe for subtle answers.
— Lai Pu-Kuang

pp. 136-137, p. 234

〈影像 1-1：徵婚啟事。香港東鐵〉
Image 1-1: Personals.
Hong Kong East Rail Line

〈影像 1-2：天下無不散的筵席。木柵動物園〉
Image 1-2: All Gatherings Come to an End.
Taipei Zoo

〈影像 1-3：與常玉不期而遇。淡水河左岸〉
Image 1-3: Encountering Sanyu.
Tamsui River Left Bank

余 白
Hubert KILIAN

〈無題〉
Untitled

自 1996 年起，余白穿梭在臺北的大街小巷，試圖捕捉最真實的臺北城與臺北人，記錄居民的生活環境及其樣貌。〈無題〉這件作品中，陽光照亮一名坐在家門前椅子上的老伯伯，強光打在他的右側，除了幾盆植栽外，還包括右臉、右手、右腳及他的助行器。不良於行的他，左手拿著鋼杯，左腳穿著特製鞋，剛巧處於畫面的陰暗處，象徵其身體微恙不欲人知。明與暗的對比，比喻人生的起起伏伏，難免有光彩與陰鬱的雙面性。—— 姜麗華

Since 1996, Hubert Kilian has roamed the streets and alleys of Taipei, endeavoring to capture the most authentic representation of the city and its people, documenting residents' living environments and appearances. In this work, sunlight illuminates an elderly man sitting on a chair in front of his house. The strong light casts upon his right side, including his face, hand, foot, and walker, as well as a few potted plants. Hindered by his mobility, he holds a steel cup in his left hand and wears a specially designed shoe on his left foot, both of which happen to be in the shadowed area of the frame. The contrast between light and darkness serves as a metaphor for the ups and downs of life, evoking its duality of brightness and gloom. — Chiang Li-Hua

p. 138, p. 234

《臺北之胃》系列 :1-2
The Stomach of Taipei Series:1-2

《臺北之胃》系列透過靜態的黑白攝影記錄臺北人的果腹之欲，因為人類需要維持生命的基本衝力，而這股生之欲的本能力量，余白以有點隱含暴力的影像來呈現，畫面呈現夜深人靜的傳統市場或攤販，煙霧瀰漫的買賣販售交易，在慘白的日光燈管或月光下，宛如可以聽見急速且響亮的磨刀聲或叫賣聲。余白在深夜裡探訪臺北人意識底層真實的樣貌，在攝影影像裡複現終將消逝的細節，他「不是為了懷舊，而是表達遺憾」。 —— 姜麗華

The Stomach of Taipei Series captures the desires of Taipei residents to satiate their hunger through static black and white photography. In his images, Hubert Kilian presents the primal force of this desire, driven by the fundamental human need to sustain life, with slightly violent undertones. The scenes feature traditional markets or street vendors in the still of the night, shrouded in smoke. Under the fluorescent lights or moonlight, it is as if one can hear the sharp sounds of knives being sharpened or vendors calling out their wares. KILIAN visits the true face of Taipei's residents during the night, revealing the underlying reality of their consciousness in his photographs. He captures the details that will eventually fade away, stating that his intention is "not to be nostalgic, but to express regret." — Chiang Li-Hua

pp. 139-140, p. 234

《臺北原味》系列 :1-4
The Original Flavour of Taipei Series:1-4

《臺北原味》系列作品，表現臺北歲月的氣息，「老舊的東西有一種生命感……拍照不見得是要把所見事物美麗化而是拍出讓人感覺到、卻看不到的東西」。2011 年至 2016 年間在臺北和新北拍攝，這些作品展現臺北某些被隱藏起來的美麗面貌，展現過去和現在融合的氛圍，也展現臺北人與城市間生活互動模式。這些影像可以被解讀為發現臺北不明的美的對話，並不是預先構想好的一張張嚴謹精確的紀錄，而是一種對於現實的詮釋，像一個虛構一直迴盪到凌晨的虛構。講述在臺北小巷茫茫的迷宮裡，無始無盡的遊走，城市本身變成了一個如夢似幻的世界。藉著重新創造這座城市的起源，我試著拍出這些獨一無二的氛圍。我玩弄時間軸，竭力營造一種存在的昏眩。我把臺北想像成劇院舞臺，上演著和存在有關的故事，時間停止了，石頭仍在。我試著捕捉這些掩藏在如幻似真的門面之後、沿著剝落斑駁的牆垣逐漸凋零的人生。於是我試著將我以為是某種永恆的臺北停格，我學著探索、了解然後去愛它。 —— 余白

The Original Flavour of Taipei Series showcases the atmosphere of Taipei through the years. "Old things have a sense of life... Photography is not necessarily about beautifying what is seen, but capturing what people can feel yet cannot see." These works were photographed between 2011 and 2016 in Taipei and New Taipei City. They reveal where the past and present merge, as well as the interaction between urban residents and the cities. These images can be interpreted as a dialogue that uncovers the unrecognized beauty of Taipei, not as meticulously precise records, but as an interpretation of reality, like a fiction. The story takes place in the vast labyrinth of Taipei's alleys, where there is endless wandering. The city itself becomes a dreamlike world.
By recreating the origins of this city, I try to capture the unique atmosphere. I play with the timeline, striving to create a dizzying sense of existence. I imagine Taipei as a theater stage, showcasing narratives related to existence. Time stands still, but the stones remain. I attempt to catch moments in the lives that gradually wither away, behind peeling and decaying walls. I try to freeze what I perceive as a certain eternal aspect of Taipei. I learn to explore, understand, and love it. — Hubert Kilian

pp. 141-143, p. 234

張志達
CHANG Chih-Ta

〈未知未來〉
Unknown Future

人們對於未知的不可控總會產生心理上的徬徨，如同身處在黑暗無光的場域的恐懼，無法確保自身是安全無虞是有所依循的。而深邃的盡頭透露出微弱的氣息，光是深井裡的一條長繩，生物對光刺激的本能趨向性得以被指引。── 張志達

People tend to feel uneasy and uncertain when faced with the unknown and uncontrollable, akin to being lost in a dark and unfamiliar environment. At the end of the darkness, a faint guiding light appears, like a rope that leads us towards our instinctual desires and needs. — Chang Chih-Ta

p. 144, p. 235

〈逆光飛翔──轉身後的自由〉
Flying Against the Light: Freedom After Turning Away

小男孩的影子倒映出天使的羽翼，而即將振翅高飛的夢想無奈地在十字間徘徊，抉擇的過程總是令人舉棋不定。以第一人稱的視角述說著自身的經歷，往往在理想與現實之間尋求最佳平衡點，隱身在背後的是現實生活中的種種挑戰，無數的門檻接踵而至，或許奮力一搏就有機會跨越，也或許必須無奈地適時的選擇妥協，但退後一步並非認輸，而是另一個視野再出發。相信天際間開了扇大門，哪天，自在的飛鳥終會為自己而飛翔。── 張志達

The shadow of a little boy reflects angelic wings, while the dream of taking off and flying high lingers hesitantly at the crossroads of decision-making. The process of choosing is always challenging. The photograph represents, from a first-person perspective, the mentality that seeks to strike a balance between the ideal and reality. Behind the scenes lie a Series of hurdles and challenges that must be overcome. While success cannot be guaranteed, stepping back does not mean giving up. It is a chance to start afresh with a new perspective, an open mind, and the belief that a door is an opening for birds to soar into the skies. — Chang Chih-Ta

p. 145, p. 235

邱誌勇
CHIU Chih-Yung

《空間物件》系列
Spatial Objects Series

或許初戀並非永遠，因為那只是預習。
或是磨難僅是為了感受枝微末節。──C. J. 湯普森
《空間物件》源自於對日常生活中不經意間所關注到的日常細微，屬《細微日常》五個系列中的一組件作品，表意著透過攝影家的眼睛，觀察日常生活中細微而美麗的物件或風景，從中發現其有意味的形式。──邱誌勇

"Perhaps first love is not forever because it is only a preview. Perhaps hardships are just for feeling delicate bits of life." — C.J. Thompson
Spatial Objects is a component Series of the *Subtle Daily Life* collection. It originated from the photographer's observation of subtle yet beautiful objects or scenery in daily life, revealing the meaningful forms they possess. — CHIU Chih-Yung

pp. 146-149, p. 235

〈幻 -1〉
Illusion-1

〈幻 -2〉
Illusion-2

〈電流 -1〉
Electric Current-1

〈電流 -2〉
Electric Current-2

王鼎元
WANG Ding-Yuan

〈野餐趣〉，《臉上的光彩 2.0》系列
Picnic, Glow on the Face 2.0 Series

自智慧型手機問世後，人類因手機使用習慣的改變而產生「低頭族」的社會現象《臉上的光彩 2.0》系列作品，作者將攝影與名畫構圖相結合，除運用編導攝影的拍攝手法外，利用數位後製加強了畫面中「光」的效果。透過戲仿諧擬的畫面反諷生活在數位時代、沉溺在電子設備中的人們，重新詮釋「低頭族」的社會現象。
〈野餐趣〉靈感來自馬內（Édouard Manet, 1832-1883）畫作〈草地上的午餐〉，因作者與好友一同參加野餐活動時，看到時下許多年輕人及家庭，跟風參加野餐派對或是露營以親近自然，他們自備食物及野餐墊於公園席地而坐，野餐的同時不忘自拍上傳至社群網站，呼應十九世紀歐洲曾一度盛行野餐作為休閒活動，於是構圖參照馬內的〈草地上的午餐〉，人物安排符合馬內作品的人物安排，肢體語言也盡量符合馬內作品中人物的姿勢。為了讓畫面場景生活化及合理化，於是放棄畫作中的裸體。畫面前面三位分別表現出野餐的人自拍及合照的動作，好似一會兒就準備分享照片至社群網站。畫面遠處一位女生則模仿馬內畫作中位於後面彎著腰沐浴女子的姿勢，只是將原本沐浴姿態的女子改為撿拾不小心掉落在地上平板電腦的女子，而掉落那臺平板電腦中的螢幕畫面顯現參考的畫作，以作為提示觀者此件作品來源的彩蛋。
—— 王鼎元

Following the advent of smartphones, the social phenomenon of 'phubbing' has emerged with evolving mobile habits. *The Glow on the Face 2.0* Series fuses photography with compositions of renowned paintings, utilizing directed photography techniques and digital post-production to intensify the images' light effects. These satirical, parodic visuals critique individuals engrossed in electronic devices during the digital age.
Picnic was inspired by Édouard Manet's painting The Luncheon on the Grass. Wang Ding-Yuan, along with friends, participated in a picnic event and noticed young people and families jumping on the bandwagon and joining picnic parties or camping to connect with nature. They brought their own food and picnic mats. While picnicking, they did not forget to take selfies and upload them to social media. This reflects the 19th-century European trend of picnicking as a leisure activity. The composition references Manet's The Luncheon on the Grass, with the arrangement of characters and body language aligning with those in Manet's work. To make the scene more relatable and realistic, the nudity in the original painting was omitted.
The three people in the foreground take selfies and group photos, ready to share the pictures on social media. In the distance, a girl imitates the pose of the woman bathing in Manet's painting, bending over, but instead of bathing, she is picking up a tablet that accidentally fell on the ground. The screen of the dropped tablet displays the referenced painting, a nod towards the source of inspiration. — Wang Ding-Yuan

p. 151, p. 236

〈鐵板燒店〉，《臉上的光彩 2.0》系列
Teppanyaki shop, Glow on the Face 2.0 Series

〈鐵板燒店〉模仿林布蘭特（Rembrandt van Rijn, 1606-1669）的畫作〈杜爾博士的解剖學課〉，作者將畫作中醫學院學生學習解剖的場景，與生活中觀察到人們在餐廳面對美食「手機先拍」的生活情境，透過聯想將畫作與情境結合。解剖教室轉變為現代的鐵板燒餐廳，手持解剖刀劃開屍體的醫生，變為拿著鏟子的廚師。屍體則變為廚師正在炒著準備要上桌的美食。而瞪大著眼睛觀察屍體的醫學院學生則變為鐵板燒台前等上菜的顧客，他們正拿起手機拍著將要端上來的美食，並準備將美食照上傳網路分享。 —— 王鼎元

Teppanyaki shop drew inspiration from Rembrandt van Rijn's *The Anatomy Lesson of Dr. Nicolaes Tulp*. Wang Ding-Yuan fused the painting's scene of medical students learning anatomy with the modern scene of people photographing food at restaurants. The anatomy classroom is transformed into a contemporary teppanyaki restaurant, with the scalpel-wielding doctor replaced by a spatula-toting chef. The dissected body evolves into the dish the chef prepares to serve. The captivated medical students become customers at the teppanyaki counter, holding their smartphones, capturing the dish as it arrives, and readying themselves to share their culinary experiences online. — Wang Ding-Yuan

p. 152, p. 236

〈過馬路不要滑手機〉，《臉上的光彩 2.0》系列
Do not use your smartphone while crossing the street, Glow on the Face 2.0 Series

〈過馬路不要滑手機〉靈感來自老布勒哲爾（Pieter Brueghel de Oude, 1525-1569）的作品〈盲人的寓言〉，聯想曾經看過一則新聞，因低頭族盛行造成交通事故頻傳，紐約有一群義工組成「導盲人」負責帶領正在使用手機的低頭族到他們想去的地方，「低頭族」在過馬路時，也算是睜眼瞎的盲人，這其實是一場街頭惡作劇表演。本作品改編為現代低頭族，拍攝地點為玄奘大學校園內某大樓前馬路的斑馬線上，拍攝對象皆是作者的學生。該建築是建在一個斜坡上，所以透過面向下坡方向的馬路，正好可以因位置的高低差而看到遠方的建築物，構圖上就符合〈盲人的寓言〉畫作中遠景有建築物的感覺，然後將畫作中盲人的手杖改為自拍棒。讓幾位學生肩搭肩行走，表演過馬路玩手機的畫面。畫面最右邊的兩位行人則是表現因為在滑手機太過專心，沒注意到前方有人撞在一起，其中一位貌似被撞倒，手機也被撞飛了起來。 —— 王鼎元

Drawing inspiration from Pieter Brueghel de Oude's *The Parable of the Blind*, this work refers to news about accidents caused by smartphone distraction. In New York, a volunteer 'guide for the blind' group emerged to assist phone-obsessed pedestrians, treating them as sighted yet blind individuals, and it was ultimately revealed as a street performance.
Adapting the painting for contemporary smartphone users, Wang set the scene at a zebra crossing in front of a building on Hsuan Chuang University's campus, featuring his students. The building is situated on a slope, allowing the composition to include distant structures in the background, reminiscent of *The Parable of the Blind*. Walking sticks are replaced with selfie sticks, and students walk shoulder-to-shoulder, portraying phone use while crossing the street. To the far right, two pedestrians, engrossed in their phones, fail to notice an impending collision—one seems to be knocked down, their phone sent flying. — Wang Ding-Yuan

p. 153, p. 236

〈懷孕家庭照〉，《臉上的光彩 2.0》系列
Pregnant family photo, Glow on the Face 2.0 Series

〈懷孕家庭照〉模仿凡・艾克（Johannes de Eyck, 1395-1441）的畫作〈阿諾菲尼的婚禮〉，拍攝一對夫妻，女方正好懷孕待產，拍攝地點在他們家中的客廳。畫面人物姿勢則是以兩人手牽手，女方拿著自拍棒以手機取景自拍，男方則是手持智慧手錶，以無線遙控的方式遙控手機拍下一張產前的紀念家庭照。被攝者家中裝飾色調本以白色為主，作者在後製時從〈阿諾菲尼的婚禮〉原畫作背景中的床得到靈感，將原本乳白色的窗簾改為暗紅色，背景窗簾前擺設一臺筆記型電腦，並開啟視訊鏡頭對著兩夫妻的背影，以對應〈阿諾菲尼的婚禮〉畫作背景中的鏡子。 —— 王鼎元

Pregnant Family Photo mimics Johannes de Eyck's *The Arnolfini Wedding*, depicting a soon-to-be-parents couple in their living room. Their poses show them hand-in-hand, the wife taking a smartphone selfie with a stick, and the husband wirelessly operating the smartphone through his smartwatch to capture a prenatal family photo. Initially, the subjects' home featured a predominantly white color scheme. However, the author drew inspiration from the bed in *The Arnolfini Wedding* background, transforming the milky-white curtains into a dark red. A laptop with an activated webcam faces the couple's silhouettes, corresponding to the mirror in the original painting's background. — Wang Ding-Yuan

p. 154, p. 236

〈泳裝拍攝現場〉，《臉上的光彩 2.0》系列
Swimsuit shooting scene, Glow on the Face 2.0 Series

〈泳裝拍攝現場〉模仿波里且利（Sandro Botticelli, 1445-1510）的畫作〈維納斯的誕生〉，拍攝攝影棚內的工作場景，攝影棚這場域象徵誕生出維納斯的貝殼，畫面呈現的故事則為拍攝中途休息的片段，左一為手拿吹風機的攝助（風神），在拍攝中間的休息時間朝著自己吹風作測試機器。攝助旁邊左二是準備補妝的造型師（花神）。右二則是幫模特兒披上外套的模特助理（春神）。模特（中）則是拿著手機直撥或是自拍自己的工作狀態（維納斯）。這件作品與原畫作不同的是作品的右邊作者增加一個讓自己背影入鏡的角色（攝影師）正在檢查相機畫面，大螢幕中的畫面是主角擺出畫作維納斯的姿勢，桌面上擺著筆電，螢幕邊貼著參考圖，筆電螢幕的桌布都是原參考畫作，作為提示觀者此件作品參考來源的彩蛋。—— 王鼎元

Swimsuit Shooting Scene imitates Sandro Botticelli's painting *The Birth of Venus*, capturing a working scene inside a photography studio. The studio space symbolizes the shell from which Venus is born. The scene presents a moment of rest during the photoshoot. To the left is an assistant (the wind god) holding a hairdryer who tests the machine by blowing air at himself during the break. To the left of the assistant is a stylist (the flower god) preparing to touch up makeup. To the right is an assistant (the spring god) helping the model put on a coat. The model (Venus in center) is holding a smartphone, either live streaming or taking a selfie of her working scene.
Differing from the original painting, Wang Ding-Yuan added a character to the right of the artwork, capturing their own silhouette (the photographer) as they check the camera's display. The large screen shows the protagonist posing as Venus from the painting. A laptop is placed on the table with a reference image attached to the screen. The laptop's wallpaper features the original reference painting, serving as an Easter egg to hint at the source of inspiration for the viewers. — Wang Ding-Yuan

pp. 154-155, p. 236

〈社團會議〉，《臉上的光彩 2.0》系列
Club meeting, Glow on the Face 2.0 Series

〈社團會議〉模仿達文西（Leonardo da Vinci, 1452-1519）的畫作〈最後的晚餐〉。拍攝對象是作者曾經教授的師大社團學生，畫面呈現著學生們正在會議中討論社團課程內容，作者試圖模仿原畫作將畫面以三人為一組分為許多不同小組，如右一至三為一組正在討論，左一至三為一組正在自拍，左四至六為一組其中兩位同學在討論、一位在記錄，右四則是聽音樂同時看著同學的畫面，右六則是手機沒訊號，右五的同學看著中間社長手機畫面，中間是社長則一面操作電腦，一面比對著手機的資料。右五的同學口袋中其實有個半露的手機螢幕，手機桌布的畫面正是作者模仿原畫作中一小部分，作為提示觀者此件作品參考來源的彩蛋。—— 王鼎元

Club Meeting is an adaptation of Leonardo da Vinci's iconic painting *The Last Supper*. The scene features students from a university club, which the artist once mentored, engaged in a meeting to discuss the club's course content. The artist emulated the original painting by dividing the scene into smaller groups of three:
Group 1 (right 1-3): engaged in discussion
Group 2 (left 1-3): taking a selfie
Group 3 (left 4-6): two students discussing while one takes notes
Group 4 (right 4): listening to music while looking at a classmate's screen
Group 5 (right 6): a student with no phone signal
At the center, the club president operates a computer while cross-referencing information on their phone. The student to the right (right 5) looks at the president's phone screen. A partially exposed phone screen in this student's pocket displays a wallpaper that includes a small section of the original painting, hinting at the source of inspiration. — Wang Ding-Yuan

pp. 156-157, p. 236

楊士毅
YANG Shih-Yi

〈繁花盛開的祝福〉
Blessings of Blooming Flowers

以剪紙的概念，在高雄衛武營音樂廳的戶外天井製作的裝置藝術作品，同時創作記錄光線變化的縮時攝影作品。我們可以看見隨著天空光線的變化，剪紙雕花鏤空的部分，因為時間的流動，會篩進不同的光影變化，明暗變化無窮。同時帶有慶祝年節歡樂的氣氛所製作生肖年的造形剪紙，也因光強度的不同，色彩隨之改變。
〈繁花盛開的祝福〉這件裝置作品刻意選擇在戶外天井上舖蓋雕花，是為了讓人仰望。楊士毅故意使用這樣的設計，因為他發現當人在抬頭的時候，就會停下來，好好觀看或是將心沉澱下來，美好的事物也因此從內心浮現。換句話說，楊士毅設計作品的重點，不是吸引別人的目光到他的作品上，而是其作品背後的意涵和理念能不能引導觀者看見自己。作品如同一點點光，照亮他人並給予一點力量，讓人自我觀照，這就是他賦予作品的意義。另外，他覺得默默付出的人都如同天上掉下來的天使，生肖牛變成一個天使牛。在這個畫面空間裡面，唯一有翅膀的天使在地上不在天空，因為長出翅膀，不是為了飛向遠方，而是為了把美好的事物帶給每個人所愛的人，而且當我們只要意識到光的存在，隨時都有追求幸福的力量。 —— 姜麗華

In this captivating installation upon an outdoor patio outside the concert hall of National Kaohsiung Center for the Arts, the artist employed the concept of paper cutting to create a visually dynamic piece, accompanied by a time-lapse photographic work that records the shifting light. As the sky light transforms, the intricate cut-outs cast ever-changing shadows, producing infinite combinations of light and shadows. The paper cutting, adorned with festive zodiac animals, alters its colors based on the light intensity.
Entitled *Blessings of Blooming Flowers*, the installation invites viewers to gaze upward, a deliberate choice by the artist. Yang Shih-Yi observed that looking up constrains movement, prompting people to pause, reflect, and discover beauty within. Rather than seeking attention for his work, Yang Shih-Yi aims to guide viewers to self-discovery through underlying meanings and concepts. The piece serves as a beacon, illuminating and empowering people to see themselves. The artist considers selfless individuals angels, transforming the zodiac ox into a corresponding angelic figure. In the spatial composition, the winged angel remains grounded, symbolizing the desire to bring beauty and love to those around. The presence of light always guides people to find the strength to pursue happiness. — Chiang Li-Hua

pp. 158-159, p. 236

李毓琪
LI Yu-Chi

《近郊》
Suburbs

它的起源來自夜晚，和一次夢境。
光線不斷前進，凝結被光顯影的局部環境與地形。
微弱的光源照亮被遺忘、擱置的記憶和意識，在黑暗中，與光明的二元對立彼此消解，輔助共存。
意識之光引領我，在心靈的近郊中去探索那更廣袤的黑暗。
去聆聽、安放與遺忘。 —— 李毓琪

It stemmed from the night and a dream.
Light continually advances, solidifying the local environment and terrain revealed by its illumination.
The dim light uncovers forgotten, abandoned memories and consciousness. In darkness, the binary opposition between light and darkness dissolves, fostering coexistence.
The light of consciousness guides me to explore the vast darkness within the suburbs of my mind.
To listen, find peace, and forget. — Li Yu-Chi

pp. 160-161, p. 236

《近郊》＃ 02
Suburbs 02

《近郊》＃ 18
Suburbs 18



隱劍之影
THE SHADOW OF METAPHOR

石萬里
SHIH Wan-Li

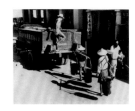

《高雄市政發展》系列 -89
The Development of Kaohsiung City's Governance Series-89

石萬里的《高雄市政發展》系列大約從二戰後國民政府來臺的 1940 年代至 1970 年代左右。顧名思義,這是一系列關於高雄市政發展與都市計畫的記錄照片,拍攝內容從最早的戰後高雄殘破的房舍、布滿砂礫碎石的泥地、貧瘠荒蕪的農地、淹水的馬路等「百廢待舉」的景象,一直到政府推行市政建設後的造橋鋪路、鋪設自來水管、架設電線桿、進行鐵路工程等基礎建設,乃至於設立學校、圖書館、醫院等更多現代化的都市建設之發展進程,拍攝年代長達三十年,為高雄市都市計畫進行的始末,留下難以計數的影像檔案。這張《高雄市政發展》系列 -89 是 1954 年 6 月 1 日,高雄市衛生單位派遣水肥車為民眾抽取家中水肥的記錄照片。畫面中人物有的穿木屐戴草帽,有的穿功夫鞋戴斗笠,有的則著襯衫西裝褲,從這幾種風格迥異的衣裝風格並存,可看出各種文化留存在高雄這塊土地上的痕跡。 —— 呂筱渝

Shih Wan-Li's *The Development of Kaohsiung City's Governance* Series comprises a collection of photographs documenting the urbanization process and urban planning of Kaohsiung from the 1940s to the 1970s, after the Kuomintang government arrived in Taiwan following World War II. The Series captures the transformation from the aftermath of the war, including destroyed buildings, rubble-filled land, impoverished farmland, and flooded roads, to the construction of bridges, roads, water and power supply systems, and railway projects during the government's implementation of urban construction. It also covers the construction of infrastructure, such as schools, libraries, and hospitals, spanning 30 years. The Series provides a valuable historical record of Kaohsiung's urban development and planning.
The Development of Kaohsiung City's Governance Series-89 captures the Kaohsiung city health department dispatching a septic truck to clean out a cesspool on June 1, 1954. The photo showcases the diverse cultural influences in Kaohsiung, with people dressed in various styles, including wooden clogs and straw hats, Kung Fu shoes and bamboo hats, and dress shirts and suit pants. — Lu Hsiao-Yu

pp. 164-165, p. 224

李鳴鵰
LEE Ming-Tiao

〈女子像〉
Portrait of a Woman

在攝影術發明以前,肖像畫作為主要人物畫中重要的題材。雖然東、西方在肖像畫上的表現,媒材的運用與其功能性都不盡相同,但絕大部分以頭部與臉部表情經常是主要表現的焦點,從人物的五官刻劃出情感與氣質,從裝扮、服飾或珠寶等彰顯人物的政經地位等。在攝影技術發展之後,由於在時間上比繪畫更快速完成人物的描繪,肖像照逐漸成為身分認證的資料。這張〈女子像〉的照片李鳴鵰直接在人物頭像上做光影的變化,並非唯美的沙龍照,也不是寫實的肖像紀錄。照片中的女子臉微側,淺笑望向鏡頭之外,陽光透過窗櫺映照到女子臉部,形成的條紋如同紋面般產生獨特的線條,也引人聯想這樣的條紋是否有隱射其他的意涵。柔化的花草樹影背景對照清晰的人物臉部特色,形成強烈的視覺張力,也讓這件人物肖像攝影具備鮮明的藝術風格。 —— 姜麗華

Portraiture had been a significant genre in figurative art even before the advent of photography. Despite cultural differences between eastern and western portraiture in expression, medium, and purpose, both forms of art place the head at the center of attention, and convey emotions through facial features, and social status through clothing and jewelry. As photography replaced traditional portraiture, it became a more functional means of identity verification. *Portrait of a Woman* displays a unique artistic style through its manipulation of light and shadow. The subject's face is altered through this process, with the woman's slight smile and gaze towards the camera adding a touch of charm. The sunlight filtering through a window creates distinctive stripes on the subject's face, adding to the photo's appeal. The background of flowers, trees, and shadows serves to contrast the clear facial features of the subject, thereby creating a powerful visual tension that characterizes the portrait. — Chiang Li-Hua

p. 166, p. 224

〈工作一天要回家啦〉
Heading Home After a Day's Work

臺灣早期農業社會中，水牛是相當重要的勞力來源，因此人與牛之間有著密切的情感，而牧童和水牛更是常見的農村景象，也是早期描繪鄉村生活最常取材的主題之一。日本時期，臺灣農村的水牛牧童的主題象徵南國的風景氛圍，戰後則是農村常見的日常景致，呈現牛隻和農人的畫面，經常象徵刻苦耐勞、辛勤努力的精神意涵。

李鳴鵰這件作品〈工作一天要回家啦〉，就構圖上而言，以剪影呈現牧童牽著一頭牛，反射在路面上拉長的影子表明拍攝時間已近黃昏，在日落西山的歸途中，工作整天後的牧童牽著牛正要返家，因無法看到牧童此刻的表情，鎮日的勞累不言而喻。因以逆光的方式拍攝牧童和牛隻而呈現鮮明的輪廓，背景相當簡潔，整件作品在光影之間的表現達到極致，也凸顯攝影師在攝影技巧外，刻意展現出來如繪畫般的畫面。——姜麗華

Water buffaloes played a crucial role in Taiwan's early agricultural society, forging an emotional bond with humans. The image of young cowherds herding buffaloes was a common rural scene and a popular theme in early Taiwanese art. During the Japanese colonial period, water buffalo and cowherd themes symbolized the exotic scenery of the south. Post World War II, they became a prevalent rural landscape imbued with the spirit of diligence and perseverance so prevalent amongst farmers and their livestock.
Heading Home After a Day's Work, portrays a cowherd leading a water buffalo back home at sunset. The elongated shadow on the road indicates the time of the shot, and the pair stand out against the backlit sun, creating a sharp silhouette. The photographer's technical skills and the simple background bring the deliberate painting-like composition and expression of light and shadow to the fore. — Chiang Li-Hua

參考來源：
林以珞－國美館重建臺灣藝術史計畫「110 年攝影作品詮釋資料撰研計畫」

Reference:
Lin Yi-Luo, Interpretive Data Compilation and Research Project for Photography Works, ROC Era 110

p. 167, p. 224

秦凱
Dennis K. CHIN

〈水車〉
Waterwheel

十七歲的秦凱在上海舊貨攤買了一部 Agfa 牌毛玻璃對焦二手相機就開始拍照，〈水車〉是秦凱當時拍攝的作品，參加上海《良友》畫報舉辦的攝影比賽，榮獲首獎。得獎後的他，逐漸對於銀行的工作失去興趣，經常趁機外出拍照。當《良友》畫報編輯邀請到雜誌社協助拍攝，他毅然決然辭去銀行的職位，專職為《良友》畫報拍照，開啟他的攝影人生。這張〈水車〉是在蘇州鄉下捕捉到的畫面，因為此地有很多稻田需要灌溉，剛好這對農家夫婦正在踩水車灌溉水田，被他拍下踩水車的瞬間，他逆光拍攝農家夫婦剪影，扶著前面桿子努力地踩踏著，桿子有點像兩根十字架，象徵一種為天地、為生存奮鬥拼命的精神，這種逆光剪影拍攝手法，在那個年代非常少見，足以說明他具有藝術美學的天分。——姜麗華

At 17, Dennis K. Chin bought a second-hand Agfa camera with a ground-glass focusing screen from a Shanghai flea market and won first prize with Waterwheel in Shanghai *Liangyou* Magazine's photography competition. After receiving the award, he gradually lost interest in his job at the bank. When *Liangyou* Magazine invited him to join their team as a photographer, he resigned from his bank job and devoted himself to photography. In rural Suzhou, Dennis K. Chin photographed a farming couple treading a water wheel to irrigate their rice paddies. Taken against the light, the shot created a silhouette of the couple, who were working hard to tread on a pole resembling a cross, representing the spirit of struggle for survival. This backlit silhouette technique was uncommon at the time and demonstrated his natural artistic talent. — Chiang Li-Hua

pp. 168-169, p. 225

周鑫泉
CHOU Shin-Chiuan

〈羊群歸途〉
Returning Flock of Sheep

身兼警員身分的周鑫泉，任職於澎湖派出所期間，觀察到警局附近有一條柏油路經常有牧羊人趕著羊群路過，這樣美麗畫面在他腦海裡迴盪不已，他思索各式的構圖，甚至記錄牧羊人何時趕著羊群去到西嶼山上放牧，歸途經過跨海大橋的時間又是何時。琢磨嘗試拍攝多次，思考用什麼方法才能拍攝出他心目中理想作品，終於在 1973 年完成這幅〈羊群歸途〉。他為了擷取因對著太陽拍攝，所產生逆光的影子，同時畫面的背景還能看到跨海大橋，便調動一輛消防車協助拍攝，並在適當時機才升起消防雲梯並站上制高點，按下快門拍攝落日餘暉下羊群長長的身影。終其一生熱愛寫實攝影的他，在人生最忙碌的時刻，還是忘情不了攝影及對這塊土地的關注，利用任職於澎湖閒暇之餘創作了令人難忘的精采作品。——姜麗華

Returning Flock of Sheep is a remarkable masterpiece that showcases the beauty of the shepherding life. Chou Shin-Chiuan was a police officer stationed at the Penghu Police Station then, struck by the sight of shepherds and their flocks crossing the nearby road. With his keen eye for composition, he carefully recorded the shepherds' movements, noting when they passed by the bridge to Xiyu Mountain to graze. Chou's dedication to his craft culminated in this stunning photograph, completed in 1973. To capture the perfect shot, he ascended to a high point using the ladder of a fire truck and utilized backlighting to create the long shadows of the sheep under the glow of the sunset. Despite his busy schedule, Chou never lost his passion for photography and his love for the land, creating impressive art outside his shifts. — Chiang Li-Hua

參考來源：
楊永智－國美館重建臺灣藝術史計畫「110 年攝影作品詮釋資料撰研計畫」

Reference:
Yang Yung-Chih, Interpretive Data Compilation and Research Project for Photography Works, ROC Era 110

p. 170, p. 225

周鑫泉
CHOU Shin-Chiuan

〈共謀大計〉
Conspiracy

周鑫泉於 2004 年走訪中國浙江省各地，記錄當地的人文風光與民情風俗。他認為人與環境的關聯與生活經驗息息相關，而這種人文紀實的影像才會更有價值，因此他所拍攝的庶民生活點滴，都與時代背景緊密相關，而非去除歷史脈絡或時空環境的人像與景觀攝影。

這張〈共謀大計〉是周鑫泉參加一場浙江的農曆年廟會，在表演完後看到兩名佝僂的年長者，在暖暖的冬陽下同坐一張長板凳，熱絡地抽菸閒聊。兩人駝背的身形通過陽光投影到地面，黝黑的影子連成一氣，乍看像兩個密謀者悄聲共商大計。這幀原本以彩色底片拍攝的作品改以黑白沖印，凸顯人物、焚香、光、影等影像元素，而影子衍生的戲劇效果，更為這張照片平添一股趣味。——呂筱渝

In 2004, Chou Shin-Chiuan traveled to Zhejiang Province, China, and captured the local culture and customs. His humanistic documentary photography emphasizes the connection between people and the environment, resulting in snapshots of ordinary lives closely related to the historical background of the time. *Conspiracy* was taken during a Lunar New Year temple fair in Zhejiang. The photo depicts two hunchbacked elders sitting on a bench in the warm winter sun, their shadows resembling two conspirators secretly discussing a great plan. Originally shot on color film, the work was later printed in black and white to highlight the visual elements of the characters, incense, light, and the dramatic effect derived from the shadows. — Lu Hsiao-Yu

p. 171, p. 225

〈洱海漁歌〉
Erhai Fishing Song

鸕鶿，又名魚鷹，善潛游，是雲南省洱海漁家用以捕魚的好幫手。破曉時分，漁人載著鸕鶿的舢舨到捕魚處，再讓魚鷹鑽入湖中將魚吞進喉囊後跳回主人身邊，漁人再捏住魚鷹的頸子將魚隻擠出來，如此反覆至太陽完全升起才結束工作。

這張作品拍攝幾艘舢舨在湖泊捕魚，遠方山巒疊嶂、雲霧裊繞，逆光的漁人和魚鷹於湖邊，此刻安靜地彷彿只能由正在拍打翅膀的魚鷹製造視覺聲響；逆光的剪影與反射的倒影皆映於湖面，湖光山色、人禽共生的恬適，組成一幅雋永的景致。然而如今隨著捕撈工具的日新月異，一如牛車與農夫的關係，魚鷹不再為漁人所用，這幀 1994 年〈洱海漁歌〉的人文風情也已成過往雲煙。——呂筱渝

Cormorants were helpful companions to fishermen on Erhai Lake in Yunnan Province, serving as skilled divers. At dawn, fishermen took their cormorant-laden boats to the fishing grounds, where the birds dived into the lake to catch fish in their throat pouches. The birds then returned to their owners, who held their necks and squeezed the fish out. The process would continue until sunrise, signaling the end of work. The backlit scene of the fishermen and birds creates a serene and timeless view of the coexistence of humans and birds, with mountains and clouds in the distance. In this quiet scene, the flapping wings of cormorants is the only sound that is received visually. With the modernization of fishing tools, the practice is now a relic of tradition, making this photograph a captivating document of the past. — Lu Hsiao-Yu

pp. 172-173, p. 225

邱德雲
CHIU De-Yun

《汗流脈絡》系列 -13
The Context of Sweating Series-13

《汗流脈絡》系列記錄勞動者農村耕耘、拓荒開墾的史跡，表現寫實的鄉土情懷，張張都是真實的故事。《汗流脈絡》系列 -13 畫面裡一名農耕者頂著烈日，手持鏟子正在為生活打拼，彎腰的身體映照出宛如一頭牛的身影，顯現莊稼人刻苦耐勞的硬頸精神。——姜麗華

The Context of Sweating Series is a photographic collection that captures the historical footprints of rural laborers as they toiled and forged ahead in land establishment. Each image in the collection depicts a true story and expresses a sentiment bound to the motherland. In *The Context of Sweating* Series-13, the farmer's unrelenting spirit is vividly portrayed as he works tirelessly under the scorching sun, holding a shovel in hand. His hunched body, reminiscent of an ox, reflects the indomitable and tenacious spirit of the diligent people who never cease in their pursuit of a better life. — Chiang Li-Hua

pp. 174-175, p. 226

謝震隆
HSIEH Chen-Lung

〈橋下〉
Under the Bridge

謝震隆對於光影掌握拿捏相當精準得當、曝光精確，營造出清楚的明暗對比與物體的質地感，對於構圖熟稔隨性自然、不生硬。這幅〈橋下〉構圖大膽，橫跨地面上方的橋，在陽光的照射下，投下大範圍的陰影，意外成為人們避暑之處，橋下的陰影處也因此聚集許多活動。此作品於 1963 年獲得義大利 Concorso Fotografico Ferrnia 比賽入選，畫面的構圖巧妙，謝震隆讓一道巨大黑影從對角線橫切而下，上方乾涸的泥地占三分之二的畫面，下方不到三分之一畫面面積則是潺潺的河水，其中可見兩位庶民在水邊悠哉地垂釣，一位在陰影處，另一位則在陽光下，其身影與袋子的影子拖得細長，形成有趣的對應。此作光影的處理十分細緻，從俯視的角度可以看到河床上清晰的皺褶紋路，形成不規則的線條圖形，河床的泥土質感顯露無遺，人物和釣竿顯得清晰明亮，富有層次感。在這個光線斜照的時刻，透過構圖與光影的搭配，謝震隆塑造出一幅饒富趣味的影子戲法。 —— 姜麗華

Hsieh Chen-Lung's photography is characterized by a remarkable command of light and shadow, resulting in precise exposure and the vivid contrast and texture of the objects. His compositions are both natural and expertly crafted, exemplified in his piece *Under the Bridge*. The bold composition features a bridge casting a large shadow, unexpectedly transformed into a gathering place for individuals seeking shade. Hsieh ingeniously divides the scene with a massive black shadow that diagonally cuts through the border of the dry land and the stream. Two people leisurely fish along the riverbank, with one basking in the sunlight and the other hidden in the shadow. From a bird's-eye perspective, the texture of the riverbed's mud is visible, revealing intricate details of the environment. The characters and their fishing rods are rendered with crisp detail and contrast, creating a multi-layered image. Hsieh's playful use of composition and light and shadow transform the moment to a captivating and visually stunning piece. *Under the Bridge* was selected for the Italian *Concorso Fotografico Ferrmoa* competition in 1963, solidifying his reputation as a talented photographer. — Chiang Li-Hua

p. 176, p. 226

〈倒影〉
Reflection

在謝震隆的攝影理念中，兼顧畫面比例與平衡的構圖固然理想，但構圖的重要性卻不及照片所拍攝的內容，因缺乏內容的照片，即便構圖良好，卻仍顯空洞。因此，談及攝影，謝震隆總記著父親的提醒，在按下快門之前，對於要拍什麼、怎麼拍，心中須先有一個「主意」。作品〈倒影〉，顯然謝震隆所聚焦的拍攝主題為影，畫面表現一名挑著扁擔的男子於水中的倒影，形狀猶如一座天秤。作品中的光源從男子的背向而來，男子背光的正面因而顯得陰暗不清。前方所延伸出的影子，因水的折射產生一深一淺的層次，與水面的漣漪，相互堆疊。在陽光照射下，扁擔的一端閃閃發光，裡頭裝的應是男子所捕的漁獲。謝震隆作品中人物與影子有趣的虛實相映，不僅反映出攝影家對光影的敏銳，亦述說早期鄉村社會裡，經常於太陽底下辛勤勞動的人們。 —— 姜麗華

Hsieh Chen-Lung's photographic philosophy emphasizes the importance of content over well-balanced composition. Speaking of photography, Hsieh follows his father's thoughts on having a clear vision of what and how to shoot before pressing the shutter. *Reflection* centers around the theme of shadows and captures the reflection of a man carrying a shoulder pole in water, like a balance. The light source behind the man casts his front in darkness and creates an extended shadow. The image's layered effect is a result of water refraction and the overlapping ripples on the water surface. The man is carrying the fish he caught, as suggested by the shining end of the shoulder pole under the sunlight. Hsieh's sensitivity to light and shadow is evident in his work, which also highlights the rural people who worked under the sun. — Chiang Li-Hua

p. 177, p. 226

參考來源：
吳佳蓉－國美館重建臺灣藝術史計畫
「109 年度攝影類作品詮釋資料撰研計畫」

Reference:
Wu Chia-Rong, Interpretive Data Compilation and Research Project for Photography Works of NTMFA Reconstructing History of Art in Taiwan, ROC Era 109

鄭桑溪
CHENG Shang-Hsi

〈信徒〉
Believer

鄭桑溪年輕時吸取西方現代攝影精神，講究表現光影的變化，構圖大膽且獨特，在形式與技術層面上特別突出，營造畫面獨具的迷惘氛圍。在這幅〈信徒〉中，鄭桑溪在彰化八卦山的寺廟裡攝取一名女信徒與她身旁所攜帶的包袱，而她正低頭虔誠的跪地膜拜。鄭桑溪從俯視的視角拍攝，構圖中我們看到這名人物僅占中間偏上方一小部分的空間，畫面上方與下方的空間都籠罩在黑暗中。光線從婦女的背後襲來，投射在這名女信徒身後形成拉長的身影，影子與下方闇黑的背景融為一體。而位於畫面中間泛白的部分，猶如杏核狀的巨大眼睛，彷彿是大佛的視角亦在凝視著渺小的信眾，在靜謐的空間中散發出莊嚴的氣氛，透過巧妙又戲劇性的光影組構，傳達出聚光燈下人物聚精會神的敬意。── 姜麗華

Cheng Shang-Hsi absorbed Western modern photography at a young age, emphasizing expressions of changes in light and shadow, creating a bewildering atmosphere, with bold and unique compositions that are outstanding in terms of form and technique. In *Believer*, Cheng captured a female worshiper in a temple on Bagua Mountain in Changhua, carrying a bundle and devoutly kneeling on the ground. Cheng shot from a bird's-eye view, so we can see the figure of this woman occupying only a small part of space in the middle and upper part of the composition, with the rest shrouded in darkness. The light comes from behind the woman, casting a long shadow, and blending the shadow with the dark background. The whitish part in the middle of the image, as if an apricot kernel-shaped giant eye of the Buddha gazing at the humble worshiper, adds solemnity in the space. Through ingenious dramatic lighting and shadow composition, this image conveys a worshiper's great respect. — Chiang Li-hua

p. 178, p. 226

〈打球〉
Playing Ball

1960 年代臺灣攝影圈以唯美沙龍攝影為主流，而鄭桑溪受到西方現代攝影影響，以強調光影來創作，善用 Pentax S2 單眼反光相機及 200mm 長鏡頭，用鏡頭發揮創意讓人產生微觀美學意象，這種光影對比強烈的作品在當時是前所未有的。尤其 1965 年他與張照堂的「現代攝影」雙人展，他刻意選了一些特殊構圖、光影較強烈、內容超現實異樣的作品展出。這幅〈打球〉著重在光影的表現，他刻意從高處俯視拍攝實際上只有六名小男孩一起在日照下打球，因斜陽逆光產生黑色的影子，那顆球變成兩顆，而人體的形象僅有黑體的輪廓，看不清表情，也分不清影子與真實的人體差別，宛如有十位孩子一起在打球嬉戲，讓原本孩童們平日習常的運動，變成一群影子彷如在多次元魔幻空間裡舞動著。── 姜麗華

In the 1960s, Taiwan's photography scene was dominated by salon photography. However, influenced by Western modern photography, Cheng utilized a Pentax S2 SLR camera and a 200mm telephoto lens to create imaginative images with strong contrasts of light and shadow that were unprecedented at that time.
In his joint exhibition with Chang Chao-Tang titled Modern Photography in 1965, he selected works of special composition, strong light and shadow, and surreal elements. *Playing Ball* emphasizes light and shadow: Cheng took the photograph from a high point, capturing six young boys playing ball in the sunlight; due to the backlight, it is hard to differentiate between the shadows and the ball and the kids, giving the impression that there were ten children playing together. The children's play appears as shadows dancing in a magical dimension. — Chiang Li-hua

參考來源：
楊永智—國美館重建臺灣藝術史計畫
「108 年度典藏品詮釋資料撰研工作計畫」

Reference:
Yang Yung-Chih, 2019 Interpretive Data Compilation and Research Project for Photography Works of NTMoFA

p. 179, p. 226

莊靈
CHUANG Ling

〈峽谷──花蓮太魯閣〉
Gorge — Hualien Taroko

此作 1986 年攝於花蓮太魯閣峽谷的靳珩橋附近，當時亮麗的朝陽正照在溪谷對岸的大山絕壁上；而反射著耀眼陽光的白色大理石山壁，在兩側陰黯山影的夾襯和對比之下，剛好形成一幅 Y 字形的構圖，於是便成就了一張看不到立霧溪的少見太魯閣峽谷景觀。── 莊靈

The image was photographed in 1986 near the Jinhean Bridge in Taroko Gorge, Hualien. The bright morning sun was shining on the steep cliffs on the opposite side of the valley. The white marble cliff reflected the dazzling sunlight and was framed by the dim shadows of the surrounding mountains to form a Y-shaped composition. A rare view of Taroko Gorge without the Liwu River visible in the photo was thus created. — Chuang Ling

p. 180, p. 226

〈白公祠牆外——重慶忠縣〉
Outside the Wall of Baigong Shrine-Chongqing Zhong County

這是 1998 年長江三峽建壩合龍的翌年夏天，作者偕同兩位兩岸的攝影好友，再度深入三峽未來淹沒區，用影像繼續記錄當地即將消逝或巨變的地理景觀、產業、人文和文化古蹟旅次時所攝。白公祠是紀念唐代大詩人白居易的祠堂，他曾在四川忠縣任過官。祠堂就建在長江南岸山坡高處，那裡地點僻靜，祠內展品簡陋，無甚可觀；而作者卻在祠堂斑駁的黃色外牆壁面上，發現一塊由周遭林木和牆沿下的疏落植栽，在下午陽光照射下所形成的斜角投影，其光影映照十分動人，於是便立刻按下手中的相機快門。—— 莊靈

In the summer of 1999, a year after the completion of the Three Gorges Dam, Chuang Ling and two photographers from both sides of the Taiwan Strait ventured once again into the soon-to-be-submerged areas of the Three Gorges to document the disappearing geographical landscapes, industries, cultural heritage, and historical relics. Baigong Shrine is a temple dedicated to the Tang Dynasty poet, Bai Juyi, who once served as an official in Zhong County, Sichuan. The shrine was built on a slope on the south bank of the Yangtze River, in a quiet location with simple exhibits inside. Chuang discovered a fascinating diagonal projection on the dilapidated yellow wall of the temple caused by the surrounding trees and the sparse vegetation along the wall in the afternoon sunlight. The interplay of light and shadow was so captivating that the photographer pressed the shutter to capture the moment. — Chuang Ling

p. 181, p. 227

〈1950 年代臺灣省立農學院（今興大前身）各系系館長廊〉
The Corridors of the Department Buildings of Taiwan Provincial College of Agriculture (Present Day National Chung Hsing University) in the 1950s

這張攝影是作者還在農學院念書時畢業前的習作，距離今天已經有六十二年之久；它是為了參加 2022 年，作者應興大藝術中心邀請，舉辦「影紀母校 · 尋藝一生——莊靈校友攝影特展」而被重新發掘出土的歷史紀錄影像。其實之所以選它，除了因為是母校校景，更因老建築獨特的光影結構和氛圍，充分顯現出上個世紀中葉，整個社會雖然樸素、簡陋，卻平靜而安詳；並且對未來充滿希望的特質與精神！—— 莊靈

The photograph was taken as an exercise right before Chuang Ling graduated from Taiwan Provincial College of Agriculture over 62 years ago. It has been rediscovered for the special exhibition School Memories and Artistic Pursuits: Chuang Ling's Alumni Photography Exhibition held at the Chung Hsing University Art Center in 2022. The image does not merely depict the campus of Chuang's alma mater, but delivers the peaceful atmosphere of mid-20th century society through the unique lighting and serenity of old structures. Despite the simplicity and crudeness, the social climate of the time was full of hope toward the future. — Chuang Ling

pp. 182-183, p. 227

謝明順
Vincent HSIEH

〈自在〉，《雕塑情懷的「像雕」》系列
Ease, Sculptural Sentiments Series

作品《雕塑情懷的「像雕」》系列，借以探問何謂藝術，何謂美，沒有定義；何謂創作，如何創作最佳，沒有正解，卻有很多答案。
攝影到底是寫實、寫意、記錄抑或只是一種再現？至今沒有定論，不過，它屬於藝術則有定見。
當攝影、繪畫和雕刻混合一體出現時，前所未有，個人稱它為「像雕」。混合媒材的創作，眾所周知，混合藝趣的手法唯我獨享；先求唯一，再求第一，個人終生不渝的「像雕」作品，只求大家的認識、認知，不奢求大家的認同。個人認為「只要我喜歡，有什麼不可以」只能巧妙地出現在藝術創作上，為沒有定義的定義下定義；因為，只有自我，才有自己。—— 謝明順

The Series embodies a sculptural sentiment and seeks to explore the nature of art and beauty. There is no definitive answer to what constitutes creativity or the best way to create, but only possibilities.
Is photography about realism, expressionism, documentation, or merely representation? There is no consensus to this day. However, it is agreed that photography belongs to the realm of art.
When photography, painting, and sculpture converge in an unprecedented fusion, I call it, Like Sculpture. The use of mixed media in art is well-known, but the blending of artistic interests is something exclusive for me to indulge in. My life-long dedication to Like Sculpture strives for uniqueness first and foremost, and then for being the best. I only seek reception and acknowledgment from others, not necessarily their agreement. I believe the idea that 'as long as I like it, what's wrong with it?' can only be truly applied to artistic creation, defining what is undefined, because only through self can one truly find oneself. — Vincent Hsieh

p. 184, p. 227

張照堂
CHANG Chao-Tang

〈板橋〉
Banqiao

1962-1965 年間是我的大學時代，受到西方文學、繪畫、電影、戲劇等現代思潮的影響，對「存在與虛無」的生命質疑與迷津產生莫大的關注與想像；身體在，靈魂在嗎？靈魂不在，光影在嗎？存在有虛無嗎？虛無無存在嗎？當手上剛好有一部相機，「在與不在」就成為一種無法遁逃與解脫的尋覓方向。

我冀求尋找的不是風景，是氛圍，是一種絕對的狀態。這樣的狀態，或許想表達一種全然的安靜、空無或迷茫，或許試圖呈現一種微妙的想像或期待，抑或許想醞釀另一種呼之欲出的能量騷動。現實在，現實似乎又不在，人出現或曾經出現，但似乎只留下一些殘缺與模糊的蹤影。「人」在鏡頭前妝臉作勢，沒有直言的告白，只有緘默的等待。那凝結的瞬間，或許也是時光的永恆。

我在這樣的風景中，陷入迷失的喜悅，或許也找到心靈的撫慰與釋放。—— 張照堂

During my college years from 1962 to 1965, I was influenced by modernism in Western literature, painting, film, and drama. I became obsessed with questions and quandaries surrounding existence and nothingness. Is the soul present when the body is? Can light and shadow exist without the soul? Does existence contain nothingness? Does nothingness lack existence? When I had my camera in my hand, being and not being drew me to explore the inescapable and unresolvable path.

What I sought was not scenery, but atmosphere, an absolute state. Such a state might deliver a profound sense of stillness, emptiness, or bewilderment. It might attempt to present a subtle imagination, or anticipation, or perhaps ferment another sort of emerging and restless energy. Reality exists, yet seems not to; people appear or have appeared, but seem to leave only fragmented and blurry traces. Before the camera, these 'people' posture with painted faces, offering no explicit confessions, only silent waiting. The frozen moment might be an eternity.

In such a scene, I found myself delighting in being lost, and, perhaps, discovering solace and relief for my mind. — Chang Chao-Tang

p. 185, p. 228

葉　裁
YEH Tsai

參考來源：
古少騏－國美館重建臺灣藝術史計畫
「109 年度攝影類作品詮釋資料撰研計畫」

Reference:
Gu Shao-Chi, Interpretive Data Compilation and Research Project for Photography Works of NTMFA Reconstructing History of Art in Taiwan, ROC Era 109

〈鄉間馬路三人行〉
Three People on a Countryside Road

連接新竹市與竹東鎮的東西向道路 122 縣道，在日本時代即已修築完成，分別是由「新竹竹東道」、「竹東上坪道」和「上坪井上道」連接，這條路在戰後延伸到南寮，而井上更名清泉，遂被稱為南清公路。葉裁所拍攝的這段路，就是南清公路還沒有截彎取直的竹東托盤山老路段，方位是新竹往竹東方向。托盤山位在三重里，因山頂形狀像是平平方方的托盤而得名，這裡的土質是適合製造紅磚的紅黏土，因此這條路的兩側分布著數間磚窯。這幅〈鄉間馬路三人行〉是葉裁在托盤山崗俯視而下拍攝而成，畫面中蜿蜒伸展的道路構成主要的背景。畫面裡三個人都沿路往同一方向前進：最上方辛勤的挑擔婦女，中間奮力將腳踏車騎爬上坡的騎士，以及拿著豬籠子行走的農人，蜿蜒山路與人的行進，形成一致的方向性和律動。被陽光照得亮晃晃的鄉間馬路，三名人物有著剪影的效果，分布的位置也錯落有致，像是一匹白布上的圖案，綴成一幅靜謐又生動的鄉間景致。—— 呂筱渝

County Highway 122 is an east-west line that connects Hsinchu City and Zhudong Township. It was built during the Japanese Colonial period and consists of three sections, including Hsinchu Zhudong Road, Zhudong Shangping Road and Shangping Inoue Road. After WWII, the county highway was extended to Nanliao, and Inoue was renamed as Qingquan, becoming known as the Nanqing Highway. The section in Yeh Tsai's photograph is the old Zhudong Tuopan (Tray) Mountain section of the Nanqing Highway, which had not yet been straightened out. It is located in the direction of Hsinchu to Zhudong. Tuopan Mountain is located in San Chong Village and named after its plateau-shaped peak. The soil there is the perfect material for red bricks, and there are several brick kilns on both sides of the highway.

Three People on a Countryside Road was taken from a high vantage point on Tuopan Mountain. The winding road makes up the background of the image. In the picture, three people are walking in the same direction along the road: a hardworking woman carrying a load at the top, someone in the middle struggling to ride a bicycle uphill, and a farmer carrying a pig cage. The winding mountain road and people's movement create a consistent directionality and rhythm. The road surface shining in the sunlight creates a silhouette effect for the three figures, whose positions are scattered in an orderly manner. The silhouettes resemble a pattern on white cloth, producing this tranquil and lively rural scene. — Lu Hsiao-Yu

p. 186, p. 229

簡榮泰
CHIEN Yun-Tai

參考來源：
簡榮泰，《舊鄉・新情攝影展》，
臺中：臺灣省立美術館，1992 年，頁 12。

Reference:
Chien Yun-Tai, Familiar Town and Novel Sentiment
Photography Exhibition, Taichung: National
Taiwan Museum of Fine Arts, 1992, p.12.

〈臺北新莊〉，《舊鄉》系列
Xinzhuang, Taipei, Familiar Town Series

這幅〈臺北新莊〉是農家曬稻穀的日常場景，簡榮泰營造的畫面有如水蜻蜓飛舞在水面上，隨意點水形成的水波紋，一圈接一圈無盡地向外擴散，像似漣漪的波紋逐漸消失，只剩餘水的痕跡。當稻穗低垂就是收割的時候，收割後將稻穀分離出來，最後過程即是曬乾的工作。大部分農民會鋪曬在自家庭院，或在馬路空地曬乾。曬穀期間需要豔陽、高溫的大熱天，因此曬穀子是件相當辛苦的差事。這項工作通常由農家婦女負責，為避免被強烈的陽光曬傷曬黑，即使酷熱難耐，也需將全身上下緊緊包裹、頭戴斗笠，連頭臉也得包得密不通風。〈臺北新莊〉的農家女子手持曬穀耙，反覆且均勻地翻耙稻穀。強光從左側照射她的身體，映照在其右側的身影彷彿在訴說：「誰知盤中飧，粒粒皆辛苦。」── 姜麗華

The photo captures the daily scene of farmers drying rice grains. Chien Yun-Tai's composition resembles dragonflies hovering over the water's surface, forming ripples that spread outwards and gradually fade away. When rice stalks bow down, it is time for harvest. After threshing, the final step is drying. Women usually undertake the tough job of drying the grains in scorching weather. In the photograph, a farmer woman is sieving the rice grains repeatedly and vigorously while wearing a hat and a mask to avoid sunburn. The strong light from the left casts a shadow on her right side, making her look like a mechanical robot. The image conveys the idea that 'Every morsel from the dish is hard-earned.' — Chiang Li-Hua

p. 187, p. 229

阮義忠
JUAN I-Jong

〈宜蘭南澳武塔〉，《人與土地》系列
Lighthouse in Nanao, Yilan, The People and Lands Series

1950 年宜蘭縣南澳鄉武塔小學，由於該校學生不多，連升旗典禮也顯得很迷你。隊伍前面低年級的小學生穿著過大而略顯厚重的長袖制服，學童唱國歌時煞有介事的嚴肅表情，在這布滿黃土石礫、彷彿風一吹就能揚起漫天風沙的操場上更顯天真爛漫。而〈宜蘭南澳武塔〉正是臺灣 50 年代，物資和基礎建設皆缺乏的山地部落的寫照。儘管生活貧困，阮義忠刻意以景深淺淺的長鏡頭壓縮透視感，讓這幾位孩子拍起來像是由土地裡長出來，隱喻在這貧瘠荒涼的土地上，也能長出如嫩芽般、堅韌的生命力。── 呂筱渝

Lighthouse in Nanao, Yilan captures the mini flag-raising ceremony at Wuta elementary School in the mountainous tribal areas of Taiwan in the 1950s, where resources and infrastructure were severely lacking. The photograph features only seven students, with younger students in oversized long-sleeved uniforms singing the national anthem with a serious expression. Juan compressed the perspective with a shallow depth of field, making these children look like they are growing out of the ground, symbolizing the tenacity of life that could thrive in this barren land. — Lu Hsiao-Yu

p. 188, p. 230

林國彰
LIN Kuo-Chang

〈西園路艋舺公園美人照鏡池〉，《臺北道》系列
Xiyuan Road Bangka Park Beauty's Mirror Pond, Taipei Dao Series

先生。要不要按摩。青草巷祈福牆前。一個摩登女子搭訕。國語腔講兩遍。轉頭看。龍山寺前美人照鏡池。牛模牛樣亮牛燈。群牛開口笑。臺北燈節請牛神跳舞。電光牛霹靂避疫。時逢十二月冬雨。白天霪雨鬱卒。夜晚濕冷憂傷。覆帽戴口罩的雨衣人。蹲坐池邊。看艋舺燈火幢幢。柯市長點亮臺北城。像余光中守夜人。最後的守夜人守最後一盞燈。繞龍山寺行七擺。街巷淅瀝。夜市浮華。燈節從元宵節延宕到耶誕節。不過熱鬧十個夜晚。燈節放縱視覺幻光之樂。視線凝視在節慶複製的歡樂城。龍山寺 1749 年初建時。風水師指地形如美人穴。寺前鑿一蓮花池給美人照鏡。平日只遊民圍觀水舞。昨夜落幕。隔天再去看。街路清潔溜溜。說好的七彩八寶新世界。一盞燈都沒有。如美人照鏡池。── 林國彰

The massage lady asks, "Do you want a massage?" in front of the prayer wall in Qingcao Lane. A chic lady speaks Mandarin with a Taiwanese accent. Turning around, the beauty looks at herself in the mirror by Longshan Temple's pond. The ox-shaped lantern lights. The laughing ox's mouth opens wide. The Taipei Lantern Festival invites the ox god to dance. The electric light ox repels the pandemic. In December, it rains heavily during the day, making people depressed. At night, it is wet and cold, making people sad. People wearing raincoats with hats and masks squat by the pond, watching the lights of Mangka. Mayor Ko lights up Taipei City, like the night watchman coming out of Yu Guang-Chung's pen. The last watchman guards the last lamp and circles around Longshan Temple seven times. The streets are quiet, and the night market is flashy. The Lantern Festival was postponed to Christmas. However, the celebration only lasts for ten nights, giving visual pleasure through lighting. Gaze lingers on the joyous city replicated by the festival. When Longshan Temple was first built in 1749, a geomancer claimed that the terrain was like a beauty's cave. A lotus pond was dug in front of the temple for the beauty to look at herself. On ordinary days, only the homeless gather to watch the water dance. When the night ends, the streets are clean and tidy. However, there are no lights in the promised colorful new world. It is clear like the beauty's mirror pond. — Lin Kuo-Chang

p. 189, p. 230

〈寶慶路西門舊址〉，《臺北道》系列
West Gate Old Site on Baoqing Road, Taipei Dao Series

西出西門無故城。站在寶慶路成都路衡陽路漢中街中華路一段五條路交會口。尋西門城不著。此時此地。只餘逆光黑影。遮蔽了來時路。歷史不曾回返。西門舊稱寶成門。出城即到艋舺做生意。繁華勝處有寶物成就之意。1905 年日治時臺北市區改正。拆西門城。拆城垣護城壕。改設三線路。周添旺鄧雨賢作月夜愁歌曰。月色照在三線路。風吹微微。等待的人那未來。今日來者不是戀人。而是獵獵大旗人橫走。沿四周斑馬線繞轉。彷彿向消失的西門城巡禮。大路箭頭逆西。反向成都路盡頭直奔淡水河。前無古人。西出西門無故人。── 林國彰

Standing at the intersection of Baoqing Road, Chengdu Road, Hengyang Road, and Hanzhong Street on Zhonghua Road Section 1, one can no longer find the old West Gate. It has vanished into history, leaving only silhouettes against the backlight, blocking the way back. The West Gate was formerly known as Baocheng Gate, a gateway to the bustling markets of Báng-kah. The gate's name represents prosperity. In 1905, during the Japanese colonial period, Taipei City underwent major reconstruction. The West Gate was demolished, along with the city walls and moat. The Three-line Road was established in its place. On a moonlit night, Chou Tian-Wang and Deng Yu-Hsien wrote a ballad, 'The moon shines on the Three-line Road, and the wind blows slightly. I wait for my lover, but he never shows up.' The one who came is not a lover, but a person carrying a fluttering flag. Circling around the intersection, as if paying tribute to the disappeared West Gate. The arrow points west. Chengdu Road leads straight to the Tamsui River. The vanished West Gate stands silent, with no one to cross it. — Lin Kuo-Chang

p. 190, p. 230

〈忠孝東路忠孝大道〉，《臺北道》系列
Zhongxiao East Road Zhongxiao Boulevard, Taipei Dao Series

日落忠孝大道，光斑逆影照耀。K 在路上走。口罩人尋找失落的現在。空心人撿拾過去愛憎。不是森山大道來臺北掃街。而是濱口龍介電影重映。偶然與想像不就是紀實與虛構。在車上。在路上。路口遇見。錯身而過。女人與男人與戀人與他人。喋喋不休的我愛。翻來覆去。到老不相識。馬路相逢無朋友。冷眼人間。再無言語。山川道路流傳。一路走一路看。走無目的之目的。不期偶遇。以為大城市捉迷藏。陷迷宮逃不走。2001 年納莉颱風水淹臺北。捷運板南線淡水線癱瘓。忠孝東路成了忠孝大道。曾經是路。大河。大道。早忘了 1989 年夜宿忠孝東路往事。歌手陳昇拿起來放下。輕唱。忠孝東路你走一回，你有沒有認得誰。── 林國彰

As the sun sets over Zhongxiao East Road, its rays cast reverse shadows across the street. K is walking here; a masked figure searches for the lost present; a hollowed-out person scavenging for remnants of their past loves and hates. This is not Moriyama Daido photographing Taipei, but Hamaguchi Ryusuke's film revival. Wheel of Fortune and Fantasy plays with reality and fiction. Drive my car. Hit the road. Meet at the intersection. Pass each other by. Women, men, lovers, and strangers babble about love. No words are left in this cold world. The landscape of mountains, rivers, and roads endures, and we walk aimlessly, only to encounter the unexpected. In this big city, we feel as if we are playing hide and seek, but, in fact, we are trapped in a maze, unable to escape. In 2001, Typhoon Nari submerged Taipei, paralyzing the Bannan and Tamsui MRT lines, turning Zhongxiao East Road into a river. The road, the river, the boulevard, all memories of the night spent on Zhongxiao East Road in 1989, are now distant and forgotten. Singer CHEN Sheng sings softly, "Have you ever recognized anyone, walking down Zhongxiao East Road? — Lin Kuo-Chang

p. 191, p. 230

張國治
CHANG Kuo-Chih

〈如織的麵線歲月〉
Noodle Years Woven Like Fabric

過往金門的物質資源有限，島民製作生產手工麵條和麵線維生，創作者先祖亦曾在金門城起家厝靠著製麵條和麵線維生，金門手工麵線靠日曬工法生產保存，曬麵線形成特殊的人文景觀，經常吸引攝影家采風。陽光穿梭於民家曬麵線之埕，映照一個個曬麵線木架上身長之麵線中，形成一場光影動人的視覺變化，稱之「如織的歲月」帶有圖像下的深刻寓意。── 張國治

In the past, Kinmen's limited resources led islanders to rely on handmade noodles and vermicelli production for their livelihood, a tradition upheld by the artist's family. The sun-drying process for producing and preserving local handmade vermicelli creates a unique cultural landscape that attracts photographers. Sunlight filtering through noodle-drying racks in courtyards casts captivating light and shadow on the strands of vermicelli hanging from wooden frames. This scene, referred to as Woven Years, holds profound symbolism within the image. — Chang Kuo-Chih

pp. 192-193, p. 231

〈溫柔的拒馬圍籬〉
The Tender Barricades

2017 年 1 月 11 日下午 02:14:26 拍攝的作品〈溫柔的拒馬圍籬〉，是以諷喻式命名的，拒馬圍籬尖銳如蝴蝶對稱的鉤刺，在陽光下隨著黃色塑膠布受風之蠕動，卻投下曲折波浪的影子，無形中隱約削減了街頭示威或抗爭運動的緊張之氣氛，或防範竊盜入侵的森森然之樣態。—— 張國治

The Tender Barricades was captured on January 11, 2017, at 02:14:26 PM, with a metaphorical title to evoke a contrasting atmosphere. The sharp butterfly-symmetrical spikes of the barricade, when contrasted with the undulating shadows created by the yellow plastic sheet fluttering in the wind, generate an unexpected visual tension. This imagery delicately softens the intensity typically associated with protests or imposing barriers intended to deter intrusion. — Chang Kuo-Chih

p. 193, p. 231

高志尊
KAO Chih-Chun

〈Paris, 1999〉
Paris, 1999

創作者遊移在巴黎與偶遇的孩童玩起影子遊戲，剪影的手勢和看不見的臉孔，像似正與牆壁上的雕像神祕地交談許願。掌握光影巧妙的明暗關係，傳達生命不可觸及的奧秘。—— 姜麗華

The artist wanders through Paris, playing a shadow game with the children he encounters on the street. The silhouetted gestures and unseen faces seem to secretly talk with and make wishes upon the sculptures on the wall. Kao Chih-Chun masters the delicate interplay of light and shadow to present the intangible mysteries of life. — Chiang Li-Hua

p. 194, p. 231

《光的調色盤》系列
The Palette of Light Series

《光的調色盤》系列作品之一，乃 1990 年代起逾十餘年之實驗性創作，拍攝時刻意排除攝影的社會性，且以手工暗房使影像回歸媒材自身。這些作品不具特定的時代背景，淡化拍攝周圍的所在，時空被抽離或壓縮，客觀世界的真實感因此變得淡薄，僅存的只有簡潔、明快的空間構成；素淨或飽和的色彩運用，視覺元素「線條」、「色塊」、「光影」成為作品中唯一的基調。當「時間抽離」、「空間壓縮」、真實性消失、氛圍（aura）乍現時，攝影現場屬於作者個人純粹的視覺或心靈體驗，或能透過影像作品傳遞給觀者。—— 高志尊

The Palette of Light is a Series of experimental works spanning over a decade, beginning in the 1990s. The artist intentionally removed social aspects from the shooting process and used handcrafted darkroom techniques to emphasize the essence of the medium itself. These works lack a specific historical background, and the surroundings of the shooting are downplayed. Time and space are either detached or compressed, causing the sense of reality in the objective world to fade away. What remains are concise spatial compositions and clean, saturated colors. Visual elements such as lines, color blocks, and light and shadow become the sole basis of these works. When time is detached and space is compressed, authenticity disappears and an aura emerges. The shoot site then transforms into the artist's personal, pure, visual or spiritual experience, hopefully conveyed to viewers through these images. — Kao Chih-Chun

pp. 195-197, p. 231

〈阿爾〉*Arles*　　　　〈京都〉*Kyoto*　　　　〈Paris, 1994〉*Paris, 1994*　　　　〈Hawaii〉*Hawaii*

傅朝卿
FU Chao-Ching

《時向》系列
Temporal Dimension Series

「詮釋攝影」是除了攝影基本的藝術及真實本質之外，再加入攝影者本身對攝影主題的看法。一張詮釋攝影的照片，不但寫實，也有美感，更重要的它表達了攝影者的思想，不只是記錄。1990 年代，我將詮釋攝影分為四大系列，分別是「形向」、「人向」、「時向」與「幻向」，一直創作至今。「形向」系列表達的形體與空間的互動關係，照片呈現物質與美學雙重特質；「人向」表達的是人與空間互動的畫面，是人與空間不經安排的自然邂逅；「時向」表達的是時間對空間造成的影響，節氣光影的變化，讓空間有了時間的痕跡；「幻向」則捕捉空間中種種有如幻境的假象，暗示都市中的不真實容顏。 —— 傅朝卿、姜麗華

'Interpretive photography' goes beyond the conventional notions of art and reality, infusing the photographer's unique perspective on the subject matter. These photographs not only encapsulate aesthetic and realistic elements, but, crucially, embody the photographer's thoughts beyond mere documentation. Since the 1990s, the artist has devised four distinct Series within his interpretive photography: 'Formative Dimensions;' 'Human Dimensions;' 'Temporal Dimensions;' and 'Illusory Dimensions;' and this remains an ongoing creative endeavor.
'Formative Dimensions' unveils the intricate interplay between form and space, blending materiality and aesthetics within each photograph. 'Human Dimensions' captures the unscripted encounters between people and space, illustrating the dynamic interactions within their environment. 'Temporal Dimensions' conveys the profound influence of time on space, as shifting light and seasonal shadows etch the passage of time. 'Illusory Dimensions' reveals the enigmatic illusions within space, alluding to the surreal facades nestled within urban landscapes. — Fu Chao-Ching and Chiang Li-Hua

〈時向：編號 1985-1（斯德哥爾摩市政廳）〉
Temporal Dimension: No. 1985-1 (Stockholm Town Hall)

〈時向：編號 1985-1（斯德哥爾摩市政廳）〉拍攝地點是在斯德哥爾摩市政廳，隨著季節與天候的變化下光影與空間所形成的空間形體也會產生差異性，借以詮釋斯德哥爾摩市政廳的柵門，在陽光照耀下產生的影子格線，形成異質的空間感。 —— 傅朝卿、姜麗華

Captured at Stockholm City Hall, this image reveals the ever-changing spatial forms created by light and shadow as seasons and weather shift. It interprets the grid-like shadows cast by the gates under sunlight, invoking a distinct spatial perception.— Fu Chao-Ching and Chiang Li-Hua

p. 198, p. 231

〈時向：編號 1986-1（臺北地下道）〉
Temporal Dimension: No. 1986-1 (Taipei Underground Pass)

〈時向：編號 1986-1（臺北地下道）〉拍攝地點臺北地下道，由下往上拍出長長的階梯，以及路經地下道口的行人被夕陽拉長的身影，相互映趣，也把地下道空間通常具有幽暗的特色表露無遺，說明同一處空間在烈日照射之下與陰影壟罩下，會產生不同感受。 —— 傅朝卿、姜麗華

Taken at a Taipei underpass, this image captures the extensive staircase from below and the pedestrians' elongated shadows cast by the setting sun. The scene reveals the underpass's inherent darkness while emphasizing the contrasting sensations experienced in the same space, whether bathed in sunlight or shrouded in shadows. — Fu Chao-Ching and Chiang Li-Hua

p. 199, p. 231

何經泰
HO Ching-Tai

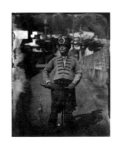

〈陳家祭司（謝慧光）〉，《百年不斷的人神之約》系列
Chen Family Priest (Xie Hui-Guang),
The Hundred-Year Covenant Between Man and God Series

《百年不斷的人神之約》系列何經泰刻意運用逾百年歷史的濕版火棉膠古老攝影技術，拍攝臺東土坂部落排灣族傳承百年人神誓約的祭典「五年祭」（Maljeveq），表現祭儀物品及參與祭祀祝禱的人物，從其穿著傳統服飾與頭冠的裝飾，溯源族群的文化情境脈絡。因純手工操作濕版火棉膠所具有不穩定的特性，致使畫面產生不可預期的線條、斑點、不規則紋路的肌理，營造脫離現實的視覺經驗，拓樸出土坂村排灣人的信仰，敬神的虔誠，迴盪於天地人神交界的異質空間，瀰漫一種虛幻縹緲的氛圍。〈陳家祭司（謝慧光）〉肖像人物是一名穿戴傳統服飾與配件的祭司，擔任向祖靈及部落各神壇獻祭，祈求祖靈保佑，除增強神壇力量、驅邪避凶外，並發給參與「五年祭」各勇士護身符安身辟邪，保佑參與的家族能在祭典中一切安泰，圓滿執行祭典事宜。—— 姜麗華

In The Hundred-Year Covenant Between Man and God Series, Ho deliberately used the collodion method, which dates back over a century, to photograph the 'Maljeveq' ritual of the Paiwan people of the Tjuabal Tribe. The ritual honors the covenant between man and the gods, and the Series features the ceremonial objects and the participants of the event, showcasing traditional clothing and headwear and tracing its cultural setting and context. The instability of the collodion process leads to unpredictable lines and spots, as well as irregular patterns and textures that enable a visual experience that transcends reality and presents a topology of the faith and devotion of the Paiwan people of the Tjuabal Tribe. Lingering within the heterogeneous space between the heavens, earth, man, and the gods, the works emit an illusory sense of ethereality.
The portrait Chen Family Priest (Xie Hui-Guang) features a priest in traditional clothing and accessories. The priest is responsible for praying for blessings and protection from ancestral spirits at the various altars of the tribe. Apart from enhancing the powers of the altars and warding off evil, the priest also hands out amulets to warriors who participate in the 'Maljeveq' ritual, praying for peace and protection for the families of participating individuals, concluding and perfecting the ritual. — Chiang Li-Hua

p. 200, p. 232

〈陳栢淵〉，《白色檔案》系列
Chen Bo-Yuan, The File of White Terror Series

《白色檔案》系列主要記載的內容，關於一群因二二八事件被無情迫害的政治受難者。何經泰特意搭配黑布「捆包」（各種裝置手法）拍攝的現場，凸顯臺灣在控制人民言論與思想的「白色恐怖」年代裡，這群人身上所遺留的黑色陰影記憶。何經泰詳實記載他們的出生年、入出獄與刑期，一同為那個荒謬的時代做見證，藉以昇華他們的創傷，轉化為警覺與關切，讓受傷的心靈獲得救贖，給予應有的尊嚴與珍視。
〈陳栢淵〉肖像人物生於臺南市，1959 年被捕入獄，1975 年釋放出獄，刑期十五年，罪名參加叛亂組織，當初他並不知情接觸的人，竟是共產黨的地下組織，逃亡八年之久，因其家人被脅迫，在母親陪同下自首。回首過往事端，他皆非出自自願，何經泰特意將原本一塊黑布，撕開成一段段的線條狀，暗黑的背景與其身上的黑色線條，暗喻黑牢裡的欄杆，臉上的光與影各占一半，象徵其半生皆是身不由己無辜地身陷牢獄之災。—— 姜麗華

The White Terror File Series primarily documents a group of political victims of the February 28 Incident. Ho deliberately used a black cloth to 'wrap' (a kind of installation method) the photography scene as a way of accentuating the dark shadows, the memories left behind by the speech and thought censorship during "the White Terror." Ho documented the years in which the subjects were born; when they entered and when released from prison; their sentences, bearing witness to the absurdity; endeavoring to transform their trauma into caution and a way of expressing care; redeeming their pasts and giving them the dignity and acknowledgment they deserve.
The subject of the portrait Chen Bo-Yuan was born in Tainan City and sentenced to 15 years in prison for joining rebel organizations; he was imprisoned in 1959 and released in 1975. At the time, Chen had no idea that the people he contacted were from an underground communist group. Chen fled his sentence for eight years, but turned himself in at the prompting of his mother because his family was being persecuted. None of Chen's encounters were of his own volition. Ho ripped a piece of black cloth into strips, the black background and the black stripes on the subject alluding to the bars in a dark cell. Half of the face of the subject is hidden in shadow, while the other half is exposed to light as a symbol of how Chen spent half of his life in jail, despite being innocent. — Chiang Li-Hua

p. 201, p. 232

〈李明輝（化名）〉，《白色檔案》系列
Li Ming-Hui (Alias), The File of White Terror Series

〈李明輝（化名）〉肖像人物生於臺南縣將軍鄉，1950 年被捕入獄，1963 年釋放出獄，刑期十三年，感化三年，從小生活窮苦，他想從歷史、哲學、經濟去探索臺灣社會問題的癥結所在，因而閱讀馬克思文集，接觸社會主義革命觀，期望改變社會的不公、不義，讓窮苦人家只要努力工作，可以有改變命運的機會，才會加入組織。雖然事過境遷，但他不願意使用真名發表，也不願讓人看清楚相貌，何經泰特意安排他站在黑幕後面，以剪影背光的形體，訴說這段事件並沒有隨著出獄而真正消失。 —— 姜麗華

The subject of *Li Ming-hui (Alias)* was born in Jiangjun District, Tainan County; he was sentenced to 13 years in prison, imprisoned in 1950 and released in 1963, with three years of probation. Li grew up in poverty and wanted to investigate the root of the problems of Taiwanese society through history, philosophy, and economics. He read the works of Karl Marx and encountered the socialist ideas of revolution; he joined a group hoping to change the injustice of society so that people from financially disadvantaged backgrounds would have the opportunity to change their fate through hard work. Although years have gone by, Li is still reluctant to use his real name and for others to see what he looks like; therefore, HO arranged for Li to stand behind a black cloth and be captured as a backlit silhouette, expressing the idea that the incident was not erased by Li's release from jail. — Chiang Li-Hua

p. 201, p. 232

洪世聰
HUNG Shih-Tsung

〈頂洲 -016〉，《自相似》系列
Ding-Zhou-016, Self-Similarity Series

鏡子看了自己？還是想著自己？
或是看著影子寫自己呢？
思維中的我！那是自我的想像，或只是表象，
借光嗎？好辨識自我藏在其中，
快門下的影子，是真實，也是自相似的我嗎？ —— 洪世聰

Mirrors show us ourselves? Mirrors come up with our self?
Or are we perhaps writing ourselves through our shadows?
The "I" in my thoughts! Is it my own imagination, or merely a facade?
Want to borrow a light? It will be easier to recognize the self hidden within...
The shadow captured by the shutter: is it real; or the self-similar image of myself? — Hung Shih-Tsung

pp. 202-203, p. 232

〈古坑〉，《後設與換位》系列
Gukeng, The Meta and Transposition Series

紅線界域了白與黑的領域，淺水灘的清晰形體是雨水的累積，路燈投映在地上的影子是彎折而模糊的黑體，此暗夜的路燈成為白晝的影畫。空白與實體成為去背與真實影像的二維對照，停僅蔥翠隱藏在矩形的視框內，此窄縫中的外在，有如跳脫出白晝的現實。 —— 洪世聰

The red line delineates the boundary between the domains of white and black. The shallow pool assumes a clear shape with the accumulation of rainwater. The shadow of the streetlamp on the ground is a bent and blurred black mass, imbuing the lamp with the quality of a daytime painting in the darkness. The interplay between blank space and solid form creates a two-dimensional contrast between the background and the real image. The lush greenery is concealed within the rectangular frame, and the external world within this narrow aperture seems to transcend the reality of daylight. — Hung Shih-Tsung

p. 204, p. 232

〈外澳（2007）014〉，《迫降》系列
Forced Landing: Waiao (2017) 014

探視這一片領域，物體，我忽視它在此域隱含的角色，牠游離無法掌控，也牽動我的情緒而感受此敬畏。影子的存在只是牠歸所前的假象，將之位移而賦予漂浮，是最終的歸所。 —— 洪世聰

Exploring this realm, I neglect the implied role of the objects: they wander, eluding my control; they stir my emotions, filling me with awe. The existence of shadows is merely an illusion before their return to their origin, shifting and floating, but ultimately returning to their source. — Hung Shih-Tsung

p. 205, p. 232

張宏聲
CHANG Hong-Sheng

〈花好，一如人生一般，不再回首的一程。〉
Flowers, Like Life, is a Journey Without Looking Back.

〈花好，一如人生一般，不再回首的一程。〉畫面如題，一朵鮮白色的蓮花，象徵出淤泥而不染的美好，一名隱身在暗處的女子，宛如身處蓮池中，被蓮花、蓮藕等圍繞，暗喻她不可復返的一生……。—— 張宏聲、姜麗華

The image, as the title suggests, features a pristine white lotus flower emerging from mud, signifying the beauty of purity and resilience. A woman, concealed in shadows, is portrayed as if she were submerged in a lotus pond, surrounded by lotus flowers and stems. This suggests that she is in a state of irreversibility, unable to return to her previous life. — Chang Hong-Sheng and Chiang Li-Hua

p. 206, p. 232

〈一切的因緣，起於執起相機之剎那；一切之心念，終於快門結束的當下。〉
It All Began the Moment the Camera Was Raised and Ended When the Shutter Clicked.

〈一切的因緣，起於執起相機之剎那；一切之心念，終於快門結束的當下。〉畫面如題，一切起因發生在攝影棚內，作為被拍攝對象的母子塑像，在燈光照射下產生的影子，宛如一尊佛陀或是對應攝影者的想像，而所有一切的想像即其心念……。—— 張宏聲、姜麗華

The photo shoot took place in a photography studio, with a mother-and-child statue as the central subject. The statue's shadow was cast under the light in a way that resembled either a Buddha or the photographer's imagination. The imaginings are a reflection of the artists' thoughts and perceptions. — Chang Hong-Sheng and Chiang Li-Hua

p. 207, p. 232

葉清芳
YEH Ching-Fang

《現實 ・ 極光 ・ 邊緣》—1990s
Reality · Aurora · Periphery -1990s

狗兒面對走近的生人感到不安，夾著尾巴、耳朵癱軟、身體緊繃、眼神疑懼，連腳步都顯得遲疑。反觀泡在水塘的水牛，正在以牠蜷曲短尾悠哉地朝背上潑水。葉清芳在取景時，把水泥地的邊緣線放在景框的右下角，將這個長方形的畫面，切成左下半的三角形和右上半的梯形。這個幾何構圖的梯形裡，另外還包含另一塊由乾草地構成的三角形。就視覺的層次上，近景陰暗處的土狗和遠景明亮處的水牛，在各自所在的幾何區塊中的比例上合宜，予以整體畫面一種均衡和穩定感。 —— 呂筱渝

In a stranger's presence, the dog exhibits unease—tail tucked, ears drooping, body taut, gaze wary, and steps hesitant. In contrast, a water buffalo joyfully splashes in a nearby pond. Yeh Ching-fang frames the shot with a concrete edge in the lower right, segmenting the rectangular image into a lower-left triangle and an upper-right trapezoid. This geometric composition further integrates a triangular patch of dry grass. Visually, the proportions of the apprehensive dog in the dim foreground and the carefree water buffalo in the bright background harmonize within their respective geometric areas, imbuing the overall image with balance and stability. — Lu Hsiao-Yu

p. 208, p. 227

《現實 ・ 極光 ・ 邊緣》—1980s
Reality · Aurora · Periphery -1980s

在圖像的視覺空間裡，足以產生生動且難以捕捉的符號意義與場景效果，如同這幀照片在簡單的方形、圓形等幾何構圖中包含引導視覺的動態線條，使得視線彷彿隨著行駛中的摩托車不斷前進，同時也將如此真實的場景從現實的景象中抽離，安置在獨立存在的朦朧、神秘而溫馨的視覺空間，而且也在這個平面化的圖像空間構築了一種感知與記憶的深度。
在這個偶然、隨機拍攝的景象，葉清芳運用慢速動態攝影的特性，記錄了路上一家三口在雨中騎乘摩托車的平凡題材，透過光影反射的高度對比及其造成的剪影效果、速度性的線條感，與三人身上塑膠雨衣的反光造成視覺性的對比錯位，以及潮濕路面上樹木的模糊倒影，將雨中即景的詩意表現得淋漓盡致。 —— 呂筱渝

The photographer captured a family of three riding a motorcycle in the rain, utilizing the characteristics of slow-motion photography to create a poetic expression of the moment. The highly contrasting light and shadow reflections and resulting silhouettes, the sense of speed conveyed by the lines, and the visual contrast caused by the reflection of the plastic raincoats worn by the three people, as well as the blurred reflection of the trees on the wet road surface all contribute to the overall effect. The viewer's gaze is drawn into an independent, hazy, mysterious, and warm visual space, constructing depth of perception and memory in this flattened image space. — Lu Hsiao-Yu

p. 209, p. 227

蔡文祥
TSAI Wen-Shiang

《墨行》
Movements of Ink

《墨行》這六件作品創作思考主要始於文藝復興以來，藝術流於追求形象和表現性層面，忽略了純粹情感的重要性。此系列作品借用觀看視角的改變及光、影與建築柱體的接觸，藉以探索攝影真實，視覺介面的創作能否從再現自然及反映現實的框架中解放出來。攝影見證客觀世界的痕跡與真實意義的追求不再是創作的目的，而是去實踐影像內外與人之間的對應關係，思維一種視覺構成與抽象情感生成或連結方式，攝影不應或不再只是被動的複製紀錄，而是創造特定事物的思維。
作品的樣貌是藉由「光」行移軌跡，點、線、面所結構出的簡單幾何圖形，加上飽和、純粹的黑、白與灰階色彩，呈現基本光影透視，建構出空間的虛與實及動與靜，這樣的創作企圖，是希望能超越色彩、物體、空間，旨在表達純粹情感的世界。攝影不再只是講求凝結瞬間的再現美學，所要表達的是一種全新對於觀看本質的追求與挑戰，是以主觀為中心的觀察與反應，呈現一種不真實的現實。 —— 蔡文祥

Movements of Ink is a collection of six works that reevaluates the artistic focus on imagery and expressiveness since the Renaissance, aiming to emphasize the significance of pure emotion. This Series explores the potential of photography and visual interface by altering the viewer's perspective and examining the interplay of light, shadow, and architectural elements, ultimately transcending the confines of reproducing nature and mirroring reality. This artistic endeavor shifts its purpose from capturing traces of the objective world to establishing a symbiotic relationship between the internal and external aspects of image and the observer. It delves into the connection between visual composition and abstract emotions, transforming photography from passive replication to the creation of distinctive thoughts.
Utilizing the movement of light to construct simple geometric shapes and employing saturated, pure black, white, and grayscale colors, the works create an interplay of void and substance, movement and stillness within the spatial realm. This approach transcends color, objects, and space, expressing a world of unadulterated emotion. The Series challenges conventional aesthetics, emphasizing the essence of observation and subjective reactions to present an illusory reality. — Tsai Wen-Shiang

pp. 210-211, p. 233

賴永鑫
LAI Yung-Hsin

〈窺視——新北汐止〉
Peek: Xizhi, New Taipei City

優良的攝影作品，光、影與色彩、構圖等，雖非絕對考量因素，卻是必然的條件。
攝影是捕光捉影的遊戲，是光影的藝術，因此光及影調的運用與控制，對於表達作品情緒，有著很大的影響。
攝影，並不單單為了製造一張美麗的照片，它可以被賦予個性，可以說故事，它是理性與感性並存的交織。這是攝影的魅力及樂趣所在。
〈窺視——新北汐止〉拍攝灰鷹（money），常常依附在壓克力板上，窺探籠子外的世界。可能因為長時間關押，牠竟啃去了自己一根腳趾。 —— 賴永鑫

Quality photography is not solely based on light, shadow, color, and composition, but they are essential elements.
Photography is a game of capturing light and shadow. It is the art of using light and shadow to express emotions.
Photography is not just about creating a beautiful picture. It can be given personality and tell a story. It is an intertwining of rationality and emotion.
When I photographed the bird, it clung to the acrylic board, peering into the world outside the cage. Perhaps due to long-term captivity, it bit off one of its claws. — Lai Yung-Hsin

p. 212, p. 233

陳淑貞
CHEN Shu-Chen

《AFTER》系列
AFTER Series

《After》（空場之後）創作內容主要以臺灣汽車旅館在投宿者離開之後的空場狀態，作者在經歷創傷事件後，以身為女性的視點，重新閱讀汽車旅館裡充滿性別象徵、殘餘父權、英雄主義、金錢遊戲等符號的相關詮釋及置身於此空間時的觀察與攝影創作的關聯性，得到領略與啓發，並同時以攝影創作來自我療癒，透過介入汽車旅館空間創作時的心理衝擊狀態與影像美學轉化實踐創作，來解析臺灣汽車旅館中的特殊空間文化，充滿異質性及脫離現實感的空間特質，尤其在投宿者遺存的痕跡、氣味、食物及被單皺摺狀態，呼應將自身的觀看過程，轉化成影像實踐的創作形式。因時常在汽車旅館的空間裡，觀察並體驗「光」的流動及隱匿的「影」，當置身於這些被刻意營造設計的空間裡，有著更多異於一般平凡室內可視光源呈現，有時這現象並非只是視覺性的光感，更是一種知覺的喚醒。空間因「光」而存在，我們自身也因「光」而重組自我存在的樣貌，「光」成了一種介面，進而傳達訊息為我們詮釋並賦予意義。而隱匿的「影」，彷彿是為了「光」而存在著，他們相互依附呈現共生的自然現象。在可視的光之外，我們卻也經常沉溺於暗黑的系統裡，因著這些暗黑系統，某種程度也投射自我生命的本質與那種生命裡不可承受的輕。── 陳淑貞

The *AFTER Series* focuses on the state of Taiwanese motels after guests have departed. The artist, having had a traumatic experience, reinterprets these spaces through a feminine perspective, examining symbols of gender, lingering patriarchy, heroism, and money games. This inquiry and photographic expression serve as a source of insight, inspiration, and self-healing. Immersing herself in motel spaces, the artist delves into the psychological impacts and aesthetics, analyzing Taiwan's distinctive motel culture and its surreal, detached nature. The remnants left by guests – scents, food, and wrinkled sheets – reflect the artist's transformation of her observations into creative practice. The artist consistently experiences and observes light and concealed shadows in these spaces, noting the extraordinary visual light sources in these intentionally designed environments. At times, the experience extends beyond visual perception to awaken the senses. Spaces owe their existence to light, which also restructures our own being. Light acts as an interface, communicating messages and bestowing meaning, while hidden shadows appear to exist symbiotically in tandem with light. Beyond visible light, people often find themselves indulging in the dark, which, to some extent, reflects the essence of life and the unbearable lightness within. — Chen Shu-Chen

pp. 213-214, p. 234

賴譜光
LAI Pu-Kuang

「哪裡有陰影，哪裡就有光」──雨果
這是一場人生的饗宴，還是自我的救贖之旅？
哪裡有陰影，哪裡就有光，一個逐光追影的獨行者。
像是傳說中的唐吉軻德或是薛西弗斯，自以為可用觀景窗捕捉生命意義的人。
受到法國作家雨果的精神召喚，踏上沒有起點、也沒有終點的音像旅程，
即使狄更斯早已預言：這是一個最光明的時代，也是最黑暗的時代。
我依然彎下身子摸石過河，在朝聖路上匍匐前行，
於明暗之間、陰陽之外，繼續尋找宇宙間最幽微的答案。 ── 賴譜光

"Where There is Shadow, There is Light" — Victor Hugo
Is this a feast of life or a journey of self-redemption?
Where there is shadow, there is light; I am a lone traveler chasing light and shadow.
Like the legendary Don Quixote or Sisyphus, a photographer believes he can capture the meaning of life through a viewing window.
Summoned by the spirit of French writer Victor Hugo, I embarked on an audiovisual journey with no beginning and no end.
Even though Dickens has prophesied, "It is the best of times and the worst of times,"
I bend down to feel the stones as I cross the river, crawling forward on my pilgrimage.
Between light and darkness, beyond Yin and Yang, I keep searching the universe for subtle answers. — Lai Pu-Kuang

pp. 215-216, p. 234

〈影像 2-1：逆光而行。臺北大稻埕〉
Image 2-1: Going Against the Light.
Taipei Dadaocheng

〈影像 2-2：生命的偶然與必然。臺灣北海岸〉
Image 2-2: The Chances and Certainties of Life.
The Nothern Shore of Taiwan

〈影像 2-3：我以為我是誰。京都嵐山〉
Image 2-3: Who Do I Think I Am.
Kyoto Arashiyama

余 白
Hubert KILIAN

《臺北原味》-5
The Original Flavour of Taipei -5

《臺北原味》系列作品，表現臺北歲月的氣息，「老舊的東西有一種生命感……拍照不見得是要把所見事物美麗化而是拍出讓人感覺到、卻看不到的東西」。2011 年至 2016 年間在臺北和新北拍攝，這些作品展現臺北某些被隱藏起來的美麗面貌，展現過去和現在融合的氛圍，也展現臺北人與城市間生活互動模式。這些影像可以被解讀為發現臺北不明的美的對話，並不是預先構想好的一張張嚴謹精確的紀錄，而是一種對於現實的詮釋，像一個虛構一直迴盪到凌晨的虛構。講述在臺北小巷茫茫的迷宮裡，無始無盡的遊走，城市本身變成了一個如夢似幻的世界。藉著重新創造這座城市的起源，我試著拍出這些獨一無二的氛圍。我玩弄時間軸，竭力營造一種存在的昏眩。我把臺北想像成劇院舞臺，上演著和存在有關的故事，時間停止了，石頭仍在。我試著捕捉這些掩藏在如幻似真的門面之後、沿著剝落斑殘的牆垣逐漸凋零的人生。於是我試著將我以為是某種永恆的臺北停格，我學著探索、了解然後去愛它。 —— 余白

The Original Flavour of Taipei Series showcases the atmosphere of Taipei through the years. "Old things have a sense of life... Photography is not necessarily about beautifying what is seen, but capturing what people can feel yet cannot see." These works were photographed between 2011 and 2016 in Taipei and New Taipei City. They reveal where the past and present merge, as well as the interaction between urban residents and the cities. These images can be interpreted as a dialogue that uncovers the unrecognized beauty of Taipei, not as meticulously precise records, but as an interpretation of reality, like a fiction. The story takes place in the vast labyrinth of Taipei's alleys, where there is endless wandering. The city itself becomes a dreamlike world.
By recreating the origins of this city, I try to capture the unique atmosphere. I play with the timeline, striving to create a dizzying sense of existence. I imagine Taipei as a theater stage, showcasing narratives related to existence. Time stands still, but the stones remain. I attempt to catch moments in the lives that gradually wither away, behind peeling and decaying walls. I try to freeze what I perceive as a certain eternal aspect of Taipei. I learn to explore, understand, and love it. — Hubert Kilian

p. 217, p. 234

汪曉青
Annie Hsiao-Ching WANG

《陷入黑色低潮的女人》系列 NO-10、NO-8、NO-1
The Woman Drowning in Black Tides NO-10, NO-8, NO-1

《陷入黑色低潮的女人》系列作品是藝術家二十一歲時首次以攝影創作發表的作品。表達當時年輕女性隱隱地承受一種沉悶、迷惑、抑鬱、不明所以的壓力……而不由自主地陷入在莫名的黑色低潮中。高反差的張力，強調當陷入低潮時那種濃烈的情緒，以致於重要的變得更重要，不重要的就變得不存在。而模糊訴說著無助、無奈、無法理清、捉摸不定的內在感受。身體的變化、內在的感受與社會上對女性期待、規範、禮儀等，無論合理或不合理，繁瑣且多樣地、無時無刻地以不同方式圍困著花樣的青春，而難以逃脫。 —— 汪曉青

The Woman Drowning in Black Tides Series was the artist's first published artwork created with photography at the age of 21. It expresses the subtle pressure that young women at the time experienced, as they felt stifled, confused, depressed, and inexplicably overwhelmed, involuntarily swirled into emotional black tides. The high-contrast tension emphasizes the intense emotions experienced when in the depths of despair, making the important even more important and rendering the unimportant nonexistent. The images convey a sense of helplessness, frustration, confusion, and elusive inner feelings. The physical changes, inner feelings, societal expectations, norms, and rules of etiquette placed on women, whether reasonable or unreasonable, intricately encircle the blossoming youth at all times and in countless ways, making it difficult to escape. — Annie Hsiao-Ching Wang

pp. 218-219, p. 235

張志達
CHANG Chih-Ta

〈Blossoming〉
Blossoming

捱過了濕冷的冬日，終於來到欣欣向榮的季節，傍晚時分，暖暖的夕照令人身心舒暢，白色的花朵井然有序綻放著，為偌大的廣場增添無限春意。 —— 張志達

Having endured the damp and cold winter days, we finally arrive at the thriving season. In the evening, the warm glow of the setting sun brings comfort to both body and soul. The blossoming of white flowers adds spring charm to the vast plaza. — Chang Chih-Ta

p. 220, p. 235

〈Cycle〉
Cycle

這不完整的圓是出口也是入口，依循著某種世俗既定的規範與價值觀前進，似乎就有機會達到普世價值的社會認同地位，但無形中似乎被制約了，過程中陷入無限的循環是否失去了潛在的初衷，自我核心價值的尋找成了無解的課題。 —— 張志達

This incomplete circle serves as both exit and entrance. By following certain societal norms and values, it seems that one has the opportunity to reach a universally valued social identity. However, the trajectory also forms an endless, constraining cycle, potentially causing people to lose their original intentions. The search for one's core values becomes an unsolvable issue. — Chang Chih-Ta

p. 221, p. 235

楊士毅
YANG Shih-Yi

《黑暗中的自然》系列
Nature in Darkness

《黑暗中的自然》以遊戲自拍的方式進行人體攝影創作，去掉衣物（象徵著社會規範或制度）這些形式所加之於身的不自然線條，使人原始美麗的線條與本性呈現或自然的展露出來。我們也知道這樣的追求是對的、是自然的（我們小時候便是如此），但為何這樣自然的畫面卻只能在黑暗的空間中進行，因此在畫面的構圖安排上，兩人遊戲、開心卻又時而帶點哀愁，時而似已得到回歸，卻又時而帶著不自然且生疏的動作。他們靠近光源靠近窗口，卻又好像又有所顧慮而不敢走出去。
在這樣衝突、矛盾的畫面中，我們探見了種悲哀，當人習慣於在某種制度的約束、規範下生活，在他追尋所想望的解脫過程中，就算他得到了想要的自由，卻又因長期受規範且已成習的心理影響，而自由的如此不自然。
受限於規範中該是不自然，但人們卻似乎已習慣成自然；自由自在的展現內心所散發出來的美，該是自然，但人們追尋到時卻又有些生疏，且只得以在黑暗中進行。
什麼是自然？什麼是不自然？而黑暗中的自然算是自然嗎？在這裡不需要有答案，因為我們看見了問題，自然便懂了追尋…… —— 楊士毅

Nature in Darkness explores body photography through a playful, self-portrait approach. By removing clothing which symbolizes societal norms or regulations, it reveals the inherent beauty and primal nature of human body forms. Such images can only be captured in darkness, even though nudity and bodies are natural. The subjects engaged in play, at times joyful or melancholic, approaching the light source and window, yet hesitant to step outside.
In the conflicting images, we glimpse a certain sadness. Accustomed to living under constraints, people may find that even when they attain freedom, it feels unnatural due to the psychological impact imposed by long-term conformity. Displaying inner beauty should be natural and carefree, but people feel it foreign and only reach for it in darkness.
What is natural? What is unnatural? Is nature in darkness considered natural? Recognizing these questions, we are driven by nature to pursue the answer. — Yang Shih-Yi

pp. 222-223, p. 236

比喻 逐光追影及它義 隱喻
SIMILE Chasing Light, Shadows, and Alternative Meanings METAPHOR

隱喻之影 The Shadow of Metaphor 2023.07.27 〜 2023.11.19
比喻之光 The Light of Simile 2023.08.17 〜 2023.12.10

展覽 EXHIBITION

指導單位	文化部
主辦單位	國立臺灣美術館、國家攝影文化中心
總策劃	陳貺怡
副總策劃	汪佳政
策展人	姜麗華、呂筱渝
展覽總監	蔡昭儀
展覽執行監督	鄭舒媛、傅遠政
展覽執行	白于均
展場製作	五顏六色總合藝術有限公司
空間設計	陳聖華、邱憲章
文宣設計	賴貝姍
展場燈光	也許有限公司
翻譯	韞藝術翻譯工作室、高慕曦

Supervisor	Ministry of Culture
Organizes	National Taiwan Museum of Fine Arts, National Center of Photography and Images
Commissioner	CHEN Kuang-Yi
Vice Commissioner	WANG Chia-Cheng
Curators	CHIANG Li-Hua, LU Hsiao-Yu
Exhibition Director	TSAI Chao-Yi
Exhibition Supervisors	CHENG Su-Yuan, FU Yuan-Cheng
Exhibition Coordinator	PAI Yu-Chun
Exhibition Production	Colorful Design Co., Ltd
Exhibition Design	CHEN Sheng-Hua, CHIU Hsien-Chang
Graphic Design	LAI Pei-Shan
Exhibition Lighting Design	Mad B LLC
Translator	YUN ART Studio, Mu-Hsi KAO

網站 Website	ncpi.ntmofa.gov.tw
展覽地點 Venue	國家攝影文化中心臺北館 National Center of Photography and Images, Taipei 100007 臺北市中正區忠孝西路一段 70 號 NO.70, Section 1, Zhongxiao W. Road, Zhongzheng Dist., Taipei 100007, Taiwan

專輯 CATALOGUE

發行人	陳貺怡
編輯委員	汪佳政、亢寶琴、蔡昭儀、黃舒屏、賴岳貞、林明賢、
	尤文君、曾淑錢、吳榮豐、粘惠娟、駱正偉
主編	蔡昭儀
執行編輯	白于均
專文撰稿	姜麗華、呂筱渝、曾少千
校對	白于均、林學敏、鐘悠儀
編輯製作	五顏六色總合藝術有限公司
書籍設計	賴貝姍
翻譯	蘊藝術工作室、高慕曦、碧詠國際翻譯社
譯文審稿	Matthew Townend
出版單位	國立臺灣美術館、國家攝影文化中心
	403414 臺中市西區五權西路一段 2 號
	電話：04-23723552
	傳真：04-23721195
製版印刷	偉城印刷有限公司
出版日期	2023 年 8 月
GPN	1011200814
ISBN	978-986-532-852-8
售價	NTD 980 元
	www.ntmofa.gov.tw

Director	CHEN Kuang-Yi
Editorial Committee	WANG Chia-Cheng, KANG Pao-Chin, TSAI Chao-Yi, Iris HUANG Shu-Ping, LAI Yueh-Chen,
	LIN Ming-Hsian, YU Wen-Chun, TSENG Shu-Chi, WU Rong-Feng, NIEN Hui-Chun, LUO Cheng-Wei
Chief Editor	TSAI Chao-Yi
Executive Editor	PAI Yu-Chun
Contributors	CHIANG Li-Hua, LU Hsiao-Yu , TSENG Shao-Chien
Proofreaders	PAI Yu-Chun, LIN Hsieh-Min, CHUNG Yu-Yi
Production Coordination	Colorful Design Co., Ltd
Book Design	LAI Pei-Shan
Translator	Yun Art Studio, Mu-Hsi KAO, APTA
Translation Editors	Matthew Townend
Publisher	National Taiwan Museum of Fine Arts, National Center of Photography and Images
	No.2, Section 1, Wu Chuan West Road, Taichung 403414 Taiwan
	TEL: 04-23723552
	FAX: 04-23721195
Print	Wei Chen Printing Co., Ltd.
Publishing Date	August 2023
GPN	1011200814
ISBN	978-986-532-852-8
NTD	NTD 980
	www.ntmofa.gov.tw

國家圖書館出版品預行編目(CIP)資料

比喻·隱喻 : 逐光追影及它義 = Simile·Metaphor :
chasing light, shadows, and alternative meanings/
蔡昭儀主編. -- 臺中市 : 國立臺灣美術館, 國家攝影文化中心,
2023.08
288 面 ; 23 x 27.5 公分
ISBN 978-986-532-852-8(平裝)

1.CST: 攝影集 2.CST: 視覺藝術

958.33 112011076